394
BAR

Barber, Richard

Tournaments

$29.95 25768

DATE		
JAN 08 1992		
JAN 07 1993		
MAY 11 1993		
OCT 19 1994		
MAY 09 1995		
FEB 27 1996		
FEB 26 2000		
MAY 03 2004		

RANCHO HIGH LIBRARY
1900 E. OWENS AVE.
NO. LAS VEGAS, NV 89030

© THE BAKER & TAYLOR CO.

TOURNAMENTS

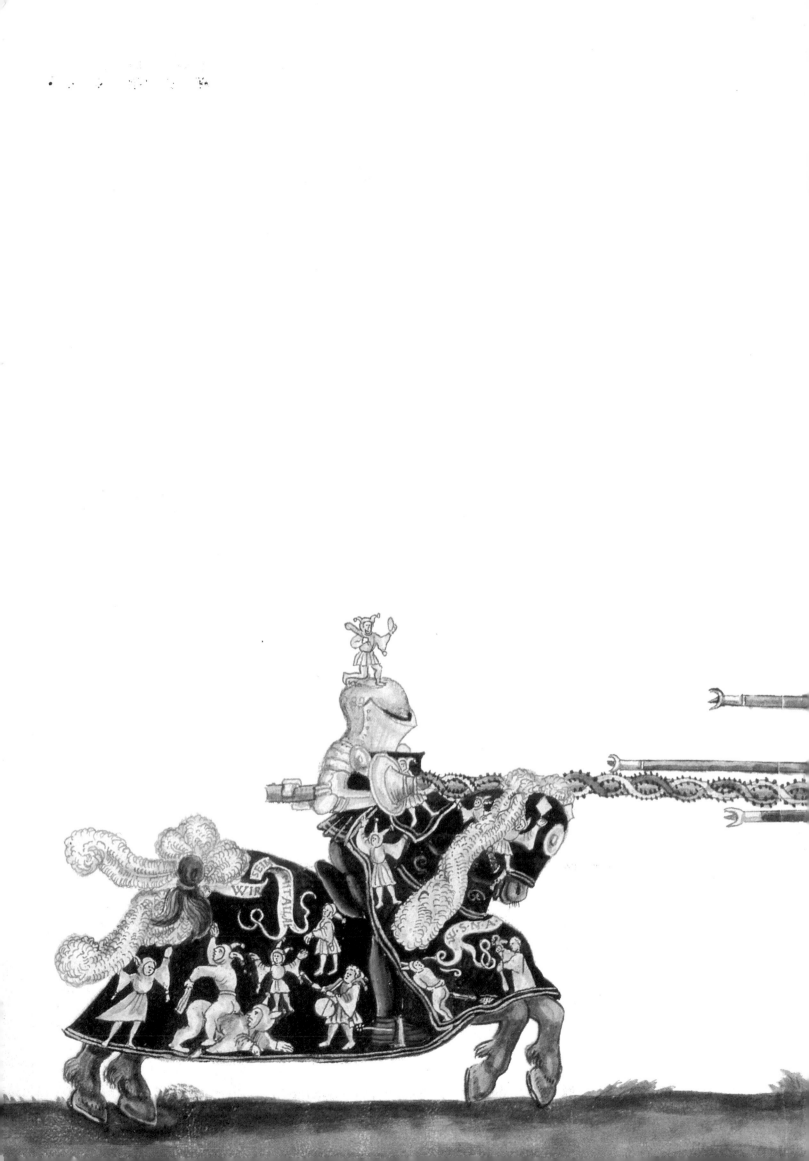

RANCHO HIGH LIBRARY
1900 E. OWENS AVE.
NO. LAS VEGAS, NV 89030

TOURNAMENTS

Jousts, Chivalry and Pageants in the Middle Ages

RICHARD BARBER & JULIET BARKER

WN

WEIDENFELD & NICOLSON

NEW YORK

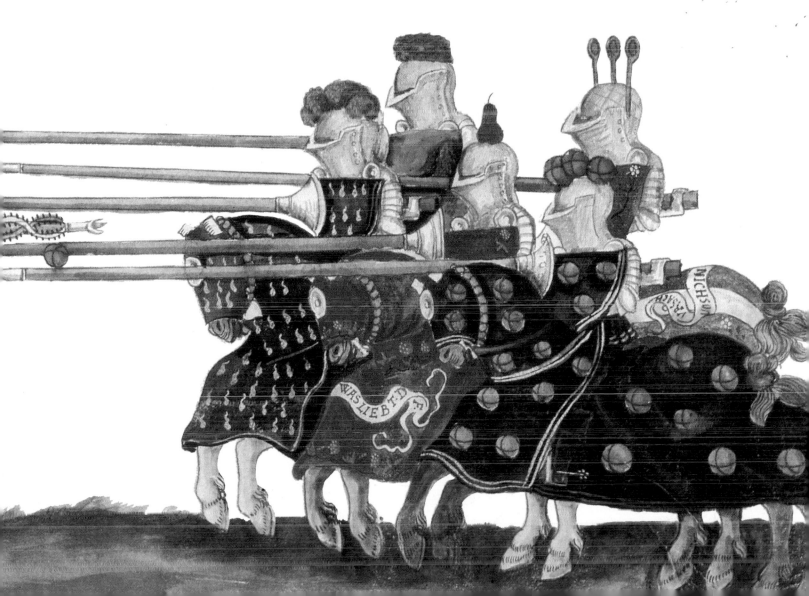

Copyright © 1989 Richard Barber and Juliet Barker

All rights reserved. No reproduction of this book in whole or in part or in any form may be made without written authorization of the copyright owner.

Published by Weidenfeld & Nicolson, New York
A Division of Wheatland Corporation
841 Broadway
New York, New York 10003-4793

Published in Canada by General Publishing Company, Ltd.

First published in Great Britain in 1989 by The Boydell Press, Woodbridge, an imprint of Boydell & Brewer Ltd., Woodbridge, Suffolk.

Library of Congress Cataloging-in-Publication Data
Barber, Richard W
 Tournaments / Richard Barber & Juliet Barker. – 1st ed.
 p. cm.
 Bibliography: p.
 ISBN 1-55584-400-6
 1. Tournaments – Europe – History. 2. Knights and knighthood –
Europe – History. 3. Tournaments in literature. I. Barker, Juliet
R. V. II. Title.
CR4553.B37 1989 89-30829
394'.7–dc19 CIP

Manufactured in Great Britain by Purnell

First American Edition

10 9 8 7 6 5 4 3 2 1

*Front endpaper: the entry of the judges into the town where the tournament is to be held, from René d'Anjou's treatise.
(Bibliothèque Nationale, MS Fr 2692 f.41v–42)*

Contents

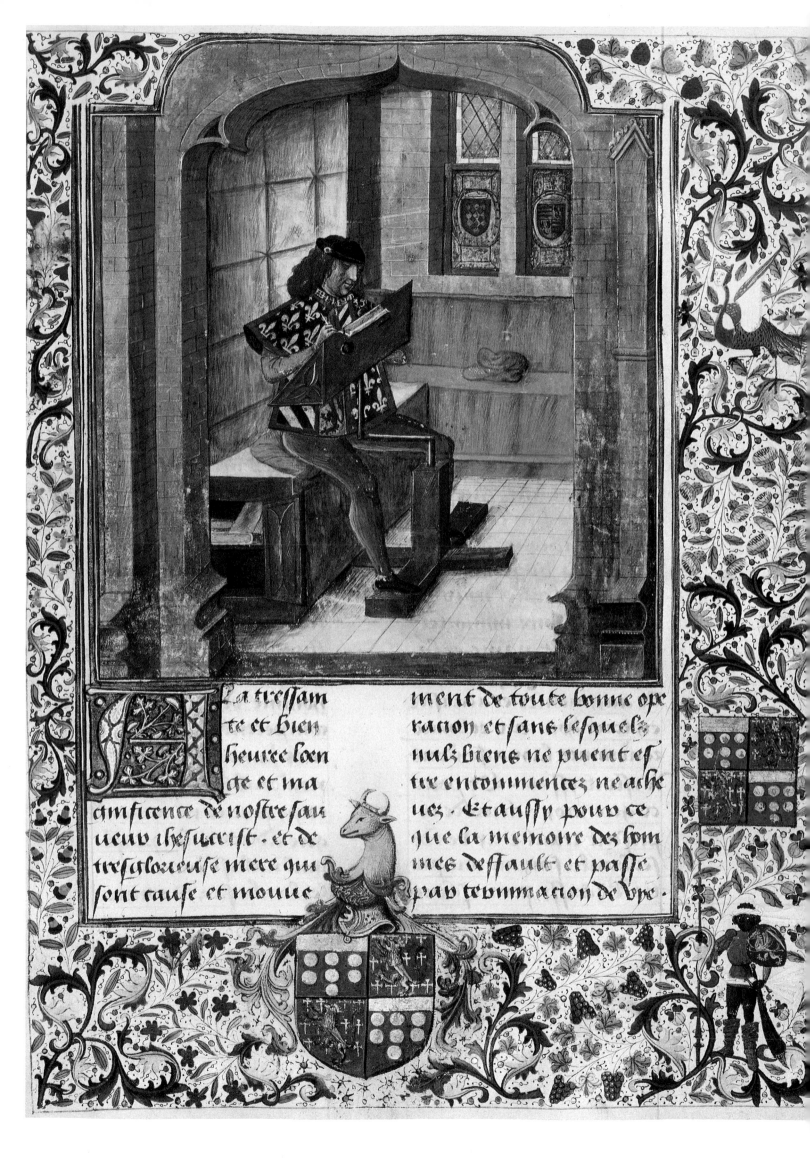

La tressam
te et bien
heuree loen
ge et ma
ctmscence de nostre sau
ueur ihesucrist · et de
tresglorieuse mere qui
sont cause et mouue

ment de toute bonne ope
racion et sans lesquelz
nulz biens ne puent es
tre encommencez ne ache
uez · Et aussy pour ce
que la memoire des hom
mes deffault et passe
par terminacion de vie ·

Prologue

In the grey world of everyday life, the light and colour of pageantry has always offered an escape from mundane reality. Medieval life was generally duller, greyer and harsher than ours; its great occasions stood out all the more sharply against such a background. Imagine a world where vivid colour was a luxury; where music was heard only at fairs, courts and suchlike great gatherings; where entertainments might be seen at rare intervals, and then only in towns and cities, a world where after nightfall the darkness was broken by no more than a few feeble gleams. Today, when our senses are bombarded with a surfeit of riches, we can still respond to the pageantry of a great occasion. The effect on a medieval onlooker of such a pageant was many times more intense.

Tournaments were at the heart of much medieval pageantry, and it is this image that remains with us today. They combined the spectacular with all the excitement of a dangerous, skilful sport, and the attendant hero-worship of its stars. Added to this, there was an element of idealism, for the tournament was central to the world of chivalry, and the ladies who watched from the stands were there to inspire as well as admire, to strengthen their knights' courage by their presence. By the end of the middle ages, tournaments were immensely expensive to stage, and hence were aristocratic, exclusive rarities, usually associated with some great occasion of state.

The tournament as pageant in its most elaborate form can be seen in the great *The tournament as pageant:* festival held at Bruges in 1430 by Philip the Good, duke of Burgundy (and king in all *Bruges 1430* but name) on the occasion of his marriage to Isabella of Portugal. The marriage itself took place at the nearby town of Sluys on 7 January; the following day, the new duchess made her formal entry into Bruges, where a range of elaborate temporary buildings had been added to the duke's palace to provide a huge banqueting hall and the necessary kitchens and larders. Outside the palace, a great wooden lion crouched, a gun beneath one paw and a stone under the other, from which red and white wine flowed into a basin day and night. Within the courtyard, a stag and a unicorn held flasks from which hippocras and rosewater poured. And inside the hall itself, a gallery was provided with space for sixty men – heralds to announce the different stages of the feast and musicians to play for the dances. The whole room was hung with specially woven cloth, bearing the duke's device of a gun with flaming cannonballs. On a gilded tree, standing on a lawn within the hall, hung the arms of the duke's various lordships, with his own arms in the midst.

When the duchess made her entry, in a gilded litter carried by two horses, the crowds were such that it took her two hours to make her way, through streets entirely hung in vermilion cloth, to the ducal palace, where a fanfare of 76 trumpets welcomed her. After attending church, a great banquet took place; we have a minute description of it from the duke's herald, Jean le Fèvre, lord of St Remy. He tells us exactly who sat where – surprisingly, the duke dined in his private chamber, while the duchess presided at the feast – and what was served, particularly the elaborate confectioneries displayed on the sideboard of ladies holding unicorns mantled with the duke's arms, or a wild man on the ramparts of a castle, with the same arms displayed on his banner.

Facing page: The biographer of Jacques de Lalaing, one of the greatest jousters of the fifteenth century, records his exploits.
(Bibliothèque Nationale, MS Fr 16830, f.1)

The culmination was a vast pie, containing a man dressed as a wild beast and a live sheep with gilded horns which had been dyed blue. The feast was followed by dancing, at which both ladies and knights changed their dress two or three times, and which continued until after midnight, when a tournament was announced for the following day.

The tournament lasted from Monday to the following Sunday, with Friday as a rest day: the first three days were taken up with individual combats or jousts, for which the market place was divided into three sets of lists, each with barriers along the sides and a low fence down the centre, to prevent the knights from actually colliding with each other. The contestants were divided into two teams, 'within' and 'without', or defenders and attackers; each day a prize in the form of a jewel or a golden chain was given to the best knight and squire from each team. There was great display among both spectators and participants; Jean le Fèvre comments that even the duke's officers and pages appeared in different costumes, and the silken dresses were weighed down with jewellery and furs. Each evening there was dancing. To crown these festivities, Philip the Good announced the foundation of a new order of knighthood, the order of the Golden Fleece, to consist of twenty-four knights only, a number associated both with the legendary Round Table of King Arthur, and, more realistically, with the highly successful English order of the Garter. Among the members of the new order were several knights who had taken part in the tournament.

Philip the Good's festivities at Bruges belong at the end of a lengthy tradition, and they raise a host of intriguing questions. How did mock warfare become a sport? When was the idea of a tournament invented? Were there set rules and forms? How widespread was the sport? What do we know about the details of technique and armour? The answers are surprisingly difficult to discover, and it has only been in the last few years, with the revival of interest in the ethics and reality of chivalry, that scholars have begun to answer some of these questions. This book uses this recent research to set out a coherent picture of the medieval tournament, but many of the conclusions must inevitably be provisional. Medieval historians – unless they were heralds, like Jean le Fèvre – often ignored tournaments altogether, or noted only the briefest details, so we have to hunt the smallest scraps of evidence and piece together what we can, from account books, letters, the odd note in a chronicle and (with great caution and as a last resort) the chivalric romances. It is rather as though we had to write a history of football from the news pages of modern newspapers: the sports reports of the middle ages (if they ever existed) have by and large vanished.

Technical terms Let us begin by defining our terms. In the account of Philip the Good's festivities, we have used the word 'tournament' to describe the whole occasion, simply because this is familiar to the modern reader as a general term. But 'tournament' also had a special technical meaning, and in this sense should not be applied to the events at Bruges. In a tournament, the two teams met as if in the open battlefield, in a general free-for-all or *mêlée*. It was much the most hazardous form of the sport, and as a result became increasingly rare with the passage of time. As the tournament in its technical sense became rarer, so the word for it was applied more widely to all forms of knightly combat (particularly in Germany), and it is therefore retained in the present book as a general term. The alternative, common in English and French chronicles in the period 1100–1400, is *hastiludium* or 'hastilude', literally a game fought with spears, and this can be applied to all forms of mounted combat, whether *en masse* or individual. 'Jousts' are specifically single combats, one against one, though the jouster may belong to a team; in the period up to 1400, they were usually fought without a central barrier to separate the combatants. 'Lists' were the enclosed area in which

Richard Beauchamp, earl of Warwick, jousts at Calais against Sir Colard Fynes in 1399.
(BL MS Cotton Julius E IV art.6. f.16)

tournaments or jousts are fought; in the earliest period of the tournament, the boundaries were very wide, and were not always clearly defined, but from the thirteenth century onwards a fenced enclosure seems to have been standard. We shall explore the detailed implications of all these terms later in the book.

But beyond the technicalities of the sport itself, there are a wider set of questions. What was the social function of the tournament? How does it fit into the world of chivalry as a whole, and what is the ethos behind it? And how does it relate to the laws of church and state? Here again we need to look briefly at the evidence, and define some of our terms. Just as the form of the tournament moves from mock-warfare to individual combat, so its social function changes from that of a game with military overtones to a purely sporting occasion with little practical application: a good parallel would be the development of modern yacht racing, which started as speed trials between working boats, such as those recorded by Samuel Pepys as an official of the English navy in the 1660s, and became a sport which has nothing to do with the commercial business of shipping, highly stylised, with elaborate rules, and extremely expensive – all three characteristics shared with the great tournaments of the fifteenth century. As to the tournament's place in the world of chivalry, we shall see how literature had a considerable influence on the tournament, and how the chivalric romances provided a literary framework for many occasions. In some cases, life imitated art even more closely, and the theory of the tournament is closely bound up with literary ideals. Furthermore, we shall see how the question of knightly status interacts with the tournament: the quest for individual fame rather than team victory is closely linked with the need for identification in the *mêlée*, and leads to the development of personal coats of arms. And the opposition of state and church to the dangerous rough and ready fighting of early tournaments gradually declines; the pendulum swings the other way, and it is the prince himself who becomes the chief patron of full scale tournaments.

And then we need to look at tournaments from the point of view of the participants. Were they simply a necessary part of training for warfare in the early days, and a required social ritual once their immediate military function was over? Far from it: no

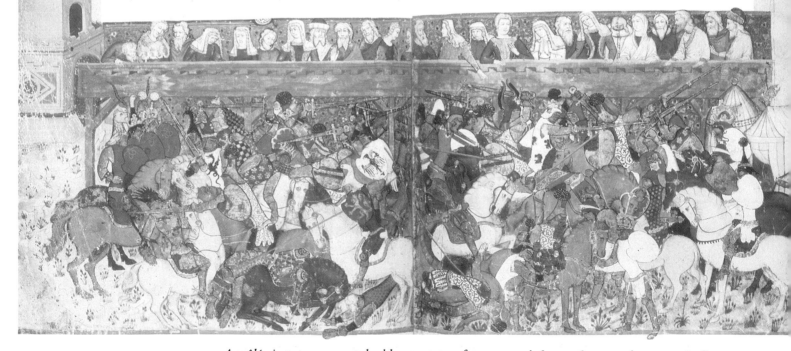

A mêlée in progress, watched by spectators from a stand, from a fourteenth century Italian manuscript of the romance of Meliadus.
(BL MS Add. 12228, ff.150v–51)

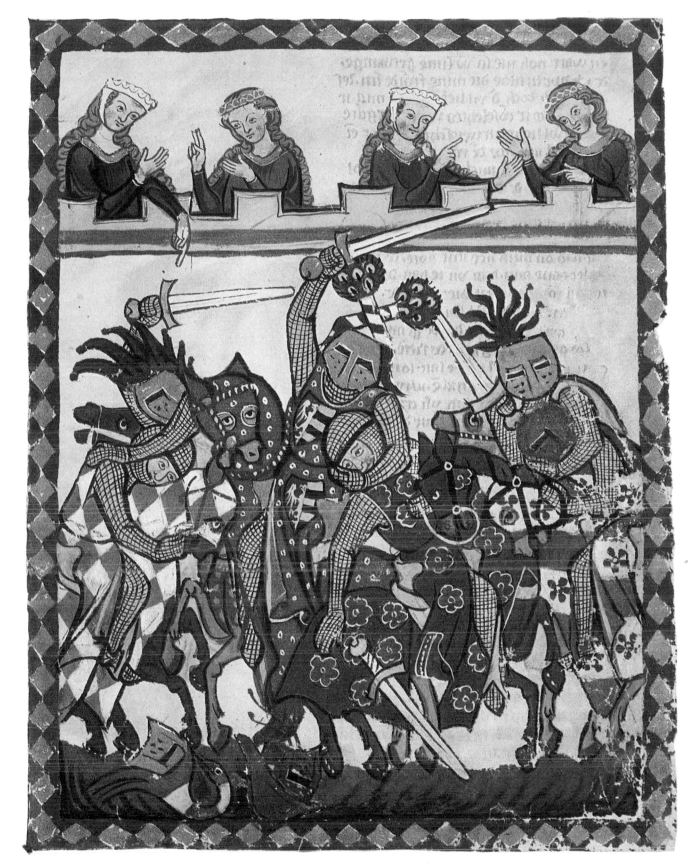

The dukes of Anhalt in a mêlée with swords: notice that, as in Edward I's encounter in the
'Little Battle of Chalons', one of them is wrestling with his opponent: from the fourteenth
century Manesse anthology.
(Universitätsbibliothek, Heidelberg, MS Cod. pal. Germ 848, f.17)

other sport, except hunting and hawking, aroused such enthusiasm. Tournaments were immensely popular, although it is difficult to gauge their frequency with any degree of accuracy, given that only major tournaments have found their way into the records. Like all sports, there seem to have been sudden bursts of enthusiasm, prompted by favourable circumstances: in the 1170s and 1180s in France, under Edward I and Edward III in England, in Castile under Juan II, and at the court of the princes of Saxony in the mid-fifteenth century. Several of the great knightly orders were intimately linked with jousting: the first three such orders to be founded – St George in Hungary, the Banda in Castile and the Garter in England – were all associated in some degree with tournaments. Equally, individual enthusiasm, as in the case of Ulrich von Liechtenstein in the early thirteenth century, could provoke a whole series of jousts, while in the fifteenth century we find knights travelling from Spain to England or from Burgundy to Spain with letters of challenge to all comers, in search of such single combats. Not all of them found fame and glory: in satirical attacks on knights, the knight who has frittered away his estates at tournaments is a stock figure.

Skills required in tournaments Tournaments were a highly skilled and often highly dangerous sport. We know relatively little about the detail of training for arms, but it was unusual for knights or squires under eighteen to take part in a major tournament, and most of the participants would have had long years of apprenticeship or experience of real warfare. The manipulation of a powerful, thoroughbred horse and a heavy lance, complicated by the restricted movement and vision imposed by armour, was a skill acquired only with patient practice at such devices as the quintain and the ring. And danger was inherent in tournaments: it is difficult to assess just how dangerous they were, since the one item most likely to be mentioned by a chronicler is the death of an important lord in a tournament. Perhaps the best comparison is with mountaineering or motor-racing today, sports which make the headlines when the inherent danger which is

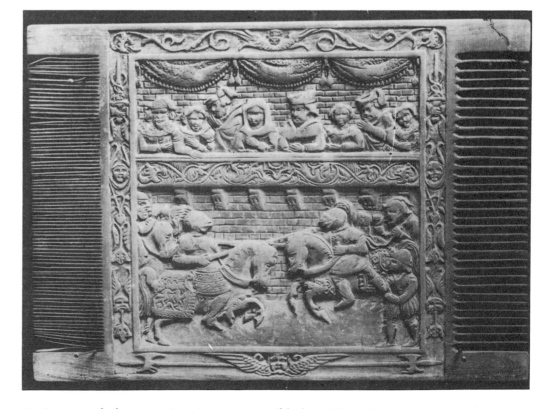

An ivory comb showing a jousting scene, possibly from fifteenth century Germany. (Jesús Bertran collection) (Foto MAS, Barcelona)

always present becomes a real disaster. In tournaments, there was an added complication: apart from accidents, there was always room for treachery, for the substitution of sharp weapons for blunted ones; and even without treacherous intentions, a fully armed knight who lost his temper in the *mêlée* could easily kill his opponent in a fury and regret it afterwards.

But this is to dwell on the black side. Early tournaments were undoubtedly crude and violent affairs where a thick skull and a strong arm were needed: but jousting came to be a sport where the correct physical co-ordination of horse and rider resulted in a safe but spectacular splintering of lances. Indeed, the problem with most tournaments was almost certainly a lack of the excitement that such occasions demanded: not many courses – a charge by two opposing knights – could be run each day; and, as with the jousts on the last two days at Bruges, only a few spears might be broken. The evidence from sixteenth-century Germany bears this out, because at Maximilian I's court, knights were equipped with shields which were spring-loaded so that they flew apart if struck in the right place, an attempt to enliven the sport for both spectators and participants.

The presence of spectators undoubtedly influenced the evolution of jousts in a number of ways. The first evidence we have for ladies being present at jousts is in literary sources in the mid-twelfth century; they are very rarely mentioned in historical evidence before the thirteenth century, but the evolution of personal heraldry and of the function of heralds points to the presence of a large and interested audience who needed to know who the individual knights were; and the swing away from the *mêlée* or tournament proper, where it was difficult to tell what was happening, to the much more easily understood individual jousts, was probably the result of spectator interest. It was also favoured by knights who wished to impress the spectators, particularly their ladies, as there could be no doubt as to the identity of the participants and the result.

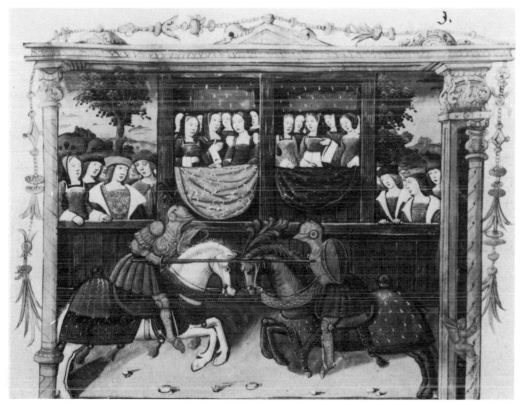

The seventh of the 'twelve tournaments of the shepherds' fountain', from an early sixteenth century MS (Fotomas Index, London)

*Tournaments as social
occasions*

The development of the tournament into an elaborate social occasion was also due
to the presence of spectators. The private free-for-alls of the twelfth century involved
little more than common acceptance of a few minimal rules: the fighting was para-
mount. At the other extreme, in the late sixteenth century, the pageantry was every-
thing, and the jousting a formality: in Italy and France, it was eventually replaced by
'carrousels' or equestrian ballet. The most elaborate form of the tournament proper
was that outlined by René, count of Anjou and titular king of Sicily, in his treatise on
how to hold a tournament, written in the 1450s. Preparations began months, even
years ahead, with the issue of invitations through heralds, and the jousting itself was
preceded and followed by elaborate ceremonials, banquets and dances; the whole
event was expected to last a full week, with the jousting beginning on the Monday.
The surrounding pomp was designed to involve the spectators, and to extend the
excitement of the occasion beyond the actual contest in the lists; and to further this
end, there was always the possibility of mounting the occasion as a kind of drama,
with knights and ladies playing parts based on chivalric romances. This tradition,
which first appears in Cyprus in 1223, was an important and powerful element in the
history of the tournament, and survived the tournament itself to become the court
masque of the seventeenth century.

But even a week-long event was not enough to satisfy the real enthusiasts. In the late
fourteenth century, a new form of knightly combat evolved, which could be made to
last as long as the participants wished. This was the passage of arms, based on episodes
in the Arthurian romances, where knights undertook to defend a given place – usually
a ford or a bridge – in single combat, until they were defeated, in which case their
conqueror took over their task: the romance of *Yvain* by Chrétien de Troyes, written
about 1170, is the earliest literary example. In the passage of arms, however, the
defence was for a stated period, and defeat did not mean surrender to the new cham-
pion. The famous *Passo Honroso* was held in 1434 by Suero de Quiñones and nine
others at the bridge of Orbigo in northern Spain, for a fortnight before St James's day
(25 July), with the object of breaking 300 lances; if they failed to do so in the specified
time, they would remain there for a further fortnight. In fact, they broke 178 lances in
the period 12 July to 9 August, and 69 knights came to joust with them. There was
about two hours' worth of jousting each day, which hardly made it an exciting
occasion for onlookers: it was entirely for the benefit of the knights involved. The
Passo Honroso and other passages of arms had little pageantry about them, though
they were carefully refereed and recorded by heralds; these, rather than the spectacu-
lar ceremonial jousts, were tournaments for the connoisseur.

The organisation of any tournament was a complex affair, involving all the labori-
ous business of letters in an age when communication was far from easy. One solution
to this seems to have been to announce details for the next tournament at the end of the
previous one. Another, found exclusively in Germany, was the tournament society,
an institution which appears in the mid fourteenth century in Bavaria and which may
help to account for the high frequency of tournaments there when they were com-
paratively rare in France and England. These societies were in effect permanent
tournament teams from different regions; instead of summoning individual knights, a
challenge could be issued by one society to another. Equally, the knights might agree
to meet annually for a tournament, as in the rules of the Bavarian society.

With this highly formal structure of the sport went an increasing interest in record-
ing the result. We have only two full-length works on tournaments before 1400, both
heralds' descriptions in verse. In the fifteenth century, we find both prose treatises
on the management of tournaments and elaborately decorated books recording

encounters between individuals: the most ornate series is that of the Saxon princes, and the genre culminates in the engravings by Hans Burgkmair recording Maximilian I's tournaments. Pride in the family record in tournaments is evident from the beginning, as the earliest apparent records of tournaments stem from attempts to rewrite the history of a particular house to include early participants in such occasions. There must have been many more records such as the note by the lord of Cronberg in Nassau of his son's tourneying record, written at the end of the family's collection of legal deeds: the German tournament books survived because of their profuse illustration where other such documents would have perished.

For participation in tournaments was normally restricted to knights, and evidence of such participation was valuable support for a family's claim to nobility. This equation of tournaments with knightly status was extended, in Germany particularly, to the idea that only worthy knights could take part: although the rules dealing with the expulsion of knights who have breached the code of chivalry sound theoretical rather than practical, there are indeed actual examples of adulterous knights being banned from tournaments, and soundly beaten into the bargain. Yet curiously it is in Germany that we have evidence for tournaments in which citizens of non-knightly status took part, who in the circumstances of the times were unlikely to have been candidates for admission to the chivalric world.

These, then, are the broad topics which we will deal with in the following pages. But before we begin at the beginning, it may be helpful to say a little more about the sources for what follows, and the problems they create. Firstly, we have tried to work as far as possible from historical sources only; but every historical narrative is also a work of literature, and nowhere is the borderline more difficult to define than in the

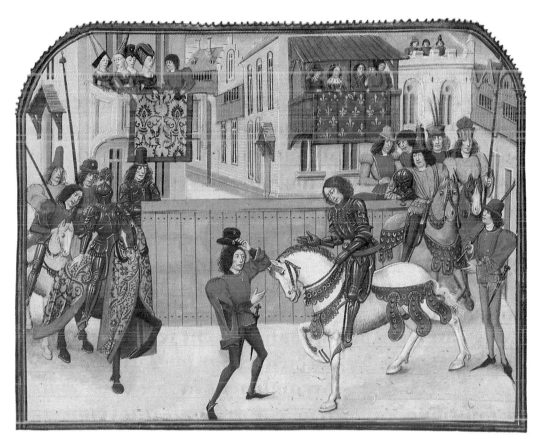

Knights entering the lists for a joust, from a fifteenth century French romance illustrated by a Flemish artist. (Brussels, Bibliothèque Royale Albert Ier, MS 6 f.51v)

three major early works on tournaments, *The history of William the Marshal*, *The tournament at Chauvency* and *The romance of Le Hem*. All three were written by minstrels or heralds who had witnessed some or all of the events they described, or had talked to eye-witnesses; but equally they were writing for patrons who wanted a certain view of events. More problematic for us, they were writing for an audience who did not need to be told the ground-rules of the sport. So while we learn a good deal about the participants and their prowess (or lack of it), the actual proceedings have to be reconstructed from incidental remarks. Only one full description of a fourteenth century tournament survives, that of the jousts of St Inglevert in 1390, and it is not until the fifteenth century that we get formal accounts of the rules for holding tournaments, written by heralds or other experts in the field. At the same period, we get a number of full descriptions of tournaments, particularly *pas d'armes*, and it is all too easy for these to influence our view of what went on in earlier tournaments.

Nature of the evidence Our main evidence for incidents at tournaments, usually mishaps or fatal accidents, comes from chronicles. The majority of medieval chronicles were written by members of religious orders, who could not take part in them, and in most cases might never have seen one; so the details are always very brief. Even secular chronicles before the fifteenth century rarely give additional details, and the chronicle evidence consists of hundreds of minute scraps of information. Similarly, the evidence to be found in legal and administrative records is thin and widely spread: the legal records tell us for the most part about bans on tournaments, though financial records do

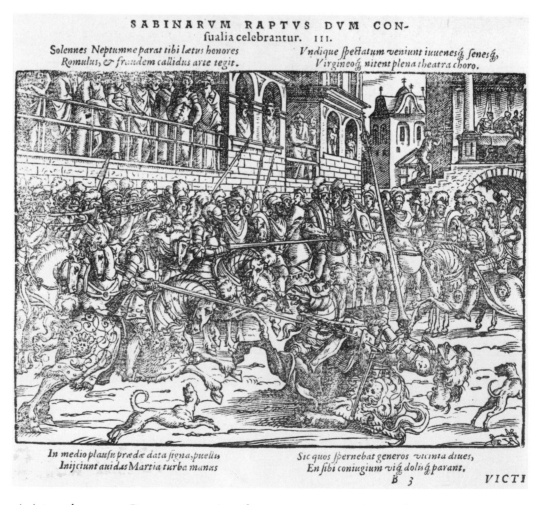

SABINARVM RAPTVS DVM CON-
fualia celebrantur. III.

Solennes Neptumne parat tibi lætus honores
Romulus, & fraudem callidus arte tegit.

Vndique ſpectatum veniunt iuuenesq́ ſenesq́,
Virgineoq́ nitent plena theatra choro.

In medio plauſu prædæ data ſigna, puellis
Inijciunt auidas Martia turba manus

Sic quos ſpernebat generos vicinia diues,
En ſibi coniugium viq́ dolisq́ parant.

B 3 VICTI

A sixteenth century German engraving of a tournament, complete with musicians.
(Fotomas Index, London)

provide tantalising glimpses of the cost of armour and costumes, and the production of specially designed tournament armour. Personal letters, rare enough throughout the middle ages, tell us a little about attitudes to tournaments and the practical problems – such as simply finding horses and armour – which the would-be tourneyer had to face.

Memoirs, biographies and autobiographies, of which a number survive from the fifteenth century, give us a much more vivid picture of events (although we have to beware of taking everything at face value). We have also the elaborate letters of challenge which became part of tournament etiquette, and some of the literary scripts which framed the action of a tournament in a romantic or mythical setting. We have, however, deliberately restricted our use of medieval romances themselves as evidence for the way in which tournaments were run, because it is quite probable that the scenes imagined by the authors of the romances were only later translated into reality. The classic example of this is the Order of the Round Table, described in detail in a thirteenth century romance, which has no real-life parallel until the early fourteenth century. It would be perfectly possible to write an account of medieval tournaments entirely from romance material, and it might not be a bad account, either: but we are primarily concerned here to establish something of the *history* of the tournament, and for this purpose, we can only refer to the romances in support of what we can show to have had some existence in reality. As we have already noted, literature undoubtedly inspired many real-life tournaments, and provided the framework for others: and we shall concentrate on life imitating art in this way, rather than assuming that art is a true mirror of historical reality.

For, as with chivalry as a whole, there is an undoubted tension between vision and reality in the history of tournaments. The imagined panoply of heraldic colours, gules, argent, or, azure, brilliant in the sun, the bravery and skill of the knights, the devotion of their ladies, could all too easily prove to be a damp succession of uncontrolled and unsuccessful charges by inexperienced riders, endured by a handful of bored spectators. Like chivalry, the tournament came to be an institution with high ideals and aims; how this came about, and how close the real tournament was to achieving those ideals, we shall try to outline in the following pages. If nothing else, it has been a fascinating quest, taking us from one end of Europe to the other; and it has proved a richer and more diverse subject than either of us expected when we began.

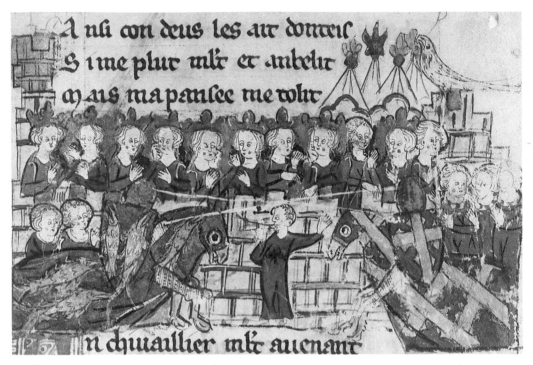

Celebrating a tournament: dancing and a joust with ladies watching from behind a barrier and tents in the background, from the fourteenth century manuscript of Jacques Bretel's Le Tournoi de Chauvency. (Oxford, Bodleian Library MS Douce 308 f.117, 123)

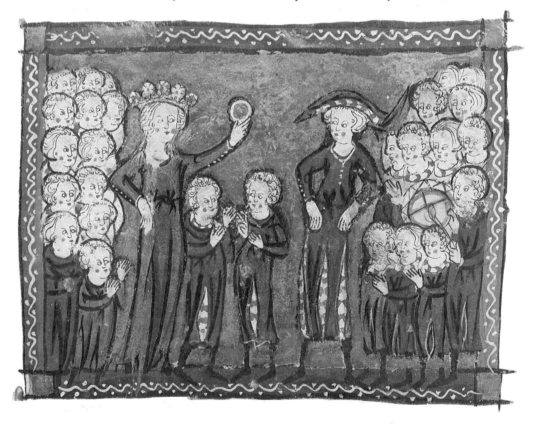

1

The Origins of the Tournament

Military games and exercises are as old as the history of war itself. The advantages of training and discipline from early youth in the bearing of arms and practice of martial skills had been realised since the days of ancient Sparta and Rome. The example of the classical world, particularly that of Rome, was cited and emulated throughout the medieval centuries and tournaments too were seen as a continuation of this tradition of military exercise.

However, faced with the simple question, 'When was the first tournament held?', we cannot give an answer. At what point tournaments emerged as a distinct form of martial sport is not clear, and their origins have been further obfuscated by chroniclers anxious to claim the longest possible record of participation in tournaments for their patrons. The games of horsemanship held in 842 to celebrate the alliance of Louis the German and Charles the Bald have been claimed as the first tournament on record, though it is clear that these simple manoeuvres, where the two teams charged each other, wheeled about and took turns to simulate flight, involved none of the actual combat which was an essential part of the tournament, and which sets it apart from simple equestrian manoeuvres.[1]

They are described in terms not unlike the games at the funeral of Aeneas' father Anchises in Virgil's *Aeneid* where the riders

first galloped apart in equal detachments, then in half-sections of three broke ranks and deployed their band as in a dance; and then, at another order, they turned about and charged with lances couched. Next they entered upon other figures too, and reversed these figures, with rank facing rank across a space between; and they rode right and left in intertwining circles. And they began a pretence of armed battle, sometimes exposing their backs in flight and sometimes turning their spear-points for attack. Then they made peace again and rode along in an even line.'[2]

The herald Georg Ruexner, in his *Turnierbuch* of 1530, described the elaborate tournaments held by Henry the Fowler at Magdeburg in 938. The convincing detail of his lists of tourneyers and his regulations for the conduct of the sport are marred by the anachronism of his vocabulary which indicates that the whole affair was simply a heraldic fabrication of the fifteenth and sixteenth century. Similar motives had led the early thirteenth century chronicler, Lambert of Ardres, to attribute the death of Raoul, Count of Guines, to an ambush in a tournament held in the early tenth

century.[3] A tournament at this early date seems unlikely, however, especially as there is no other indication in any contemporary source to suggest that the sport had developed at this time.

New cavalry tactics in the eleventh century

The tournament seems to have emerged as a distinct form of martial game at the end of the eleventh century, somewhere in the environs of northern France. This is the same period in which a new tactic, which was to have far-reaching consequences, was introduced to the battlefield. This was the use of the couched lance by a group of horsemen who mounted a closely coordinated charge as a single unit. Prior to this, there had been three alternative methods of wielding the lance, which was one of the main weapons of war. It could be used as a javelin to hurl overarm at the enemy, or it could be used as a spear to be held either overarm or underarm to jab at the opponent. The disadvantage to all three methods was that once the lance had made contact it was difficult to retrieve it and therefore the warrior was left vulnerable.

The couched lance, on the other hand, was held tightly tucked under the right arm so that a heavier (and more effective) lance could be used. The full weight of man and horse were behind each blow and the warrior was distanced from his opponent, making him less vulnerable to attack. Unless it broke in the onslaught, the lance was retained by the knight who could use it repeatedly if required to do so.

The combined effect of a company charging with their lances was enough to 'make a hole in the wall of Babylon',[4] according to Anna Comnena, the Byzantine princess who witnessed its devastating effect during the First Crusade. The new tactic seems to have originated in northern France, and it was largely responsible not only for the success of the Franks on the First Crusade but also for the conquests of the Normans in places as far apart as southern Italy and England. The Bayeux Tapestry, which so vividly portrays the Norman conquest of England, seems to have captured iconographically the period of transition from the older methods of lance warfare to the new; both kinds of fighting are depicted there.

The significance of the new method of combat was that it required training and practice in order to carry it off. Moreover, as its maximum effect could only be obtained by a number of knights acting in unison, it was *team* training and *team* practice that was necessary. The tournament fulfilled all these needs admirably and indeed may have developed precisely as a result of those needs.

The tournament, in its strictest sense, was a *mêlée* fought out over several miles of open countryside encompassing rivers, woods, vineyards and farm buildings – all of which provided useful opportunities for ambush and sortie. The boundaries were unmarked in the early days, though the field was vaguely designated by reference to two towns: tournaments were thus proclaimed 'between Gournai and Ressons', for example, or 'between Anet and Sorel'.[5] The only formal limits were certain specially designated areas which were fenced off as refuges where knights could rest or rearm in safety during the combat.

Several companies of knights took part, under the leadership of the same lords whom they followed and served in warfare, and often as many as two hundred knights participated on each side. At this early period there were no rules to distinguish the tournament from real battle: there were no foul strokes or prohibited tactics and, even if there had been, there was no-one to supervise or enforce them. It was thus quite common for several knights to band together to attack a single tourneyer: there were instances of tourneyers being attacked despite the fact that they had lost vital parts of their armour in the skirmishes and occasions on which any weapon to hand was used – including bows and arrows and crossbows. The only concessions to the sporting nature of the combat were the provision of refuges and the *sine qua non* that the object

of the game was to capture and ransom the opposing knights, not to kill them. Here was a rough and tumble game which was so strongly imitative of battle that it often became indistinguishable from it – a far cry from the disciplined cavalry exercises held for the entertainment of Louis the German and Charles the Bald.

Because the couched lance was introduced in the latter half of the eleventh century, and because the tournament seems to have arisen in response to the training the new technique required, it is possible to regard more seriously the smattering of references to tournaments which fall in the late eleventh century. The earliest of these occurs in Geoffrey of Malaterra's account of the wars of the Norman adventurers, Robert Guiscard, Duke of Calabria and Roger, Count of Sicily. At a siege in 1062 the young men from both armies who were 'ambitious for praise' tourneyed together under the city walls and one Arnold, the Count's brother-in-law was killed.[6] Geoffrey was writing in 1110, so that even if his account may be anachronistic for the year 1062, jousting of this kind must have been familiar by the turn of the twelfth century.

Earliest references to tournaments

The second, more famous reference occurs in two local chronicles of the town of Tours in northern France. Under the year 1066 the *Chronicle of St Martin of Tours* records:

> In the seventh year of the emperor Henry and the third year of king Philip, there was a treacherous plot at Angers, where Geoffrey de Preuilly and other barons were killed. This Geoffrey de Preuilly invented tournaments.

An abbreviated version of this account appears in the derivative short chronicle of Tours, under the year 1062:

> Geoffrey de Preuilly, who invented tournaments, was killed at Angers.

Both chronicles were compiled by Péan Gatineau, a canon of St Martin at Tours.[7] Unfortunately for the early history of tournaments, Péan Gatineau was writing in the first two decades of the thirteenth century (a hundred and fifty years after the events he was describing and a hundred years after Geoffrey of Malaterra) when the sport was already very popular. The contemporary sources on which he was relying, while relating Geoffrey de Preuilly's treachery and subsequent murder, make no mention of tournaments in any form. The suggestion, therefore, that Geoffrey invented tournaments, unless it relies on some oral tradition collected by Gatineau, is without foundation.

By the turn of the twelfth century, references to tournaments are on the increase and the sources are more reliable. The Byzantine princess, Anna Comnena, who had no interest in claiming early origins for the sport, relates a most fascinating anecdote in her *Alexiad*.[8] One of the French knights who went on the First Crusade sat on the Imperial throne in the presence of the Emperor. When this insolent gesture was reproved he made a defiant speech challenging the Emperor:

> I am a pure Frank and of noble birth. One thing I know: at a crossroads in the country where I was born is an ancient shrine; to this anyone who wishes to engage in single combat goes, prepared to fight; there he prays to God for help and there he stays awaiting the man who will dare to answer his challenge. At that crossroads I myself have spent time, waiting and longing for the man who would fight – but there was never one who dared.

Although a tournament is not specifically mentioned by name in this account, all the elements of the game are here including the crossroads, the challenge and the chance encounter which became such features of knight errantry in the chivalric romances and the historic *pas d'armes*. Indeed, this appears to be a very early reference to the specific form of the sport known as 'seeking adventures'.[9]

The possibility that tourneying was already known at the time of the First Crusade is corroborated by the monastic chronicler, Robert the Monk, who noted that the crusaders spent their leisure moments running at the quintain[10] – an exercise popularized by the advent of the tournament. The First Crusade was dominated by the Franks, though recruits were drawn from other European countries too, and it is not unlikely that it may have provided the opportunity for the French to show off their new sport to their admiring and imitative peers. This would help to explain the proliferation of references which now begin to be drawn from a wider area.

Some of the earliest evidence comes not from chronicle sources but from charters. In 1114 the Count of Hainault made a settlement with the town of Valenciennes in which there was a clause providing for the punishment of townsmen continuing personal feuds outside the town when they were away at tournaments or on business.[11] Although the authenticity of the clause is not entirely free from suspicion, the various elements do hang together. Much of the documentation of the tournament is concerned with banning or controlling the sport to avoid breaches of the peace. Even though tournaments were considered a knightly prerogative, in the early days townsmen frequently attended and took part in the action as members of the foot companies of the knights involved. Later in the century, for example, the Count of Auxerre gave the burgesses of Rethel a charter in which he promised not to lead them too far from the county in times of war or *chevauchée*, but reserved the right to lead them to tournaments at Chablis, Joigny or Rougemont.[12]

An English charter of c.1125–50 provides an extraordinarily early example of tournament service. Osbert of Ardern granted Turchill Fundus a carucate of land in return for his performing the service of carrying Osbert's painted lances from London to Northampton to his house at Kinesbury whenever he received a legal summons; he would also have to carry the lances and accompany him whenever Osbert wished to go overseas to tourney.[13]

Increasing popularity of tournaments

At about this same time, 1125–30, there is a sudden crop of tournament references in chronicle sources. As they fall in different parts of Europe, this suggests that tourneying had begun to acquire a following outside France and that the popularity of the sport was spreading. Galbert of Bruges tells us that Count Charles the Good of Flanders, who was murdered in 1127,

> frequented tournaments in Normandy and France, and outside that kingdom too, and so kept his knights exercised in time of peace and extended thereby his fame and glory and that of his country.[14]

Similarly, Otto of Freising describes how, after Duke Frederick of Swabia and his brother Conrad had raised the siege of Nuremberg in 1127, the knights from the town engaged 'in military exercise now commonly called a tournament' against those who had besieged them, after they had pursued the enemy to Würzburg.[15]

By 1130 the sport had proliferated to such a degree that it attracted the attention of the church. Significantly, the first official pronouncement on the subject was a condemnation. This was hardly surprising as the church had played a leading role in Europe in its efforts to control and prevent the violence of medieval society. The

Peace of God and the Truce of God movements had for over a century formally attempted to limit martial activity and protect non-combatants. Local church councils had prohibited fighting from Friday to Monday and on feast days. Enforcers of these rules were sought among the local knights who acted as champions of the church and their efforts were backed up by ecclesiastical sanctions against offenders. It was therefore inevitable that the church would set its face against the imitation warfare of tournaments and it was in similar terms that it attempted to ban them. At the Council of Clermont in 1130 the ninth canon issued stated that

> we firmly prohibit those detestable markets or fairs at which knights are accustomed to meet to show off their strength and their boldness and at which the deaths of men and dangers to the soul often occur. But if anyone is killed there, even if he demands and is not denied penance and the *viaticum*, ecclesiastical burial shall be withheld from him.[16]

It is significant that, although the sport had become so popular that it merited clerical attention and prohibition, it was still new enough for its terminology to be unfamiliar outside knightly circles. The odd phrase 'detestable markets and fairs' clearly puzzled even later ecclesiastical commentators such as Raymond Penaforte who explained it away by saying that the same sins were evident at both markets and tournaments.[17] The reason, however, appears to be simpler than that: markets were frequently held in association with tournaments because the knights who gathered there with their entourages needed food, drink, apparel and arms.

Although the Clermont canon was repeated verbatim and confirmed at the second Lateran Council in 1139 and the Council of Rheims in 1148,[18] it is not until the third Lateran Council in 1179 that an explanatory phrase was added.[19]

Interestingly, this same dilemma over what name to give the sport is reflected in the first fictional account of a tournament which dates from the same decade as the Clermont canon. Geoffrey of Monmouth, in his semi-fictitious *History of the Kings of Britain*, gives this account of the events at King Arthur's plenary court at Whitsun:

> By this time, Britain had reached such a standard of sophistication that it excelled all other kingdoms in its general affluence, the richness of its decorations and the

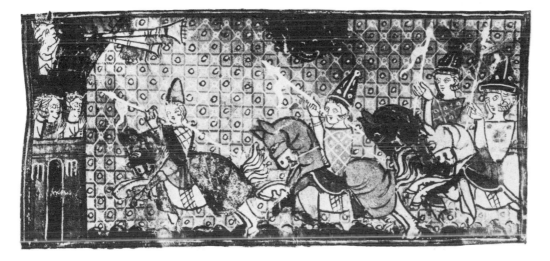

Riding to a tournament, early fourteenth century. The miniature is from a moral tract, hence the devils hovering to seize the souls of those killed in the tournament. (BL MS Royal 19.C.1. f.204)

courteous behaviour of all its inhabitants. Every knight in the country who was in any way famed for his bravery wore livery and arms showing his own distinctive colour; and women of fashion often displayed the same colours. They scorned to give their love to any man who had not proved himself three times in battle. In this way the womenfolk became chaste and more virtuous and for their love the knights were ever more daring.

Invigorated by the food and drink they had consumed, they went out into the meadows outside the city and split up into groups ready to play various games. The knights planned an imitation battle and competed together on horseback while their womenfolk watched from the top of the city walls and aroused them to passionate excitement by their flirtatious behaviour. The others passed what remained of the day in shooting with bows and arrows, hurling the lance, tossing heavy stones and rocks, playing dice and an immense variety of other games: this without the slightest show of ill-feeling. Whosoever won his particular game was then rewarded by Arthur with an immense prize. The next three days were passed in this way.[20]

The tournament on this fictitious occasion was evidently an *ad hoc* arrangement. There were no lavish preparations and the knights themselves seem to have organized the proceedings in Arthur's name. Geoffrey either records for the first time or (more probably) foreshadows two major developments in tournament history: the presence of ladies and the use of personal heraldry. There is no substantial historical evidence for the first for another fifty years, while devices on shields seem to have been general rather than individual at this early date.

Tourneying at this period seems to have happened with little prior arrangement. A certain conjunction of events could often spark off a bout of tourneying. William of Malmesbury, for instance, describes how King Stephen's men, confronted at the siege of Lincoln in 1141 by the knights of Robert, earl of Gloucester, began the battle by performing 'the prelude to battle, which they call a joust (*justam*), because they were

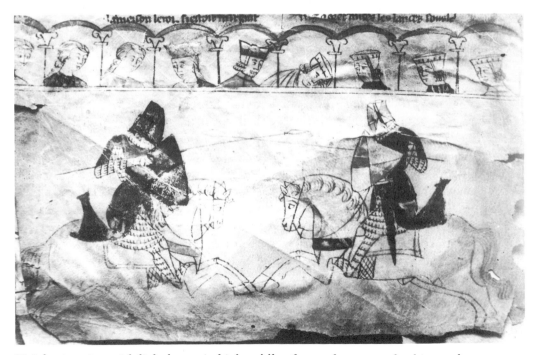

Knights jousting with light lances in high saddles, from a fragment of a thirteenth century French manuscript of the romance of Lancelot.
(Deulofeu collection, Puigcerda, Gerona) (Foto MAS, Barcelona)

skilled in the art'.[21] On this occasion, however, they had chosen the wrong moment and their less chivalrous opponents promptly rode them down and began the battle in earnest. This did not mean that the king's men had a monopoly on the sport: shortly afterwards, at the siege of Winchester, it was the earl's knights who daily rode out of the city 'to perform chivalrous deeds'.[22]

In England, Stephen's troubled reign seems to have seen a particularly virulent outbreak of tourneying. In addition to the instances already cited, in 1140 Ranulph, earl of Chester was able to recapture Lincoln castle from the royalists with only three men-at-arms because the military garrison had deserted their posts in order to take part in martial sports elsewhere.[23] The first identifiable English casualty in the sport – Hugh Mortimer, who was killed at a tournament at Worcester – also dates from Stephen's reign.[24]

Early tournaments in England

According to William of Newburgh, there was a particular reason for the number of tournaments occurring at this period.[25] In the days of Henry I and Henry II, tourneying was placed under firm royal prohibition and anyone wishing to indulge in the sport had to travel overseas to do so. However, due to the shameful weakness of Stephen's rule, there was no proper government and therefore tournaments flourished. William of Newburgh here points out for the first time what was later to become almost a truism: that there was a distinct correlation between the amount of (particularly illicit) tourneying activity and the amount of government control. During periods of weak kingship, such as the reigns of Stephen, Henry III and John in England, tournaments became increasingly frequent and often had distinctly subversive overtones.

The tournament was being used as a cover for rebellion as early as the 1140s. When Frederick Barbarossa, himself a knight 'trained, as is customary, in military sports', invaded Bavaria to attack his enemy Henry of Wolfratshausen

the Bavarians, and particularly the counts and other nobles, betook themselves to the stronghold of the aforesaid count, as though to celebrate a passage of arms which we are now accustomed to call a tournament (*tyrocinium quod modo nundinas vocare solemus*). And so that most redoubtable youth (Frederick Barbarossa), coming upon the Bavarians as they stood outside the wall awaiting him under arms, assaulted them not as in play, but manfully making a serious assault.[26]

Likewise, in 1158, the men of Piacenza in Italy took the opportunity to continue their feud against the men of Cremona by challenging them at the Imperial assembly at Roncaglia to a 'combat, which they commonly call a tournament'.[27]

Tournaments and war

In both cases (as in the Würzburg episode of 1127 and at the battle of Lincoln in 1141) what actually followed was a military action: Lincoln is a skirmish, Wolfratshausen the prelude to an actual battle, and Roncaglia the result of an ancient rivalry. We have to remember also that 'torneo' in Spanish was for a long time an exclusively warlike manoeuvre, before it came to mean 'tournament' in our sense in the thirteenth century. Yet these episodes are not simply to be dismissed as evidence that tournaments at this time were hostile engagements only. Otto is sure of the difference: 'not as in play', he says, implying that the element of play is the distinguishing mark of the tournament. And the episode at Roncaglia, although close to some kind of private warfare, would not have been permitted by the Emperor if it was to have involved open hostilities, given that one of his declared intentions on that

occasion was to put an end to such disturbances of the peace. Not for the last time, it looks as if old scores were being settled under the guise of a tournament.

Otto of Freising's rather odd phrase for the tournament in the passage about Frederick Barbarossa's invasion of Bavaria – *nundinas* – reflects the terminology of the Council of Clermont canon prohibiting tournaments rather than contemporary chivalric usage. It is significant that it was not until the Third Lateran Council of 1179 that the confirmation of this prohibition on *nundinas vel ferias* at last carried the vitally important explanatory phrase 'which are commonly called tournaments [torneamenta]'.[28] By this time, the sport had become so popular that its terminology was no longer unfamiliar even outside knightly circles. It is also significant that the 1170s saw not only a remarkable rise in tourneying activity but also the emergence of a new genre of literature.

The *chansons de geste* of the early twelfth century, with their dreary round of battles and feuds and their emphasis on the ties of loyalty between men and lords, were challenged in the 1170s by the new romances. Here was a new set of values, stressing the importance of courtly love and service to the mistress who inspired that love, played out against a background of court ceremonial. The tournament now took a central role in chivalric literature: it was there that the heroes of romance won their ladies, proved their prowess and displayed their legendary strength and courage.

The arch-romancer and great innovator of the genre was Chrétien de Troyes and it is no accident that his patrons were Henry, count of Champagne and Philip, count of Flanders who were both devotees and patrons of the tournament. The importance of this connection cannot be over-emphasised for Henry of Champagne was married to the daughter of Eleanor of Aquitaine, and his brothers-in-law were Henry, the Young King, Geoffrey of Brittany and Richard I. Eleanor's family were equally lavish in their patronage of courtly literature and chivalric sport. Her small circle of inter-related, powerful, rich and cultured young men met regularly on the tournament

Initial showing jousting knights from a Provençal manuscript of the poems of Bertran de Born, written in the thirteenth century. (Bibliothèque Nationale, MS 854 f.174v)

fields of northern France and the Low Countries. During the day they exercised themselves in arms and in the evenings they would gather round the fires and tell stories. Arnold of Ardres, who was also part of this charmed chivalric circle, employed several *jongleurs* and ancient knights, each with a different speciality – tales of the Holy Land, Arthurian romances or Carolingian *chansons de geste*.[29]

Patronage of chivalrous sport and courtly literature went hand in hand. Naturally, because they were catering for the interests of tourneyers, the romance writers dwelt at great length on the sport and painted it in glowing colours. This, in turn, helped to give tournaments greater prestige because they played such a decisive role in the lives of romance heroes. Thus a kind of symbiosis developed between tournaments and courtly literature, each feeding the other and thereby encouraging their mutual development.

It was largely due to this meeting of like minds – the Young King, Henry of Champagne and Philip of Flanders – that in the 1170s and the 1180s there was such a proliferation of tournaments. If the chronicles of Arnold of Ardres and William Marshal are to be believed, tournaments were held almost fortnightly in the region at this time. Many of the protagonists were young men, only recently knighted, the eldest sons of nobles sent away from their patrimonies with a band of similarly placed peers, to learn the skills of knighthood. Thus began what became a great tradition: a period – perhaps months, perhaps years – of chivalrous apprenticeship spent on the tourneying circuits of northern France. Nearly a hundred years later, despite the fact that tournaments were no longer prohibited by the secular authorities elsewhere in Europe, the tradition was still in force and young knights like Edward I of England, for example, still travelled to this area for two years of tourneying.[30]

William Marshal

The 1170s and 1180s seem to have been a period of particular brilliance. There were a number of outstanding personalities tourneying at the time and their patronage of literature ensured that their feats were recorded for posterity. The most informative and important of these chronicles was the biography of William Marshal, a knight of relatively humble birth whose prowess at the tournament attracted royal attention and ultimately, if indirectly, led to his becoming Protector of England during the minority of Henry III. William's career was the very stuff of romance and he became a legend in his own lifetime, sought after by, among other, Philip of Flanders who recognised his abilities from encounters in the lists. Despite financially attractive offers, however, William remained loyal to the Young King whose martial training had been entrusted to him.

William's skill at tournaments was renowned. At his first outing, at Le Mans in 1167, riding a borrowed mount in the company of his lord, William of Tancarville, he won four and a half horses for himself together with a similar number of horses for his esquires, baggage horses and equipment.[31] This success, together with his own lack of prospects, encouraged him to adopt a hard-headed and business-like approach, completely at odds with the idealism of romance tourneyers. William's object was to win as much booty, in the form of ransoms, horses and equipment, as possible. He even went so far as to enter into a partnership with another knight of the Young King's household. For two years they followed the tourneying circuit, fighting as a team and dividing their winnings. A royal clerk kept a record of their successes and he noted that in the ten months between Pentecost and Lent, they captured one hundred and three knights, together with their horses, harness and baggage.[32] For a knight without a patrimony, success at the tournament could be a means of gaining wealth without the social stigma attached to trade and at the same time enhancing his reputation for knightly skills.

The tournament as depicted in the history of William Marshal is a far cry from the world of Chrétien de Troyes, despite the fact that their roots were the same. Here is Chrétien's account of the tournament at Tenebroc in his romance *Erec et Enide*:

A month after Pentecost the tournament assembles and opens in the plain below Tenebroc. Many a pennon flew there, vermilion, blue and white, and many a wimple and sleeve that had been given as tokens of love. Many a lance was carried there, painted in silver and red, others in gold and blue, and many more of different kinds, some banded and some spotted ... Thé field is completely covered with arms. The ranks shudder on both sides, and from the clash there rises a loud din, with a great cracking of lances. Lances break and shields are holed, the hauberks are torn and rent, saddles are emptied and riders tumble, whilst the horses sweat and lather. All draw their swords on those who clatter to the ground. Some rush up to accept their surrender, others in their defence.

Astride a white horse, Erec came to the front of the rank quite alone to joust, if he could find an opponent. From the other side the Haughty Knight of the Heath spurs against him, mounted on an Irish horse that carries him along at furious pace. Erec strikes him on the shield protecting his breast with such force that he knocks him off his steed; then leaves him on the field and spurs on ... All those who saw this joust were quite amazed and said that anyone who pits himself against so good a knight has to pay too high a price.

Erec's main concern was not with capturing horses or riders, but to joust and do well so as to show off his prowess. He makes the ranks in front of him tremble, his valour putting new heart into those who were on his side. To discourage his opponents all the more, he did take some horses and riders.[33]

Beside Chrétien's account, the descriptions of tournaments in the history of William Marshal, which are some of the fullest in medieval sources, are perfunctory. The companies line up to face one another; one company usually conducts itself in a

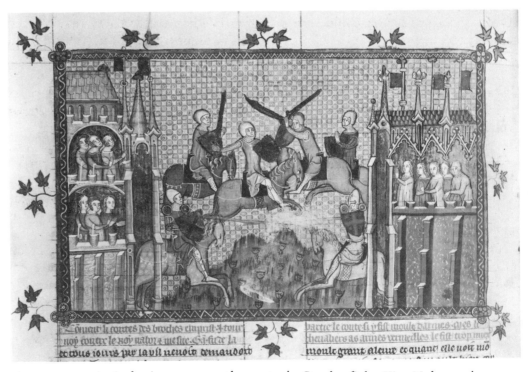

A tournament in Arthurian romance: the comte des Broches fights King Nabor and Gawain. Both stages of the mêlée, with lances and swords, are shown in this French miniature of 1344. (Bibliothèque Nationale, MS Fr 122 f.80v)

disciplined and orderly fashion, the other in a disorganized muddle, as the leaders vye for the privilege of striking the first blow. Inevitably, the company proceeding in serried ranks is victorious – it is the company manoeuvre, not the skill of the individual, which wins the day. There are no love tokens or devices and (except on one occasion) no watching ladies. Erec's altruism in seeking only to prove his prowess in the combat is not shared by William Marshal and his contemporaries who, as we have seen, had more material benefits in mind. Though outstanding feats of arms and public acclamation of success are valued, it is victory and booty which are the prime concerns.

Instances of the pragmatism of participants in tournaments in northern France at the end of the twelfth century abound. The flower of chivalry, Philip of Flanders, is not above holding his men back from the fighting until the other tourneyers are all exhausted and therefore make easy pickings. He is only out-manoeuvred when William Marshal persuades the Young King to adopt the same tactic and thereby turns the tables on the Flemish.[34] William himself, when dining at an inn while a tournament is taking place round him, cannot resist capturing a tourneyer who falls off his horse and breaks his leg in front of him, even though he is not actually participating on this occasion.[35] There are other good stories about William: he once lost a prisoner as he was leading him back to his tent when the latter was knocked off his horse by a drainpipe unnoticed by his captor; on another occasion, he won the prize at a tournament, but could not be found for the presentation, and was eventually traced to the local forge, where he had his head on an anvil for a blacksmith to beat his helm back into shape so that it could be removed.[36] These episodes are far more down to earth (and humorous) than anything offered by Chrétien de Troyes. They are, however, a good counter-balance to the rarified atmosphere of the romances and paint a more realistic picture of the pleasures and pains of tourneying.

There was a much more serious side to the sport, nevertheless, which was minimized or ignored even by the author of the *History of William Marshal*. Although rules and regulations were rudimentary to say the least, customs quickly developed and became universally accepted. For instance, the division into tournament teams was usually decided by the area from which the participants came but an alignment of teams contrary to custom could cause real offence. When Baldwin of Hainault joined the French (who would otherwise have been outnumbered) instead of his natural allies, the Flemish, at a tournament between Gournay and Resson in 1169, Philip of Flanders was so infuriated that he immediately attacked with all his horse and foot drawn up 'as if for war'.[37] An injudicious selection of party could therefore cause political affront, with repercussions beyond the lists. Likewise, it was all too easy for feuds and personal vendettas to be carried on to the field. A year after this particular example, Baldwin went to another tournament at Trazegnies; when he heard that one of his enemies, the Duke of Brabant, would be attending, he ensured that he took a larger force of foot soldiers than was his usual practice, to protect him in the *mêlée*.[38] It is easy to see how such incidents could spark off real conflict, especially when the line between behaviour appropriate to a tournament and the conduct of a battle was so fine.

Of concern to those working the land, if no-one else, was also the attendant disorder and destruction. The tourneyers in the history of William Marshal show a complete disregard for the state of the property on which they are fighting; vineyards and orchards get trampled, barns and farm buildings are used as ambuscades and even the streets of villages unfortunate enough to have been designated within the tourneying area became part of the action. Very real financial losses could be suffered by the non-combatants on whose land the sport took place.

The beginning of formal rules

Deaths in twelfth century
tournaments

Another problem, also minimized in the *History of William Marshal*, was the number of deaths caused by tourneying. In the rough and tumble of the *mêlée*, particularly when real hostilities had prompted the tournament in the first place, the dangers were considerable. The twelfth century had already seen a large list of prominent tournament casualties including Geoffrey, Count of Brittany, son of Henry II, who was killed in a tournament near Paris in 1186 and Leopold, Duke of Austria, who died in 1194 after his horse had fallen on him 'while he passed the time in a warlike exercise and game'.[39]

Attempts were made to avoid such loss of life: the church's prohibition on the sport was generally ineffectual as local interest overrode ultramontane directives. In 1175, however, archbishop Wichmann of Magdeburg ordered that the church's decree of excommunication and refusal of ecclesiastical burial to those killed in tournaments should be strictly observed, after he had heard of the death of Conrad, son of the margrave Dietrich von der Lausitz, who had received a fatal wound in an Austrian tournament. It was not simply Conrad's status which prompted this action but the fact that this 'plague of a sport', as the chronicler calls tournaments, had already claimed the lives of sixteen knights in Saxony that year. The archbishop sent messengers to Austria to ensure that Conrad was not given ecclesiastical burial and refused to relent, until evidence was provided that Conrad had repented and taken the Cross before his death; his relatives also had to swear on holy relics 'to abstain from tournaments forever, not to permit any such occasion on their domains, and to prevent their men and knights by all possible means from taking part in them'.[40]

Archbishop Wichmann's action appears to have been an isolated one, however, and in general the church did not enforce its prohibitions against tournament victims, preferring instead to rely on excommunication of living tourneyers and promulgating exemplary histories to show the benefit of abstaining from the sport. In the 1150s, for example, a knight riding to a tournament at Jülich in the Rhineland as a 'Rittmeister', or captain of a band, heard that his wife had died in his absence. He therefore foreswore chivalry and became a hermit.[41] The eighth abbot of Villers, a monastery in Brabant, had similarly abandoned tournaments and the chivalric life when, on returning from a tournament at Worms, he and a companion had been inspired by the idyllic countryside to reject the vanities of this world. They swore to abandon tournaments for five years to go and join 'the wolf-coats of Kloster Himmerod', in other words to take monastic vows with the grey-clad brothers there.[42] At about this same time we also hear of Frederick, Count of Anvorden, who became a pilgrim after the death of his wife, repenting the time he had wasted in 'tournaments and other warlike games'.[43] Such pious stories did little to turn knights away from hastiludes, however, and a much more effective method of enforcing prohibitions had to be devised. Not surprisingly, it fell to the secular authorities to attempt to control the sport.

In England this was achieved quite brilliantly by Richard I who, well aware of all the problems caused by tournaments, drew up his innovative and unique decree of 1194 by which, in blatant contravention of the church's ban on tournaments, he laid down a licensing system which would enable them to be held legitimately on English soil – it is interesting that the decree did not cover his foreign dominions where tournaments were already rife. Richard's decree is worth looking at in some detail because it was the only one of its kind and because it had far-reaching effects on the development of tournaments in England.

Richard, as we have already noted, was one of the charmed inner circle of chivalrous patrons in northern France, although before he came to the throne, he himself had preferred the minor warfare that went on almost continually in the duchy of Aqui-

taine to tournaments, and rarely, if ever, took part in them. Yet Richard appreciated not only the over-powering attraction which it held for his knightly subjects, who would tourney whether or not he permitted it, but also the advantages of an apprenticeship in arms served in the lists. As William of Newburgh put it:

> The famous King Richard, observing that the extra training and instruction of the French made them correspondingly fiercer in war, wished that the knights of his kingdom should train in their own lands, so that they could learn from tourneying the art and custom of war and so that the French could not insult the English knights for being crude and less skilled.[44]

To this end, Richard introduced a decree which recognized five places in England as official tournament sites: between Salisbury and Wilton (Wiltshire), Warwick and Kenilworth (Warwickshire), Stamford and Warinford (probably Suffolk), Brackley and Mixbury (Northamptonshire) and Blyth and Tickhill (Nottinghamshire). Any knights who wished to tourney could go to any of these sites having first obtained a licence in the form of a charter for the tournament to actually take place for which he had to pay ten marks. In addition to this, he had also to obtain a personal licence in the form of a fee graduated according to his rank, ranging from twenty marks for an earl to two marks for a landless knight. It is significant that no tourneyer of lower status than a landless knight was envisaged – Richard would certainly not have missed the opportunity of charging a fee for any participant – and that foreign knights were specifically prohibited from tourneying in England.[45]

Richard I's official regulation of tournaments

The tournament decree set up a system whereby English knights could tourney legitimately (as far as the state was concerned) and peacefully against their fellow countrymen. Perhaps it was his own or his brothers' personal experiences of tourneying which made Richard exclude foreign knights, for this effectively prevented the setting up of a tourneying circuit in England like the one in northern France and the Low Countries which they had frequented. It was certainly one way of trying to limit the potential for disaster by excluding the sort of political rivalry consequent upon a mix of knights of different origins.

The choice of five sites was also a deliberate attempt to limit destruction. As the tournament ranged over a wide area of countryside it was definitely an advantage to have a location designated in advance, well away from the most vulnerable places such as towns, monastic houses and royal forests. Richard certainly seems to have had an eye for the preservation of his forests as the preamble to his decree specifically stated that its purpose was:

> so that our peace shall not be broken, the power of our justiciar shall not be threatened and loss shall not fall on our royal forests.[46]

The special form of oath to be sworn by all would-be tourneyers also included clauses protecting the royal rights of *vert* and venison. The five designated sites were fairly well spread over the country to serve the needs of the knightly classes but there was noticeably no provision of sites in either the west or the north of England – both areas where royal control was comparatively weak and therefore most vulnerable.

Richard's decree was made in the full knowledge that it was in breach of the church's professed ban on tourneying. It was a pragmatic attempt to extend some control over a sporting craze which would brook no opposition; it was also an extremely useful method of raising funds for a king whose coffers were always empty.

Financially, he could not lose from licensing tournaments: there were the fees payable for conforming to the decree and there were the even heftier fines payable for breaching it. Financial considerations probably weighed just as strongly with Richard as the desire to improve military standards in his kingdom.

Richard's decree of 1194 was unparalleled elsewhere. Though the counts of Flanders, Hainault, Champagne and the rest patronized and personally participated in the sport, just as Richard did, they made no effort to legitimise it or monopolise its control. The kings of France similarly ignored the possibilities presented by licensing the sport and, with singular ineffectiveness, continued to issue prohibitions of tournaments alongside prohibitions on private war. It even seems that no king of France actually participated in a tournament after his coronation until the middle of the fourteenth century when the hapless John II attempted to do so in order to imitate the chivalrous reputation of Edward III. Whether this reticence on the part of the French kings was due to their supposed special relationship with the papacy is not clear: it is certainly interesting that it was an Avignon Pope who, at the request of the French princes, revoked the church's ban on tournaments in 1316 and that it was not until long after this date that French kings felt able to enter the lists in person.

The unique nature of Richard's decree allowed the pattern of English tournaments to travel along a distinct and separate route from tournaments on the Continent. In England, the fact that a tournament was either legitimate or illegitimate, licensed or unlicensed, gave it a special relationship with politics and therefore nuances which were simply non-existent elsewhere. Similarly, the fact that it was *royal* control of the sport enabled the kings of England to use their patronage to considerable propagandist effect. English kings did not lose their royal dignity by participating in a sport which was no respecter of persons; indeed, by so doing they enhanced their chivalric reputations and won an international renown.

Knights fighting on foot, from a fragment of a thirteenth century French manuscript of the romance of Lancelot.
(Deulofeu collection, Puigcerda, Gerona) (Foto MAS, Barcelona)

By the end of the twelfth century, the tournament had entered the realms of chivalrous mythology. No courtly love lyric, romance or adventure was complete without its tournament and in practice only the Iberian peninsula seems to have been without the sport – or at least without any surviving record of it. By 1200, knights were tourneying regularly throughout the rest of Europe, in France, the Low Countries, Italy and Germany as well as in England and even (occasionally) in the Frankish kingdom of Jerusalem. Although differing forms of the sport were to evolve in the different areas, there was enough in common for tourneyers to be able to travel from country to country in search of what had become their favourite pastime. The tournament was a firmly established part of knightly life.

Riding at the quintain; a border from a fourteenth century psalter. The revolving arm and counterweight are clearly drawn.
(BL MS Facs 237, pl.XIX)

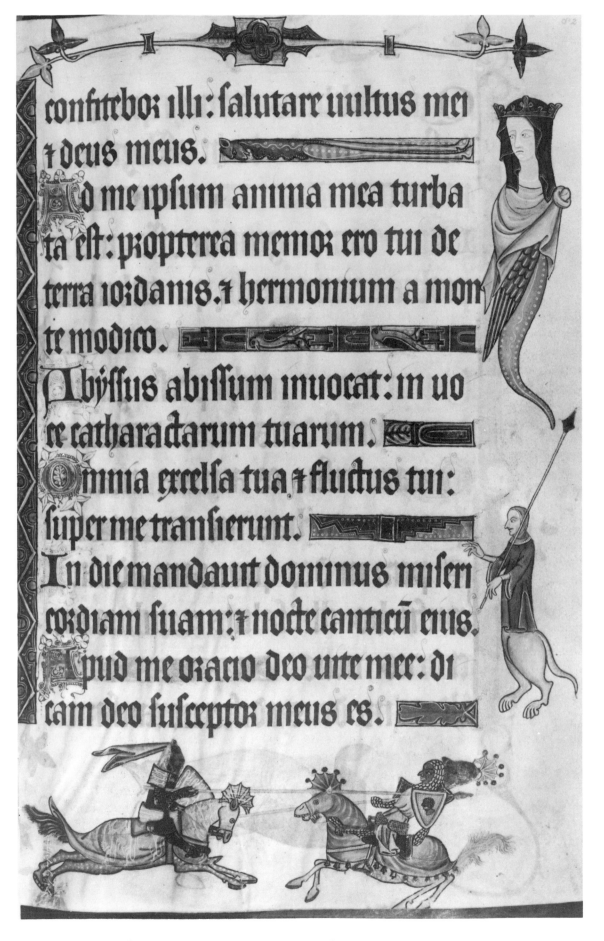

confitebor illi: salutare uultus mei
† deus meus.

Ad me ipsum anima mea turba
ta est: propterea memor ero tui de
terra ioidanis. † hermonium a mon
te modico.

Abyssus abissum inuocat: in uo
ce catharactarum tuarum.

Omnia excelsa tua. † fluctus tui:
super me transierunt.

In die mandauit dominus miseri
cordiam suam: † nocte canticum eius.

Apud me oracio deo uite mee: di
cam deo susceptor meus es.

A page from the Luttrell Psalter, c.1340, with a border miniature showing a knight defeating a Saracen: Edward III's several 'costume' jousts must have looked like this. (BL MS Add 42130 f.82)

2

The Tournament in North-West Europe to 1400

England

If the tournament actually began in France, it was not long before the initiative passed to England. Richard I's decree of 1194 licensing tournaments set England apart from her neighbours. Although the church still officially disapproved, in England it was possible to tourney with royal approval. More important, the decree allowed English kings to exert a control and influence over the sport which was denied to contemporary rulers elsewhere. For this reason, tourneying in England assumed a greater importance and significance than elsewhere, and therefore attracted more attention from the chroniclers.

It was thus no coincidence that the first recorded examples of tourneying in the thirteenth century occur in conjunction with the revolt which led to the signing of Magna Carta. The rebel barons were to be found meeting at tournaments in order to discuss their grievances, and, by their presence in arms, to threaten king John.[1] A baronial tournament at Stamford was postponed and moved to Staines in case the king seized the opportunity to recapture London.[2] The barons were also to be found tourneying against the French knights who, under Prince Louis, had invaded England in support of their cause. A particularly interesting feature of this hastilude was that the participants were all clad 'in lineis et levibus', in other words, in padded garments instead of armour and using lightweight lances instead of the usual heavy war ones. These are the classic hallmarks of a *béhourd*, and reinforce the idea that this was a friendly meeting in arms. Despite these precautions, a prominent English baron, Geoffrey de Mandeville, was killed.[3]

Tournaments and Magna Carta

When John died, leaving a minor as his heir and a regency which was at first in the hands of that familiar figure from the world of tournaments, William Marshal, and then under protection of the papacy, tourneying was strictly prohibited as a potential source of political disturbance. Royal prohibitions were issued with monotonous regularity, and although some events were held in defiance of the ban, punishments quickly followed. The earl of Aumâle, who rebelled in 1219, was excommunicated in that year for taking part in a prohibited tournament at Brackley;[4] four knights had their lands temporarily confiscated for illicitly tourneying at Blyth in 1223[5] and approximately three years later Matthew de Berghefelde was accused of holding an illicit 'buhurdicio' in Berkshire, the first formal English reference to a *béhourd*.[6]

When Henry III assumed personal rule, he seems to have come under pressure to relax the prohibitions. In 1228 he undertook to secure an ecclesiastical licence from the Pope for a tournament at Northampton so that the participants would not be excommunicated; when it actually took place, he sent letters to all his household knights positively ordering them to attend.[7] Four years later, he allowed tournaments

at Dunstable, Brackley, Stamford and Blyth,[8] though in the same year he also prohibited a 'round table' at an unspecified place somewhere in England – the first event of this kind actually recorded under that name.[9] The rebellion of Richard Marshal put a stop to his leniency, and a string of prohibitions followed. Those events that did take place in contravention of his wishes were marred by excessive violence and ill-feeling. A tournament at Blyth in 1237 between northerners and southerners turned into a battle and the papal legate had to be called in to reconcile the combatants; Gilbert Marshal, Robert de Say and numerous other knights were killed at an ill-named 'fortunium' at Hertford in 1241 which appears to have been simply a tournament under another name in order to evade the prohibitions; and in the following year, Walter Biset murdered Patrick earl of Atholl as he slept after a tournament of English against Scots at Haddington, because the earl had unhorsed him in the course of the fighting.[10] The problems culminated in a particularly vicious series of tournaments prompted by the political hostilities between the English baronial party and the French court party. At Newbury in 1248, the king's half-brother, William de Valence, was set upon and beaten with clubs; he took his revenge the following year at Brackley, dealing out the same treatment to William de Oddingseles. On the latter occasion, Richard earl of Gloucester decided to fight on the side of the court party, contrary to his usual custom, and this was seen by his former allies as a statement of political intent and a betrayal of his party.[11] The enmity between the two groups which had prompted the tournaments in the first place was only exacerbated by them. At Rochester in 1251, for example, the barons defeated the court party and put them to flight but then the barons' squires blocked their route to safety, and beat them with clubs.[12] Even a game which did not involve man-to-man combat, like the quintain, could end in conflict, as the king's household found to their cost when they challenged the citizens of London and were defeated.[13]

Edward I and tournaments
The revival of licensed tournaments in England only took place with the coming of age of Henry III's son, the Lord Edward (later Edward I). His tourneying career began with a *béhourd* at Blyth in 1258, in padded clothing and with light weapons. Despite these precautions, William Longsword and Robert de Quincy were killed and Roger Bigod's faculties were permanently impaired as a result of injuries received in the combat: Edward himself escaped unscathed.[14] His enthusiasm for the sport grew quickly; even when civil war loomed in the 1260s, the main protagonists – the Lord Edward, Richard earl of Gloucester, Simon de Montfort and his sons – were also to be found in the lists.[15] The Lord Edward's victory was marked by a public edict in 1267 allowing tournaments to be held throughout the realm, which was secured by the prince, his brother Edmund, and their cousin, Henry of Almain.[16]

With Edward's accession to the throne, the future of tourneying was assured. Henry III had shown no personal interest in the sport, but Edward participated whenever he got the chance. Tournaments occurred so frequently that only the most important can be noticed here. In 1278, Edward himself sponsored what was clearly a classic example of a *béhourd* at Windsor[17]; thirty-eight knights, including the king, took part wearing specially-commissioned armour made of *cuir bouilli*, leather boiled until it was almost as hard as metal though much lighter. Whalebone swords and wooden shields were also used. Although the accounts for preparing the armour are extant, there is no record of what actually occurred in the field.

Edward's victories over the Welsh were celebrated with a great show of chivalric strength; a round table – the first to be held by a king in England – was organised at Nefyn in 1284, and the same year also saw a splendid tournament at Caernarvon to celebrate the birth of the prince of Wales.[18] The frequency of tournaments in his reign

is shown by the royal household accounts; among other entries, these record six tournaments attended by John of Brittany in 1285–6 and seven attended by John of Brabant in 1292–3, none of which are mentioned in other sources. Both young men were affianced to Edward's daughters, and their expenses were met by him.[19]

War on three fronts and the necessity of sending armies to Gascony, Wales and Scotland at the end of the 1290s put a damper on tourneying activity, and, for the first time in his reign, Edward was obliged to seriously attempt its suppression. On at least two occasions, large numbers of knights were committed to prison and had their lands seized for leaving the king's army without permission during lulls in the fighting to attend jousts in England.[20]

By the end of Edward's reign, knights habitually looked to the royal court for leadership and patronage of chivalric sports, a situation unique to England. The joust, which had been rare before his accession, was already overtaking the tournament in popularity. Most important of all, however, Edward I had established himself as the great patron of the round table which he had, almost single-handed, revived. Round tables were held under his auspices at Kenilworth and Warwick in 1279, Warwick in 1281, Nefyn in 1284, and Falkirk in 1302.[21] Another round table, of uncertain date but associated with one of Edward's two marriages, is described in unusual detail by a contemporary Dutch chronicler.[22] By his patronage Edward had not only encouraged the development of all forms of the sport, but had also made the crucial discovery that it had valuable potential for increasing his political prestige, a discovery which was to have a major influence on the later history of the tournament.

His son, Edward II, lacked his father's knightly skills and, like his grandfather, allowed patronage of the sport to pass into the hands of those not necessarily well-disposed towards him. He allowed his favourite, Piers Gaveston, to hold a number of tournaments against the English earls, who did not take kindly to the public humiliation they suffered in defeat at his hands.[23] In 1308, Edward made his one and only attempt to seize the initiative by holding a tournament at Kennington, at which he appeared in person as the 'King of the Greenwood'; the earls held aloof, however, and his preparations went for nothing. The following year, Giles de Argentine, one of the outstanding chivalric figures of his generation, adopted the same role with great success in jousts against all comers at Stepney.[24]

Tournaments and the opposition to Edward II

Before the earls aired their many grievances against Gaveston and his cronies at the parliament of April 1309, they held a tournament at Dunstable; the earliest surviving English tournament roll of arms, listing two hundred and eighty-nine knights who attended the tournament, was produced for this occasion. Such rolls were both a register of participants and valuable evidence of a given knight's claim to the use of his particular coat of arms; in this case, there may also have been political undertones.[25]

Three years later, the earls used the excuse of holding tournaments to gather together enough men-at-arms to raise an army which marched against Gaveston, captured and murdered him.[26] After these experiences, Edward II seems to have set his face firmly against all forms of hastilude, and prohibitions flowed thick and fast from his chancery. The only time he seems to have relaxed his hostile attitude was in 1323, at the instigation of his brothers, Edmund earl of Kent and Thomas earl of Norfolk; he allowed jousts at Lincoln and a great tournament at Northampton, at which knighthood was conferred on Geoffrey Scrope and three other young men.[27]

Edward III's reign began with a flourish as far as tournaments were concerned. Roger Mortimer, mentor to the fourteen year old king, was an enthusiast, and celebrated his accession to power with a series of splendid tournaments which culminated in round tables at Ludlow and Wigmore.[28] Edward himself held a three week

long festival of jousts, *béhourds*, dancing and singing to celebrate his marriage to Philippa of Hainault in January 1328, and she seems to have encouraged his taste for chivalric pursuits. After their marriage she was to be found in regular attendance at the innumerable jousts he patronised, and her presence in the stands gave increased respectability to the sport and encouraged other women to attend. Undoubtedly, the presence of women lent lustre to the proceedings and promoted those aspects of the sport most calculated to appeal to spectators. It is no coincidence that there was a remarkable growth in pageantry in Edward's reign; colourful costumes, processions of participants, fantastic themes, role-playing and play-acting became part and parcel of the fourteenth century joust and tournament.

Royal patronage of tournaments revived

The overthrow of Mortimer and Edward's return from France after doing homage for Gascony were marked by a series of small scale tournaments, or more properly jousts, at Canterbury, Cheapside and Dartford (where the king rode under the banner of William de Clinton). Comparatively detailed accounts exist for two other occasions in 1331 which are worth examining because they reveal how far the organisation of these jousts had developed, and also because they are typical of jousts at this period. Both were held in London. At Stepney on 16 June Robert Morley held three days of jousts: the festivities were opened by a procession of the twenty-six defenders and their challengers, all clad in similar costumes bearing a golden arrow motif, through the streets to St Paul's, where they offered oblations before processing to the market place, which had been enclosed and sanded for the occasion.[29] Three months later, on 22 September, another of Edward's closest companions, William Montacute, held a three day jousting festival at Cheapside. Once again the market place was enclosed and a stand built for the ladies; it collapsed while the jousts were in progress, causing a number of injuries. Again, the whole affair was opened by a splendid procession in which the defenders, all dressed as Tartars, were each led through the streets by a damsel in matching costume. A particularly interesting feature of these jousts was that Edward III ordered all the able-bodied knights of the realm to attend, presumably to ensure the success of the occasion; this was unusual enough to draw comments from the chroniclers.[30]

The popularity of this type of combat with its sophisticated settings and its appeal to spectators sounded the death-knell of the old *mêlée* style tournament. These had been kept alive by the need to approximate the conditions of real battle so that knights could train and practise handling their weapons. Jousting also fulfilled these require-

Knights jousting before a lady, and (facing page) jousting scenes from the magnificent manuscript of the Romance of Alexander completed by a Flemish scribe in April 1344. At the foot, knights receive their helms from ladies before jousting.
(Oxford, Bodleian Library, MS 264 f.101v)

Comment aucuns v dauns v peter ordinerunt pour empoisdumuer,
louir roy aliee v deuserut le venym sifoit p grant engyn q null p garri q de se gufta.

ments, but had the added attraction of being safer because fewer knights were involved. It also appealed to knightly vanity because the combatant's prowess was so much more evident to the spectators. Only a few more old-style tournaments are heard of after this period; one in 1334, recorded in the second Dunstable roll of arms, and the last English one on record, also at Dunstable, in 1342 when two hundred and thirty knights returning from Scotland celebrated their success with a large tournament.[31]

As the old *mêlée* style tournament faded into obscurity, those knights who liked their sport rough and enjoyed the dangers of mixed combat sought their excitement in other spheres. The almost continual warfare between England and France, and between England and Scotland, gave rise to a new variant of the sport. This was the border feat of arms, which contemporaries usually called a 'hostile combat' or 'jousts of war'.

Jousts of war The first manifestation of this occurred as a consequence of the flaring-up of hostilities between England and Scotland. Jousts of war between English and Scottish knights were fought during the sieges of Cupar, Perth and Alnwick Castle; on the last occasion they were described as 'great jousts of war on agreed terms'.[32] In 1341 Henry earl of Derby, who was already a noted tourneyer in England, held two important border combats. The first was at Roxburgh, where the earl and three companions jousted *à outrance* against a party of equal numbers led by William Douglas; Douglas was mortally wounded.[33] The second, more elaborate, affair was at Berwick, when twenty English knights challenged twenty Scots to three days of jousts *à outrance*. There were three deaths and many casualties, including one English knight, Richard Talbot, who would have been killed if he had not been wearing protective armour contrary to the agreed terms of the combat. In what seems a curiously inappropriate conclusion to the hostilities, the heralds present awarded prizes to the best performers on each side.[34]

The successful conclusion of the Scottish campaign provided the excuse for a series of elaborate jousting festivals held under the king's aegis, culminating in 1342 when he held a fifteen day long festival in London which was proclaimed throughout Europe and attracted many foreign knights, including those from Hainault who had fought on his campaign.[35] The following year, after a quarrel with the Pope over the Statute of Provisors, one of the king's household knights, Robert Morley, proclaimed three days of jousts at Smithfield in which he played the part of the Pope and his twelve companions appeared as cardinals.[36]

In 1344 Henry earl of Derby initiated another tourneying trend when he was given royal licence to hold annual jousts at Lincoln. He was to be the leader of a group of knights, who, after his death, were to enjoy the privilege of choosing his successor.[37]

Costume jousts Edward's triumphant homecoming from the Calais campaign was marked by celebrations in which the king and the Black Prince, who had distinguished himself in France, played a prominent role. The royal wardrobe provided fabulous costumes for jousts at Reading, Eltham, Windsor, Lichfield, Bury St Edmunds and Canterbury, which were issued to the king, his household, his minstrels, the queen and her ladies, and, perhaps most significantly of all, to the captive nobility of France and Scotland, among them the king of Scotland himself.[38] Events such as these not only commemorated Edward III's success in war by the obvious parading of his prisoners, but also contributed greatly to his international reputation as a chivalric figure. Ten years later he was able to repeat the exercise with even greater glory and acclaim, because among the captives present were not only the king of Scotland but also the king of France.

Edward's latest victories were marked by jousts at Smithfield in June, an unusual torch-lit jousting festival at night in Bristol, and a magnificent round table at Windsor in 1358, which Edward had proclaimed by heralds throughout France, Germany, Brabant, Flanders and Scotland at a cost of £32.[39]

The Windsor round table was particularly appropriate as a mark of Edward's successes on the battlefield of France, because an identical occasion had been used to launch the Calais campaign in 1344. His first great round table was held at Windsor that year; proclaimed at home and abroad, it lasted three days and the team of twenty defenders was led by the king in person. Over three hundred knights and three hundred ladies attended, but what made the event so remarkable was not its size, but the fact that an attempt was made to establish a permanent order of chivalry – one of the first of its kind in Europe. In direct imitation of the thirteenth century French romance of *Perceforest*, Edward persuaded the best tourneyers to join a fraternity of knighthood, and began to build apartments to house this round table at Windsor Castle.[40] Building operations lapsed after a couple of years because the money was needed more urgently in France, but an important chivalric precedent had been set, and Edward's reputation was only increased by this excursion into the world of romances.

After the glorious pageantry in the wake of the English victories in France there were comparatively few hastiludes in Edward's later years. A few notable ones did occur, but at irregular intervals: for the marriage of John of Gaunt and Blanche of Lancaster, the king with his sons and nineteen other nobles held the field against all comers, dressed as the mayor and aldermen of London. At Cheapside in 1362 seven knights jousted as the Seven Deadly Sins against all comers – much to the pious horror of the chroniclers.[41]

Jousts held by Edward III in honour of the Countess of Salisbury in 1342, at which John Beaumont was killed, from a fifteenth century copy of Froissart's Chronicles. (Oxford, Bodleian Library, MS Laud Misc. 653 f.5)

In April of the same year, a five day festival of jousts was held by the king at Smithfield; a great number of foreign knights attended, including Spanish, Cypriot and Armenian knights.[42] Ironically, the last recorded jousts of Edward's reign were in London in 1375, where the proceedings were dominated by his mistress, Alice Perrers, who flaunted her relationship with the now enfeebled king by appearing as the 'Lady of the Sun' (the sun being Edward's personal badge) and leading the tourneyers in procession to the lists for a festival which lasted seven days.

The joust as court monopoly

Under Edward III, hastiludes of all kinds had flourished. At home, jousts were held principally for the entertainment and for the benefit of the spectators; they were sponsored at every possible opportunity by the king and his court. Royal births, marriages and personal triumphs were the occasion for chivalric sport as much as moments of political achievement. By personal example and lavish patronage, Edward III made the joust *à plaisance* a court monopoly. On the other hand, for those knights who preferred more hazardous encounters, he seems to have positively encouraged the holding of hostile combats between knights of warring countries. If such episodes were fostered in the right way, they did not dissipate the strength of his armies but encouraged a spirit of prowess which could only inspire others and improve morale.

It might have been expected that Richard II's reign would prove to be an anti-climax after the achievements of Edward III. Surprisingly, however, Richard was to prove as lavish a patron of chivalry as his grandfather. By this time, knights were accustomed to looking to the royal court for patronage of hastiludes; but it is to Richard's credit that, despite his political problems, he never allowed this patronage to pass into Henry Bolingbroke's hands, even though the latter had a great aptitude for and love of the sport.

Richard first appeared at jousts in the Great Hall at Windsor as a child, but only in a passive role as recipient of a challenge from an esquire dressed as a damsel.[43] Indoor jousts, which of necessity must have been on a smaller scale than those held in London's market places, became a popular form of the sport, and this is one of the earliest instances in England. Several days of jousts were held at Westminster in 1382 to celebrate Richard's marriage to Anne of Bohemia and her coronation, and four years later Smithfield was the location of two days of jousts at which Richard's sun badge was prominently displayed.[44]

The revival of hostilities with Scotland led to a number of applications to the king for licence to perform 'feats of arms' against various named and unnamed Scottish knights. In 1386 Thomas Clifford was given a general licence to undertake feats of arms in the Scottish marches; in 1392 John earl of Huntingdon received similar permission for the Berwick area, and in 1393 licences were issued to four English and four Scots travelling to Carlisle 'to hold jousts of war there'.[45] The most famous of such encounters was held not in the Borders, however, but on London Bridge, where it was assured of maximum publicity. Four Scots, led by David Lindsay, fought single combats against four Englishmen, first with lances of war and then on foot with daggers. Despite the defeat of the English, Richard II rewarded the triumphant Scots with valuable gifts.[46] Three years later, in 1393, three Scottish lords returned to repeat their victory in London, but this time the English had their revenge and carried the day.[47]

Perhaps the most memorable of Richard's hastiludes were the October jousts of 1390. Announced in parliament and also proclaimed overseas, they were attended by the counts of St Pol and Ostrevant and the duke of Gueldres as well as large numbers of English. Twenty knights, led by the king, bearing the device of the white hart – the first public appearance of Richard's most famous badge – paraded through the Lon-

don streets from the Tower to Smithfield. They were followed by sixteen esquires bearing the device of a silver griffin. Each company held the field against all comers, and prizes were awarded to the best performers.[48] Eight years later Richard attempted to repeat the success with a jousting festival at Windsor at which forty knights and forty esquires, all bearing the device of a white falcon, would joust against all comers. According to Froissart, few nobles attended because of their increasing hostility towards the king.

The deposition and murder of Richard II marks the start of a sharp decline in English tourneying activity. Despite his own remarkable tourneying career as earl of Derby, Henry IV seems to have given little time to the sport after his coronation. An assassination plot against him and his sons at jousts at Windsor Castle, planned by supporters of Richard II, failed,[49] but it may have left its mark. Courtesy demanded that hastiludes were laid on for the arrival of the Holy Roman Emperor later that year; and Richard Beauchamp earl of Warwick fought jousts against all comers on behalf of Henry's bride, Joan of Navarre, at her coronation, as was his customary right as constable of England. Jousts were also held for the arrival of the Byzantine emperor, Manuel Comnenus, and the remarkable challenges for this occasion still survive.[50]

The end of the golden age of English tourneying

If there were few court-sponsored jousts in Henry IV's reign, there was no lack of hostile border combats. English knights continued to meet their enemies for jousts of war on the borders of Scotland and France, and challenges passed frequently across the Channel. The most notable of these encounters was the staging of combats in London between four Scots led by the earl of Mar and four English led by the earl of Kent.[51]

If Henry IV's patronage of hastiludes had been desultory and far from whole-hearted, Henry V's was non-existent. Once he had relaunched the war against France, his attitude was that no chivalrous sport should be pursued if there was the chance of real combat on the battlefield. He positively frowned on any form of joust which might detract from his cause, though his ambassadors were entertained at the French court by feats of arms *à outrance* between French and Portuguese knights.[52] Henry's attitude was neatly summarised in 1420 when, after his marriage to Catherine of France, the French proposed the customary celebratory jousts. Henry replied sternly that the knights could better prove their prowess by laying siege to Sens, where they could joust and tourney to their hearts' delight for a deserving cause.[53]

Henry's preoccupation with the waging of serious warfare and his formidable disapproval of all forms of hastilude reflected the established tradition that military sports were all well and good in peace, but in war they simply distracted knights from the campaign in hand. His opposition, however, meant the end of the sport in England for the time being, since without royal patronage they were no longer feasible. The initiative in jousting fashion passed elsewhere, notably to Spain; but first we return to the history of the joust in France.

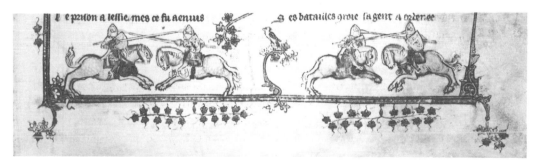

Pairs of knights jousting, from the Romance of Alexander, dated 1344; a simple form of horse-armour protecting the head and chest is shown.
(Oxford, Bodleian Library, MS 264 f.92)

France

Much the same sort of pattern of development occurred in France as in England. The huge *mêlée* tournament which dominated the twelfth and most of the thirteenth centuries began to lose its popularity as the small-scale joust emerged towards the end of the thirteenth century. There was a similar growth of emphasis on the need to provide entertainment for spectators, which led to the use of increasingly elaborate settings and attendant pageantry.

The most significant difference between England and France was that from the end of the twelfth century the English kings had a profound effect on whether tourneying flourished or was suppressed, whereas in France the king's interest – at least at the beginning of the period – was virtually irrelevant. French kings had no effective powers of intervention, since they had no equivalent to Richard I's decree of 1194 or to Edward I's Statute of Arms of 1292, which also regulated tournaments. They evinced an extreme reluctance to take part in any kind of military sports in their own person; it was evidently held to be unfitting for an anointed king to risk receiving blows or, even worse, unhorsings at the hands of his subjects, and though several kings of France attended tournaments in their youth, it was not until the middle of the fourteenth century that we find a king entering the lists.

Tournaments rare in France itself

Unwilling or unable to take part in the sport, the kings of France deprived themselves of the chance to identify with the interests of their chivalric subjects, and ignored the opportunity which hastiludes offered for purposes of propaganda. The patronage therefore passed into the hands of the great barons, so that in the thirteenth century there was no single focal point for the sport, and references to hastiludes in France are few and far between.

In 1209, Prince Louis was compelled to promise his father that he would not participate in tournaments; he was allowed to watch them, however, on condition that he wore only a haubergeon and a *chapel de fer*, the simple iron cap of a footsoldier. In this armour he would be protected from accidental knocks if the action spilled over from the lists but he would not be tempted to take part in the action. At an unspecified date, but some time before 1258, the sire de Nesle was accused of having forced the men of Noyon to go to a place near Beaulieu, where they were compelled to make lists and dig ditches for his forthcoming tournament.[54]

In 1260 Louis IX prohibited all tournaments throughout his realm in preparation for his crusade.[55] The prohibition can have had very little effect, as the Lord Edward took the opportunity that very year to leave England on a tourneying tour of northern France which was to last for two years.[56] Ten years after he left France, Edward was back again, breaking his return journey from crusading in the Holy Land to tourney against the duke of Burgundy at Chalons. The tournament was fought *à outrance* and involved large numbers of footsoldiers. When the duke seized Edward round the neck and attempted to pull him from his horse (a move which was not prohibited by such basic rules as existed at the time) tempers flared and the tournament turned into a full-scale battle involving the footsoldiers and the use of crossbows.[57]

Le Hem, 1278

A few years later, in 1278, one of the best-documented of all French hastiludes was held at Le Hem in Picardy; it was a spectacular Arthurian festival arranged by the lords of Longueval and Bazentin. The proceedings were initiated by 'Dame Courtoisie' and presided over by a 'Queen Guinevere'; all the attendant knights had to bring a damsel with them, in imitation of the knights errant of the romances, and an elaborate scenario was created for them. Seven knights came to surrender themselves to the 'queen' because they had been defeated in combat elsewhere by the 'Chevalier au

Lyon' or 'Knight with the Lion'. They were followed by the Chevalier au Lyon himself, entering in triumph with the queen's damsels, whom he had supposedly rescued, and even a real lion in his retinue.

The occasion for the jousts in question, which lasted for two days, was the public beating of a damsel who was being punished on her lover's orders for declaring that Guinevere's knights were the best in the world. This provided the opportunity for various knights to vindicate her claim against her lover. The complex arrangements involved not only the knights, but also the ladies and spectators, so that each had an integral role to play. The play-acting element also embraced all present, since the setting was Arthurian and the whole occasion was obviously and deliberately an imitation of Arthurian literature, even to the point of having a buffoon to take the part of Sir Kay.

Interestingly, the festival at Le Hem was held in contravention of Louis IX's prohibition on tournaments and this may explain the absence of a *mêlée* tournament on the third day of the proceedings which was the usual format for this type of occasion. It also explains the long diatribe at the beginning of the poem about the festival (*Le Roman du Hem*) written by a minstrel called Sarrasin, who complains that Louis' ban has impoverished all the minstrels, heralds, armourers, saddlers and provisioners of France who were dependent on the tournament for their trade.[58] Another interesting point is that Robert d'Artois, who played the starring role of the Chevalier au Lyon, was under excommunication in 1278 for having participated in tournaments and then in 1279 for having done so again in breach of an oath.[59]

There was also an important tournament at Compiègne in 1278, which was important enough to be commemorated by a roll of arms; this included many foreign knights, including an English contingent led by the earl of Gloucester.[60] In 1280, Philip III repeated the prohibition on tournaments but also forbade the holding of jousts as well. This was probably only a temporary ban, though the next great occasion on record was held at Chauvency, just outside the French king's jurisdiction, and included a *mêlée* tournament. In 1285, Louis de Looz, count of Chiny, held a week-long festival on the river plain at Chauvency; there were jousts on the Monday and Tuesday, but those on the Wednesday were cancelled when a knight was injured and it was feared that the tournament might be at risk. The event culminated in a *mêlée* tournament on the Thursday. The French visitors lodged at Chauvency with the count's younger brother, while the count of Luxembourg and his men and the knights of Flanders, Hainault and Ruy lodged at the count's own castle of Montmedy, a few kilometres to the east. The lodging arrangements provided a natural division into two

Chauvency, 1285

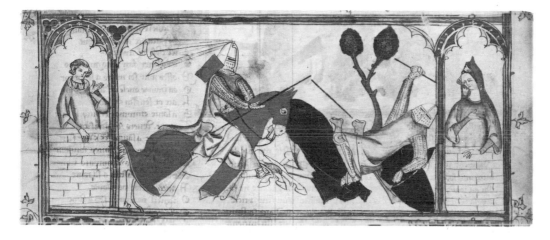

Thirteenth century joust.
(Bibliothèque Nationale, MS 146 f.40v)

sides for the actual combat. There were no Arthurian or play-acting elements in these festivities, but the week's events were preserved in the verses of Jacques Bretel.[61]

On neither of these great occasions was there any question of the king of France being present, though it was hoped that Edward I of England would attend the Le Hem jousts with a company of knights. In 1296 Philip IV issued a decree prohibiting, during the waging of public war, all private wars, duels, tournaments, jousts, and ridings (*equitaciones*) – in other words, all gatherings of armed men.[62] In the next few years he repeated this prohibition at intervals, in terms which echoed those used by the kings of England for nearly a century. In 1304 he ordered the arrest and seizure of all horses, arms and equipment of nobles going to tournaments in defiance of his prohibition, and forbade anyone on pain of death to assist tourneyers by supplying them with lodging, food or merchandise.[63] The prohibition was repeated several times during the year and again in 1305 and 1311.[64] In 1312 he prohibited all tournaments, jousts, 'tupinaires' and other feats of arms both inside and outside the realm for three weeks; but in this case his object was to ensure the maximum attention for the great festival he was holding to celebrate the knighting of his three sons.[65] On 5 October 1314 jousts and tournaments were again forbidden because the king was planning a crusade, and it was argued that hastiludes delayed such projects and caused unacceptable losses of men and horses at a crucial time; the prohibition was repeated on 1 April 1316 by his successor Philip V for the same reason.[66]

More favourable royal and papal attitudes

Five months later, Pope John XXII, who had come to the papal throne under the aegis of France and whose residence was established at Avignon rather than Rome because of the schism, lifted the church's ban on hastiludes which had been in operation since 1130.[67] Tourneyers were no longer threatened with excommunication and refusal of ecclesiastical burial if they were killed in the sport and the enforcement of prohibitions now rested solely in the hands of the secular authorities. The removal of

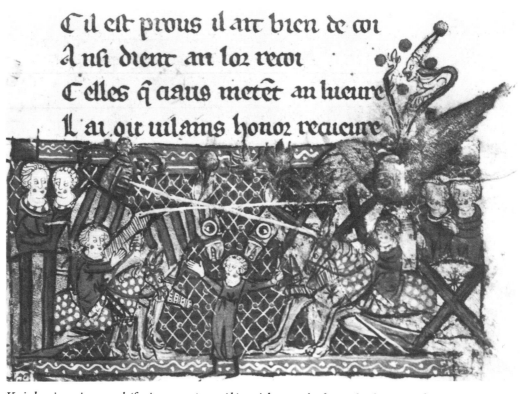

Knights jousting, and (facing page) a mêlée with swords, from the fourteenth century manuscript of Jacques Bretel's Le Tournoi de Chauvency.
(Oxford, Bodleian Library, MS Douce 308, ff.114 and 131)

the formal and universal church ban also made it possible for the kings of France to patronise tournaments openly, and even to participate in them, for the first time.

In 1329 Philip VI held jousts at Amiens to celebrate the occasion of his receiving homage from Edward III of England. The following year, the burgesses of Paris held a round table which was attended by the citizens of Flanders; there was already a long tradition of jousting in the Flemish towns. Two years later, in 1332, the provosts of Hainault and Valenciennes attended a second round table hosted by the burgesses of Paris.

The outbreak of war against England, however, gave great impetus to the development of hostile encounters, which, as we have already seen, flourished in border areas during periods of conflict. A typical example of this kind of encounter took place in about 1343, when Thomas Colville, an English knight, forded a river to joust against (and kill) a French knight who had offered a challenge from the supposed safety of the opposite bank. In 1344 Philip VI found it necessary to establish a French version of the round table to rival that set up by Edward III which was attracting knights from all over Europe to the English cause; Philip's version was specifically aimed at German and Italian knights. During the English siege of Calais the presence of the opposing armies encouraged daily bouts of jousting *à outrance*, but two of the most spectacular encounters of this type were more formally arranged and involved greater numbers of participants.

At Ploermel in Brittany in 1351, thirty French knights fought against thirty English with no restrictions as to weapons, with the result that six French and nine English were killed and several more died of their wounds later. According to Jean le Bel, the English had demanded jousts on behalf of their respective ladies, but this appears to be a romantic view of a challenge which really arose between two garrisons attached to the rival parties claiming the duchy of Brittany. Interestingly, for what was essentially a chivalric combat, all the fighting took place on foot, and most of the participants were mercenaries.[68]

'Combat of Thirty', 1351

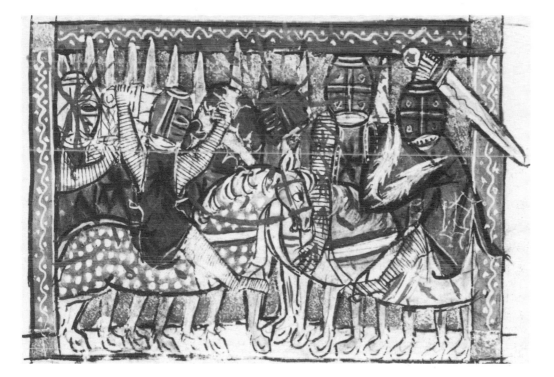

The widespread fame achieved by this 'Combat of Thirty' probably inspired a similar event on the marches of Gascony the following year: twenty French knights challenged twenty Gascons attached to the English cause to mortal combat, and casualties were again very high.[69] It was echoed as much as thirty years later, in 1382, when fifteen English knights fought fifteen French knights at Rennes.[70]

More commonplace were the single combats which seem to have been an accepted part of any siege. A typical example took place at the siege of Rennes in Brittany: the young Bertrand du Guesclin fought three courses with lances, three with battle-axes and three with daggers against an English esquire, Nicholas Dagworth. Both parties fought valiantly, no harm was inflicted, and the whole affair was viewed with great pleasure by both armies.[71] Similar challenges were fought during the earl of Buckingham's expedition to France in 1380, with combats at Vannes, Chateau Josselin and Montenoir. In 1387 the nephew of the captal de Buch jousted three courses of war against a Gascon attached to the English party at Bordeaux; and the following year a French knight fought five courses each with lance, sword, dagger and axe against an English knight who was in the company of the recently exiled duke of Ireland.[72]

In the same year (1388) four French knights took the unusual step of travelling to attend the English parliament, where they announced a challenge to jousts *à outrance* at Calais. John, Lord Beaumont, and Piers Courtenay were given royal licences to travel to Calais, where they upheld English honour in the combats.[73] For Piers Courtenay, this event seems to have marked the beginning of a jousting career in northern France. In 1389, he jousted in Paris in the presence of the king, who stopped the combat after only one course; against the king's express command, Courtenay then jousted *à outrance* against the sire de Clary at Calais, where he was badly wounded in the shoulder.[74] He had recovered sufficiently to intercede with Richard II on behalf of

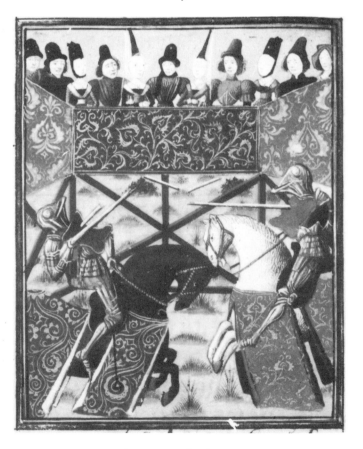

Piers Courtenay jousts with Guy de la Tremouille, from a manuscript of Froissart's Chronicles (BL MS Harley 4379 f.19v)

three French knights, Boucicaut, de Roye and de Sempy, who had proclaimed (with Charles VI's approval) a jousting festival for sixty days on the marches of Calais, at St Inglevert. These were the most famous French jousts of the fourteenth century. In the letter outlining the details of the jousts, the defenders offered to hold the lists for thirty days from May 20 next, and to 'deliver from their vows all knights, squires and gentlemen, from whatever countries they may come, with five courses with a sharp or blunt lance ... or with both lances'. The challengers were to touch a shield of war or of peace belonging to one of the defenders on the previous day, to give notice of their intention to fight, and to indicate which lance was to be used. The letters were widely circulated, and aroused particular enthusiasm in England, as a year's truce with France was in force, and the younger knights were eager for action. About a hundred English knights and squires crossed the Channel to take up the challenge, and many more came to watch; about forty knights came from other countries. In the event, the total number of jousters was in fact only thirty-nine, and the whole of the proceedings lasted four days, from 21 May to 24 May. There were no serious injuries, even though most of the English knights chose to joust *à outrance*, and the jousting was generally reckoned to have been of a high standard, with several knights unhorsed and many unhelmed, and a good number of spears broken. When the English party left on the evening of 24 May, no other challengers appeared, although the three knights held their places until mid-June in accordance with the terms of the original letter.[75] Charles VI granted 6000 francs to the three defenders in a writ dated 13 May, and is said to have attended the jousts incognito as a spectator.[76] At the end of the thirty days the three challengers returned to France covered with glory, and donated their arms in triumph to the church at Boulogne.[77]

Jousts at St Inglevert, 1390

In 1389 there were also two famous sets of jousts associated with the royal court. The jousts at St Denis in 1389, according to the chronicler of St Denis itself, were held after the coronation of Charles VI's queen Isabella in order to 'ensure powerful friendships and gain the favour of strangers'. This did not impress the populace, who muttered – no doubt thinking of their taxes – that such amusements were unbecoming to the king's majesty.[78] Charles himself was one of the thirty knights who challenged an equal number of defenders, the latter wearing the royal device of the blazing sun. Three days of jousting followed: on the first day, Froissart records that 'the number of knights made it difficult to give a full stroke, and the dust was so troublesome that it increased their difficulties'. The next day, when the esquires fought, two hundred water-carriers were employed to water the square, but 'notwithstanding their efforts, there was still a sufficency of dust'. The ladies, who watched from scaffolds around the square, joined with the heralds in adjudging the prizes each evening, and on the Friday, after the main jousts had ended, knights appeared in the wooden hall which had been specially built for the occasion and tilted for two hours indoors.[79] Although Froissart's account might imply that there was a general *mêlée* on the first day, it seems more likely that these were multiple jousts going on at the same time. The Spanish knight Pero Niño found this when he came to Paris twenty years later:

Royal jousts at St Denis, 1389

> There is neither one that holds the lists, nor joust of one man against another by champions assigned; but each attacks whomsoever he will. All are assailants; ten, or twenty, or thirty, or more, take their place on one side, and as many on the other. As soon as one takes his lance, the other at once grasps his; and not only one goes out against him, but in their great ardour it happens that two or three come forward together against him who has stood forth, notwithstanding their courtesy ...[80]

Something of the splendour of the occasion can be gleaned from the accounts of the duke of Burgundy: his son, the count of Nevers, had only just begun to joust, appearing in the lists for the first time in the previous year; and he gave Mlle de la Riviere, daughter of one of Charles VI's counsellors, a diamond ring for leading him into the lists. The gold which was taken off the duke's doublets after the festival fetched over 1000 francs, and more than 500 ostrich feathers were used, including one on the beaver hat, lined with sendal silk and adorned with a silver fringe and three pheasant feathers as well, which the duke wore as he entered the lists. An immensely detailed list of embroidered clothing made for the duke's sons for the queen's entry also survives, including the 26 sets of jousting armour decorated with the sun which they and their 24 companions wore.[81] Several days of jousting and feasting also celebrated the knighting of Louis and Charles d'Anjou by the king. A great wooden hall was built, lists were made of wood and linen (indicating that painted cloth draperies were used) and a large wooden stand was commissioned for the spectators. The day after the complex pageantry of the knighting ceremony, jousts were held. Reginald de Roye, of St Inglevert fame, was one of the company of twenty-two defenders, all clad in the same livery and each led by a lady dressed in green, who held the field against all comers.

By the end of the fourteenth century, therefore, France enjoyed the same diversity of hastiludes as England. On the one hand there was the deadly serious hostile combat generally fought in border country against the enemies of France, and on the other the increasingly court-centred joust *à plaisance* with all its attendant ritual and pageantry. The large scale *mêlée* tournament had died out in the early fourteenth century, though the Hundred Years War gave added impetus and motivation to those seeking glory and entertainment in the lists.

A magnificent thirteenth century ivory saddle-bow from the Louvre, with highly realistic figures of jousting knights, showing the relatively light armour of the period.
(Musée du Louvre OA 3361; photo Musées Nationaux, Paris)

Low Countries

The history of tourneying in the Low Countries – Flanders, Hainault and Brabant – follows the same pattern as in England and France, with one important difference. In this comparatively urban area, hastiludes were not solely the province of the knightly ranks of society, but were also patronised and fought by burghers of the towns and cities. This is not to say that the nobility had no role to play: far from it, for the counts of Flanders were amongst the greatest patrons of chivalry from the twelfth to the fourteenth centuries. But they, like their nobility, were town based and therefore the type of market-place joust which appeared in England and France in the fourteenth century was already in evidence in the Low Countries at least a century earlier.

One of the earliest round tables on record took place in 1235 at Hesdin in Flanders. A large number of Flemish barons attended, together with knights from further afield, and in response to the preaching of the crusade there, many of the tourneyers, including the duke of Burgundy and the counts of Chalons, Nevers and Brittany, took the cross.[82] The *dits et contes* of Baudoin de Condé, a minstrel who was writing at the court of Hainault between 1240 and 1280, make it clear that there was already a highly developed system of tournament organisation at that time. Although much of his work is taken up with complaints about the pride, greed and corruption of heralds – the minstrel's natural enemy, since they compete for the same largesse – he also sheds incidental light on the formalised nature of tournaments, fought within lists and with heralds in attendance to make the necessary proclamations.[83]

Round Table at Hesdin, 1235

The Low Countries were not exempt from the problems which tourneying caused elsewhere. In 1284, the citizens of Douai and Lille were at loggerheads. When Douai held its annual spring jousting festival, the city refused to supply opponents for two jousters from Lille, in defiance of custom. After the intervention of the son of the count of Flanders, who was present, some opponents were found, but to preserve the honour of all concerned, he finally had to arrange for one of his own esquires to run the courses against the men from Lille. Instead of pacifying them, however, this had the opposite effect, and the entire contingent from Lille withdrew the next day in high dudgeon.[84]

One of the most notorious episodes was not caused by any hostility or rivalry between the combatants. In 1294 the duke of Bar proclaimed a round table at Bar-sur-Aube to celebrate his marriage to the daughter of Edward I of England. John, duke of Brabant, who was also married to a daughter of Edward I and had fought in over seventy tournaments in England, France, Germany and even further afield, as well as in the Low Countries, was killed in the first encounter by a French knight.[85] This emphasises the ever-present danger of tourneying, even when the event was a celebration and precautions had been taken against accidents.

In 1300 Bruges was the setting for jousts before the Guildhall in honour of Philip the Fair of France; many English and German knights attended the jousts, and the French queen complained in jest that she was surrounded by a thousand queens – the ladies among the spectators who were role-playing for the occasion. Another tournament at Mons in 1310 also attracted considerable numbers of foreign knights, including the elder Hugh Despenser and Robert d'Enghien from England. There is no record of it in the chronicles, but we know of it from the roll of arms drawn up to commemorate it.[86] In 1327 Jean count of Hainault left England (despite attempts to persuade him to stay) because he wished to attend a tournament at Condé and he took with him a company of fifteen English knights who were also eager to take part.[87]

Jousts as civic festivals

By this time, however, the records of civic festivals become more lengthy and frequent. They always involved elaborate pageantry and role-playing, with an emphasis on chivalric romance and lore. In 1326, nine burghers of Hainault jousted as the Nine Worthies who represented the epitome of chivalric prowess.[88] At Tournai in 1330–1, thirty-one burghers held an immensely elaborate round table; each of the defenders dressed as and bore the arms of one of the thirty-one kings contemporary with king Arthur. The year previously they had formed a society of the round table, and had sent out invitations to the festival which were accepted by fourteen cities, including Valenciennes, Paris, Bruges, Amiens and Sluys. Each company from a visiting city was met outside Tournai, and escorted to their allotted lodgings. The jousts themselves took place in the market square, and there was an impressive procession of the participants to the lists. Jean de Sottenghien won the prize, a golden vulture, and the affair was concluded by a banquet at the Hotel de Ville organised by one of the citizens, Jacques de Corbry.

The citizens of Valenciennes took the romance elements to spectacular lengths in their own festival held in the same year. Not only did damsels lead the jousters through the streets to the market place by lengths of gold thread, but they were also preceded by a great castle, 'which moved very richly by ingenious means'. Above the castle, which was probably the focal point for some of the defenders, were four angels with young infants, and above them the allegorical figure of the god of love himself. Another company arrived preceded by a castle which boasted a hermit, seven fairies and a device for releasing live birds.[89]

Festivals at Lille

Perhaps the most important of all the festivals of this type was that of the 'Roys de l'Espinette' (King of the Thorn) or 'L'Epervier d'Or' (The Golden Sparrowhawk) held each year at Lille since at least 1278, though detailed accounts do not survive until the fourteenth century.[90] In 1335, for example, knights from Valenciennes attended dressed in scarlet and carrying three live swans as a rebus on the town's name – 'val aux cygnes' or valley of the swans; they presented a model of the town flanked by towers and bearing standards of the city's arms to the 'roi d'espinette' himself, who appears to have been the victor of the previous year. A Valenciennes citizen, Jacques Grebert, won the prize in the jousts, and was carried off in triumph by four damsels.[91] The importance of the annual Lille festival was acknowledged by Philip IV of France when he exempted it from a general prohibition on jousts in 1338.[92] Winning the jousts carried immense prestige, and the triumphant knight was often honoured by his own city; in 1352, for example, Michiel Anguille of Ypres was rewarded by his fellow citizens with a gift of Rhenish wine.[93] The main prize of the festival was a golden thorn, which seems to have been a symbol of Christ's crown of thorns. On the other hand, the festivals were firmly rooted in the literary tradition of the romances, and were even called the 'festival of the lord of Joy', a direct reference to the twelfth century romance *Erec et Enide* by Chrétien de Troyes. As at the other urban festivals, great emphasis was placed on the procession of jousters through the streets to the lists, with the important corollary that the civic pride of the participating towns led to great ingenuity in creating mechanical effects rather than simply the wearing of liveries, which seems to have been the custom in England and France. The presiding 'roys de l'espinette' was assured of great honour throughout the year of his office and rode in triumph to a formal coronation which preceded the jousts; the festivities as a whole lasted up to two weeks.[94] At some time in the fourteenth century, the appointment of the new 'roys de l'espinette' came to be made by a college of former 'roys', and thus took on something of the format of an order of chivalry.[95]

The civic festivals which played such an important part in the life of the Low

Countries had no parallels in England or France, though there are traces of such events in Paris. What is remarkable about these festivals is that they continued to be held, year in, year out, every year from the end of the thirteenth century to the last part of the fifteenth century. The expenses were borne by the city, sometimes in conjunction with prominent citizens, and there was no distinction between the social rank of the participants. Burghers assumed the right to carry arms and to armorial bearings without hesitation, even if these were normally regarded as the jealously-guarded privileges of the knightly classes, and they jousted indiscriminately against the hereditary nobles in the lists. It is true that these festivals tended to be purely local in character – it was exceptional for foreign knights to attend – but they provided a continuity of practice and a standard of spectacle unique in Europe.

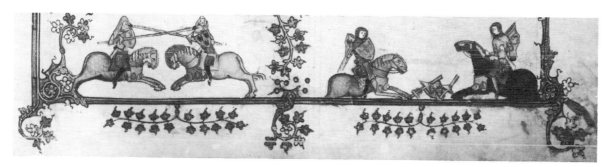

Jousters and a double fall: the knights on the right have elaborate crests. From the Romance of Alexander, dated 1344. (Oxford, Bodleian Library, MS 264 f.113)

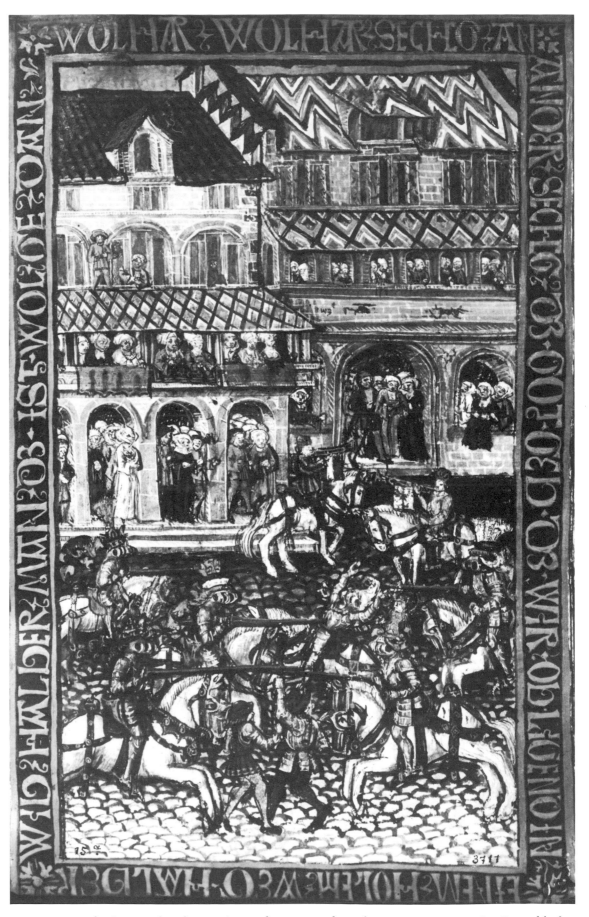

Mêlée in a marketplace; a sixteenth century coloured engraving representing Leopold of Austria's tournament at Zofingen, 1381 (Bürgerbibliothek, Luzern: Diebold Schilling, Luzernerchronik, (1513) f.15) (Photo Schweizerisches Landesmuseum, Zürich)

3

The Tournament in Germany

We have already seen that tournaments were known in Germany by the mid-twelfth century, and had spread as far as Austria by 1175; but the evidence for tourneying east of the Rhine continues to be slender until the 1220s. In 1225, we hear of a tournament to celebrate the successful conclusion of a siege, when Ludwig of Thuringia captured the castle of Lebus near Frankfurt an der Oder; 'the soldiers unanimously agreed to have a kind of tournament called a joust, and it was held on August 16'.[1] Individual jousts predominate in all the accounts of German tourneying at this period, but this is probably due to the chances of surviving evidence rather than a real predilection among the Germans for this form. In 1227 a knight from Thuringia named Waltmann von Setenstete announced that he was setting up a 'forest'[2] (a German name for a type of 'round table' joust) near the town of Merseburg, to which he would bring a beautiful girl. Imitating a familiar pattern in the romances of chivalry, he would fight three courses (*ziost*) with anyone who challenged him, and if he was defeated, the victor could lead away the girl and take his arms and equipment as well. However, he reached the place named as the 'forest' unscathed, despite numerous challenges on the way from knights who had come from various provinces. At the 'forest', some kind of ceremony or festival was held, and he returned home in triumph with his companion.[3]

Literary influence also plays an important part in the career of one of the most *Ulrich von Liechtenstein*
famous of all tourneyers, Ulrich von Liechtenstein. His account of his travels in pursuit of two elaborate jousting challenges is one of the classics of tournament literature, but is it history in a literary form, or literature with a tinge of history? The poem which relates his adventures is entitled *Frauendienst*, 'The Service of Ladies',[4] and relates how, in pursuit of a lady who had adamantly resisted Ulrich's chivalrous attentions, he set out to prove his worth and devotion by a journey in her honour and that of all women, a 'Venus journey'. He set out from Venice, having made elaborate preparations, on 25 April 1226, and travelled into the Tirol, ending his journey at Vienna a month later, having by his own account broken 307 spears with his challengers, and having given 271 rings to knights who had succeeded in breaking a spear on him. Throughout the journey he was dressed as 'Lady Venus', both on and off the field, and he claimed that no-one penetrated his disguise, though there is high comedy in some of his narrow escapes, and it is evident that even if his identity was a secret, everyone must have known that he was a knight in disguise: at Villach he went to church in women's clothing, and admits that his appearance aroused much laughter.[5] It is the exact nature of the borderline between reality and romance that is hard to disentangle. There is clear evidence from the 1220s that tournaments were fought in a literary framework, if not actual disguise, as in the case of the knights at the court of Cyprus in 1223 who 'imitated the adventures of Brittany and the Round Table'; Waltmann von Setenstete's excursion has a similar background; and Ulrich himself

was later to describe his own 'Arthur journey', undertaken in 1240. It is difficult to dismiss all these unconnected episodes as literary works being mistaken for history. Nor is it realistic to demand supporting evidence from elsewhere before we accept Ulrich's journey as having any basis in fact: even at the end of the middle ages, our knowledge of spectacular tournaments may depend on only a single source, and many chroniclers seem to go out of their way to avoid mentioning such events. Early in his poem, Ulrich tells us about a great tournament at a diplomatic meeting at Friesach on 12 May 1224. As the knights assembled for the negotiations between the lords of Istria and Carinthia, Ulrich and his brother Dietmar encouraged them to joust; and such was the enthusiasm that the diplomatic proceedings were held up until a full-scale tournament was arranged. Only when this was over could the talks proceed. Ulrich describes the jousts in detail, and gives the correct arms for each knight. The jousts are not mentioned in any contemporary chronicle, but as we have only brief accounts of the whole political side of it, this is hardly surprising. We can point to similar diplomatic occasions throughout Europe from the late thirteenth century onwards when diplomacy and jousting went hand in hand.[6]

Factual basis of Ulrich's account

Ulrich's account of his journey, it seems to us, is firmly based on fact. But – the same is true of the far more down-to-earth life of William Marshal – we need not believe every detail. Ulrich's poem is written to entertain as well as to record his exploits; there is satire, self-mockery and, running through it all, the very literary theme of unrequited courtly love. We shall return to Ulrich's story for different aspects of the tournaments he describes. In terms of the history of the tournament, it is fair to take it as evidence of great enthusiasm for both the individual joust and for the mass tournament, though the distinction is not always clear: at Neustadt in 1240, a tournament is specifically arranged for a fortnight's time, but the assembled knights pass the interval in what can only be called a multiple joust, in which six defenders from Ulrich's 'Round Table' fought seventeen knights; they were supposed to fight one to one, but often two attackers went for a single defender and the result was not unlike a *mêlée*. Ulrich claims that over a hundred spears were broken.[7]

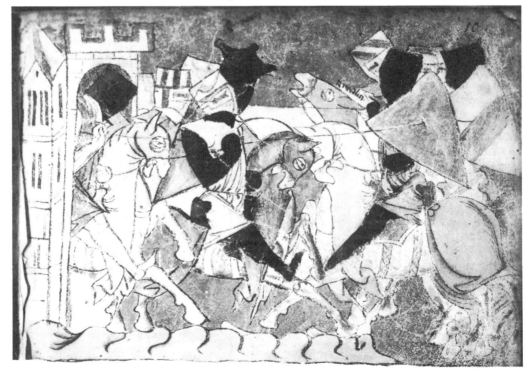

Tristan's father Rivalon is wounded in a tournament; from a German artist's version of the Tristan story, dating from about 1240.
(Munich, Bayerische Staatsbibliothek, MS Cgm 51, 10v)

The arrangements for the jousts seem to have been slightly more elaborate than in William Marshal's day: although the 'circle' of which Ulrich speaks may sometimes have been no more than a handful of attendants watching the sport, at Neustadt he specifies that there were two gates into the ring, and that everyone kept well clear once proceedings began.[8] The opening of the jousts was accompanied by processions on several occasions: at a special event such as the joust at Neunkirchen, he had three new banners made; musicians accompanied them playing on flutes, as well as squires bearing lances, and a hundred knights rode behind the banners.[9] The musicians seem to have played during the jousting as well: at one point, Ulrich comments that the noise of the combat was such that it drowned the music.[10] Similarly, at Korneuburg in 1227, Ulrich describes an elaborate procession with buglers, a single banner, and his armour paraded piece by piece.[11]

The actual presence of ladies at the jousts is more problematical. At Treviso, where Ulrich found that the local lord had banned jousting, he enlisted the ladies of the town to get the ban temporarily lifted, so that Meinhart von Gorze and Leutfried von Eppenstein were allowed to joust with him, on a bridge in the town; this had to be cleared of the crowds of onlookers who thronged the streets before the jousting could begin.[12] There is a repeated insistence that knights joust chiefly in order to win their ladies' love, but as Ulrich himself signally fails to make any impression on his hard-hearted first lady on the 'Venus journey', and is already sure of the favour of his second lady when he sets out on the 'Arthur journey', the story itself is at odds with the ethos which its author so confidently proclaims. Certainly the jousts described by Ulrich give much more scope for an individual knight to win fame than the general free-for-all of William Marshal's tournaments, and the rings promised on the 'Venus journey' by Ulrich to all those who break a spear on him are, one feels, valued as badges of achievement as much as for the impression they will make on the opposite sex. In the 'Arthur journey' the challenge is greater and the reward purely honorific:

Presence of ladies

One of the very few surviving thirteenth century shields, that of Konrad of Thuringia, c.1240; such an elaborate design would have been more suitable for tournaments than war, though there is no evidence of its specific purpose.
(Universitätsmuseum, Marburg) (Foto Marburg)

those who break three spears become members of the Round Table, and assume a suitable name.[13] The real enthusiasts for the sport were very probably the knights themselves, rather than a gallery of onlookers.

Reliability of Ulrich's narrative

But if the whole narrative is cloaked in literary devices and spiced with improbable humour, how reliable is it? How do we assess a scene such as that where Ulrich is sitting in the bath and a page enters with a beautiful set of lady's attire, which he presents to Ulrich, and then fetches two companions who shower Ulrich with rose petals? In some respects, this sounds like a genuine bit of chivalric horseplay; but Ulrich's descriptions of his relations with his lady are much more literary in tone. What we can say is that the names and places are genuine enough, and there are little touches which a writer working from imagination only is highly unlikely to have invented. At Tarvisio, a siege nearby meant that there was no jousting at first, because the knights were otherwise occupied.[14] And there are other moments which are too improbable to be invented: at one point, Ulrich slips away to spend three days with his wife, and describes his joy at being with her, an odd episode in a poem in which he is trying to win the love of another lady.[15] On another occasion, Ulrich refuses to joust with a knight disguised as a monk, though we shall see that this was by no means an unusual costume in tournaments; and it is only at the entreaty of other knights that he finally consents, though he is delighted to be able to give the 'monk' a heavy fall.[16] At intervals the poem simply becomes a list of successful and unsuccessful knights, as if the writer was working up bare notes which had run out of detail. The final pages of the 'Arthur journey', when the projected final tournament is first delayed and then banned by Frederick duke of Austria, end the quest on a decidely downbeat note – a conclusion which a purely literary writer would be most unlikely to choose.[17] So, even if we cannot quite believe the brilliant image of Ulrich von Liechtenstein preserved for us in the Manesse manuscript almost a century later, resplendent in a helmet crowned by an image of Venus as he parades before the admiring ladies, his account is a perfectly valid source for the tournaments of his day.

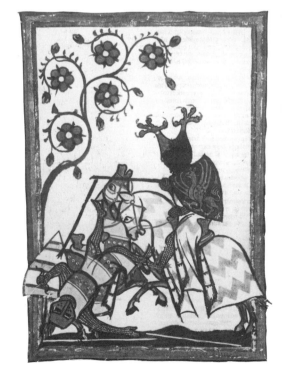 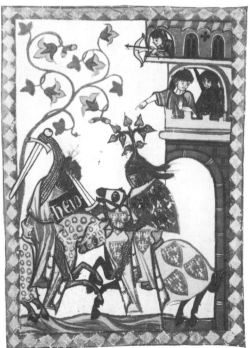

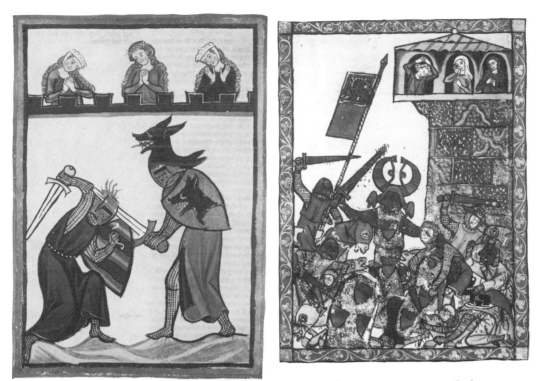

*Aspects of the tournament in the early fourteenth century, from the Manesse Anthology,
c.1300–50.
Above left: Fighting with swords on foot. Below left: a fallen knight is watched by a lady
and musicians. Above right: a mêlée. Below right: fighting with swords on horseback.
Facing page: ferocious fighting and grotesque crests.
(Universitätsbibliothek, Heidelberg, MS Cod. pal. Germ 848, ff.42v, 192v, 197v, 321v,
26v, 61v)*

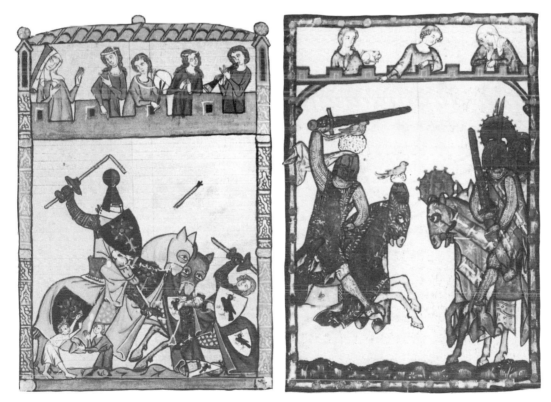

There are a handful of notices of German tournaments in the later thirteenth century, by contrast with the riches which Ulrich's narrative offers us. Some of them are concerned with disasters, the most famous being that at Neuss in 1241, where a preacher was said to have tried to dissuade the knights from jousting; in the ensuing encounter sixty knights and squires were killed, suffocated by the clouds of dust, according to Alberic of Trois-Fontaines, who claims that demons in the shape of vultures and crows circled overhead, terrifying the survivors. Another source gives the death-toll as 80, saying that the knights suddenly went mad.[18] Two members of one family were suffocated in tournaments at Strassburg; their deaths were noticed in 1279 by the chronicler because Lantefrydus de Landesperach died exactly thirty years after his father, at the same town and in the same way.[19] And at Merseburg in 1268, the local chronicler noted that not only was John margrave of Brandenburg killed in a tournament, but another knight was drowned with his squires on the way home.[20]

'Forest' at Nordhausen, 1263/7

Chroniclers with less of a taste for a heavy moral line about the evils of tournaments record happier occasions, such as the spectacular tournament or 'forest' held by Heinrich, margrave of Meissen and landgrave of Thuringia, at Nordhausen in either 1263 or 1267. Heinrich had a 'marvellously beautiful wood of green trees' built outside the town, among which was a tree with gold and silver leaves. A large number of eminent lords gathered for the tournament, 'some spurred on by courage, others spurred on by love' and if any of them broke a spear on his opponent, he was awarded a silver leaf from the tree. If he succeeded in unhorsing his opponent, he was given a golden leaf.[21] This lavish festival marks a shift in attitudes towards the tournament, in that it is one of the earlier examples of a festival under royal or princely patronage: the chronicler notes that it was a spectacle 'worthy of an emperor', and even allowing for the fact that he was writing a century after the events he describes, the way in which the margrave is the undoubted driving force behind the tournament, and uses it to display his own wealth to best effect, points forward to the elaborate royal festivals of the later middle ages, away from the highly personal enthusiasm of Ulrich von Liechtenstein and his friends. The carefully contrived scenery and the hint of some kind of 'programme' belong to the new style of jousts, highly organised and much more formal.

Kadolt von Wehing

We get a more direct glimpse of the knight's involvement in tournaments from Austria at about the same time, in a collection of letters from Lâa, near Vienna. The letters are rather formal, and may have been kept as models for letter-writing: but the people and events seem real enough. They concern Kadolt von Wehing, captain of the garrison at Lâa; we find him invited to a tournament in nearby St Polten, to which he replies that it is such short notice that he cannot make the necessary preparations; unwilling to let his friend down, he will nonetheless come rather than let their challengers win the day because of his absence.[22] On another occasion, Kadolt asks for a lawsuit to be deferred until he and his men get back from a tournament in Carinthia.[23] And when he is invited to a tournament at Eggenburg against newly-made knights from Vienna, he replies that although he is suffering from severe pains from an injury to his armpit, he will come to the tournament for the chance of showing off his skill in arms.[24] Again, Kadolt writes to a knight coming from Znaím in Czechoslovakia, some sixty miles away, for a tournament in Vienna, suggesting that he should come and rest his horses for a few days, so that they can proceed to the tournament together in good shape.[25] We are back in the world of Ulrich von Liechtenstein, of individual knights who delight in jousting and take part as and when opportunity offers, despite the difficulties of the everyday world. We know of other such enthusiasts in Vienna at this period: on 5 December 1279 Otto von Haslowe, aged over eighty, jousted with

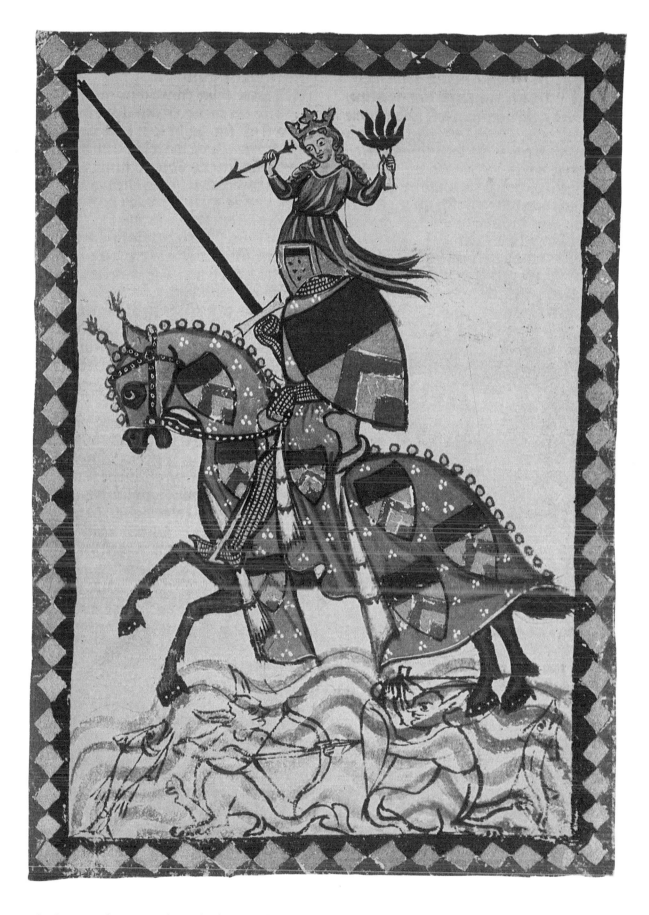

Ulrich von Lichtenstein, from the fourteenth century Manesse anthology.
(Universitätsbibliothek Heidelberg, MS Cod. pal. Germ 848, f.237)

his great-grandson, Hugo Tuers, who had been knighted that day by Rudolf of Habsburg.[26]

'Grail' at Magdeburg, 1282

One of the oddest tournament stories comes to us from Saxony a couple of years later, in 1281–2: here it seems that local enthusiasts were attempting to imitate the new high style in tournaments. According to the town chronicler of Magdeburg,[27] Brun von Schonebeck, one of the constables of the town – 'he was a learned man' – presented a joyous entertainment. He 'made a grail', and wrote courtly letters to Goslar, Hildesheim, Brunswick and other places, inviting all those who wished to practice knightly skills to come to Magdeburg. He and his fellow-constables found a beautiful woman, of doubtful morals, whom they called 'Frau Feie' and who was to be given to the victor in the jousts. This aroused great enthusiasm in the surrounding towns, and the various contingents arrived, each in their own colours. The 'grail' was set up on the marshes outside the town, and two of the constables took up their station in it; outside was a tree on which the constables' shields hung. Any would-be challenger rode up and touched one of the shields, and its owner came out to joust with him. But the end was pure anti-climax: 'an old merchant from Goslar' won the hand of 'Frau Feie', married her off with a good dowry and persuaded her to abandon her wild ways. The chronicler notes that 'a whole book in German was made about this', and that Brun von Schonebeck wrote a number of works in German, including religious treatises and many good poems. So was the whole episode a literary exercise, perhaps even a satire on the knightly aspirations of the young bloods of the city? The downbeat ending might well be taken for satire: but the chronicler draws attention at the beginning of his description to the regularity of the Whitsuntide games at Magdeburg of 'Roland, Schildekenboom (a tree of shields), round tables and other sports', and this seems to have been a more elaborate and spectacular version of the regular event. The enthusiasm of the Magdeburg citizens for tournaments is confirmed by a strip of tin figures found in the old marketplace, contemporary with this festival, which shows knights tourneying and what may be allegorical figures referring to such an occasion. So we can award the old merchant riding off home with his unlikely companion his improbable place in the list of tournament champions.

Tournaments at princely courts

By the end of the thirteenth century, the tournament was a regular feature of the gatherings of princely courts, whether official or social. In December 1290, Rudolf of Habsburg was at Nuremberg, negotiating with the princes of the empire. 'Among the other things they did there, as is the custom at royal courts, the nobles of the court took part in fierce jousts, while the populace watched them.'[28] Ludwig, son of the duke of Bavaria, 'contrary to the practice of princes' insisted on taking part, despite his friends' attempt to dissuade him. He ordered his charger to be prepared and his armour to be brought. Unable to find an opponent of equal rank, he challenged a nobleman from Hohenlohe, who at first declined the challenge out of respect for the duke; but Ludwig insisted, and they charged at each other. Two or three courses were run, in which the lord of Hohenlohe let his lance drop away, in order to spare Ludwig. In the end, however, whether because his spirit was roused or because he was asked to do so, he held his lance firm and struck the duke on the neck-armour, penetrating it and causing a fatal wound. When the lance was drawn out, it was found to have a sharpened point, 'for which nothing is impenetrable, but which goes through anything'. Amid suspicions of treachery, the lord of Hohenlohe fled, and Ludwig died some days later.

This episode underlines two aspects of jousting as well as its establishment at royal courts: the ever-recurrent danger, and the class from which the jousters came. Princes were evidently not expected to joust, though we shall see that many of them did so; it

was a sport for the men who actually fought the battles, rather than their commanders. But it was a sport which required organisation and expense beyond the means of an individual of this rank. Rather than wait on the whims of princely favour, they formed societies for the purpose, the earliest of which seems to date from the 1270s. Basle was renowned for its small but enthusiastic group of knights who appeared at tournaments – one source says there were only 'fifty or more';[29] there are records of tournaments at Basle in 1266, at Basle and in nearby Hagenau where a knight from Basle killed his opponent in 1292, and at Basle in 1300; there may have been a regular tournament at Basle on the Nativity the Virgin.[30] But more interesting than these scattered records is the report of the formation of two rival associations of knights, under the banners of a great white star on a red field (the Stars or *Sterner*) and a green parrot on a white field (the Parrots or *Psitticher*). Their formation was specifically reported by a later chronicler to be connected with tournaments, but the turbulent politics of medieval Basle meant that their activities soon spilled over into open feuding and private warfare.

In the fourteenth century, German tournaments appear to divide into two distinct types: those associated with aristocratic and imperial occasions, dynastic marriages, imperial christenings, assemblies of the great lords at the emperor's council (Reichstag) on the one hand, and regular, often annual events organised by the towns on the other hand. The difference may well be more real than apparent, because it was often the local nobles who jousted in the market square while the burgomasters and merchants looked on. On the aristocratic side, at Speyer in 1310, the emperor Henry VII celebrated the wedding of his son John to Elisabeth of Bohemia with magnificent feasting, followed by a tournament in which the Bohemian knights aroused the admiration of the spectators by jousting with spears longer and thicker than those to which the knights of the Rhineland were accustomed. Whenever a Bohemian appeared in the lists, the onlookers shouted 'Here's a Bohemian! Here's a Bohemian!' and anyone incautious enough to challenge him found that the force of a Bohemian charge was enough to splinter one of their formidable spears. Even allowing for the

Imperial tournaments and civic jousts

*Fresco of jousting knights c.1390 from Lichtenberg Castle in the Tirol.
(Photo Tiroler Landesmuseum Ferdinandeum, Innsbruck)*

enthusiasm of the Bohemian chronicler, the wedding at Speyer was an outstanding festival, and the tournament was an essential part of it.[31]

The chronicler Matthias von Neuwenburg mentions interesting tournaments at Basle and Baden in 1315 and 1319 respectively, but with only just enough detail to tantalise us. At Basle in May 1315 an imperial court on the grandest scale was held to celebrate the double wedding of Frederick of Austria, one of the rivals for the imperial title, and his brother Leopold. In pursuit of Frederick's claims, the imperial insignia were displayed, and words fail the chronicler when it comes to describing the deeds of arms in tournaments and jousts. He notes only the accidents: the count of Katzellenbogen was mortally wounded by a knight from Alsace, and his corpse, accompanied by a crowd of weeping ladies from the town, was carried down to the Rhine to be returned to his home. During the jousts, one of the scaffolds collapsed, injuring several ladies; numerous jewels 'went missing' in the ensuing confusion.[32] Scaffolds and other 'machinery for spectacles' are mentioned in connection with the tournament at the great court at Baden held by Leopold four years later for his sister's wedding; these may have been night jousts, as twelve candelabra, with candles of such size that one man could hardly carry twelve of them, were provided.[33]

John of Bohemia

Any prince who aspired to fame, it now seemed, needed to hold tournaments as a symbol of wealth and status. But it was not always easy to stage such events, as the young king John of Bohemia discovered in 1319, when he and other Bohemian knights announced an 'Artushof', a 'court of king Arthur', for which scaffolds were erected in one of Prague's marketplaces: but no outsiders responded to the invitation, and the would-be 'defenders' had to joust among themselves.[34] Two years later, another great tournament was held in Prague, at Shrovetide; again, there do not seem to have been any foreigners present, but the Bohemian knights fought eagerly amongst themselves, and when king John entered the lists he was knocked from his horse by a lance-thrust, and trampled on by the horses. In the end, unconscious and covered in mud, he was dragged to safety by his servants, while some of the onlookers, hostile to the king, applauded the disaster which had befallen him.[35]

John of Bohemia's enthusiasm for tournaments was undiminished, however; even if he does not seem to have held them in Prague again, he was to be found at other European courts in pursuit of his favourite sport. In 1324, having raised a huge ransom from Frederick, duke of Austria, he held a tournament at Cambrai in honour of the marriage of Charles IV and Jeanne d'Evreux at which substantial gifts were distributed to knights, lords and squires.[36] Reports of his deeds were rife, and wilder and wilder rumours were current: in one year, he was said to have travelled from the Atlantic to the border of eastern Poland, taking part in jousts all along his journey, while on another occasion he was said to have killed a knight in a Burgundian tournament.[37] Another chronicler records that his choice of a second wife, Beatrice, daughter of the duke of Bourbon, was influenced by her love of tournaments; she gave him magnificent presents when he was the victor. In the jousts which followed their wedding in 1335, he was seriously wounded, and, because tournaments were forbidden in France, the other participants were imprisoned. Only John's personal intervention with the French king, Philip VI, secured their release.[38]

John's son Charles became emperor, as Charles IV, and is usually portrayed as a calculating, shrewd statesman who had little time for chivalric pastimes. But there is some evidence to the contrary: Neuwenburg at least believed that he was in the same mould as his father. In 1348, Charles IV was in Swabia to obtain oaths of fealty, and came to Rothenburg, where a tournament was in progress. The king joined it in disguise, using the arms of Schilhard von Rechberg, but he was unhorsed by a knight

Illustrations from the fourteenth century Manesse anthology (facing page)
Duke John of Brabant, killed at Bar in a tournament in 1294 (top left).
Duke Heinrich of Breslau receives a wreath from his lady (top right).

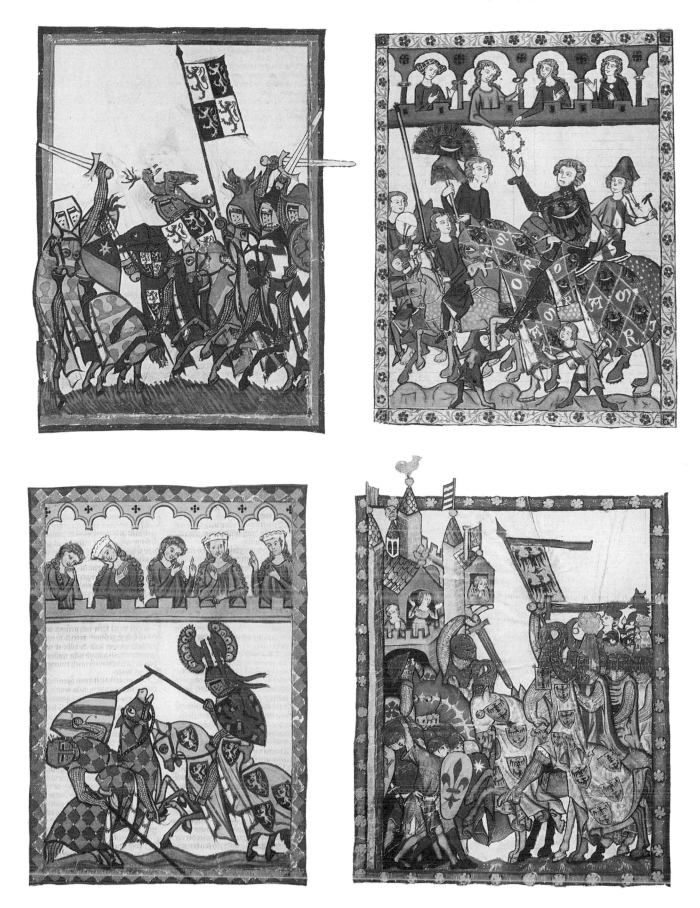

The attitudes of the onlookers reflect the fortunes of the knights below (bottom left).
Count Wernier von Honberg in a mêlée outside a castle, with his banner displayed (bottom right).
(Universitätsbibliothek, Heidelberg, MS Cod. pal. Germ 848, ff.18v, 52, 43v, 11v)

called von Stein. The latter realised that it was the king and seized his horse, which the king had to ransom for sixty marks. The next day, the helms were put out on display so that the two teams could be chosen, and one helmet was shown without insignia. The other knights guessed that it belonged to the king, and called off the tournament in case he came to any harm and the Swabians were accused of treachery as a result.[39] Although there is no mention of jousts at his coronation in 1347, the christening of his son Wenceslaus at Nuremburg in 1361 was marked by extensive jousting: 'after the child was baptised, the lords began knightly play, jousting with blunt and sharp spears, fighting with swords, and tourneying, so that all the streets were full, and there was a tournament outside the town'.[40] In 1376 Charles IV was at a tournament in Lübeck, and the following year, when he and his son Wenceslaus went to Paris on a state visit, there were many tournaments throughout the country, though it is not clear whether these were in honour of the imperial progress or taking advantage of the emperor's absence![41]

City jousts in the fourteenth century

Parallel with these tournaments on state occasions or involving the high nobility, the German city records reveal whole series of regular jousts within the towns. Because we only know of them from brief entries in the accounts, we have little idea as to who took part: at Frankfurt the records start in 1351; there were six up to 1358, followed by annual jousts from 1361–9, and then a less regular series, roughly once every three years to 1400.[42] At Cologne, the town accounts from 1371 to 1381 show a fee paid on twelve occasions to a family whose house was taken over by the city council so that they could watch the jousting from it. Another entry notes that archers were hired to guard the gates during a tournament: we shall return to the problem of public order during tournaments.[43] At Munich, there were tournaments almost every other year from 1370 to 1440; the city paid for the construction work at the place of the tournament, and for the extra archers and watchmen on the towers and gates. We do get a glimpse of the contestants: a tournament and joust were held by the sons of Munich citizens at some time between 1359 and 1364. In 1371 the duke of Bavaria and numerous nobles were present, but other jousts seem to have involved citizens only. At Göttingen, we actually have a record of those present at two tournaments, in 1368 and 1370. Otto duke of Brunswick was the organiser of the tournament, but the city councillors gave gifts of wine and provisions to him and his guests; the most important ones, including several counts, are listed, with about a hundred lesser figures on each occasions, but the note of the gifts ends 'and there were many other knights here who are not written down here, and whose names were not written in the guest-houses. The lady of Cleves was here . . . and many other ladies, all very beautiful'. The participants were granted immunity from Saturday until Wednesday, unless they owed money to or had injured any citizen, and severe penalties were threatened for any citizen who disturbed the peace.[44] Similar ordinances were enacted at Strassburg in 1390: in addition, prices were fixed for the period of the tournament, and instructions were issued to ensure that there were no artificial shortages of bread, meat or fish. The same regulations were reissued in 1408, with additional rules about conduct in the tournament area and provisions for the town's safety. No spectators or unarmed persons were to mix with the participants, and no-one was to ride into the ring without the magistrates' permission. Only five of the town's gates were to be open, each manned by twelve armed men, and no less than five hundred men were to be stationed on the Rossmarkt itself, where the tournament was taking place, two hundred on each side and a hundred around the barrier itself.[45]

Black Shrove-Tuesday, Basle 1376

Such precautions were undoubtedly vital, and not always successful. At Basle in 1376, the need for extreme caution on the part of the townsmen was amply demon-

strated. What came to be known as 'Black Shrove Tuesday' began as a tournament held by duke Leopold of Austria on Shrove Tuesday, a traditional day for celebrations of this kind. The occasion seems to have been poorly marshalled: the horses charged among the spectators, and spears fell among them; whether or not the attack was intentional, it was certainly interpreted as such, and the townsmen rang the church bells as an alarm signal. They armed themselves, and set out for the castle, where the tournament was being held. The nobles retreated into the houses where they were staying, but these were attacked and a number of important prisoners were taken, including Rudolf of Habsburg and five other lords of high rank, as well as a large number of knights and squires. Three squires in the service of the count of Freiburg were killed. Leopold of Austria escaped, but the bishop of Chur and two canons from Strassburg were not so lucky. But in the long term it was the town that suffered: although the town council had twelve of the ringleaders executed, Leopold of Austria managed to secure an imperial condemnation of the town, and Basle had to sue for peace.[46]

Leopold of Austria had considerable interests in Basle, and the episode is a reminder of the tensions between a landed aristocracy and the wealthy and ambitious townsmen anxious for independence. Awareness of the danger and the increasing formality of the tournament, rather than political changes, prevented the recurrence of such episodes after 1376. At Speyer in 1433, for a joust with sharpened weapons between Seyfried von Veningen and the lord of Rechberg, the by now familiar regulations for public order and control of prices were issued: even a single combat of this sort was regarded as dangerous, because of the lords' retinues, and on this occasion six hundred men were kept in readiness in the guildhalls.[47] Even though the lord of Rechberg was mortally wounded in the fourth course, there was no breach of the peace. The full-blown tournament was unquestionably more threatening, both to participants and onlookers: at Darmstadt in 1403 26 knights were said to have been killed as a result of a feud between the knights of Franconia and those of Hesse.[48] The trend, however, was towards respectability and order; we find clerics openly holding tournaments, at Borch in 1387, where the archbishop of Mainz was host, at Andernach in 1402, in honour of the marriage of the bishop of Cologne's niece, and in 1466 at Cologne, when bishop Rupert of the Palatinate held a tournament in honour of the

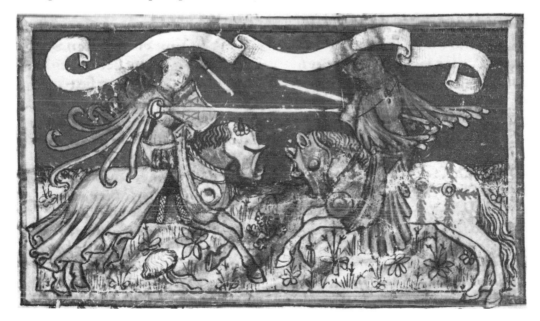

Miniature dated 1403 from a German book of moral tales; the knights wear elaborately cut surcoats. (Universitätsbibliothek, Basel MS A.N.III 17 f.31)

Bohemian knight Leo von Rozmital. We hear more of travels in search of tournaments, whether short or long distance: the knights of Ingolstadt came to Munich on a 'tournament journey' in 1399, while at Vienna in 1436 one of the most far-flung of challenges was fought, between the Spaniard Fernando de Guevara and Georg Vourapag, a Bohemian knight.[49]

Tournament Societies

This was the golden age of the tournament societies, and general enthusiasm for the sport was greater than ever. Knightly societies of various kinds had existed for centuries, many of them not unlike the guilds of tradesmen in the cities, founded for mutual support and for religious devotion; unlike the guilds, we know relatively little about them, and the majority are simply names. What is important is that the idea of a confraternity of knights was a familiar one; and it was a natural step to create such confraternities for the purpose of holding tournaments. The distinguishing mark of the societies was that they were outside the patronage of lords and princes, and were democratic in structure, with leaders elected from the membership: their rules were created by common consent of those concerned.[50]

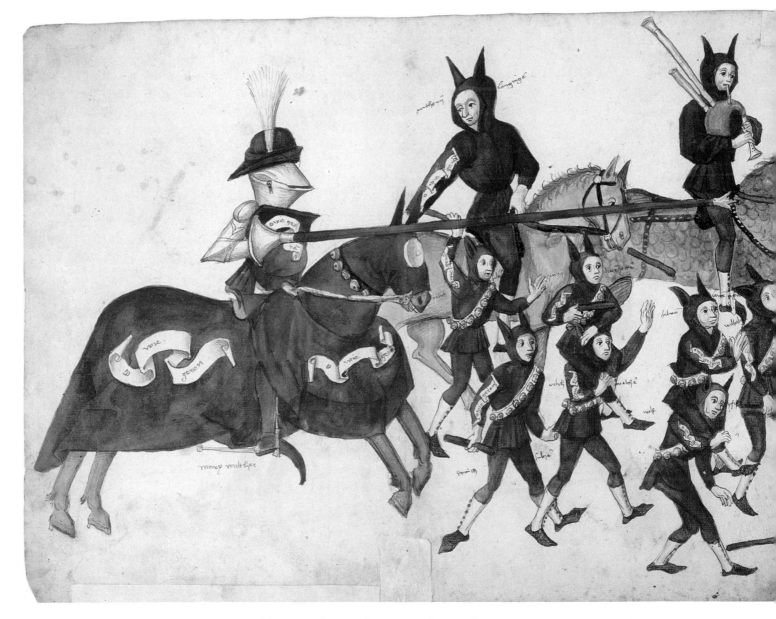

Marx Walther at a Shrovetide joust, with attendants apparently in fools' clothing.
(Munich, Bayerische Staatsbibliothek MS Cgm 1930 ff.13v–14)

By 1485, there were no less than fourteen such societies in existence, and their representatives met at Heilbronn to discuss the formation of a kind of union of tournament societies. Individual societies had merged over the years, and this attempt at unification was a symptom of the problem that faced all the societies. Tournaments were immensely expensive to stage, and because the societies valued their independence from the great princes, they relied on their members' own more modest resources. The ordinances agreed at Heilbronn make a point of banning excessive display, and only one general tournament was to be held each year in order to keep costs down. But precisely this need for moderation was the downfall of the grandiose scheme: the demand was for more tournaments, and if the societies could not provide them, their members would turn elsewhere, to the courts which could afford such occasions. Two years after the agreement at Heilbronn, the last tournament of the united societies was held.

We can glimpse a little of the world of the individual enthusiasts, notably through letters in the archives of the princely families of Saxony and Brandenburg. Perhaps the

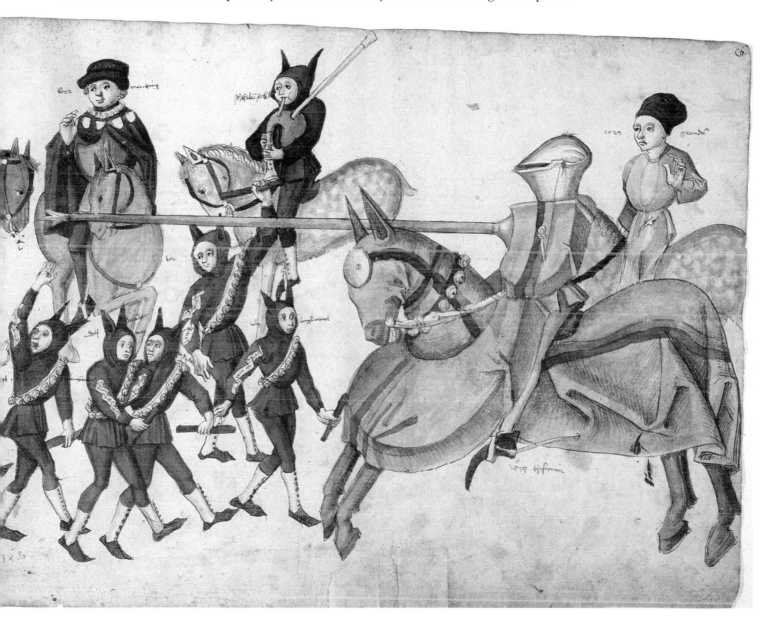

most intimate glimpse is in the papers of the Cronberg family, where a proud father has made a note at the end of the family deeds:

Philip of Cronberg learns to joust

> My eldest son Philip's first tournament was at Wiesbaden on October 5, 1410. After that, at Mainz on 18 November, and a week afterwards at Frankfurt, then one at Boppard at Christmas and one at Mainz the following Easter (1411), and one at Worms a fortnight after Easter. Then one at Würzburg three weeks after Whitsun and one about November 11 at Frankfurt, and one at Landau a fortnight after Easter (1412) and one at Heilbronn and one at Wiesbaden on Shrove Tuesday (1413) and one in November at Boppard and one in November at Worms.[51]

Philip was born in April 1393, and was therefore seventeen when he entered the lists at Wiesbaden. His father had reason to be proud not only of his son, but also of his own achievement in providing Philip with the means to fight so regularly. We find members of the house of Jülich and Berg writing to each other about the problems of equipping themselves and their followers for tournaments in the 1420s. Adolf von Berg had to borrow horses from his sister-in-law for a tournament at Cologne in 1417, and was in turn asked for the loan of horses by Rupert, the count palatine, for an event at Creuznach in 1423.[52] In the following years, he was frequently asked for the loan of horses, and most of the other surviving letters about tournaments from this period are concerned with the same problem. Requests for the loan of armour are much less common, simply because so much of it was close-fitting and hence made to measure for an individual. The overall impression from the letters is that even relatively minor occasions needed a good deal of organisation, and that long notice was needed by the participants: Wilhelm of Saxony writes in 1477 that he is happy to accept an invitation to a wedding, but cannot take part in the jousts because 'the time is too short for our people to prepare themselves'.[53] More curious is an appeal from the count of

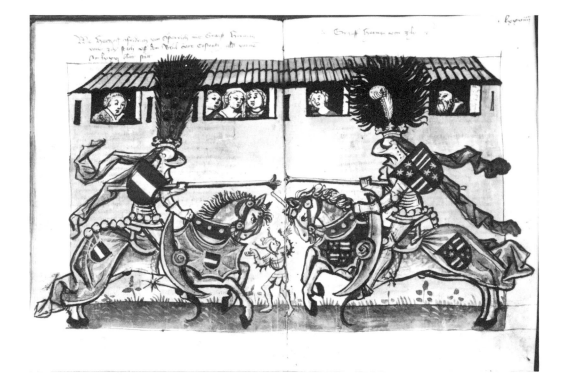

Friedrich duke of Austria jousts with count Hermann von Cilli during the Council of Constance, 1415: the miniature dates from c.1470.
(Badische Landesbibliothek, Karlsruhe, Codex St Georgen, pp. 78–79)

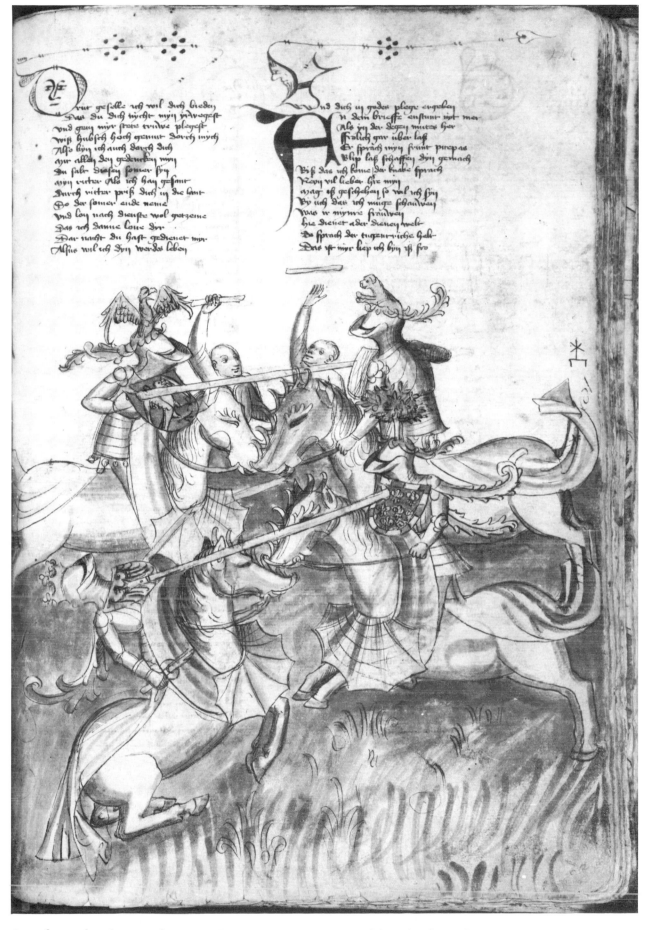

Joust from a late fourteenth century German manuscript. Two of the riders have the classic écranché shields which provide a rest for the lance.
(Germanisches Nationalmuseum, Nürnberg, MS 998 f. 226)

Würtemberg to Albrecht of Brandenburg for instruction in 'subtle, secret arts, which will help me to prevail in jousting'; but the letter is damaged, and the context of his request is lost.[54] Perhaps the request should be linked with the prohibition against the use of charms and magic letters found in some regulations for individual challenges at this period. What principally emerges from these letters is the enthusiasm of the princely houses for tournaments; the Brandenburgs' love of the sport is further underlined by Wilwolt von Schaumburg, a noted jouster who took service with Albrecht of Brandenburg in the mid-1470s, and by Jörg von Ehingen, who was in his service in 1455; both describe how tournaments and jousts were a frequent feature of court life at Rothenburg, Freiburg and elsewhere.[55]

Schaffhausen, 1430

The German tournament in the late fifteenth century had in theory become the exclusive preserve of the highest aristocracy, particularly with regard to admission to such events. Only those who could produce evidence of noble birth on both sides of the family for four generations – 'four ancestors' is the phrase used – were technically allowed to take part. Regulations of this kind appear as early as the 1430s, when a Spanish diplomat named Pero Tafur watched a tournament held at Schaffhausen, not far from Basle:

> A grand tourney was being celebrated there, which the nobles had arranged in this manner. Certain knights gathered together and made a list of all the noblemen in the district, and they caused a painter to paint the coats of arms of each one, which a herald carried from house to house, presenting the shield and giving notice that on a certain day every nobleman should present himself in that place, fully equipped with arms and horses, to take part in a tournament. They gave notice also to all the great ladies in those parts. Then the nobles and ladies assembled at their own cost, and when all were gathered together the elders went apart with certain matrons and took counsel, and enquired whether any nobleman had done ought amiss, whether any had forced or dishonoured matron or maid, or had seized the goods of a minor who had no protector, or had debased himself for greed of money by marrying a woman of low birth, or had otherwise degraded his rank. Thus the misdeeds of each were brought to light, and when any culprit was found they provided as follows. Certain knights were summoned, and when such an one appeared in the lists, they were ordered to fall upon him and beat him with rods and drive him thence. This was done, and afterwards the older knights and ladies drew near to the culprit and told him why

The elector Augustus of Saxony unseats Hans Caspar von Rüxleben in a joust on Shrove Tuesday 1466 at Dresden. (Ernst Haenel, Der saechsischen Kurfuersten Turnierbücher ... 1910)

he had been beaten. Then they escorted him back and allowed him to take his place with the other noblemen in the tourney, as if he had purged his offence and done his penance. But if he refused to attend he was sentenced to a double punishment, and if, after a third summons, he still remained obdurate, he was no longer regarded as a noble since he had refused to joust with his peers. In these parts all can joust and in any knightly sports, but only nobles of known escutcheon can take part in the tourney. This is a good and worthy custom, since thereby everyone knows who can lay claim to chivalry and high lineage, and those who have been guilty of base deeds may be brought to shame. I was bidden to join with the other nobles and witnessed the rejoicings.[56]

Tafur remarks on the sharp distinction between jousting – 'all can joust and join in any knightly sports' – and the tournament proper, to which entry is strictly limited. This exclusiveness seems to have been a purely German phenomenon; although noble birth was required at tournaments elsewhere, there was not the same degree of insistence that the display of helms and shields which preceded the tournament was a rigorous test of aristocratic descent and chivalrous behaviour. The same aristocratic element in German tournaments is reflected in a whole series of books, both manuscript and printed, from the early sixteenth century, the most spectacular visual record of the sport to survive. Beginning with the tournament books of the electors of Saxony, one of which may have been executed by Lucas Cranach the elder,[57] there is a similar compilation for Wilhelm IV of Bavaria by Hans Ostendorfer (1529)[58] and the genre culminates in Hans Burgkmair's triumphal images of the imperial tournaments held by the emperor Maximilian,[59] and the romances written around him, *Freydal* and *Weisskuenig*.

Tournament books

The tournament books of the electors of Saxony are almost entirely visual. There is a minimum amount of detail – the names of the contestants and the date of the encounter. They are largely imaginative reconstructions of the events of the 1480s to 1560s, and there is little evidence of changing fashions in their brilliantly-coloured pages: the sport appears in these manuscripts as an archaic ritual of elaborately-clad knights who form a kind of acrobatic procession on opening after opening as they contrive to unhorse their opponents in a kaleidoscope of different postures, from the dramatic downfall of both knights and their horses amid shattered spears, to the formal politeness of an encounter in which the jousters have missed each other completely. By contrast, Burgkmair's images of the emperor in the lists allow no such undignified scenes; here decorum prevails, even the lances break tidily, and a slight

Johann Friedrich of Saxony, 'the Magnanimous', unseats an unknown opponent.
(Ernst Haenel, Der saechsischen Kurfuersten Turnierbücher ... 1910)

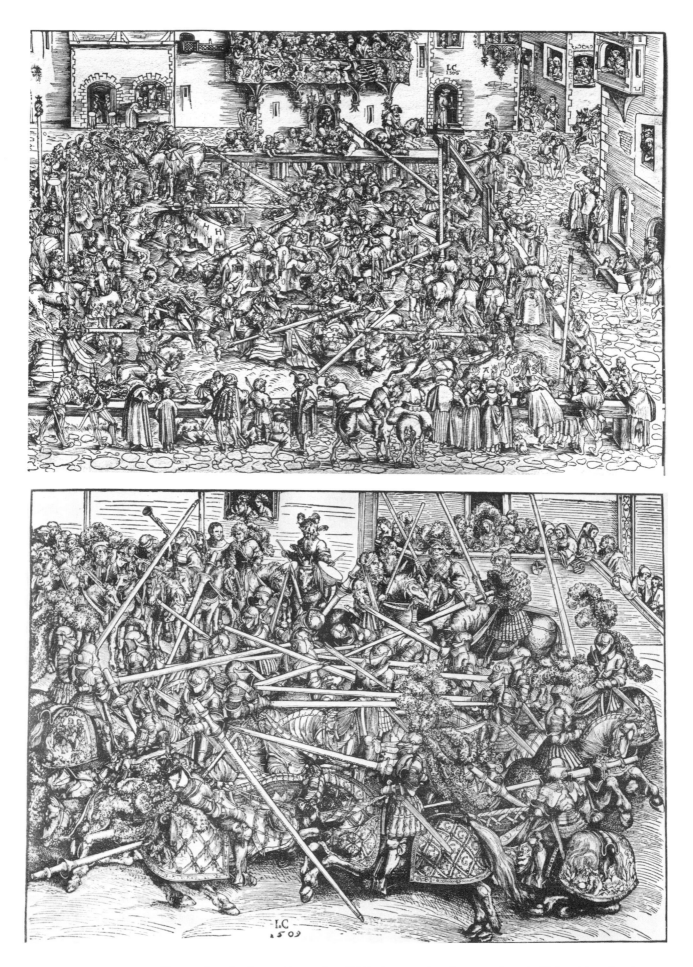

Engravings by Lucas Cranach Mêlée in a marketplace: a relaxed affair with a simple barrier on which the citizens lean to watch proceedings. Dated 1506. Below: a mêlée type tournament in 1509; such events would have been something of a rarity by this time. (Bildarchiv Foto Marburg) (Radio Times Hulton Picture Library, London)

leaning-back in the saddle is the only indication of an imminent fall. Burgkmair's book begins with a splendid procession of knights equipped for all the twelve variations of jousting and for the 'field tournament'. This ritual element is even more marked in the Kraichgau tournament book of 1615, which is simply an illustrated version of the printed accounts of the history of the tournament, with complete imaginary heraldry for each event; the formal jousting figures seem insignificant beside the welter of armorial bearings so lovingly portrayed.[60]

In the early fifteenth century, with the rise of the tournament societies, the history of the tournament became a question of interest to antiquaries. Finding references to 'warlike sports' in the time of Henry the Fowler, who ruled the Holy Roman Empire from 918 to 936, the town chronicler of Magdeburg in the thirteenth century interpreted this as meaning that Henry had encouraged tournaments. This story was taken up in the 1430s in a work probably commissioned by the chancellor of emperor Sigismund, Caspar Schlick; the unknown author of this, a chronicle of tournaments, made the emperor a crucial figure in the development of tournaments, claiming that Henry held the first German tournament in 938 – two years after his death – and this was accepted as a tradition until the eighteenth century.[61] Accounts of historical and fictional tournaments were added to this narrative, and it became the pattern for subsequent accounts of the tournament. Marx Wuersung produced the first printed account of the origins of the tournament in 1518, and Georg Ruexner, 'imperial herald Jerusalem', wrote a book listing the thirty-six 'official' tournaments held between 938 and 1487; his work went into several editions, and became the accepted pseudo-history of the sport.[62]

Antiquarian ideas about origins of the tournament

But there were other jousting enthusiasts besides the princes and the emperor, and even if their activities might not be approved by heralds like Ruexner, they could also commission records of their achievements. Hans Burgkmair produced a record of the jousts held at the wedding of Caterina Fugger, a member of the great Augsburg banking family, in 1553;[63] it was a fairly modest affair of seven encounters of three courses each. By comparison, the tournament book of Marx Walther of Augsburg is much more lively; his crest appears to have been three sausages on a spike,[64] and he seems to have been a skilled and respected jouster who enjoyed thumbing his nose at the pretensions of the nobles. One of the illustrations shows us a general tournament fought with lances, precisely the sport which was supposed to be reserved exclusively for the aristocracy.[65] Marx Walther and his fellow-patricians were considered worthy competitors by dukes Christoph and Wolfgang of Bavaria; in 1452, they challenged them to a joust, with four participants on each side, in which Marx Walther and his companions came off victors. Marx Walther's book also records what seems to be a Shrovetide joust, with men in fool's clothing surrounding the jousters[66] and, most impressive of all, the day when Marx rode into the Fronhof at Augsburg with a small boy sitting on the end of his massive lance.[67]

Despite these individual enthusiasts, the revival of large-scale tournaments was short-lived: the last tournament of the societies from the four lands was held at Worms in 1487. The tournament and jousting became chiefly the preserve of imperial and princely courts, where participation was by invitation only, though the city tournaments continued at Augsburg and elsewhere into the sixteenth century. The idea of an independent nobility, regulating its own affairs by chivalric rules, which underlay the ordinances we have just quoted, flourished only briefly; and yet the chivalric exploits of the emperor Maximilian, including his appearances in the lists, undoubtedly owed much to this renaissance of knightly consciousness. In addition to the tournament book already discussed, Maximilian arranged for printed accounts of

his career to be produced, relating his adventures under the guise of fiction.[68] *Theuerdank* (1517) was the only one to be completed, but the engravings for *Freydal* and the text and pictures for most of *Weisskuenig* also survive. At Maximilian's court, chivalric sports attained an unprecedented variety, particularly in terms of fighting on foot, which was a relatively minor part of earlier tournaments and jousts. These were single combats, well adapted to display the prowess of a would-be hero-king, but also closely related to the changing style of real warfare, following the dramatic victories of the Swiss pikemen in the 1470s. Maximilian's activities in this sphere take us beyond the world of the tournament proper into the foot-tournaments of the sixteenth century and into the history of the duel. His tournaments are more orthodox, though they do contain increasingly artificial apparatus, such as spring-loaded shields which fly apart when struck on the right spot, and highly specialised armour. The emperor's own enthusiasm for the joust is parallelled by that of Henry VIII in England and Francis II in France, and it is still a genuine interest in warlike pursuits; a revealing picture in *Weisskuenig* shows the emperor as a child playing with toy tournament figures, emphasising the way in which his whole upbringing had centred round chivalry.

But the role of the tournament in the political and social world, whatever Maximilian's personal feelings about it, had moved on; we are deep in the Renaissance world of princely magnificence, and despite the emphasis on foot combat, the realities of warfare have moved elsewhere. It is only Maximilian's own prowess, 'so skilled with the lance that no opponent of equal birth was to be found in Germany or elsewhere',[69] that sets him firmly in the medieval tradition: he was known to joust with men-at-arms of humble origin in order to find a match for his dexterity. After him the German tournaments belong largely to the realm of political spectacle; and on this high note, we leave Germany and turn to Italy and Spain.

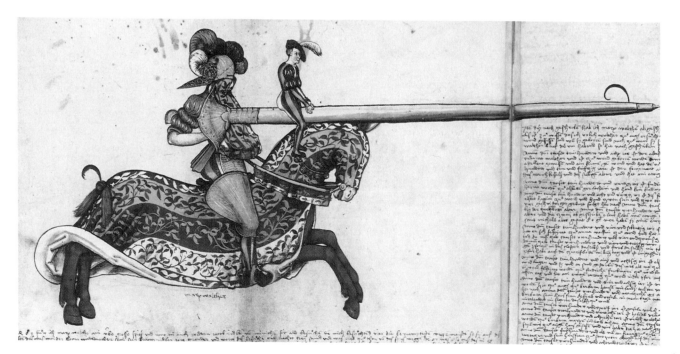

Marx Walther displays his prowess by riding into the lists at Nuremberg with a small boy on the end of his massive lance.
(Munich, Bayerische Staatsbibliothek MS Cgm 1930 ff.20v–21)

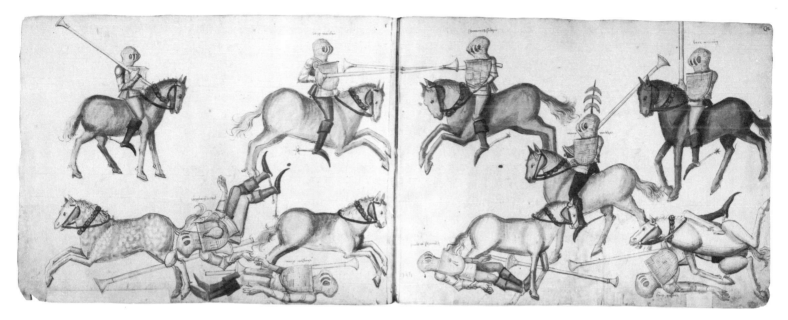

The jousting book of Marx Walther, with his crest of three sausages on a spike, at a civic joust.

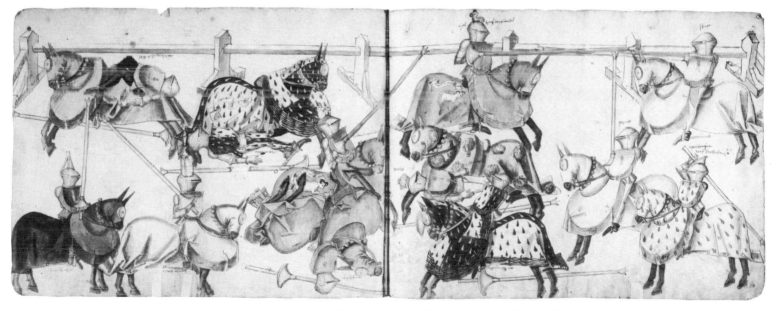

Marx Walther is unhorsed in a civic joust in 1518. He is the second figure from the left at the top.
(Munich, Bayerische Staatsbibliothek MS Ggm 1930 ff.7v–8, 3v–4)

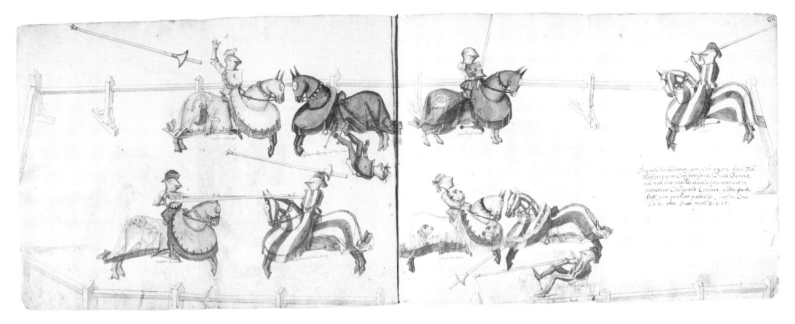

Marx Walther jousts at Nuremberg on 6 February 1492 against the dukes of Bavaria in the cemetery of the collegiate church.
(Munich, Bayerische Staatsbibliothek MS Cgm 1930, ff.10v–11)

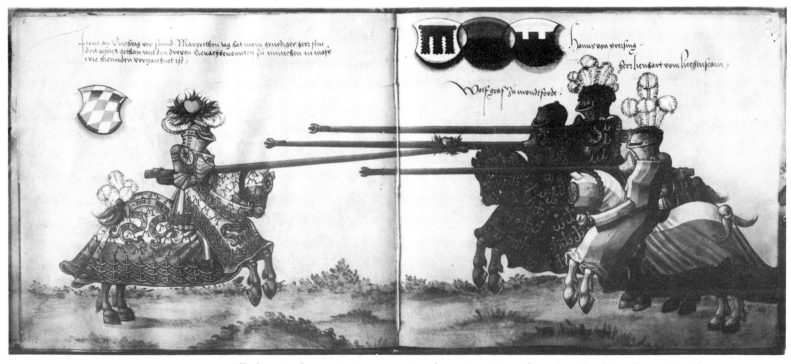

Wilhelm IV of Bavaria jousts on 11 July 1510 in Munich against Graf Wolf von Montfort, Haus von Preysing and Leonhard von Lichtenstein.
(Munich, Bayerische Staatsbibliothek MS Cgm 1929 ff.8v–9)

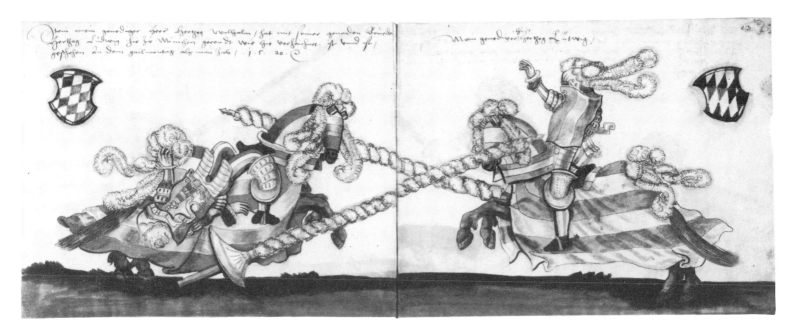

Above: Wilhelm IV is unhorsed by his brother Ludwig at a joust in Munich in July 1520.
(Munich, Bayerische Staatsbibliothek MS Cgm 1929 ff.22v–23)

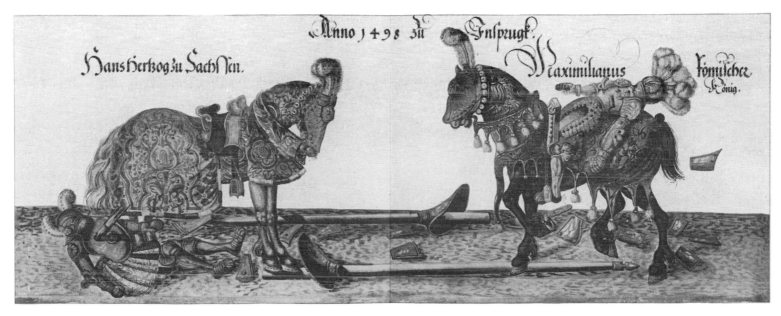

Heinrich duke of Saxony defeated by the emperor Maximilian at Innsbruck in 1498.
(Friedrich Haenel, Der saechsischen Kurfuersten Turnierbücher 1910)

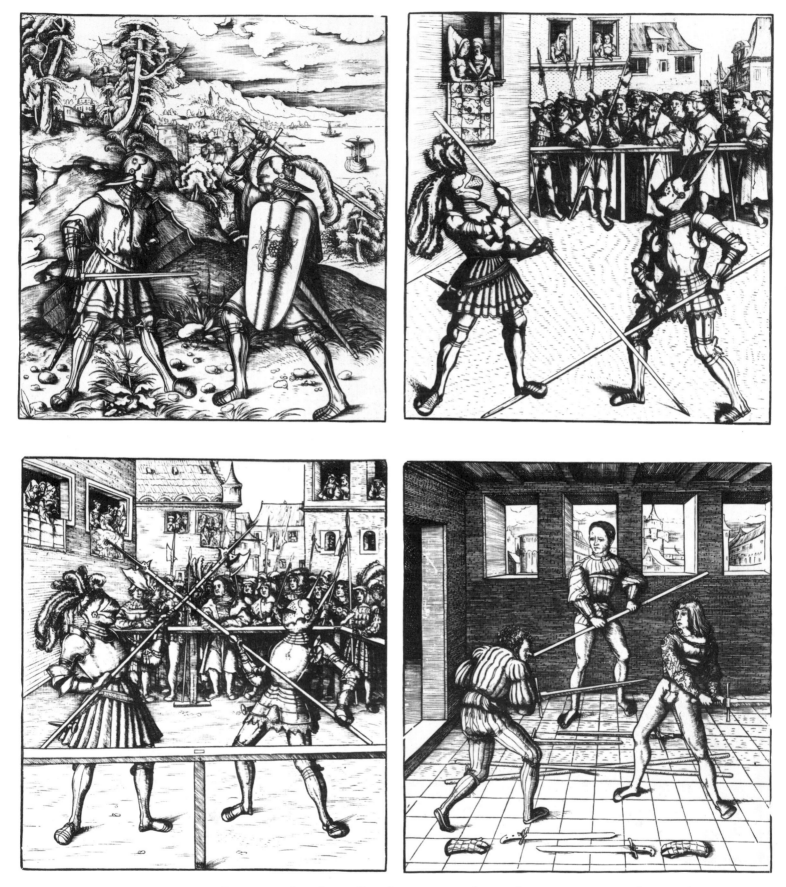

Four types of combat on foot, from Der Weisskünig, the romantic version of Maximilian I's youthful exploits. Top left: fighting in full armour with shields and swords; top right: fighting in full armour with long spears; bottom left: fighting in full armour with halberds; bottom right: fencing with long swords.
(From Jahrbuch der Kunsthistorischen Sammlungen 6, Wien 1888

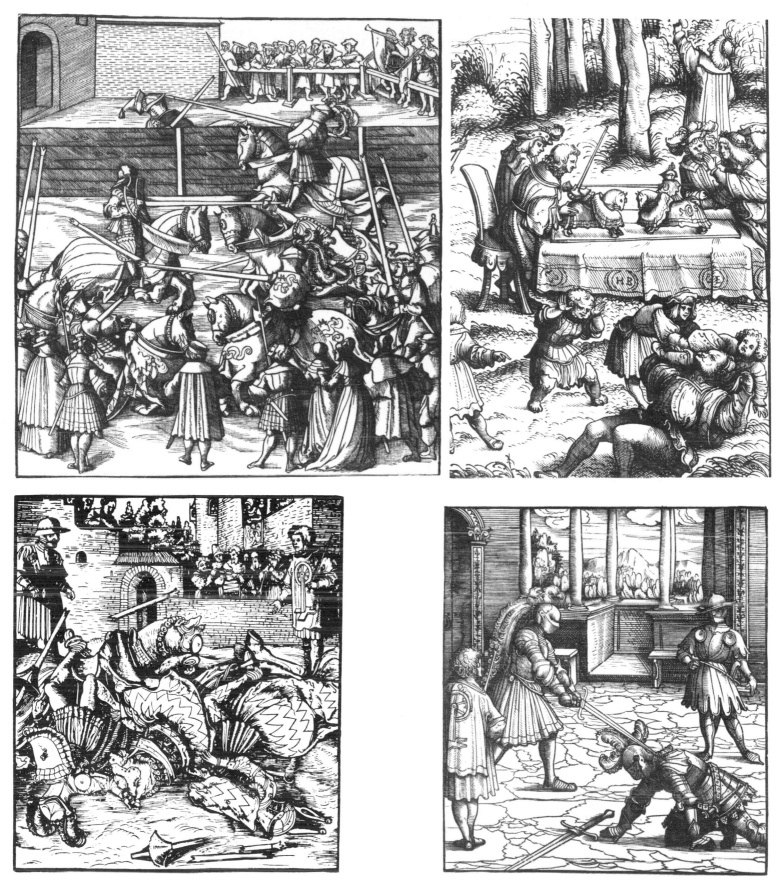

Top left: 'Jousting and tilting in all kinds of ways': from Der Weisskünig. In this background, knights joust with a tilt, while the foreground shows either a mêlée or two pairs of knights fighting in the open field; top right: the youthful games of the emperor Maximilian including jousting with model horsemen; bottom left: a spectacular fall in a joust with lances fitted with coronals, from Der Weisskünig; bottom right: Maximilian ('Theuerdank') overcomes an opponent in a combat on foot. (From Jahrbuch der Kunsthistorischen Sammlungen 6, Wien 1888

roit estre se trop protom non. et
tout soit il si bons chrs com il
uoit. si dist il quil se uoloit espro
uer encontir lui. et faire son poir
de reuenchier la uergoigne de so
compaignon. se il autrement le
faisoit adonc faudroit de couenat
ablro. lors in fait nulle autre de
morance. aincois prist tot main
tenant son escu. et son glaiue. 7
crie adonc au bon chrs tant co
il puet. sire chr gardez uos de
moi. a loster uos estuet encontre
moi. il not mie bien fine sa pa
role. que li bons chrs li uint au
senir des esperons. et li done en
son uenir un si grant cop. quil
le change si durement. que nis
sire Gau na poir ne force quil
se puist tenir en sele. aincoys uo
ide an deus les arcons. et chiet
a terre. si felonessement. que bie
li est auis quil est de celui che
oir la chanoyle del col rote. si se
pasine adonc de la grant ango
isse. quil se sent. Quant li chrs
a fait ces deus cop. il ne sareste
mie fors els. ainz sen uait oltre
et done son escu a ses escuiers.
et son glaiue qui encor estoit
tout entiers. sire sire fait li mor
holt. or mest auis qui mielz ue
nist aces deus chrs. quil se fus
sent tenu enpes. quil uos eusset
apele de la ioste. Sire ce dit li bo
chrs encor sunt il noueax chrs
si apprengnent. le comencemet
ce est une usance des armes por
ter. il porroient adonc au loing
estre bons chrs. et se il sunt ore

abatu encore sen porront par aue
tur reuenchier. ou sor moi. ou sor
un autre. li chrs ne dist mie plus
au morholt de ceste chose. aincois
sen entra tout errament deenz le
chastel. et sa ala adonc herbergier
en la meson dun uauasor. dom il
estoit molt acointes. et sachiez
tout certainement. quil fu trop li
ez. et trop ioiant del chr. quant
il le uoit. Car autre fois lauoit il
ueu enson hostel. et bien sauoit il
tot ueraiement que ce estoit ser
toute toute le meillor chr quil
seust

Lou il estoient leanz descen
duz. et desarmez. atant ez
uos leanz uenir. un yral de torno
iement. nul tornoiement mesch
poir acelui quil ne uenist. quil
conoissoit toutes les bons chrs.
qui au tornoiement uenoient. 7
toutes les autres qui de grant bo
te estoient renomez. Quant il uo
it leanz le bon chr. celui qui senz
poir. estoit aprez. quil auoit la
ueu encontes grant besoignies.
et bien sauoit tout certainemet.
que entoute le reaume de la grant
bretaigne. ne soloit auoir nul
meillor chr de cestui. ne qui tat
fust prisiez. de tant hardement.
ne de halte proesce. et la auoit
auques grant tens. quil nauo
it este adonoiement uenuz. et
quant il le uoit orendroit. reco
noissant et bien set quil uient
a ceste riche tornoiement. il sen
uet tout errament agenoillier
deuant lui. et li baise adonc le

A spectacular fall, amid a shower of broken lances. Meliadus, Italy, c.1350.
(BL MS Add 12228 f.71v)

4

The Tournament in Italy and Spain

Italy

One of the problems we have already encountered with the early history of tournaments is whether there was ever a strong tradition of displays of horsemanship, and hence of games on horseback, in the time of Charlemagne or even in the late Roman empire. The only definite account of such an occasion is Nithart's description of the games before Louis the German and Charles the Bald in 842, but there are other occasions when we cannot be sure whether the subject is a real tournament or simply a display of skill without actual combat. This is particularly true in Italy, where parade-like festivals on horseback seem to have been present throughout the middle ages, and the term *hastiludium* had its literal Latin meaning of 'a game with spears' on many occasions. So Hugo, viscount of Pisa, who passed his life in 'hastorum ludis' in the early twelfth century, was actually doing something linked to horsemanship rather than mock warfare; 'games with spears' is followed by 'coursing of horses' (*cursibus equorum*) in the list of his activities, as described by Laurence of Verona in 1115.[1]

Games on horseback

In 1265, Charles of Anjou was welcomed to Rome by horsemen wielding spears who executed elaborate manoeuvres; but the spectacle was based on classical tradition and not on the contemporary tournaments, and the chronicler Malaspina borrows heavily from Virgil's description of the funeral games in honour of Aeneas' father which we have already quoted. It is only in Italy that this tradition seems to have survived, beyond the Carolingian period, and we therefore have to look carefully at the context of any 'hastiludium' that appears in the chronicles. The borderline between the *béhourd* and the *hastiludium* was evidently a narrow one, for two writers describing an entertainment on the frozen river Po in 1216 use the words 'bagordare' and 'hastiludio discurrere' to describe the same occasion. But when Obisso marquis of Este, loses an eye in a *hastiludium* in which he is fighting 'for love of a certain lady who was present', we can be reasonably sure that it was an orthodox tournament.[2] On many occasions, displays of horsemanship and light-hearted jousting in *béhourd* style were evidently preludes or accompaniments to full-scale tournaments and organised jousts; there was no hard and fast distinction.

The first specific appearances of full scale tournaments and jousts on Italian soil are largely associated with the presence of foreigners, and have already been mentioned: at Cremona in 1158, the inhabitants honoured Frederick Barbarossa by holding a tournament. Similarly, the jousts and tournaments held in Venice and the Tirol, during Ulrich von Liechtenstein's Venusfahrt of 1227, were fought exclusively among the German aristocrats of that area – we meet no Italian names. The first record of a purely Italian tournament comes from Siena in 1225. The local chronicler has this to tell us about the occasion:

Gherardo di Raghona, *podestà* (captain) of Siena, gave in his time as captain a fine and noble joust, which was held in the great and beautiful meadow outside the Porta Camollia, and among all those who entered, except the three mentioned below, there was no-one who was not unhorsed by the fiery horses which they had. And in the end, Buonsignore of Arezzo, won the said joust. And this joust was made for the strangers, and not for the citizens and nobles of Siena. And the gift which the said Buonsignore gained was a very swift horse with silk trappings, as well as a set of fine steel armour, such as a prudent man should wear. To Aliano, who was second, was given a helmet with the arms of the commune of Siena. And to Manette, who was third, were given a sword and steel gauntlets. And Manette was the person who arranged this joust, because he was a great armourer, and was leader of men at arms, a very rich man, and he was commissioned to arrange the said joust and given gifts for that purpose, because he was retained by Gherardo di Raghona, who was our *podestà*, and Manette was his nephew.[3]

Jousting at Venice

Two decades later there are records of tournaments in the splendid setting of the Piazza San Marco in Venice, in 1242 and 1253, the latter for the election of a new doge. In 1272, six gentlemen from Friuli challenged the Venetians during the three days of carnival, preceding Lent, one of the traditional times for jousts. A number of lances were broken, one knight was dishelmed, and although no-one was unhorsed, the jousts were evidently remembered as a great success: the honours went to the Friulian challengers, but the citizens of Venice acquitted themselves valiantly.[4] Fifty years later, in February 1322, jousts were again held in the piazza, which was profusely decorated with banners, pavilions, shields and paintings for the occasion: the doge presided over the event from a balcony outside the west door of San Marco, and the fighting took place in a fenced-off area in the middle of the square, 'lest men were hurt by the horses, and so that the game could be played better.'[5] The victors were rewarded with golden crowns and silver belts. Jousts were evidently highly popular with the Venetians, as the rulers of the city had to impose controls in 1367: on grounds of state security, no jousts or any kind of tournament were to be held anywhere without the permission of the council of eight.[6]

Tournaments were certainly much more frequent in Italy in the early fourteenth century. About 1310, Folgore di San Gimignano, so called because of the dazzling (*folgorante*) life-style he maintained in the little Italian city of San Gimignano in Tuscany, wrote two sequences of sonnets in which he mentioned tournaments: in the days of the week, Thursday is the day for combat, 'every Thursday a tournament, knights jousting one against one; let the battle be in a public place, fifty against fifty, a hundred against a hundred.'[7] And for May, in the sequence for the months, he wrote:

> I give you horses for your games in May
> And all of them well trained unto the course,
> Each docile, swift, erect, a goodly horse;
> With armour on their chests, and bells at play
> Between their brows, and pennons fair and gay
> Fine nets, and housings meet for warriors
> Emblazoned with the shields ye claim for yours,
> Gules, argent, or, all dizzy at noon day:
> And spears shall split, and fruit go flying up

In merry interchange for wreaths that drop
From balconies and casements far above;
And tender damsels with young men and youths
Shall kiss together on the cheeks and mouths;
And every day be glad with joyful love.[8]

The chronicles bear out the poet to some extent, for between 1320 and 1340 eight tournaments or jousts are recorded in northern Italy: there was a great festival at Rimini in 1324 for the knighting of Pandolf Malatesta and his sons, to which 1500 minstrels came, as well as all the nobles and great men of Tuscany, the Marches, Romagna and almost the whole of Lombardy.[9] In 1328 Can Grande della Scala celebrated the conquest of Padua with a similar festival, to which minstrels of many nations flocked. 'There were beautiful ladies there, jousts and tournaments: in short, nothing was lacking to make the rejoicing perfect'.[10] In 1329, jousts were held in Florence for the same reason, to mark the end of a war with Pistoia, in Piazza Santa Croce: they lasted three days, with six knights as defenders: 'there were many good blows and knights unseated, and there were always many beautiful ladies on the

Tournament at the castle of Love: notice the ladies throwing wreaths, as in Folgore di San Gimignano's poem. Ivory mirror-case, c.1400.
(Florence, Museo del Bargello) (Photo Scala)

balconies...'[11] The wedding of Marsilio di Carrara and Beatrice de Corrigo at Verona in 1334 and the capture of Treviso by the Venetians in 1338 were marked by jousts. A joust at Bologna in 1339 defended by three knights and six squires, all clothed in white, was interrupted by a strange incident when Giovanni di Taddeo Pepoli, son of the lord of Bologna, came in disguise into the lists, without his father's knowledge. When Taddeo di Pepoli learnt of it, he had the joust broken up, but eventually the pleas of the other jousters persuaded him to relent. Three judges were put in charge of proceedings, and a notary wrote down the hits scored according to their verdicts, the earliest evidence we have for a scoring system.[12]

*'The Green Count',
Amedeo VI of Savoy*

 The different social structure in Italy, where there was none of the tension between landed gentry and city-dwellers, but where the richest and most powerful men were proud of their citizenship, meant that jousts were exclusively a city phenomenon, even when the cities moved from republics and oligarchies towards princely rule. Enthusiasm for jousting in a particular ruling family came to be an important factor from the mid-fourteenth century onwards, as in the jousts held at the Mantuan court of the Gonzagas in 1340, 1366, and 1380.[13] In Savoy, where the social structure was close to that of France, with a distinct feudal nobility, the enthusiasm of the 'Green Count', Amedeo VI of Savoy, for tournaments was similar to that of his slightly older contemporary, the Black Prince. The most magnificent of these occasions, the moment at which 'the count, "beau et gracieux adolescent", created the sensation that subsequently earned him a place among the chivalrous figures of his century' was held at Bourg-en-Bresse at Christmas 1352.

> When the trumpets announced the entry of the combatants into the lists, the count appeared at their head resplendent in green silk and velvet vestments under his armor, an emerald plume on the crest of his silver helmet, and astride a magnificent charger richly caparisoned in silver and green. Behind him rode eleven of his noblest knights, also in green, and all were led into the arena by

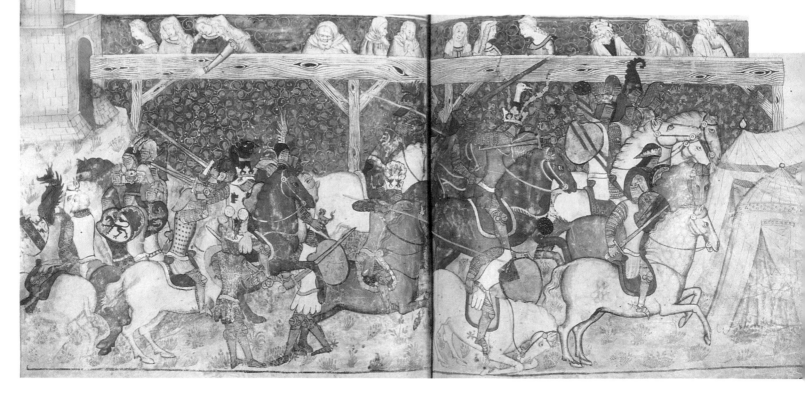

A dramatic mêlée, with no fences to the lists, but the pavilions evidently mark one boundary, the stand another. Meliadus, Italy c.1350. (BL MS Add 12228 f.197v–198)

lovely ladies, each holding her champion captive by means of a long green cord attached to the bridle of his charger. Then the damsels, also in green robes, released their knights, and the tournament began. When the jousting had ended for the day, the ladies descended once more into the arena to 'recapture' their champions and lead them back into the castle. Then the banqueting began in the great hall, in the course of which gold rings or batons were awarded to those adjudged the most valorous in the day's contests of skill and strength.[14]

Although other knights were declared the individual winners on each day Amedeo was acclaimed as the overall winner; according to the romantic chroniclers of the next century, he was offered all three gold rings and the traditional kisses by the ladies who awarded the prizes. He accepted the kisses and asked for the gold rings to be given to the victors of the different days; at which the latter gallantly protested that they would have much preferred the kisses. The household accounts give the more prosaic detail that there were 1460 horses at Bourg over Christmas, and generous gifts – forty florins in one case – were given to minstrels and heralds. The green silk and cloth bought on this occasion was to become the count's livery in future years.[15] Two years later, another great tournament was held by Amedeo at Chambéry during the Christmas season, probably to celebrate the end of a prolonged and intermittent war with the dauphins of Viennois. These were the high points of a long tradition of tournaments at the court of Savoy, beginning at Chambéry in 1344 and which continued through the reign of Amedeo VII, 'the Red Count' into the early fifteenth century. The Red Count earned as high a reputation as his father in the lists: in 1383, in a single combat with the earl of Pembroke and another English nobleman, he broke 47 lances. Under Amedeo

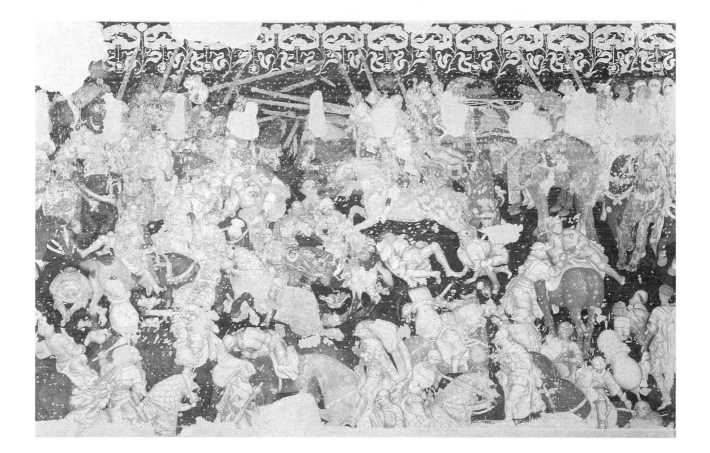

The surviving fragments of Pisanello's fresco of a tournament in the ducal palace at Mantua. (Photo Scala)

A vivid underpainting from Pisanello's frescoes at the ducal palace in Mantua, catching in sketch form episodes from a tournament.(Photo Scala)

VIII, his son, there were tournaments almost every year between 1400 and 1412, including two at Christmas feasts and one for the wedding of a Savoyard nobleman.[16] Although one of the Savoyard tournaments was in celebration of the marriage of the Green Count's sister to Galeazzo II Visconti of Milan in 1350, Savoy increasingly looked towards France and the Empire rather than Italy, and its chivalry was French rather than Italian in style.

In Milan, the Visconti dynasty also aspired to a European role, most notably with the marriage of Lionel, duke of Clarence (son of Edward III of England) to Galeazzo II's daughter in 1368: in the tournament which followed the Green Count was victor. It may have been in respect of this occasion that the pope tried to prevent Lionel from undertaking a 'deadly hastilude which he had vowed to perform', but it seems more likely that this refers to a combat *à outrance*. Galeazzo's brother Bernabò gave a brilliant festival to mark the signing of the treaty of Bologna in April 1364, at which the two teams were dressed in white and green respectively. The celebrations were interrupted by the death of a member of the Visconti family on April 7 but after two days' pause, the final grand tournament between the teams was held.[18] In 1395, for the installation of Giangaleazzo Visconti, the most artistic and splendour-loving of the dynasty, as duke of Milan, two hundred riders took part in the jousts after the ceremony, and there were more than four hundred participants in the tournament the following day.[19]

On a lesser scale the Gonzagas at Mantua and the Carraras at Padua regarded jousts as an essential part of the ceremonial of their courts. Jousts in celebration of victories, for the installation of a new lord, or for a wedding are recorded in 1377, 1379, 1380 and 1392: in the last instance, it was the wedding of the son of Francesco Novello da Carrara to the daughter of Francesco Gonzaga:

> The marquis Alberto da Ferrara proclaimed a tournament for this occasion, and many lords were invited to it ... and so Francesco, Terzo and Iacomo da Carrara, sons of the lord [of Padua] went to it, and took fifty tourneyers with them. When they arrived at Ferrara, they were honourably received by the marquis and other lords, and the tournament took place; in which the lords and a number of other gentlemen took part, two hundred tourneyers in all, and the honours of the tournament were awarded to the count of Carrara. After this there were fine jousts and feasting ... [20]

The local custom seems to have been to hold the tournament first and the jousts afterwards; the same sequence was followed at the marriage of Francesco Novello da Carrara himself to Taddea d'Este in 1377, and at that of Giacomo da Carrara in 1403.[21]

In the great merchant towns, however, the *signoria* or dictatorial rule of one lord had not yet firmly established itself. In Florence, Siena and Perugia the jousts were civic in character, and the costly and highly organised full tournament does not appear, since only a lord with a substantial retinue could make any kind of showing at such an event. Siena, Perugia and Pisa had a fascinating parallel to the tournament in the team games known variously as *mazzascudo, ponte, battaglia de' sassi, elmora* and *pugna*: these were in effect tournaments for foot-soldiers, as the early accounts of the *mazzascudo* at Pisa make clear. The participants were armed with a club and a shield, and were divided into companies, each drawn from the members of a society formed for the purpose and based on a particular district of the city. It was a winter sport, when actual campaigning was unlikely, and was played on a chained-off area in one of

Milan and other courts

A player equipped for the Giuoco di Ponte. (W. Heywood, From Palio to Ponte, London 1908)

'Tournaments' for footsoldiers: mazzascudo

the squares in Pisa, which was policed throughout the day from Christmas till Shrove Tuesday, so that individuals could challenge each other as and when they liked. On holidays, a general battle took place, which attracted a large audience. This opened with single combats; lovers would paint their lady's face on their shields and fight in their honour, until the general combat was announced by a trumpet-blast. In the later version of this game, played on the Ponte Vecchio at Pisa, the players wore the equivalent of footsoldiers' armour, except that a great deal more padding was worn. The *mazzascudo*, or club and shield, evolved into a single implement for attack and defence, the targone, a kite-shaped pointed shield, with which the player thrust and parried.[22] The *battaglia de' sassi* or battle of the stones at Perugia was similar, but with the addition of *lanciatori*, who threw stones, to the men armed with club and shield. It was as dangerous a sport as the tournament, and its counterpart in Siena, the *elmora*, was banned on this score in 1291, after ten gentlemen and many others were killed in such a game. Thereafter the Sienese fought with their fists alone, and the game was known as the *pugna*.[23]

These games – if one can properly call them that – seem to have been peculiar to Italy, and to have arisen out of local social conditions, particularly the nature of the civic militias and the absence of a feudal military organisation. There appear to be no records of jousting in Pisa, and less than half a dozen occasions when jousts were held in Siena; almost all of these were in honour of visiting magnates, such as Giangaleazzo Visconti, who was entertained by jousts in which three teams drawn from different quarters of the city competed with each other.[24] At Perugia, it was only under the *signoria* of Braccio de Montone that jousts were held, in 1416, 1417 and 1423. Montone was a great enthusiast for the lists, and made a considerable impression when he led a company of tourneyers to take part in jousts at Florence in 1420.[25]

Florence was alone among the merchant cities of Tuscany in having a substantial tradition of jousting. Between 1387 and the seizure of power by Lorenzo de' Medici in 1434, there were at least a dozen jousts. We know of those in 1392 and 1396 from accounts: £100 was paid to three leading citizens in 1392 for expenses for the

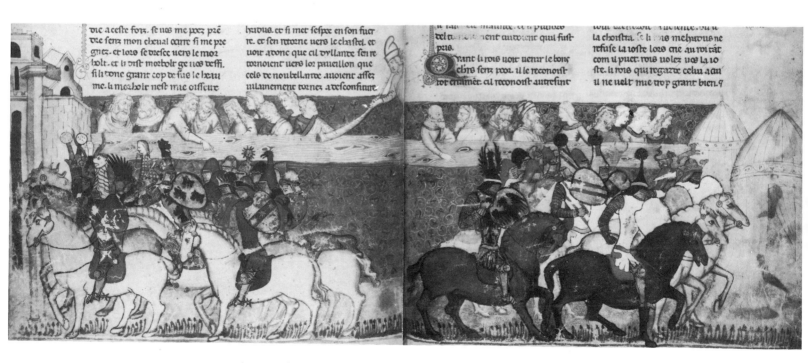

Blowing the retreat: knights leaving the lists at the end of the day. Meliadus, Italy, c.1350. (BL MS Add 12228 f.170v–171)

Facing page: mêlée, from a delicate late fourteenth century manuscript of the romance of Guiron, by an unknown Italian master.

(Bibliothèque Nationale, MS nouv. acq. 5243 f.55)

veu le bon chr sanz peoz. Oxe oil venuz est
sanz faille. er fer il de moi mille nouell. sue
oil si me oselt der. il reconuit maitenant ce
qe ge disoie de nos. ce me dist vn de sa cpnigne
or me di fer li rois qel gent a il en sa cpagnie.
sire il a le axvii. oylande. er mish bly. er miser
G. er deus autres cpaignoz. Ha fer li roi oxhl.
puisqil a cels auec lui. li rois aztus iest sanz
faille. il me poise de mon saignoz qi oxie moi
poztera armee a ceste asemblee. qi ne fait de
touz les autres. bie puet dire le bo chr saz peoz
qil a des bos chr auec lui. lozs sen uait li rois
pelinoz er dit tout cest asaire. er il responde
sur se der me oselt il me poise de ce qe li rois
va entre nos. mes puis qe nos entrez en cestui
fait. il est mestier qe nostrauaillo en sit qe
nos en issom a henoz.

Cl sint parole li roi oxlv. er li roi pelinoz de lor
apareil. li autres chr qi par le chastel estoient
sont gnt ioie a se solacet durent. A tex iaxx
qe il targe moult qe le soir. a le ioz soit venuz
qil fussen en celle besoge. loz aumes sot apa
reliees er les cheuax. mout se trauaille chascus
en droit soi de fobir sex armes. er en lixer. qi
deuoit a a bo a bel. il son tier au cs bie cpares
li roi de nobelande suit de mand. qant chr poiont
estre de sa partie. Er li an qant dict qil poiont
bien estre du vga. o. de sa ptie. li rois en est liez
durent. de res nouell se vait il mout sbon
fortat. celle nuit sont si gint leete si git
feste. en cest cha bel. qe len ni oist veu tout
la ville biuit tote de ioie. ieiat sot tuit er
pouie er riche. A lendemai qant il aiozne
li chr qi en pens estoient de poztez armes

tournament to be celebrated in Florence 'for the honour and dignity of the commune of Florence', while in 1396 146 florins was spent on two ornate helmets for those who 'ran the best course in the jousts held this month for the honour and magnificence of the commune of Florence.' The diarist who recorded the three jousts held in October and November 1406 also lays great emphasis on prizes: on 24 October the eighteen jousters in the piazza Santa Croce competed for a silver-gilt lion and a velvet cap, while on 31 October, following the knighting of 60 squires from the Guelf faction, eight jousters braved the rain in the piazza Santa Maria Novella to compete for a helmet. The writer notes that the lists 'were not covered', implying that this was sometimes done. The jousts four weeks later were again in the piazza Santa Croce, apparently the traditional site for such events, but the lists were exceptionally large, occupying almost the whole square, 125 paces by 60 paces. There were fourteen to sixteen jousters, the prizes being a helmet with a silver dragon's head, and a 'jousting helm with two golden wings with many green, white and red feathers.' In 1415, it was minuted that 'Saracens' or quintains should be erected on the piazza della Signoria 'as usual', and jousts held, for St Barnabas' day (11 June).

In the last years of the independent republic, jousts were particularly frequent: the conquest of Pisa in 1419 was marked by a joust held by the Guelf captains; in 1420 Braccio da Montone visited the city, as already noted, and in 1427–9 there were jousts every year, recorded by Francesco di Francesco Giovanni, whose brother Giovanni was clearly an expert in the lists. In the jousts of January 1427, Giovanni won first prize, riding a bay horse. Francesco notes that jousts were held 'in the open field, without stakes (stechato) or central barriers (tenda)', implying that these were now usual.[26]

The Florentine jousts were seemingly restricted in general to natives of the city; in Bologna at the same period we find a very different situation. At the tournament in 1392 at the end of a campaign against Genoa, the participants were Italian and German condottiere, who fought first with lances and then with scimitars. There were 34 Italians and 33 Germans, and the honours of the day, after a long combat, were adjudged equal.[27] In 1407, the jousters were six citizens and the rest were mercenaries from outside the city; one of the latter, Elcio de Trani, won the helmet valued at 300 ducats given by the papal legate.[28]

Milan, 1435

From the 1430s onwards, with the rise of the Medici in Florence, it is the princely jousts which predominate; a joust at Milan in 1435 vividly conveys the atmosphere of such an occasion. Filippo Visconti had just returned to Milan after his victory at Pavia, bringing king Alfonso of Aragon, his brothers and four hundred Aragonese nobles as prisoners. Jousts were held to celebrate his triumph, and the duke was eager that one of his men should be the first to win the honours of the day. However, Carlo Gonzaga was the easy victor on the first two days, and when the duke bemoaned this among his intimates, one of them told him: 'You have in your prison one of the best lances in Italy, my nephew Venturino Benzone; if you deign to set him free, I am sure that the prize will not be carried out of your realm.' Venturino was summoned and agreed to take on all comers, provided he was allowed a little time to rest and was given a good horse. The next day Venturino jousted with Carlo Gonzaga, and on the last course succeeded in striking him on the helm with a heavy lance; Carlo and his horse came down, and Venturino was declared the victor, to the delight of the duke, who had regained his prestige, and Venturino himself, who had regained his liberty.[29] The concept of the personal prestige of the duke being involved in his subject's victory in the lists is a new one; a fourteenth century ruler might have fought there himself, but would not have attached such importance to the nationality of the winner. The

Gonzagas were among the most avid jousters of the period: we hear of jousts at Mantua in 1410, 1463 and 1469, and they appear as victors or runners-up at Milan as described above and at Bologna in 1487; Federico Gonzaga was a spectator at Ferrara in 1462, and sent a detailed account of the proceedings to his mother.[30]

Jousts were increasingly overshadowed by the splendour of the festivals of which they formed part. We can trace the detailed organisation of such occasions as far back as 1364, when a display of horsemanship and jousts were arranged at Venice to celebrate the Venetian reconquest of Crete: the director was Tommaso Bombasio, engaged specially from Ferrara. Petrarch describes part of the spectacle, the 'course' and the jousts: the course was an unarmed mimic combat, while the jousts were of the usual kind. He devotes a page to the marvellous skills shown by the young Venetian nobles in the course, but does not dwell on the details of the jousts; it is only from other sources that we learn that the king of Cyprus entered the lists, and that the name of the Venetian who carried off the first prize of a golden crown was Pasqualin Minotto. The enactment of the jousts was a ritual appropriate to such an occasion; the results of the combats were of minor importance, unless there was some accident or mischance. The surroundings, the immense crowds, the richness of the hangings and the number of beautiful ladies watching the sport, all impressed Petrarch far more than what happened to the participants, even though he watched for two days from the doge's stand, sitting on the doge's right hand as guest of honour.[31]

Festival at Venice, 1364

The same kind of considerations apply to the jousts organised in Rome itself, by no less than a cardinal, for the carnival season in 1472. Cardinal Riario, nephew of Sixtus IV, was renowned for his lavish expenditure, and this occasion was no exception. The jousters were described as 'men-at-arms' and 'heads of squadrons' from various

Carnival at Rome, 1472

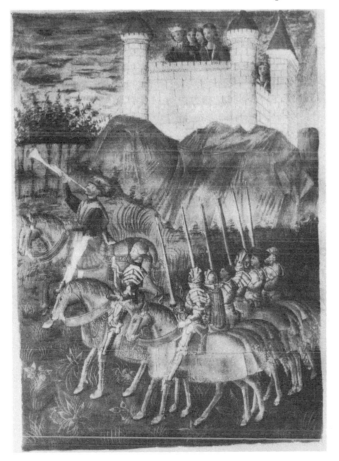

Parade before a tournament, from a fifteenth century Spanish manuscript of Virgil's works. (University of Valencia) (Foto MAS, Barcelona)

households connected with the cardinal as well as one of his own servants, a young German called Merlin. Three judges were appointed, and each jouster had to score fifteen hits to be considered for the prize. The jousts lasted for three days, and were followed by a tournament. Obviously it was impossible for high-ranking clergy to take part, and in the absence of a tradition of tournaments in Rome, the Roman nobles were not equipped to enter the lists; hence the summoning of men-at-arms instead. But it is noteworthy that the cardinal still felt that jousting was an essential part of a major festival. Later festivals in Rome turned to the 'course' described by Petrarch instead, where the warfare was purely mimic, and Riario's jousts seem to be the only recorded instance of real fighting in the lists at Rome.[32] Jousts could still be serious enough at this period, as an episode at Pavia in 1453, when a joust instituted by a newly-elected rector of the university turned into a Guelf versus Ghibelline riot. The jousters were townspeople, and the ducal officials in the town complained that various unsavoury characters appeared in the lists, armed with sticks, indicating that a riot was afoot. The prize, a length of velvet, was carefully awarded to two jousters, one from each party, but this did not prevent one of them from rallying his supporters and riding through the town to celebrate his victory; in the end, there were over a thousand armed men on the streets, in the medieval equivalent of a football riot, which lasted all night, because the governor or *podestà* had no guard with which to deal with such an event.[33] Once again, it is noticeable how the townspeople were the jousters, not princes or nobles, in what was evidently a very disorganised and uncontrollable kind of event.

Medici jousts at Florence

Contrast this with Florence, firmly under the Medici yoke by the latter half of the fifteenth century, the scene of magnificent festivals of which jousting was part; instead of a rioting rabble, we find the fantasies of gilded youth. A certain Bartolomeo Benci, anxious to improve his standing with his lady, decided to serenade her on the night of carnival (Shrove Tuesday) 1473 in high style. He and eight companions, 'splendidly dressed and with newly caparisoned horses, set out from his house at one in the morning, each attended by thirty youths bearing torches in their lord's livery, and by eight youths on horseback. They took with them a "triumph of love", consisting of cupids armed with bows set in greenery, surmounted by a bleeding heart surrounded by flames.' Machinery within made the cupids fly up and down 'as if they were alive'. At the lady's house, the leaders took up their lances and jousted under her

Fourteenth century Italian cassone or marriage chest showing a feast and a tournament. (Torello collection, Barcelona) (Foto MAS, Barcelona)

balcony; and they proceeded to do likewise at the houses of the ladies of the other eight participants, 'so that the feast lasted all night.' Benci had been prudent enough to get official permission for his serenades and jousts, for the town council decreed that if anyone was accidentally killed, no penalties would be levied.[34]

For an example of the tournament as princely triumph, we need only turn to the jousts held four years earlier by the Medici. This tournament was one of a whole series held in the 1460s and 1470s at Florence; the enthusiasm of the Medici court for jousts outstripped that of any other Italian principality. Giuliano di Piero di Medici's jousts in 1475 were celebrated in the high classical style of the Renaissance in a poem by Angelo Poliziano, and we have a very careful description of his appearance at what may have been the same joust. He rode a grey horse called The Bear, and his shield bore a Medusa's head at the top decorated with large pearls, all of which were lost in the joust. The shield was lavishly trimmed, fringed with gold and jewels, and in the centre a great flame was shown, with balas rubies for the glowing coals. His cloak was

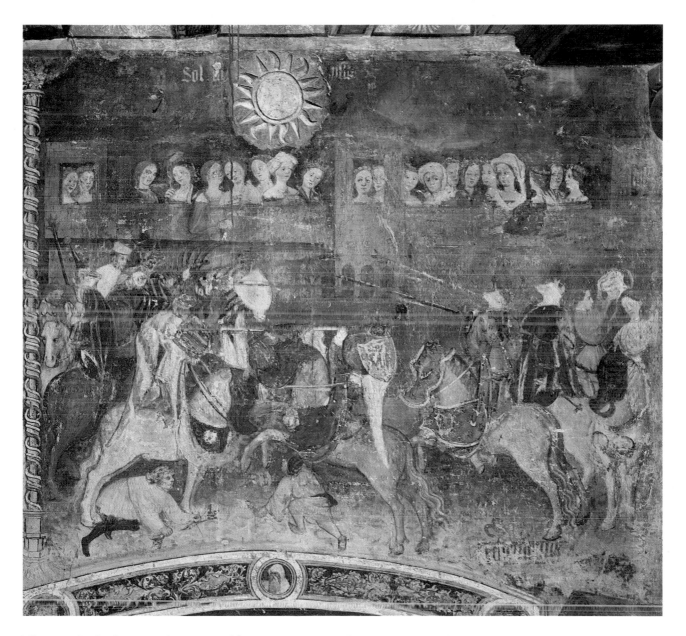

The month of February, characterised by a tournament: a fresco from Castello del Buonconsiglio at Trento, Northern Italy. (Photo Scala)

decorated with brooches and pendants and his elaborate silk head-covering had two white feathers, a balas ruby, a diamond and three pearls. Other jousters appeared with as much as twenty pounds of pearls on their costumes. Interestingly, none of the costumed jousters are mentioned as breaking spears, and their entry into the lists may have been largely for show.[35]

The emphasis in other descriptions of Italian jousts is on the appearance of the jousters and the lavish costumes, armour and sometimes scenery, as much as on the results. At the double marriage of Beatrice d'Este and Anna Sforza in Milan in 1491, the costumes were minutely recorded: Galeazzo Sanseverino, for instance, had ten attendants dressed as wild men, while others rode 'wild horses', as did Galeazzo himself. Wild men were a common enough theme in medieval festivals, but in this case Leonardo da Vinci had had a hand in their design, and they may well have been a sight out of the ordinary. All the costumes were either luxurious or elaborate, or both; Turkish costume was popular, and the crests included such flights of fancy as 'a mountain in front of which is a naked man with a letter in his hand and a book, and a star above his head'. In the jousting Galeazzo Sforza distinguished himself by breaking nine spears in twelve courses; in the other three he hit his opponent's shield, but the spear did not break.[36]

The duke of Milan, Giangaleazzo Sforza, was justly proud of his festival, claiming that 'as many lances were broken in the lists as in any joust in Italy for very many years, and these were lances of a size not merely above the normal, but beyond all belief to anyone who did not witness it'. And with this resounding claim we leave the tournament in Italy and turn to Spain.

Drawing by Jacopo Bellini of a horse and rider in fantastic guise, probably a sketch for a jousting costume. (Jacopo Bellini, The Louvre sketchbook (Woodbridge 1986))

Spain

The early history of the joust in Spain is largely unexplored territory. Despite the considerable interest in Spain in heraldry and genealogy, and in medieval history in all its aspects, the tournaments and jousts before 1400 never seem to have been studied by serious historians. One reason for this may be that the continuing warfare against the Moslems and between the various Christian kingdoms left little enthusiasm for mock warfare when real battles were to be fought. The earliest appearances of the words tournament and joust in Spanish and Portuguese are in the mid-thirteenth century, very much later than elsewhere in Europe; and it is only in the areas of Spain in closest contact with France that tournaments are recorded before 1300. Indeed, the history of tournaments in the peninsula is largely linked to the enthusiasm of particular individuals for the sport.

The earliest apparent record of Spanish participation in tournaments comes from Aragon, in Muntaner's chronicle of the deeds of Jaime I. Jaime's father had married the heiress of Montpellier: 'but as time went on, the said Lord King En Pedro, who was young, became enamoured of other gentlewomen.' One of these was a lady of Montpellier for whom Pedro is said to have 'held tourneys and knightly exercises, and [he] did so much that he made his love evident to all'.[37] In the end, Pedro had to be tricked into begetting the future Jaime I by arranging an apparent rendezvous with this lady, for whom the queen was substituted. It all sounds like a good tale, and given the rarity of tournaments in southern France, Pedro's exploits at Montpellier may well be fictitious. But tournaments were certainly held in Aragon not long after this, since the statutes of peace issued in 1235 prohibited them, and it is unlikely that such an edict would have been announced on the mere possibility that they might be held in the future.[38]

The statutes underline the lack of a real concept of tournaments, because what they prohibit is 'voluntary tournaments unless they are in war'.[39] The statutes of Aragon of c.1300 preserve this meaning even more closely, because the paragraph in which 'torneo' occurs is entirely concerned with warfare. The Spanish writers are using the word in the same sense as chroniclers a hundred years earlier in northern Europe, to mean a skirmish in real warfare. This meaning also appears in the law code of Alfonso X of Castile in the mid-thirteenth century, the *Siete Partidas*: Alfonso explains that the *torneo*, a sally by the defenders or besiegers of a castle, after which both sides return (*tornanse*) to their respective camps, is a warlike manoeuvre not to be confused 'with these tournaments (*torneamientos*) practised by men in some countries, not in order to kill each other, but in order not to forget the use of arms.' The statutes of Navarre use *torneamiento* in the sense of *torneo* in a similar passage.[40] But the next paragraph of the statutes of Aragon does imply that knightly exercises were not unknown in Spain, since it is concerned with the *béhourd*.[41]

The first authentic record of a tournament in Spain itself would seem to be at Valencia in 1272, when Jaime I met Alfonso X at Valencia: it is in the *Cantigas de Santa Maria*,[42] written at Alfonso's court, that tournaments are first mentioned in Spanish, and at this meeting, so Muntaner tells us, 'no man could describe the decoration of the houses and the games and diversions, the round tables and joined platforms for jousts between wild knights, tourneys, knightly exercises, galleys and armed lenys [boats] which seamen dragged along the *rambla* (avenue) in carts, and battles of oranges.'[43] Compare this with the accounts of Roger Mortimer's round table at Kenilworth in 1279, where jousting and a tournament formed part of similarly extravagant scenes, and the international nature of such occasions is plain; the Spaniards, with extensive

Tournaments hardly known in Spain before 1300

Tournaments in Aragon

A furious mêlée watched by ladies, a king, musicians and heralds; painted by a Florentine artist on a late fourteenth century cassone or chest. (Musée, Tours) (Photo Scala)

contacts with the French and English courts, were familiar with the fashionable customs of the period, and it is a reasonable assumption that it is only the scarcity of records that makes the Spanish tournament difficult to trace.

In 1280 at Toulouse, during a diplomatic meeting with Philip III, Jaime I's son Pedro III ordered a quintain to be set up, and he and his knights jousted:[44] but we know that he had spent some time at the French court while he was still heir to the throne: 'he remained there full two months with great disport and diversions. And he took part in tourneys, and throwing of spears, and engaged in knightly exercises with knights and sons of knights who had come with him and with many counts and barons of France who tried their skill against him for love of him.'[45] But Spanish festivals did not always include jousting: other warlike sports were just as common, as at Barcelona in 1285, where the king joined in lance-throwing and there were 'martial exercises' and sports for each afternoon for eight days. Two years later, at the end of a campaign that had ended without action, the king,

> seeing that he had not been able to fight with his enemies, commanded a tournament, that is, two hundred on the side of En Gisbert de Castellnau and two hundred on the side of viscount Rocaberti; they were the chiefs on each side. And here the most beautiful feast was made and the finest feats of arms done that had ever been done in a tournament since the time of King Arthur. And as soon as this was over the Lord King returned to Barcelona; and you might have seen every day round tables and tourneys and martial exercises and jousts and other diversions, so that all in the country went from amusement to amusement and ball to ball.[46]

The same year, at his betrothal to Eleanor, eldest daughter of Edward I, at a meeting between the two kings on the Isle of Oléron off the coast of Gascony, dagger throwing as well as jousting were among the sports; the chronicler regards the two very much on the same footing, the same sports appear at the *cortes* held at Barcelona in 1291,[47] while a writer from northern Europe would almost certainly have regarded the jousts as vastly more important.

Muntaner gives us a detailed account of a round table held in the same year by the admiral of Aragon, Roger de Luria, whose triumphant career had included the defeat of the Sicilian fleet, which led to the capture of Sicily by the Aragonese. This was a

A fourteenth century rustic panel of Spanish knights jousting, from Teruel cathedral.
(Foto MAS, Barcelona)

festival comparable to anything mounted elsewhere in Europe in the thirteenth cen-
tury. Roger de Luria had lists built with scaffolds for spectators and a wooden castle at
one end, 'from which he would issue at the approach of a knight. And on the first day
of the round table he, all alone, wished to hold the castle against any man who wished
to break a lance.' Jaime I and Sancho IV of Castile were among the spectators, as well
as lords from all over Christian Spain and as far afield as Gascony. The first challenger
was a knight of the king of Castile's court, Berenguer de Anguera, and the encounter
was so fierce that the admiral's lance was shattered and Berenguer de Anguera's
helmet was forced off, injuring his face; at which the kings were very concerned, and,
although the injuries were not serious, the round table was stopped 'for fear a quarrel
should ensue'.[48]

The Aragonese court was not unlike that of Edward I in its enthusiasm for chivalric
values, and in this seems to have contrasted with Castile, where relations betwen
crown and nobles often degenerated into open war. The military energies of Aragon
were successfully channelled into overseas ventures; and the heroic tone of the
Aragonese chronicles is justified by the achievements they record.[49] There are echoes
of the *Song of Roland* and of the Arthurian romances not only in the chronicles, but in
the attitudes of the kings themselves. Even the story of the conception of Jaime I has
overtones of the mysteries surrounding the births of Arthur and of Alexander. But
with the passing of the golden age of Aragon, the records of the tournaments also
disappear: instead, the thread is taken up by Castile.[50]

We first hear of the tournament in Castile in the shape of *béhourds* at Seville to
welcome Alfonso XI in 1324; but the earlier existence of tournaments can be deduced
from the fully-fledged tournament provisions in the statutes of the Order of the
Banda, founded by Alfonso in 1330 at Vitoria.[51] This was one of the earliest secular
orders of knighthood, predating the Order of the Garter by more than a decade, and
the rules about tournaments are unique: no other such order actually specified that
knights should enter the lists as a duty. It was envisaged that each meeting of the order
should include a tournament; but in addition to this, the king could summon the
knights to any tournament which he had proclaimed, and they were expected to
attend such events which took place within a day's ride of wherever they might be. We
know of two occasions when the knights held tournaments: the first was in 1332,
when the king was at Santiago de Compostela awaiting his coronation:

*Tournaments in Castile: the
Order of the Banda*

*Ceiling panel of knights jousting; Spanish country painting, perhaps fifteenth century.
(Varez collection, Madrid) (Foto MAS, Barcelona)*

Moreover they maintained two *tablas** for jousting, and the knights of the Banda, whom the king had made and ordained a short time before, remained all day, four of them arrived in each *tabla*, and would joust with all who sought to joust with them.

The second occasion was at Valladolid at Eastertide in 1334. The chronicler describes how Alfonso was always involved in 'tournaments and round tables and jousting' (if he was not out hunting), and how he regarded such occasions as a valuable means of ensuring that 'the knights would not lose the use of arms, and would be prepared for war when the need arose'. The knights of the Banda fought together as a team against an equal number chosen from all comers, the king being incognito as a member of the Banda. Two tents were pitched at either end of the lists, and the tournament began under the supervision of four judges. It was fiercely fought, and the king, because he was incognito, received heavy blows in the thick of the press. The judges, seeing that the contest was becoming too heated, entered the lists and forced them to part. The two sides charged each other twice more and the fighting moved to a little bridge over a river outside the town gate, where the combat continued until after noon. The judges parted the two sides, and they went to eat in their respective tents. After dinner, the knights who formed the all comers' team went to visit the knights of the Banda and the king, to hear the judges' verdict as to who had performed best; and they talked at length of the day's doings.

There is only one further occasion when we hear of the order of the Banda in connection with tournaments: in 1375, at Christmas, Enrique II held a 'famous tournament' at Seville 'in which the knights of the Banda distinguished themselves; the order had declined somewhat since its institution, but he wished to encourage the work begun by his father king Alfonso'.[52]

The order of the Banda was a short-lived institution, surviving for little more than a century; despite Enrique's attempt to revive it, its heyday was certainly past with Alfonso's death in 1350, and even in 1338, when we know that Alfonso held a great cortes at Burgos, followed by a tournament, we hear nothing of the Banda. The reasons for the tournament are very similarly phrased to those given for the 1334 event – Alfonso's enthusiasm for knightly deeds and the desire that the practice of arms should not be forgotten – and on this occasion too Alfonso fought incognito.[53]

We are only told that 'Don Joan Nunez and other lords and many other knights of the kingdom' took part. After 1339, when the truce with the Moorish kingdoms ended, Alfonso was occupied with real warfare, and it was only under his successor Pedro I, better known as Pedro the Cruel, that tournaments reappear: in 1353 Pedro fought in a tournament at Torrijos, near Toledo, where he was wounded in the right hand by a sword-point; the wound was a dangerous one, and the doctors were unable to bleed him, but he recovered.[54] Three years later, Pedro held a tournament at Tordesillas with the object of asassinating Don Fadrique, master of the powerful Order of Santiago, or so members of his household claimed in later years. But Pedro failed to give instructions to his participants in the tournament about the plot, and Fadrique escaped.[55] In the political upheavals of Pedro's last years and the reign of Henry of Trastamara, we hear nothing of tournaments, except briefly in connection with John of Gaunt's campaigns in Spain, when they seem to have involved only English and French knights.

*A *tabla* is an open flat space; in this context, it is probably a technical word for a type of tournament enclosure.

However, the principality of Navarre, whose ruler, Charles II, was a member of the French royal house, was the scene of a number of tournaments in the late fourteenth century.[56] We learn of gifts by the infante Carlos to minstrels at a joust in 1377, for which he also bought small quantities of armour. In 1387, jousts were held for the arrival of the queen, and a locksmith was paid for erecting a pavilion from which the king and queen watched the jousts in the citadel at Pamplona. In 1403, there were tournaments at Pamplona and Burleda to celebrate the coronation of queen Leonor, and 147 lances were bought from the local lance-maker, as well as 24 sets of armour and a further 24 decorated lances. The heir to the throne of Navarre was an enthusiastic tourneyer, and held a number of jousts at his residence at Olite; we shall meet him again jousting at the Castilian court in 1428.

Tournaments only reappear in the Castilian records in the reign of Juan II, or, to be strictly accurate, a year before he came to the throne, soon after his birth. It was a suitable entry into the world for a king who was to be famous only for his love of amusements, and who delegated his power to the constable of Castile, Alvaro de Luna; and it was a notable occasion, for it is the first known appearance in the lists of Pero Niño, 'always the victor and never the vanquished', as his epitaph put it.[57]

Juan II himself patronised tournaments from 1414 onwards, when jousts, as was almost traditional, were held at his coronation at Saragossa: these were marked by 'many outstanding encounters', culminating in 'a tournament of a hundred versus a hundred, white against colours'. At his betrothal to Maria of Aragon in 1418 and at his marriage to her in 1420, there were jousts and tournaments and bullfights.[58] We have a detailed account of another tournament in Madrid in 1419, at which Alvaro de Luna was wounded. Alvaro de Luna appeared in splendid array at the jousts, wearing a favour from his mistress, and broke many lances, until the king sent orders that he should leave the lists, because he had done enough, and won great honour. But Alvaro de Luna begged permission for one more joust. His opponent on the other side of the tilt was one of the best jousters at court, Gonzalez de Quadros; Alvaro de Luna struck him on the shield, while Gonzalez' lance struck Alvaro on the visor, lifting it, and striking him on the forehead with the coronal, stunning him and causing a deep wound. The joust was abandoned, and the constable only narrowly escaped death from his injuries.[59]

In 1423, at the age of eighteen, we find Juan himself taking part in jousts, and the remainder of his long reign, which ended in 1454, was the great age of Spanish tournaments. We have a wealth of detail about these events, from Alvaro de Luna's chronicle and from the chronicle written by Juan's chief falconer and close companion, Pedro Carillo de Huete.[60] Juan was a skilled jouster, and even at the age of twenty in what seems to have been his first proper joust he could hold his own against more experienced knights: at a joust near Tordesillas, he impressed onlookers by his accurate aim and firm seat, scoring several hits on his opponents' shields.[61]

Jousts were held on most formal occasions, such as the ceremony at Toledo when Doña Catalina, Juan's eldest daughter, was recognised as heiress of Castile, at Tordesillas when Alvaro de Luna was appointed constable, for the king's ceremonial first entry into Burgos, for the recognition of his son Juan as his heir at Valladolid.[62] But both the king and the constable also held jousts purely for the pleasure of it; the king's 'natural condition was to hold jousts and to do things which he enjoyed', while Alvaro de Luna, during a period of banishment from court, entertained his followers with jousts.[63] The festival held at Ayllon, a town belonging to Alvaro de Luna, in May 1432, also comes into this category. Two scaffolds were built for the spectators on a pasture outside the town, and two tents were erected at diagonal corners of the lists. A

coloured cloth on painted posts formed the tilt; and at each end of the tilt were artificial poplars, with the arms of the constable, small and square in the Italian style, hanging from them. The royal scaffold was richly decorated with cloth of gold and French cloth.

The king and twelve knights of his household opened the jousts, and were met by twelve knights coming out of the town of Ayllon, with whom they jousted one at a time. Other knights arrived as the jousts proceeded, including Fadrique de Luna, attended by four pages, splendidly dressed and mounted. Ruy Diaz de Mendoza, the king's majordomo, appeared with a cart, drawn by men on foot, on which were a dozen lances, and in the middle a seated page with a lance in hand and an azure shield; a squire walked in front of it, chained by the neck to it with a golden chain. This 'invention' as the chronicler terms it, was evidently new to Castile, though similar devices were a familiar sight in the festivals of the Flemish towns. The jousts, fought in war armour, were judged a great success, seventy knights taking part; five knights fell, and there were a number of injuries, but it was nonetheless the finest joust seen in Castile for a long time.[64]

Valladolid, 1432: Passaje Peligroso de la Fuerte Ventura

The most spectacular festival of the period was the *Passaje Peligroso de la Fuerte Ventura* (The Perilous Passage of Great Adventure) held at Valladolid in 1428 and other jousts which followed it, which lasted from 28 May to 8 June. Prince Enrique, Juan's son, gave the first festival, with a very complicated setting and scenario. In the main square a fortress was built, with a high central tower and four surrounding towers. At its foot was a belfry and a pillar painted to look like stone, on which a gilded gryphon stood, holding a great standard. A high fence with four towers surrounded it, and an outer fence with twelve towers completed the fortifications. In each of these towers stood a lady dressed in finery. Inside the fortress were rooms for the prince and mangers for the horses. A tilt made of cane ran from the fortress across the square to two more towers and an arch inscribed 'This is the arch of the perilous passage of great adventure'; on one of the towers was fixed a great golden wheel, called the 'wheel of fortune'. Before the defenders went to arm themselves, there was dancing, feasting and a musical interlude. When the challengers arrived, they were greeted by fanfares and a lady who warned them that they could go no further without jousting; they replied that they were ready. The king, on a horse caparisoned in silver and gold, took up the challenge, and broke two spears; he was followed by the king of Navarre, with twelve knights 'all like windmills', who also broke a spear. But despite all the ceremonial, the jousting was fierce: Enrique was stunned by his opponent, and one of his squires was so badly wounded that he died two hours later.

Six days later, the king of Navarre gave his festival; he and five other knights were the defenders, dressed in tasselled gorgets. He broke a number of spears on the first challengers; then Juan appeared, his lance on his shoulder, with twelve knights riding in similar fashion. In two courses, he carried off his opponent's crest, a highly skilled feat, and broke a lance; many other lances were broken before the proceedings ended with a magnificent dinner, during which many knights jousted in war armour by torchlight.

A fortnight later, on Sunday 6 June, Juan gave his own festival, in honour of his daughter's forthcoming marriage to Duarte, the heir of Portugal. A tent was pitched at the top of a flight of steps covered in cloth of gold, and the king appeared in the lists dressed as God the Father, each of his accompanying knights as an apostle with a scroll bearing his name and carrying one of the instruments of the Passion. Six of the prince's men appeared in surcoats decorated with smoke and flame, and six with mulberry leaves on theirs. They fought a number of courses, in which the king broke three

spears and the prince five; and then the prince and his men retired to disarm. The prince returned alone, to fight three more courses, and the king of Navarre followed him into the lists; then other challengers fought, 'and the jousts lasted until there were stars in the sky'.

This was followed two days later by a duel between Gonzalez de Guzman of Castile and Luis de Fazes of Aragon, consisting of eight courses on horseback and fifty blows with a dagger on foot: in each of the eight courses, they both broke their lances, and the fifty blows were accomplished without injury. Finally Alvaro de Luna held a tournament of fifty against fifty, in which he was acclaimed as the best jouster of the day, but this was overshadowed by the magnificence of the earlier celebrations.[65]

The festival at Valladolid marked a wave of enthusiasm for jousting in Spain, and was followed by a series of major festivals. At Madrid in 1433, Inigo Lopez de Mendoza was defender in a joust in war armour at the royal palace, and Alvaro de Luna the challenger. A procession of fifty lightly armed horsemen and a hundred crossbowmen on foot preceded the constable, who opened the proceedings by running several courses against Mendoza; but because the constable had more knights with him than the defender, some of the constable's men jousted against each other.[66]

The most famous of all the Spanish jousts was the *Passo Honroso*, held at the bridge at Orbigo by Suero de Quiñones and his companions in July 1434, described in detail for us by Pero Rodriguez de Luna.[67] The proceedings at Valladolid and the *Passo Honroso* predate and foreshadow the great Burgundian festivals. While both Spanish and Burgundian knights were probably imitating earlier and less well-recorded French and Flemish festivals, the pre-eminence of Burgundy in terms of chivalric activity is almost certainly exaggerated, and the Spanish achievement needs to be recognised. The *Passo Honroso* unfolds against a background of political intrigue.[68] The jousts at Valladolid had aroused much rancour; Pero Niño, who fought among the king's 'apostles' as St Paul, had joined in the lists with reluctance, even though he acquitted himself with distinction, and remembered the discontent caused by the occasion, which soon flared up into civil disturbances. Suero de Quiñones was one of the members of Alvaro de Luna's household, which he had entered as a squire in 1426 at the age of 17. If a later chronicler is to be believed, he and his brother fought in the constable's team at a tournament held at Valladolid in 1434, where two teams of fifteen fought each other in individual jousts; the king also took part, although he was not a member of either team.[69] When, on 1 January 1434, he begged leave of Juan II to hold a *pas d'armes* in order to win his freedom from a self-imposed vow to wear a chain round his neck every Thursday to symbolise his enslavement to his lady, he was only just wealthy enough to mount such an occasion from his own resources. The Quiñones family were minor Castilian nobles, and Suero was the second son; it seems that the constable, anxious to maintain his chivalric reputation, was behind the venture, though it was Suero's father who supplied the necessary funds by giving Suero part of his inheritance. This demonstration of the power and wealth of the Castilian nobility was merely another stage in the long struggle between the princes and Alvaro de Luna, but it shows how highly regarded such chivalric displays had become in Spain.

The terms of the *Passo Honroso* were published as soon as the king gave his formal permission, at the end of the dancing on the night of January 1, seven months before the appointed day for the opening of the *passo*, which was to last for thirty days or until 300 lances were broken.[70] One of the royal heralds, Leon king-at-arms, was

Passo Honroso, 1434

given the mission of publicising the event. In the hills round Orbigo, timber was felled and floated down the river for the construction of scaffolding for the lists, and Suero himself began to purchase the necessary arms and armour. The rules stated that if any knight lost a piece of armour in the lists, his opponent was to keep it; two knights succeeded in winning helms in this way. Pero Niño, 'the unconquered knight', was one of the judges, and the teams were made up of Alvaro de Luna's close associates. Meanwhile, at Orbigo, the preparations continued: the master-painter Nicolas Frances was engaged to paint a wooden figure of a herald which was placed on the bridge of San Marcos at Leon to advertise the jousts: it was put in place two days before the *passo* began, on July 10. An encampment of twenty-two tents had been erected at Orbigo, to house the knights, judges, heralds, musicians, scriveners, armourers, surgeons, physicians, lance-makers, and others. A wooden dining hall was built, where Suero and his companions and the challengers dined at one table, and visiting gentlemen 'who had come in honour of the *passo*', at the other.

The first arrivals, on 10 July, were two knights from Aragon and a German knight from Brandenburg; out of deference to the German knight's long journey, he was accorded the honour of the first joust. On the Sunday, Suero de Quiñones took formal possession of the field, with suitably lengthy speeches and ceremonial, and on Monday, after further ceremonies, the jousts began with the herald's cry of 'Laissiez-les aller, laissiez-les aller, pour faire leur devoir' (Let them go, let them go, to do their duty); even in Spain, the command was given in French. The first jousts were successful, with 3 lances broken in 6 courses; but when Lope de Stuñiga came on as defender to meet the Aragonese Johan Fabra, the score dropped to 2 lances in 19 courses. A large number of knights arrived on this day, and the defenders were kept busy for the next four days: on the Friday 54 courses were run by three pairs of opponents, with nine spears broken, and on the Thursday Pedro de Nava and Francisco de Faces ran 27 courses against each other, the highest number during the jousts. Injuries were relatively infrequent; five knights were hurt, none of them seriously, though Suero de Quiñones, who only fought again on the Thursday, dislocated his right hand. Two squires were knighted by him during the week, this being regarded as a highly auspicious moment for chivalric ceremonies.

The second week was less successful: on the Wednesday and Thursday, 21 and 22 July, there was no challengers, but many more knights arrived at the end of the week. The number of lances broken was nowhere near the target of three hundred: two weeks in the lists had brought a total of ninety. Furthermore, two Catalan knights, evidently hostile to the whole enterprise, had issued letters of challenge attempting to bring the enterprise to a rapid end by undertaking to break all three hundred lances in combats between themselves and the defenders: and when Suero pointed out that the articles of the *passo* limited each challenger to three lances, they defied him to meet them in a joust *à outrance* or *à todo trance*, in other words until one or other of the combatants surrendered, fought with sharp weapons rather than tourneying arms. The reason that the Catalan knights gave was that the *passo*, being held on the road to Santiago de Compostela, was hindering pilgrims from making their way to St James's shrine; but Suero pointed out that any knights who were on pilgrimage were specifically exempted from the challenge.

The week following St James's day saw much more activity. At least 30 courses were run each day, reaching a peak of 60 on Friday, with nine spears broken. The greatest number of spears (13) were broken on the Wednesday, but Suero himself was wounded again, in the right arm: this was the fourth and last time he was to enter the lists, and he actually jousted far less frequently than the other knights.

By the last week of the *passo* there was no hope of reaching the target of three hundred lances, largely from lack of challengers: on Wednesday 4 August, only one pair of jousters fought, breaking 3 lances in 15 courses. On the Friday, the Aragonese knight Asbert de Claramunt, riding against Suero, the son of Alvaro Gomez, who was one of the most active of the defenders, was struck in the left eye by a spear which broke his visor: he died instantly. Interestingly, there were friars at the *passo* who said their devotions each day, and Suero de Quiñones sent for them, asking them to take charge of the body and for one of them to obtain permission from the local bishop for its burial in sacred ground: death in a tournament was still evidently regarded as a reason for refusing Christian burial. Meanwhile, the corpse was taken to the hermitage at the head of the bridge at Orbigo, where Suero waited until night fall, hoping to hear that the licence had been granted. But the friar returned to say that the bishop had refused permission. A makeshift grave was dug outside the hermitage, and at nightfall the body of Asbert de Claramunt was lowered into its last resting place by the flickering light of torches, in the presence of the assembled knights, but without the church's blessing. Pero Rodriguez de Lena, evidently much troubled by this disaster, carefully explains in his account of the *Passo Honroso* that Claramunt was a very tall and strong man, and although he had been wearing a helmet borrowed from one of the defenders, he had declared that it was the best he had ever put on: the whole episode was, in Lena's view, deplorable, but a complete accident.

Death of Asbert de Claramunt

Despite the dramatic circumstances of Claramunt's death and burial the jousting continued the following day, when another mishap occured, Lope de Stuñiga breaking his lance on his opponent's horse. On Sunday, 8 August the jousts continued, even though on previous Sundays there had been a rest day, in an attempt to raise the total of spears broken, but although eighteen courses were run, only one was added to the total, and the final figure was 180 when the jousting ended the next day.

Pero Rodriguez de Lena's enthusiastic description of Suero de Quiñones' exploit has ensured its immortality, but it may not necessarily have been such an unusual event; once again, we come up against a problem of the erratic way in which tournaments were recorded, and the chance survival of such records. But the impression made by the *Passo Honroso* is confirmed by events at Valladolid six years later, when a very experienced jouster, Ruy Diaz de Mendoza, the king's majordomo and political rival of Alvaro de Luna, held a similar *passo* which was designed to outshine that of de Luna's protégé. Mendoza had nineteen other knights as defenders, as against Suero de Quiñones' nine companions, and he held his place for forty days, as against a month. Each challenger had to joust until four spears were broken. But the dangers of the sport came to the fore once again: the king intervened to forbid further combats after a knight from Toro was killed by a blow which broke his visor and a squire died of a wound in his right arm. Another knight 'escaped miraculously by the grace of our Lord' after being run through the body.[71]

International challenges recur in Spain several times in the 1430s and 1440s: in 1443 the *pas d'armes* held by the sieur de Charny near Dijon was proclaimed at the Castilian court, while five years earlier Robert, lord of 'Basce', a German knight, had led a team of twenty in jousts at Seville against the same number of Castilian knights.[72] In 1448, Jacques de Lalaing, one of the most famous Burgundian knights, jousted with Diego de Guzman at Valladolid, and in 1459 Beltran de la Cueva jousted with Breton knights at Madrid 'in the woods of the Pardo'.[73] As we have seen, Spanish knights also travelled abroad: in 1436, Fernando de Guevara set out for Vienna to challenge Georg Vourapag to a combat on foot, in which, despite the German's greater experience, Guevara won the honours.[74]

Juan II continued to patronise court jousts until his death in 1454, such as that held by Alvaro de Luna at Escalona in December 1448; but there was always an undertone of political tension, and on this occasion the jousting was ended by the king before it became too heated, 'because it was done as a great festival and pleasure, and no anger or disaffection should come between them'. A foot tournament followed, at night, in the great hall lit by torches 'until it was as bright as day', and then jousting; the constable entertained the king for eight days, and 'was much praised' for carrying out the festival in such splendid style.[75]

The reign of Juan's successor Enrique IV saw the almost complete disappearance of court jousts: only enthusiastic individuals kept up the tradition, such as the king's erstwhile favourite, Miguel Lucas de Iranzo, at his wedding in Jaen, where he had been banished. An impressive tournament was held, at which the knights fought 'as fiercely as if it were a real battle of deadly enemies', though the chronicler notes that one of the rules was that no-one was to thrust with his sword, nor to strike at his opponent's back. A foot tournament and a *pas d'armes* followed, for which a bridge was erected in the main square, on which the combats took place.[76] In the following year, jousts were also held by Iranzo at Jaen, but this is the last we hear of the sport in the troubled years before the union of Spain under Ferdinand and Isabella and the final stages of the reconquest of Granada from the Moors.

Portugal

Tournaments in Portugal are even more difficult to trace before the late fourteenth century. During John of Gaunt's campaigns, we hear of jousts in Portugal between English, French and Spanish knights, but no Portuguese knights are named as taking part.[77] But when João I married John of Gaunt's eldest daughter Philippa in 1387, there were 'feasts and royal jousts' in honour of the wedding:[78] 'royal jousts' may be related to the 'jousts in royal armour' found in the Spanish records, but the chronicler gives no further details. Such occasions were evidently not new to him, and certainly by the fifteenth century Portuguese knights were skilled jousters, as the entertainment put on in Lisbon for the ambassadors of the duke of Burgundy in 1428 demonstrates; to which we can add the special jousts in the Portuguese manner held at the wedding of Isabella of Portugal to the duke in the following year. King Duarte, for whose betrothal to the daughter of Juan II of Castile jousts had been held at Valladolid in 1428, wrote the earliest surviving descriptions of the technique of jousting as part of his book on horsemanship.[79] A number of Portuguese knights fought abroad; Jean le Fèvre describes a series of single combats at Bar-le-Duc in 1414 and at St Ouen in 1415 between Portuguese and French squires and knights,[80] while the Portuguese poet Camões in his national epic *The Lusiads* records the story of the 'Twelve of England', who fought English knights in London in honour of their ladies about the end of the

'The Twelve of England' fourteenth century.[81] However, Camões was writing some 150 years after the event, and the episode does not appear in the English records, so we have no firm historical evidence for the occasion. At the end of the fifteenth century, at the marriage of the son of João II to a Castilian princess in December 1490, both the king and his son took part in jousts, again called 'justas reaes'. A lavish tent was pitched on a meadow outside the town of Evora, decorated with the banners of Portugal and Castile, and a wooden castle was built, which was brilliantly lit at night and richly hung with tapestries, for the use of the king's party during the jousts. There were eighteen defenders, led by the king, and over fifty challengers: one French knight was among

the defenders. The chronicler records the mottoes carried by the jousters, but tells us little about the detail of the fighting, which lasted four days, and was partly held at night; the lights from the castle burned all night, and 'it was so clear that they could joust as though it was midday'. The prizes were awarded to the king, but he passed them on to other jousters.[82]

Sweden

The tournament was to be found even further afield from its origins in northern France and the Netherlands than the Iberian peninsula or Italy. Sweden, with strong links to the German cities along the Baltic shore, saw a handful of tournaments. In the thirteenth century, Swedish translations of chivalric romances mention tournaments, but the earliest actually recorded occurs in the chronicle of Lübeck, when two local nobles went to Stockholm for the coronation of Magnus II in 1336. They and many other foreigners jousted with the Swedish nobles for three days.[83] Seventy years later, when Eric of Pomerania married Philippa, daughter of Henry IV, jousting was part of the proceedings, and there was jousting at an aristocratic wedding at Stockholm in 1438.[84] The tradition of jousting at royal weddings and coronations continued into Sweden's golden age under the Vasa kings: Gustav Vasa in 1528 and Erik XIV in 1561 both held tournaments at their coronations, and Erik XIV took to the lists himself on the latter occasion. By continental standards it was a relatively modest and traditional affair; the king's opening joust resulted in his breaking a spear, but the whole supply of lance-heads for the occasions seems to have been only 75, implying a fairly small number of participants. At the end of the sixteenth century, duke Karl held a series of tournaments at Nyköping, mixed with riding at the ring and competitive shooting: Karl's court was generally austere, and the presence of tournaments shows that they were still regarded as a useful form of military training, even when the challenges were issued by knights disguised as Hector, Ajax and Achilles. Tournaments of a increasingly theatrical kind were held by Gustav II Adolfus, including a great tournament for his wedding in 1620; his namesake Gustav IV Adolfus at the end of the eighteenth century was to renew such events, in one of the earliest examples of the romantic revival of the ideals of chivalry.

Hungary, Poland, Cyprus and Byzantium

In Hungary, there is evidence that tournaments were known at the end of the twelfth century, but the first definite notice is from 1291, when the king Andreas III sent certain nobles to a tournament in Vienna.[85] From 1310, the house of Anjou ruled in Hungary, and Karoly I introduced the chivalric values and sports of the west as soon as he had established himself in his new kingdom. The first glimpse of him in the lists is in 1319, when he granted three villages to a knight as compensation for three teeth which he had knocked out in a tournament. When Karoly founded the earliest of all secular orders, the order of St George, one of the duties of the knights was 'to follow the king closely in all recreations and military games:' in the words of a recent historian of such orders, 'it may well be that the knights of the Society, like those of the contemporary Castilian Order of the Band, were expected to function as a sort of royal tournament team, and as such to set a standard of military discipline and prowess for the rest of the nobility to emulate.'[86] At Karoly's funeral in 1342, he was

Order of St George and tournaments

accompanied by three knights bearing the king's arms for war, for tournaments and for jousts respectively. Other notices of tournaments actually held in Hungary are few and far between: in 1396, before the ill-fated crusade that ended in disaster at Nicopolis, in 1412, and under Matthias Corvinus in the late fifteenth century. Matthias, a brilliant general and deeply interested in Renaissance learning, had been brought up in chivalric fashion, and held tournaments for his coronation and wedding, and for the treaty of Breslau. The scarcity of native Hungarian sources makes it difficult to tell whether these occasions were exceptional, or whether the presence of foreign envoys who recorded them for their masters in the west is the only unusual feature about them.

Tournaments may also have been more frequent in Poland than the records suggest. Peter I of Cyprus jousted at Cracow in 1364 when he and the emperor met princes of the empire there to discuss his proposals for a new crusade, and we hear of jousts in the same city in 1518 before the entry of king Sigismund's newly-married Italian wife, Bona Sforza.

Even further afield, there were certainly jousts in Cyprus from 1223 onwards, and in the Holy Land itself in 1286, for the coronation of king Henry at Acre. All this was still within the orbit of western Christendom; but the western knights also succeeded in interesting the Byzantine nobles in their favourite sport. As early as 1159, when

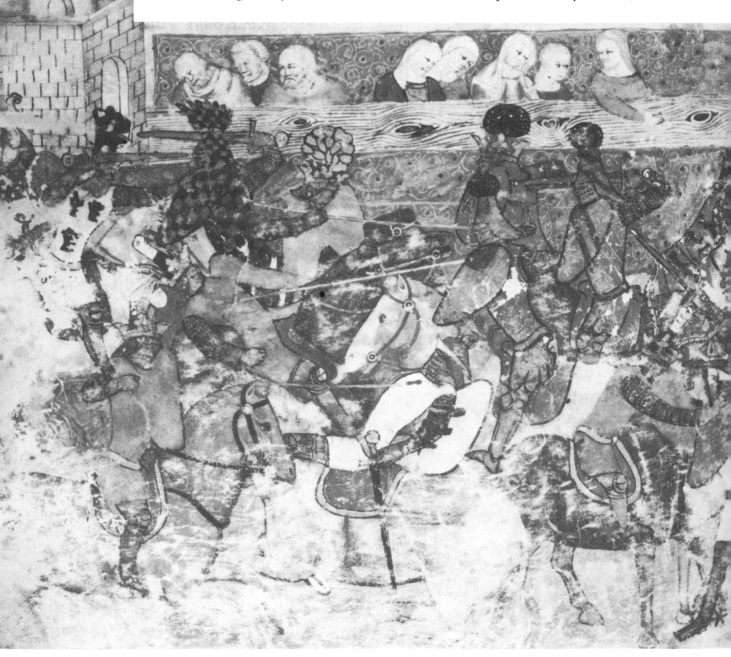

Manuel Comnenus visited his vassal, count Reynald, at Antioch (having just obtained a humiliating submission from him) a tournament was organised, apparently as a gesture of good will on the emperor's part. Manuel, an expert horseman, acquitted himself well against the westerners, led by king Baldwin of Jerusalem, though his courtiers were less at ease.[87]

In the fourteenth century Andronicus Palaeologus, who was married to the daughter of Amedeo V of Savoy, is said to have learned the sport from the Savoyard knights who escorted the princess to Byzantium; and jousts were held to mark the birth of his heir, John Palaeologus, in 1332. The emperor, according to the historian who describes the event, had often jousted before, but did so with particular enthusiasm at this celebration, despite warnings from his elders of the dangers involved. There was also a tournament fought with maces, between two teams of equal numbers, divided according to family and allegiance, in which the emperor also took part.[88] These brief appearances of the sport in a culture where the ideals of chivalry were known, but were regarded as an alien concept, mark the furthest and most unexpected limit of the tournament's appeal.

A mêlée in progress. Meliadus, Italy, c.1350. (BL MS Add 12228 f.177v–178)

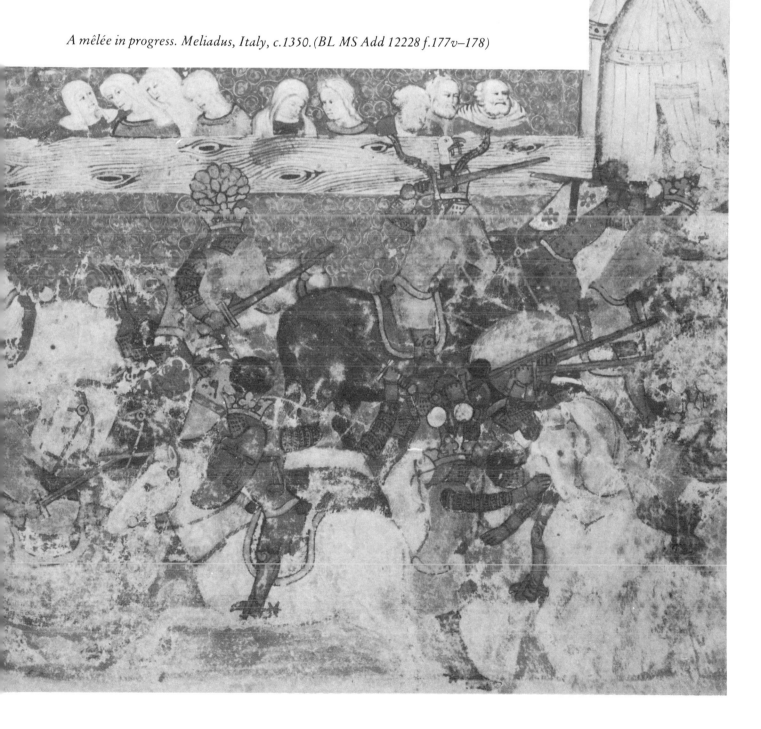

Jousting at the coronation of Joan of Navarre, queen of Henry IV, February 1402, from the
'Pageant of Richard Beauchamp', drawn about 1450–60.
(BL MS Cotton Julius E IV art.6 f.3)

5
The Late Medieval and Renaissance Tournament: Spectacles, Pas d'Armes and Challenges

In the fifteenth century, the tournament developed in two quite different ways. On the one hand, full-scale jousts became extremely expensive, surrounded by elaborate scenery and dramatic programmes, so that only the wealthiest princes could afford to mount them, while at the other extreme the individual challenge grew in popularity, as one of the few ways in which an up-and-coming knight could make his mark. The actual general *mêlée* or tournament proper, became increasingly rare, and the distinctive form of the sport was the *pas d'armes*, in which individuals or teams proclaimed their intention to defend a given place against all comers. In England and France, the joust was almost a princely or ducal monopoly after 1340; individual challenges were the only exception to this, but in times of peace a royal licence was always required for such an occasion.

The adoption of jousts as part of royal ceremonial was marked by their association with the ritual of royal 'entries' from the mid fourteenth century onwards. When a king entered a town in his domain, he would naturally be welcomed by the local dignitaries, and the ritual was an important one, because it both asserted the king's authority and the town's own independence;[1] there were good political reasons behind the ceremonies. These occasions became more elaborate in the early fourteenth century, and the formal speeches were mirrored in a primitive dumb-show on themes to do with good government and local political preoccupations. At first these pageants were derived from the mystery plays performed by the guilds, but as early as 1328 a royal entry at Paris included jousts for the entry of Philip VI;[2] other examples date from Tournai in 1355 and Paris in 1364.

Jousts as part of royal entries

The international nature of the tournament is best illustrated by the joustings of Peter I of Cyprus throughout western Europe in the years 1361 to 1365.[3] Peter was seeking support for his plans for a new crusade to be launched from Cyprus to regain the Holy Land, where the Lusignan dynasty of Cyprus would rule as kings of Jerusalem by inheritance. He arrived in the west in December 1361, and spent the next year in Venice and northern Italy; after visiting the pope at Avignon in April 1363, he set out on his recruiting drive in earnest, travelling by slow stages through France and reaching Strassburg about July 4 where a joust was held in the Rossmarkt in the presence of a large number of ladies. He continued to Mainz and Cologne, and passed through northern France on his way to England, where Edward III held a joust in his honour at Smithfield in November. Peter returned once more to France, where he stayed from December 1363 until June 1364; at the end of May, he took part in the jousts after the coronation of Charles VI. A few weeks later he was in Brussels, if we are to believe Froissart, being entertained by another tournament; other sources

Peter I of Cyprus

claim that he took part in the great tournament at Venice witnessed by Petrarch in June that year, his opponent being named as the 'son of Luchino del Verme'.[4] At all events, he set out for eastern Germany soon afterwards, and jousts were held in his honour in Saxony. He met the emperor Charles IV in Prague in August, and here he won the prize at the tournament held in his honour. In October he was in Cracow in the emperor's company, and when Charles IV took part in jousts there, a courtier remarked that no-one had ever seen an emperor joust before; to which the emperor replied that a king of Cyprus had never been seen in that part of the world before. Peter's journey continued to Vienna, where duke Rudolf arranged yet another tournament in his honour, and yet another prize fell to his lance. He then ended his journey in Venice; but his fame as a jouster was such that he was reputed to have been at the jousts for the christening of Edward the Black Prince's eldest son at Angoulême in April 1365, but this would have required a journey both from Venice to Bordeaux and back at considerable speed.[5]

The events which Peter of Cyprus attended ranged across the whole variety of occasions when jousts were deemed appropriate: the arrival of an important visitor, a coronation, the birth of a prince. Diplomacy, state affairs and dynastic celebrations alike were an excuse for chivalric display of this kind, and gradually the tournament itself became a social ritual. The etiquette surrounding the event and the dramatic framework created for it overshadowed the actual fighting. However, neither the courts of England or France, which had hitherto played such an important role in the history of the sport, figured in the development of the new type of tournament.

Royal jousts in France

Charles VI was an avid jouster in the early years of his reign. We have already described the jousts at St Denis in 1389; these were followed by jousts in March 1390 at which the prizes and gifts to the ladies cost 2054 francs. Jousts were held for the churching of the duchess of Touraine in 1391, when jousting harness was bought for the king.[6] Even after his mental illness, which began in 1392 and grew progressively worse, he remained an enthusiast. His fondness for all kinds of festivities was held to have brought on his feeble-minded condition, but his physical skills were evidently unimpaired: in 1411, clothing was given to thirty members of the king's household for jousts at Whitsun at the hotel de St-Pol; we find him taking part in jousts for the marriage of his brother-in-law, Louis of Bavaria, in 1413, and in 1415 he entered the lists when jousts were held in honour of the duke of York, sent to arrange Henry V's marriage to Charles's daughter Catherine. There were lavish jousts at Paris in 1424, lasting fifteen days, arranged by two noble families on the occasion of a double marriage, but in general the English occupation of Paris saw little ceremonial. The new mood, as we have seen, was set by Henry V's remark after his marriage to Catherine in 1420: when jousting was suggested, he replied that they ought to go out and do some real fighting. In 1431 the jousts after Henry VI's coronation at Paris were remarked on for their modest scale: the coronation and jousts were reputed to have cost no more than a citizen's family would spend on a marriage.[7] But his successor, Charles VII, was preoccupied with the recovery of the kingdom from the English, and Louis XI was temperamentally averse to displays of princely grandeur of this kind; the joust seems to have become associated in the minds of the French kings and their court with the disasters of Charles VI's reign and with the lavish life-style of their great rivals, the Burgundian dukes.

The court of Burgundy

For it was among the cadet branches of the French royal house that the tournament reached its apogee in the fifteenth century. The courts of Philip the Good and Charles the Bold in Burgundy and of René, duke of Anjou and titular king of Sicily, saw the most famous chivalric events of the period. They were not perhaps as original and

exceptional as has been made out, for we have looked at the Flemish civic festivals, the Spanish jousts at Valladolid and at the *Passo Honroso*, which rivalled and preceded them; but as a series, and as an exemplification of a particular culture, they stand alone. The model for these exploits was the famous series of jousts held at St Inglevert in 1390, but the early tournaments connected with Philip the Good, under whom the Burgundian court festivals reached their apogee, seem to have been relatively traditional. In 1423, we hear of him as judge of a tournament at Arras[8] and in 1428 he and the duke of Brabant attended a tournament at Brussels during the Shrovetide carnival. The two sides mustered a total of 'seven to eight score helmets', and the proceedings opened with a *mêlée* in the traditional style. Two days of jousting followed, with attendant feasts and dancing, and a further tournament was announced at Mons under the patronage of the lord of Croy; but this never took place.[9]

When Philip married for the third time, his wedding to Isabella of Portugal was followed by the traditional jousts, on a particularly splendid scale, perhaps partly as a response to the entertainment offered by Dom Duarte in Lisbon a year or so earlier to the embassy which was sent to negotiate the match. These are the jousts described in the prologue to the present book, which culminated in the foundation of the Order of the Golden Fleece. Interestingly, this central institution in the world of Burgundian chivalry was not closely associated with jousting, although many of its members had a high reputation in the lists: we only once hear of jousts at an assembly of the Order, at St Omer in 1441. It functioned much more as a kind of aristocratic council and focus

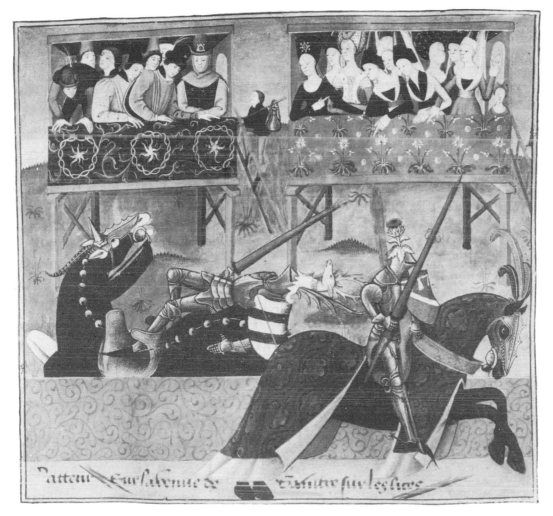

Joust from a mid-fifteenth century manuscript of the French romance Le Petit Jehan de Saintré. *The fallen knight's empty saddle reveals the high back support.*
(BL MS Cotton Nero D.IX f.40) (Radio Times Hulton Picture Library, London)

for the aspirations of Burgundian nobles, with a strong political as well as chivalric element. There was little direct involvement by Philip the Good in the spectacular chivalric feasts of Burgundy, though he undoubtedly encouraged his nobles in their enthusiasm for them and subsidised them.

The Burgundian pas d'armes

The *pas d'armes* reappears in Burgundy in 1443, at Dijon, and in the following decade there were seven such occasions, for all of which we have more or less detailed descriptions: the description of tourneying becomes a kind of minor art-form in itself, rather like the sports pages of a modern newspaper. Without the chroniclers' familiarity with the sport, however, it can become somewhat repetitive reading, as the procession of knights career down the lists with very similar results. There are perhaps a dozen variations on what can happen: a hit, a lance broken, a knight unhelmed or unhorsed, a horse out of control, a miss, a dropped lance or even a refusal by both horses to charge again. But in the mid-fifteenth century there is no question that all eyes are still on the jousters, however grandiose the surrounding pomp and pageantry, and however erudite the literary theme behind the challenges.

What was the rationale behind these events, other than pure enjoyment of the sport for both participants and spectators? Why was such emphasis laid on the surrounding ceremonies? The answers lie largely in attitudes to chivalry at this period. Through the influence of the romances, the quest for individual prowess had become the overriding theme of chivalric ambitions by the fifteenth century, and the most successful of the secular orders reflected this: it was those with an exclusive membership, such as the Garter and the Golden Fleece, which outlasted the more amorphous larger orders such as the French Order of the Star. At the outset, the Order of the Garter had successfully capitalised on the *camaraderie* of the tournament team to produce a body of knights with a strong corporate identity: a hundred years later, its

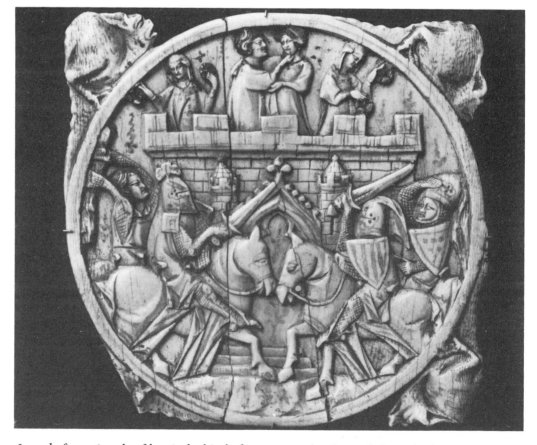

Joust before a 'castle of love', the kind of scenery used at festivals from the fourteenth century onwards. Ivory mirror-case from Paris, last quarter of the fourteenth century. (London, Victoria & Albert Museum A561–1910)

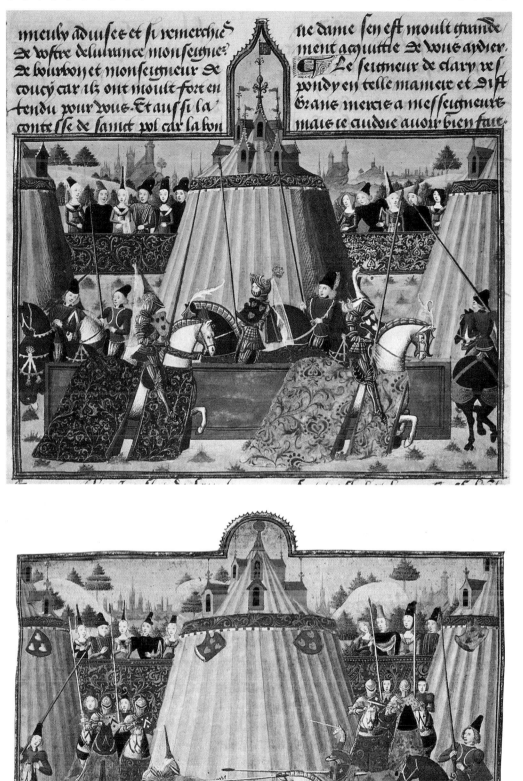

meuly aduifee et fi remerchies
de voftre deliurance monfeigneur?
de bourbon et monfeigneur de
coucy car ilz ont moult fort en
tendu pour vous. Et auffi la
conteffe de famct pol car la bon

ne dame fen eft moult grande
ment acquittie de vous aydier.
☞ Le feigneur de clary ref
pondy en telle maniere et dift
grans mercie a meffeigneurs
mais ie cuidoie auoir bien fait

Two scenes from the jousts at St Inglevert from a lavishly illustrated fifteenth century copy of Jean Froissart's Chronicles.
(British Library, MS Harley 4379, ff.19 and 20)

exclusiveness appealed to a different sense of chivalric values which placed individual achievement above all else.

Vows as a reason for holding jousts

If the skilled jouster imagined himself as a Lancelot or a Tristan, winning his lady's heart by his exploits in the lists, he also imitated the heroes of romance by the use of extravagant vows. At St Inglevert in 1390, the defenders did not actually take any vows themselves, but they offered 'to deliver from their vows' anyone who challenged them. At the *Passo Honroso*, Suero de Quiñones was seeking release from his self-imposed vow to wear an iron collar as a symbol of his love-enslavement, and this theme is closely paralleled in the 'emprise' or enterprise of the 'Prisoner's Iron' which the duke of Bourbon instituted on 1 January 1415.[10] The emblem of this order was less arduous than Suero de Quiñones' apparently realistic collar, being a chain and collar badge made of gold; and the knights professed, not individual devotion, but a generalised devotion to women. They were to wear this badge every Sunday for two years until they had found sixteen opponents who would fight them on foot, with weapons of war; the losers were to yield themselves as prisoners. Boucicaut's order of 'the white lady with the green shield' is in one respect a continuation of the jousts at St Inglevert, in that its members, in addition to a general commitment to the defence of the honour of women, were pledged to provide opponents for anyone unable to gain release from a vow to perform a specific deed of arms in the lists because of a lack of challengers.

The implication of both the proceedings at St Inglevert and Boucicaut's 'votive' order is that it is probably due in part to the far more numerous accounts of jousts in the fifteenth century that they are more in evidence from 1400 onwards. Ulrich von Liechtenstein's journey nearly two hundred years earlier is a classic example of such a vow, and it is unlikely that this chivalric ritual disappeared completely in the interval. Vows were after all a commonplace of medieval life: in the religious world, vows to go on pilgrimage or on crusade were usual, and as so often, the chivalric world mirrored that of religion in its outward forms.

Vows were not the exclusive reason for a *pas d'armes*, however. The jousts at Dijon in 1443, according to Monstrelet, were held with the permission of the duke of Burgundy 'and for his amusement'; the letters of challenge state simply that the jousts are 'for the augmentation and extension of the most noble profession and exercise of arms',[11] and Olivier de la Marche opens his account of them by saying 'As the times happened to be idle ...'[12]

Pas de l'arbre de Charlemagne, 1443

This was the first major *pas d'armes* to be held in Burgundy on record, and was to last six weeks, defended by thirteen knights and squires, an arrangement similar to that of the *Passo Honroso*. The venue was the hornbeam wood at Marsannay-la-Côte near Dijon, in which was to be found 'Charlemagne's tree'; here the challengers would find two shields displayed, black with gold tears and violet with black tears. Anyone striking the first would run eleven courses in war harness; the second entailed a duel with axes or swords. The leader of the defenders was the lord of Charny, Pierre de Bauffremont, chamberlain of Philip the Good. He arranged for the necessary lists to be built near Charlemagne's tree, and raised a stone pillar, on which were images of God, our Lady and St Anne and the thirteen shields of the defendants. A crucifix, with the figure of Bauffremont in his jousting armour as donor, was erected on the road to Dijon, as a kind of signpost. Three neighbouring castles were commandeered for the lodging of defendants and challengers.

The first challenger was a Spaniard, Pedro Vasquez de Saavedra, who had a considerable reputation, having fought in Germany and England. Bauffremont undertook the first encounter. Olivier de la Marche describes the proceedings in detail

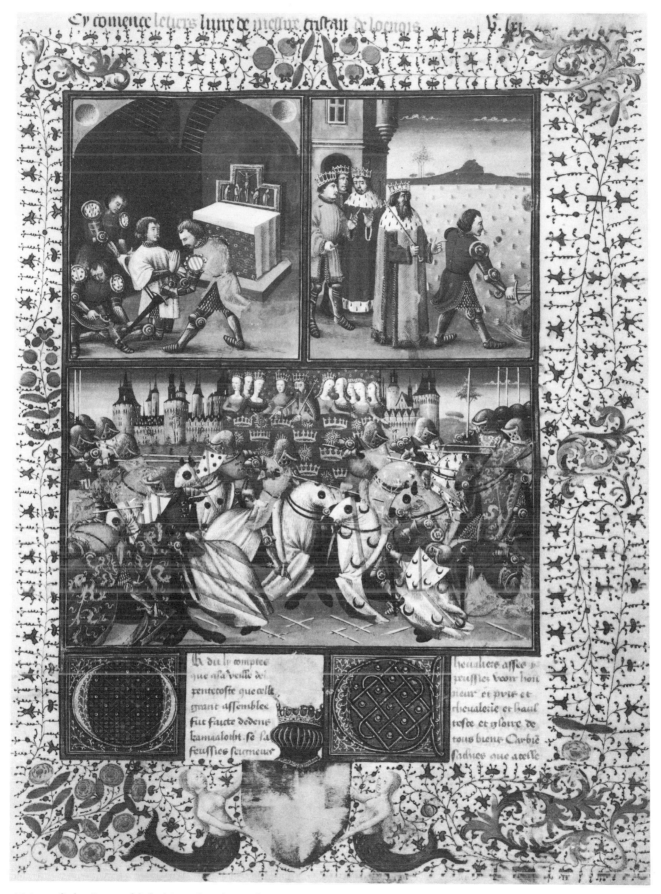

Tristan fights in an old-fashioned mêlée-style tournament: miniature from a sumptuous manuscript of the romance of Tristan by Micheau Gonnot, 1463, owned by Jacques d'Armagnac. (Bibliothèque Nationale, MS Fr 99 f.561)

because they were the first jousts he had ever seen. The duel with axes was fought with vizors raised, because the Spaniard came into the lists in this fashion, and his opponent chivalrously matched his gesture; both this and the combat on horseback passed off without injury. A succession of challengers followed, though there is an interval of almost two weeks, from 16 July to 29 July, in La Marche's account: this may be due to his absence rather than lack of action. Not all the challengers proved to be as expert as they claimed; a Piedmontese named Martin Ballart boasted that he would fight three or four of the best defenders on foot, having touched the shield for combat on horseback. When he missed in all eleven courses, his opponent reminded him of his words, and offered to take him up, but Ballart made excuses about lack of armour and left hurriedly. With this exception, the *pas d'armes* was fought courageously and with few injuries. The shields were displayed for six weeks, and at the end of the event they were taken to the church of Our Lady at Dijon and offered to her; they survived for many years in one of the chapels.

Jousts at marriage of Margaret of Anjou, Nancy 1445

Two years later, for the marriage by proxy of Margaret of Anjou to Henry VI, René of Anjou mounted a suitably grand tournament at Nancy. Of the junior branches of the royal house of France, Philip the Good as duke of Burgundy could boast a more distinguished following of knights, but René of Anjou, with much more limited resources, made as great an impression on his contemporaries in the world of jousts. René's career is a romantic tale in itself, beginning with his marriage to the heiress to the duchy of Lorraine and imprisonment in Burgundy at the age of 22 when he tried to claim her lands and was defeated by a rival. He inherited both the duchy of Anjou from his brother, and the kingdom of Naples and Sicily from his sister-in-law while he was in prison, and on his release ruled briefly as king in Naples until Alfonso of Aragon succeeded in establishing his title to the kingdom by force of arms in 1442. When the tournament at Nancy was held, he had been back in France for three years, and it was the first of a series of festivals of which his book on the organisation of tournaments was the literary and artistic summary. The 'Treatise on the form and devising of tournaments' was the first of several chivalric works, including a pastoral poem addressed to his second wife and culminating in his masterpiece, *Le Livre du Cuers d'Amours Espris* (*The Book of Heart seized by Love*) in which the allegorical adventures of Heart in search of his lady, Sweet Grace, are described.[13] It survives in one of the most magical of all medieval manuscripts, whose exquisite miniatures are sometimes attributed to René's own hand. That René had a powerful visual imagination and a taste for opulent surroundings is undisputed, and he saw the tournament as part of the rich artistic possibilities of princely life. A miniature from *Le Livre de Cuers d'Amours Espris* gives us a marvellously realistic image of how the results of literary influence on the ceremonial surrounding a fifteenth century tournament might have looked: the superb design of the knight's crests and horse-trappings, the fairylike figures of the ladies in the pageants, the wonderful tents, the columns of precious marble bearing enigmatic descriptions. It is a glimpse direct into the world of romance; and this recreation of a golden, romantic world is a powerful current in the visual element of contemporary jousts.

At the jousts at Nancy, a tent of red, white and green silk stood at one end of the lists, at the other a massive green pillar, to which were affixed the articles of the jousts.[14] René d'Anjou made his entry, followed by six horses, each with different trappings. René's own mount was in purple velvet and gold, and the others in crimson, black, blue, yellow and grey velvet, with one in white cloth of gold, each surcloth embroidered with different devices. But this magnificence was rivalled by the count of St Pol, messire de Brézé, the lord of Lorraine, and the other defenders; and even when it

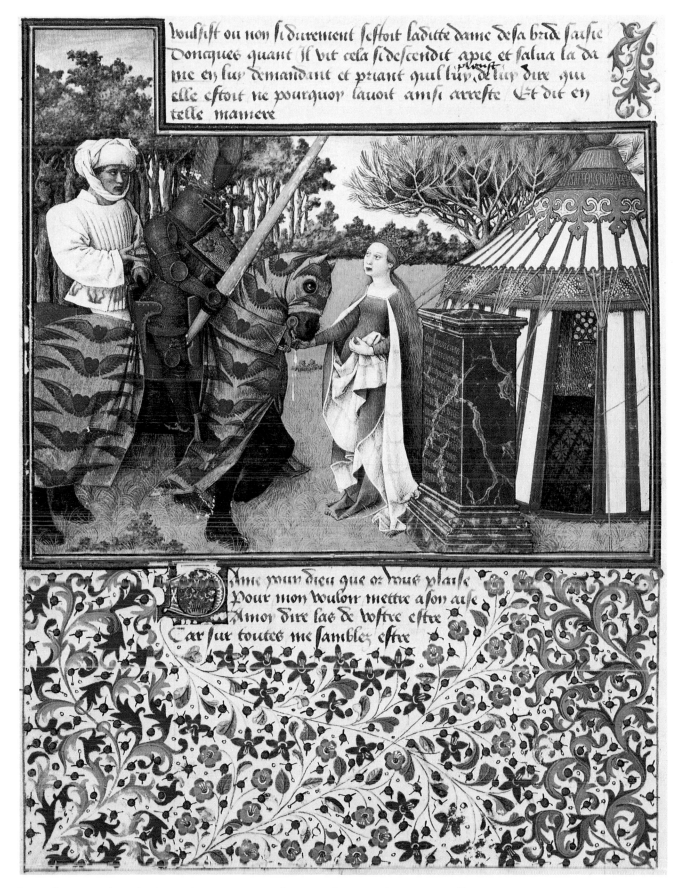

Scene from *Le Livre du Cuers d'Amours Espris* by René d'Anjou; this might well represent
a 'dramatic' episode from a contemporary *pas d'armes* such as that of the *Perron Fée*.
(Österreichisches Nationalbibliothek MS 2597, f.5v)

came to the actual jousts, the contestants appeared in equally rich attire. Charles VII himself opened the jousting, even though he had the reputation of disliking such exercises; in the three courses he ran against René de Anjou, he acquitted himself well, but his other opponent, Pierre de Brézé, one of his favourites, was blamed for jousting against the king with too solid a lance, the implication perhaps being that it was unnecessary; the king lost his shield when de Brézé struck it, but both riders broke their lances. The king was followed as challenger by the count of Foix, Gaston IV, whose biographer has left us a vivid eye-witness account of the event. Gaston IV almost unseated the count of St Pol in the first encounter, and at his third course, against the lord of Lorraine, he shattered his spear with such force that the pieces flew high in the air, to the wild cheers of the crowd. The fourth course, against Pierre de Brézé, failed, because de Brézé's horse shied away: Gaston continued down the lists, turning his Spanish steed at the end with a caracole. In all, Gaston ran twelve courses, breaking eleven 'good stout lances', unhorsing one opponent and almost unseating another. Ten further challengers followed, each of whom succeeded in breaking between six and eleven lances; but at the end of the day the challengers' prize went to Gaston of Foix, and that for the defenders to the count of St Pol.

Emprise de la gueule de dragon, Chinon 1446

René d'Anjou's next two enterprises were held in his own duchy in 1446. The first, the *Emprise de la gueule de dragon* (the enterprise of the dragon's mouth), was held near Chinon; a raging dragon was depicted on the pillar which marked the place of the jousts, with the shields of the four defenders on it. Any lady who passed was to be accompanied by a knight who would break two lances for the love of her. The king jousted with a black shield sown with gold tears and a black lance, to mark the various misfortunes which had recently befallen him.[15] The *pas de la joyeuse garde*, named

Pas de la joyeuse garde, Saumur 1446

after the famous castle of lovers in Arthurian romance to which both Tristan and Iseult and Lancelot and Guinevere retreated, was more elaborate: a wooden castle was built outside Saumur, and the jousting was opened with a procession consisting of two Turks, dressed in white leading real lions, drummers and pipers on horseback, trumpeters, and kings-at-arms and judges on horseback; they were followed by a dwarf, bearing René's yellow shield painted with 'natural thoughts' (*pensées au naturel*), and finally the king himself, led by a lady with her scarf tied through his bridle. The story goes that the event was secretly designed in honour of Jeanne de Laval, later René's second wife, but she would have been only thirteen at the time, and René does not seem to have met her until shortly before their marriage. The two lions were chained by strong silver chains to the pillar which bore the shields of the defenders. Among the judges was Antoine de la Salle, and the defenders included Ferry de Lorraine, a notable jouster who was the winner of the gold clasp decorated with diamonds and rubies which went to the best performer among those 'holding' the *pas d'armes*.

Pas d'armes de la bergiere, Tarascon 1446

René's last festival, held at Tarascon in 1449, was also the most intricate in both programme and setting.[16] The *Pas d'armes de la bergiere* (Passage of arms of the shepherdess) was a mixture of pastoral and tournament. The centrepiece of the occasion was a cottage outside which a shepherdess, played by Isabella de Lénoncourt, tended a flock of sheep, and the two knights who defended the *pas* were dressed as shepherds: these were Philibert de l'Aigue, René's chamberlain, and Philippe de Lénoncourt, father or brother of Isabella. The whole event was on a modest scale, and was designed as a private entertainment for the king and his court rather than a great public spectacle, drawing knights from far afield. It was proclaimed by just one herald, who travelled no more than sixty miles from Tarascon in search of would-be challengers, and there were only three days of actual sport. Louis de Beauvau's poem

describing the events has preserved for us a detailed picture of an occasion which must have been commonplace among princely courts in the fourteenth and fifteenth centuries, a private celebration of chivalry. Everyone, from the king's councillors to relatively inexperienced knights, took part, and no-one was too critical of their performance; the king at one point went into the lists to encourage a young knight who had been stunned by a blow from Philibert de l'Aigue, and gave him a new lance when he succeeded in breaking his own. Once again, Ferry de Lorraine was the victor.

René's treatise on tournaments seems to have been written after his own career as jouster and patron of jousters had come to an end; but there were other knights eager to continue the tradition which he had so richly encouraged. Also in 1449, Jean de Luxembourg, bastard of St Pol, held a *pas d'armes* near Calais, the letters for which were prefaced with a long tale of how he had rescued a beautiful lady, on her way to Rome as a pilgrim, from the hands of robbers. She begged him to accompany her for the rest of her journey but her rescuer pleaded that, although he would be happy to help her in due course, he could not honourably abandon his announced intention to hold a *pas* near Calais from 15 July following 'until the feast of our Lady in mid August'. Thereafter he would be free to accompany her. So the lady granted his request to undertake his enterprise before she continued her journey, and in the letters

Pas de la belle pèlerine, St Omer 1449

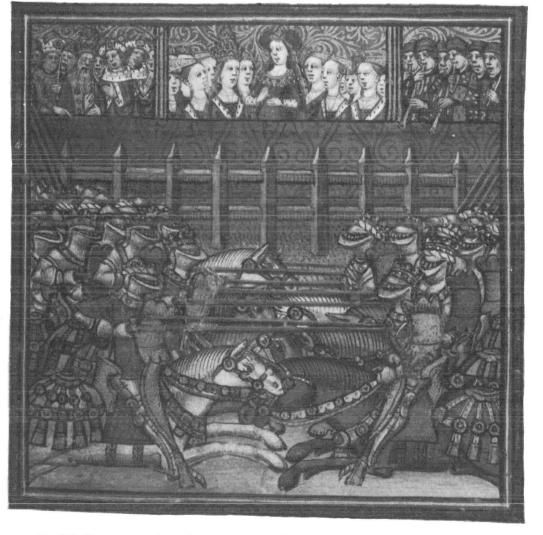

An English illustration of a mêlée, c.1450: note the stout fence surrounding the lists. (BL MS Harley 326 f.113)

announcing the *Pas de la belle pèlerine* begged knights to come forward so that her protector could accomplish his vow. His shield, white with a red band in imitation of Lancelot's arms in Arthurian romance, was duly hung on the 'cross of the pilgrim' on the date announced. The regulations were particularly detailed: lances were to be supplied by the lady, as the patron of the jousts, but knights were to provide their own iron tips; and in the combats no wrestling or handholds were allowed. The *pas* was widely proclaimed: heralds went to England, Scotland, Germany and Spain at the duke of Burgundy's expense to publicise it.

Jean de Luxembourg was an experienced jouster who had fought in tournaments for at least a decade: we first hear of him at the jousts for the betrothal of Charles the Bold and Catherine of France in 1439. However, relatively few knights took up the challenge, largely because they felt that if there was only one defendant, he might be wounded before they reached Calais, and hence be unable to complete his intended time. Those who did arrive included a knight from Swabia, aged 65, who fought skilfully with an axe, and Bernard de Béarn, who was delayed by illness and was therefore allowed to fight after the time limit had expired: his challenge ended after the first joust, when an unlucky blow removed his helmet, which injured him as it came away.

Expenses of the pas d'armes

The expenses of the occasion, as far as the neighbouring town of St Omer was concerned, were considerable: they paid 1600 écus, for the privilege of having the jousts nearby; Lille and Bruges had also tried to come to terms with Jean de Luxembourg for this privilege. The cost of building the houses and lists for the jousts amounted to £333, and the general works, such as levelling the ground and providing transport and guards, £687; without the town's support, the occasion would have been difficult to mount, but the sponsorship was evidently undertaken in the hope of a good profit from crowds of visitors, and the townspeople must have been disappointed by the poor attendance.[17]

Pas de la Fontaine de Pleurs,
Chalon sur Saône 1449

A much more successful event was the *pas d'armes* of the Fountain of Tears, in which there was once again just one defender, Jacques de Lalaing, councillor and chamberlain of Philip the Good of Burgundy, and already one of the most famous jousters of the age.[18] He vowed to set up a pavilion in a meadow near Chalon sur Saône where the 'Fountain of Tears' ran on the first day of each month for a whole year. The site was a strategic one, lying on the boundary of France and the Holy Roman Empire, but in the middle of Burgundian territory, since the duke held land from both monarchs. Outside the pavilion, a herald was to accompany a damsel with a unicorn, whose attitude of grief gave the event its name: the unicorn carried three shields, and the herald was to record the names of the challengers and the shields they had touched. The first arrival on each day was to fight within the first week of the month, and so on up to a maximum of four challengers for each new month. Weapons were to be provided, and even horses for knights who happened to be passing without suitable steeds: we have already seen from German sources how rare good jousting horses could be.

The pavilion was pitched for the first time on 1 November 1449. At the pinnacle was an image of the Virgin, and below, the lady of the fountain, with her unicorn and the three shields; a cunningly arranged jet of water made her weep copiously, her tears running down over the shields. The three shields, each strewn with tears, were of different colours to indicate the type of combat offered. Anyone striking the white shield fought with an axe; if defeated, he had to wear a golden bracelet for a year unless he could find the damsel who held the key; once released, he had to present her with the bracelet. The violet shield indicated a sword combat on foot; if one of the

combatants was forced to the ground he had to present a ruby to the most beautiful lady in the realm. The black shield indicated a wish to fight twenty-five courses with lances in war saddles; a knight who was unhorsed had to send a lance to the sovereign lord of the victor. In each case, the prize for the best performance was a golden replica of the weapon with which the challenger had fought. In all, forty-eight combats would have been possible, and Lalaing actually fought eleven opponents: but he had a long wait before the first of his challengers appeared, since no-one touched the shields in November, December or January. On 1 February, Pierre de Chandio, a squire aged 25, became the first to take up the challenge, selecting the axe as his weapon. The following month, a more formidable figure appeared, apparently by chance, the Sicilian knight Jean de Boniface; he came across the pavilion without knowing of the enterprise and claimed 25 courses with lances and 25 blows with axes: this was in excess of the rules, as only one shield could be touched. But Boniface had already fought Lalaing in single combat at Ghent in 1445, and Lalaing allowed him this exception. In the lance-combat, Lalaing split his lance from iron to guard, without breaking it and there was some argument as to whether he was entitled to another one, but Boniface also lost an irreplaceable piece of his armour, and the joust ended after eight courses. In the duel with axes, Boniface was knocked down, and had to wear the locked gold bracelet as the rules provided.

A further three months elapsed before the next challenge, and there was no action during the summer, but in October, the last month of the *pas*, no less than seven knights appeared. Anxious to bring the event to a triumphant conclusion, Lalaing waived the articles in order to allow them all their turn. One of them, the lord of St Bonnet, was brought down in a duel with axes, but refused to wear the gold bracelet, claiming that Lalaing had fallen with him, and the penalty did not apply. The next knight presented himself anonymously, in best romance tradition, but there was a reason for this; he had already watched the jousts, and no spectator was supposed to become a challenger. However, the rules were waived, and he was allowed to fight. All these challengers except one chose to fight with axes, though a squire from Saxony

The setting of the Pas de la Fontaine des Pleurs, from a contemporary account of the exploits of Jacques de Lalaing. The 'fountain' is shown as a faint blue pool, while the lady of the fountain has tears embroidered on her dress. (Bibliothèque Nationale, MS Fr 16830 f.124)

was allowed to fight with swords and to joust as well; Guillaume d'Amango was the only other jouster, and he alone did not fight with axes.

The concluding ceremonies took place on 15 October, with a great banquet and a little theatrical scene, in which the figures of the Virgin and the lady of the fountain – doubtless played by actors – addressed each other; Lalaing approached the lady of the fountain, and asked if she had further need of his services. With her gracious dismissal, and the distribution of prizes, the *pas* was at an end.

The most lavish of all Burgundian festivals, the feast of the Pheasant in February 1454 at which Philip the Good proclaimed his intention to go on crusade, naturally included jousts; but these were relatively brief, and only the appearance of Adolf of Cleves as the Knight of the Swan, the legendary founder of the Cleves dynasty, made an impression on the chroniclers. Indeed, the spectators appear to have deserted the lists before the end of the jousting to go and see the amazing and sumptuous decoration of the hall in which the feast was to be held. One spectator, after describing the tables laden with dishes and with such strange spectacles as a chapel with a choir in it, a dumb-show of Jason, monsters who served the duke at table, and an actor representing Holy Church riding on an elephant, declared that 'nothing so sublime and splendid has ever been done before'.[19]

Pas du pin aux pommes d'or, Barcelona 1455

The Burgundian court, even in its heyday, was far from having a monopoly of the *pas d'armes*; and a lavish, if brief occasion of this kind was held by Gaston IV, count of Foix, whom we have already met in the lists at Nancy in 1445. On a diplomatic visit to John II of Navarre at Barcelona in 1455, he declared a *pas d'armes*, calling himself the knight of the pine with golden fir-cones, servant of the lady of the Secret Forest.[20] Challengers were to break three lances in jousting armour, and if the defender won, his opponent was to present a jewel to the lady of the Secret Forest; if he was defeated, he would present a similar jewel to the victor's lady. The lists were erected on one of the town squares, with a pine tree with golden cones at one end. The count of Foix made his entry on a particularly fine charger, amidst the usual procession of heralds, knights and squires, as well as two Moors as footsoldiers. The event was very well attended: in two days Gaston fought 42 opponents, broke 82 lances and had 75 lances broken on him, all apparently without mishap. Admittedly the challengers were restricted to three courses, but it was one of the finest feats of arms of the period, and one which has not been given its due place in the history of jousting. It is interesting that the nobles of Aragon and Navarre were evidently ready and skilful jousters when we know so little of jousting in these countries in the fifteenth century: once again, we realise how few the records are in comparison with the historical reality.

Pas du Perron Fée, Bruges 1463

Burgundy certainly had the advantage in terms of propaganda, in that jousts were assiduously recorded there: in the statutes of the Order of the Golden Fleece, one of the duties of the king of arms of the order was to record the notable deeds of the knights, rather as in the romances, at the end of the Grail quest, King Arthur 'made great clerks to come before him, for cause they should chronicle of the high adventures of the good knights'. Just as Jacques de Lalaing's exploits near Ghent in 1453 were recorded, so his nephew Philip de Lalaing's exploits at the *pas du Perron Fée* in April 1463 at Bruges were carefully set down. The preamble is a scene straight out of the romances: a young knight is lost in strange country at nightfall, and finds a brazen horn hanging from a pillar, far from any habitation. Hoping that he might summon help, he sounds it three times, and is taken prisoner by a dwarf, servant of the lady of the magic pillar or *perron fée*. When he is brought before her, he is granted his freedom on condition that he holds a *pas d'armes* at the duke of Burgundy's court. The scenario was kept up in the lists themselves: at one end stood the *perron fée* with the usual three

shields hung on it for the different kinds of combat; but when the jousting began, four griffins drew the *perron* apart to reveal the knight, still imprisoned by the lady's dwarf, and released only in order to fight. At the end of each combat, he returned to his prison, which closed behind him. The proceedings lasted for almost three weeks, and the different types of combat were performed in turn: swordplay for four days, jousting for four days in war armour, and jousting for four days in tournament armour. It was a highly popular occasion, with 42 challengers, including Adolf of Cleves, and Jean de Luxembourg, the defender of the *Pas de la Belle Pèlerine* fourteen years earlier. The fighting passed off without incident, a good number of lances being broken, though nowhere near Gaston of Foix's average: twenty a day was the average for the defender, and slightly fewer for his opponents. The *pas* ended with the conclusion of the 'romance': a damsel in the service of the lady of the *perron fée* arrived and unlocked the knight's prison, setting him free in time for the concluding banquet and the award of prizes: Jean de Luxembourg was awarded the first prize.[21]

The proceedings at the *Pas du Perron Fée* were carefully plotted, on a modest scale: the real coming-together of Burgundian state feasts and Burgundian *pas d'armes* was to follow five years later. We have half-a-dozen eyewitness accounts of the proceedings, and it is one of the earliest occasions where we can see such reports being circulated; with the availability of printing in the following decades, full descriptions of ceremonial festivals became commonplace, complete with illustrations. The marriage of Charles the Bold to Margaret of York at Damme, near Bruges, on 3 July 1468, was a major dynastic and political event, cementing the alliance of England and Burgundy against France, and this was the reason for the exceptional scale of the display: splendour represented power, and power was the underlying theme of the day. Among the English embassy was Sir John Paston, and his letter home to his mother five days later gives the most immediate impression:

Marriage of Charles the Bold, Bruges 1468

> And the same Sunday my lord the Bastard took upon him to answer twenty-four knights and gentlemen within eight days at jousts of peace; and when that they were answered those twenty-four and himself should tourney with another twenty-five the next day after, which is on Monday next coming. And they that have jousted with him up to today have been as richly equipped (and he himself as well) as cloth of gold and silk and silver and goldsmiths' work might make them; for those of the duke's court, whether gentlemen or gentlewomen, lack nothing for such gear, and gold and pearls and jewels; unless they get it by wishing for it, I never heard of such plenty as is here … And as for the duke's court, for lords, ladies and gentlewomen, knights, squires and gentlemen, I never heard of one like it except king Arthur's court.[22]

We can fill in the omissions from other sources, including Sir John Paston's own 'great book' of treatises, which includes a copy of the challenge issued by Anthony, bastard of Burgundy.[23] It is based on a contemporary romance, the story of Florimont;[24] the knight of the Golden Tree (*Arbre d'Or*), who serves the Lady of the Secret Isle, has travelled from afar to set up his tree in the market place at Bruges, where he will defend it for eight days against four opponents each day, concluding with a tournament: the tournament is to open with one charge with the lance and continue as a *mêlée* 'for as long as the ladies wish'. A very carefully defined ritual is to be followed by all the challengers. A giant and a dwarf guard the tree: the latter is seated on a *perron* or pillar, and has a horn and an hour-glass. The knight must knock three times on the barrier with a wooden hammer, and a herald will emerge to question him. He is to ride

Pas d'armes de l'Arbre d'Or

once round the lists, and then choose one of two lances, at which the dwarf sounds his horn. When they start to joust, the hourglass is set, and the knight who breaks most lances in half an hour is to be the winner. This timed joust is without parallel in earlier tournaments, in which the number of courses is prescribed in advance.

Six days of jousting Olivier de la Marche, who was on the judges' stand for part of the proceedings, has left us the fullest account of the jousting itself.[25] On the first day, after the wedding itself, there was only time for one challenger, Adolf of Cleves, because the earlier ceremonies had taken so long. The jousting was equally weighed down with formalities, each knight being formally introduced to the ladies in addition to the rituals already described. Each day of jousting ended with a magnificent feast, with theatrical 'entremets' of suitably allegorical and heraldic significance, such as the unicorn and leopard bearing the English arms which opened the first feast, a singing lion ridden by a dwarf, and a dromedary whose rider released richly painted birds. The second day's jousting was opened by a novice, the lord of Châteauguyon, who nonetheless broke nine lances in eighteen courses; but the knight of the Golden Tree was the winner in all three of the day's encounters. The banquet that evening was on the theme of Hercules, almost in the form of a play, with a series of *tableaux*. On the third day, Jean de Luxembourg, count of St Pol, was the first jouster, but unfortunately, just as the spectators were anticipating an enthralling half hour's sport, a piece of his armour broke and he was unable to continue. The nephew of the duke of Brittany followed, and matched the defender's total of thirteen lances broken; the next knight, Anthoine de Hallewin, succeeded in defeating the knight of the Golden Tree. The evening's banquet centred round a model of Charles the Bold's new castle at Gorcum, which rose to the roof of the hall and was occupied by singers disguised as animals. The fourth day's proceedings began promisingly, with the appearance of the Enslaved Knight, servant of a Slavonian lady, who told a long story of his love in the challenge; but his armour was deemed inadequate, and he was told that he was unlikely to joust successfully. To avoid wasting time, he was allowed to go without attempting a course. Jacques de Luxembourg, the count of St Pol's brother, followed and broke seven lances to the defender's six, but the latter had his revenge by defeating a young knight named Claude de Vauldray, whom we shall meet again later. There was no feast, because it was a fast-day. The next day, the fifth of the *pas*, went off without problems: the knight of the Golden Tree defeated his brother, was beaten by another knight and drew with the third. To make up for the previous fast, the banquet in the evening was the most splendid of all with a joust between Hercules, Theseus and two Amazons as the centrepiece, continuing the earlier theme of the labours of Hercules.

On the sixth day, the challenger was Lord Scales, with whom the bastard of Burgundy had fought a duel in London in the previous year; because of this, they were sworn brothers-in-arms and the bastard delegated his role as defender to Adolf of Cleves. The joust was one of the best of the series, Cleves breaking seventeen lances against Scales' eleven: but the bastard of Burgundy, who was watching, was badly injured when a horse kicked him above the knee. The wound was so serious that he was in danger of his life, but he insisted that the *pas* must continue, at his expense, and he provided trappings for all those who deputised for him. The next challenger, Jean de Luxembourg's son, the count of Roussy, arrived in a castle with four towers, which opened to reveal him fully armed and on horseback. His character was that of a knight held prisoner by Danger and Little Hope, who had to fight at the *pas* in order to win his freedom. Charles de Visan was the defender for the rest of the day, but lost against both the count and Jean de Rochefay. Being a Friday and therefore a fast-day, there

was no feast: on the Saturday, Philippe de Poitiers took over as defendant and fought five opponents, of whom he defeated three. Again, there was no feast, and Philippe de Poitiers also defended the lists on the Sunday, the last full day of jousting. However, he was wounded by the lord of Contay, the second challenger, at the first course, and had to be disarmed. So the next challenger, the marquis of Ferrara, was appointed defender, as it would have taken too long to arm anyone else. However, his horse flatly refused to come up to the barrier, and to run the course, so he had to retire without having encountered his opponent. Contay took over as defender, but at his first joust with the English knight who was the next challenger he disarmed the latter, and the jousting came to an end. The feast that night continued the theme of the labours of Hercules, completing the portrayal of the remaining tasks.

The final day was devoted to a tournament. Despite his injury, the bastard of Burgundy arrived in a superb horse-litter, wearing a jewelled cloak and accompanied by his archers, knights and gentlemen, in such style that he 'did not seem just a bastard of the Burgundian house, but heir to one of the greatest lordships in the world'. His litter was placed on a special scaffold, separated by a palisade from the action of the tournament. The duke followed him, as leader of the challengers, and Adolf of Cleves headed the defenders. They jousted, and Cleves broke eleven lances to the duke's

Concluding tournament

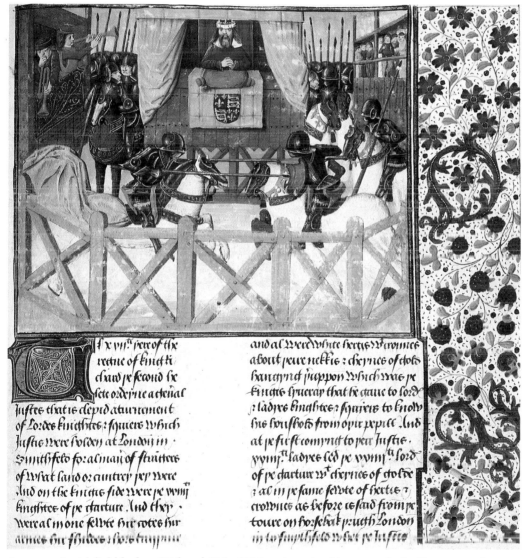

Jousts at Smithfield before Richard II in 1394, as imagined by an artist half a century later. (Lambeth Palace Library MS 6, f.233)

eight. Then the judges' stand and the barrier were quickly removed, and the two teams of twenty-five knights each ranged themselves in the square. The lance charge was followed by swordplay, which became so heated that the two teams could not be parted, and the duke had to take off his helmet, so that he could be recognised, and ride through the lists separating the duelling knights. When the tournament was finally broken off, the knights fought in small groups by their own request. The final feast repeated the theme of the Golden Tree, with thirty centrepieces of gardens, each with a golden hedge and a golden tree laden with fruit in the centre. The chief diversion was the arrival of a whale, accompanied by giants; sirens appeared from within the whale and sang, and the episode ended with a battle between twelve sea-knights and the giants. At the end of the feast, the prizes were presented. The lord of Arguel won the prize for the joust, and that for the tournament was unanimously awarded to the duke; but he refused it, and it was given to John Woodville, brother of the queen of England. The knights' enthusiasm for jousting was still not satisfied: Arguel proclaimed a further joust for the next day, but as 'it is a common thing for a crowd to joust together', La Marche gives us no account of the proceedings. On the following day, the proceedings closed with a dinner, followed by the payment of the heralds and promotion of various heralds to new offices.

The last of the major Burgundian tournaments, at Charles the Bold's meeting with the emperor Frederick at Trier in 1473, is described for us by the biographer of Wilwolt von Schaumburg. It was a much smaller occasion, and the writer calls it a 'foreign' (perhaps French?) tournament, fourteen against fourteen; it began with a volley from all the duke's guns. The fighting opened with a general *mêlée* with spears and then with swords, and this was immediately followed by fourteen single combats. The next day, the emperor and other nobles entertained themselves with informal jousts, simply as an amusement.[26]

<div style="float:left">*Pas d'armes de la dame sauvage, Ghent 1477*</div>

With the end of the Burgundian dynasty in 1477 and the French wars in Italy, the peace and prosperity needed for the great festivals vanished. Two last *pas d'armes* claim our attention, those of the *Dame Sauvage* held by Claude de Vauldray and the Arthurian jousting at Sandricourt in 1493.[27] The proceedings at Claude de Vauldray's challenge, held at Ghent in January 1470 in the presence of the duke and duchess of Burgundy, were marked by a romantic letter of introduction, describing how he had been rescued by a wild lady when he had been wounded on his first adventure, described in highly allegorical terms reminiscent of René d'Anjou's *Livre du Cuers d'Amours Espris*. The appearance of the jousters in the lists was similarly inspired by romances. The count of Roussy, the first challenger, arrived under the device of 'The Innocent', preceded by his fool, riding a donkey and designated his 'Chancellor', while he also rode in on a mule accompanied by his two smallest pages as his 'Chief Councillors'; the allusion was either satire or, more probably, a play on the idea of innocence related to characters such as Perceval in Arthurian stories, the 'pure fool' who is really a peerless knight. De Vauldray appeared with an escort of wild men and women, dressed only in long blond hair and, for the women, strangely-cut mantles. The jousts were fiercely fought; on the last of the five days of jousting, de Vauldray could not be separated from his opponent, and they exchanged more than thirty blows instead of the prescribed seventeen. De Vauldray had an impressive variety of costumes, and one wonders where he managed to finance this highly expensive display; even as chamberlain to Charles the Bold, he must have needed ducal help.

<div style="float:left">*Sandricourt, 1493*</div>

We know that Louis de Hédouville, who organised the *pas d'armes* at Sandricourt in 1493, was subsidised by the duke of Orleans to the tune of 100 gold crowns. De Hédouville was evidently one of the rising stars of the French royal court, and he

produced a scenario in which each stage of the proceedings took place in a suitable location: the 'perilous barrier' was outside the castle, with lists for the tournament at the 'dark crossroads' and the jousts at the 'field of thorns', while the closing day of the tournament took place in the 'forest without tracks'; here the ten defenders of the *pas d'armes* stationed themselves to await the challengers, 'like knights errant seeking adventures, just as the knights of the Round Table used to do in former days'.[28] And with this echo of round tables, 'forests' and other tournaments in dramatic form we take our leave of the last of the golden age of *pas d'armes*.

<div style="float:right">Challenges to combat à
outrance</div>

In complete contrast to the development of the courtly spectacle of the *pas d'armes*, and perhaps as a kind of reaction to it, we find an increasing number of combats *à outrance*. These continued to attract knights and esquires anxious for real fighting throughout the fourteenth and fifteenth centuries. Although they were essentially in the tradition of the border encounters during war, they nonetheless began to acquire a courtly veneer, and we find formal letters of challenge just as with the *pas d'armes*. Most of these are preserved as examples for future generations; some relate to individuals who sought self-glorification in feats of arms; others concern groups of knights who had formed themselves into a sort of order of knighthood whose sole object was to perform feats of arms. In both cases the readiness of the challengers to fight was often shown by the adoption of a motif, badge or device, which might also be the prize for success.

The earliest extant challenge to hastiludes *à outrance* dates from 1398, when seven French knights challenged seven English knights to a series of combats. The French had undertaken to wear a diamond for three years as a sign of their membership of the group and of their willingness to undertake feats of arms. Any knight who wished to challenge either an individual or the group could win the diamond by a successful combat in courses with lance, sword, axe and dagger. If he failed, he was to give each of the group a golden rod for their ladies.[29] The English knights who took up the challenge did so on condition that the combats were fought *à outrance* and suggested that the English king should preside over the undertaking, either in person or through his lieutenant in command of Calais.

At about the same time, another enterprise on similar lines was being considered. Five English knights had received and accepted a challenge from five French knights who wore a garter with a rod and lace attached: to win the rod they had to undertake

A joust with swords on horseback, from a fifteenth century Flemish psalter.
(Oxford, Bodleian Library, MS Douce 93, f.80v)

nine courses on foot in each of four types of combats, lance, sword, axe and dagger. For the lace, twelve courses with lances and thirty-six courses on foot with swords were demanded. For the garter itself all five knights had to fight together *à outrance* with each man aiding his own companions rather than simply fighting on his own behalf. The feats of arms were to be fought in the presence of the duke of Burgundy or the king of France.[30]

Michel d'Oris

Combats of this kind, where the ostensible object was to win a specific object worn by the challenger, were always *à outrance*, and retained their relevance to real warfare by the variety of types of combat and weaponry, and by the fact that they were fought on foot as well as on horseback, reflecting the changing expectations of knights in the field. Enguerrand de Monstrelet inserted the letters of challenge for an occasion of this kind into his chronicle, probably because they represented a good example of the genre rather than for the sake of the event itself. Michel d'Oris, an Aragonese esquire in French service, issued letters of challenge from Paris in 1400, declaring that he had undertaken to wear a piece of armour continually until delivered of it by an English knight. They were to fight a series of courses in different types of combat, which were specified in some detail. An English knight, Sir John Prendergast, took up the challenge; he explained that he did so partly to relieve the misery of the esquire and partly to fulfil a long-held wish to fight against a French opponent. Letters, almost certainly written for the protagonists by heralds, were exchanged in a rather desultory fashion, and the project came to nothing, probably because Oris had to return to Aragon.

Seneschal of Hainault and John Cornwall

Chester Herald played an important role in the challenges which passed between the seneschal of Hainault and John Cornwall in 1408–9. He acted as go-between for

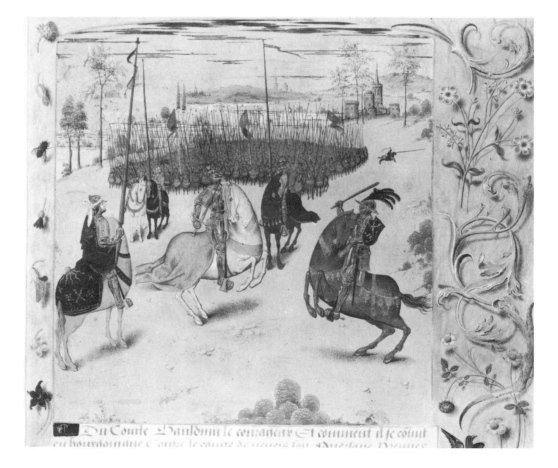

Knights fighting with mace and sword, from a fifteenth century copy of Gislebertus of Mons' Chronicles of Hainault.
(Oxford, Bodleian Library, MS Douce 205 f.16)

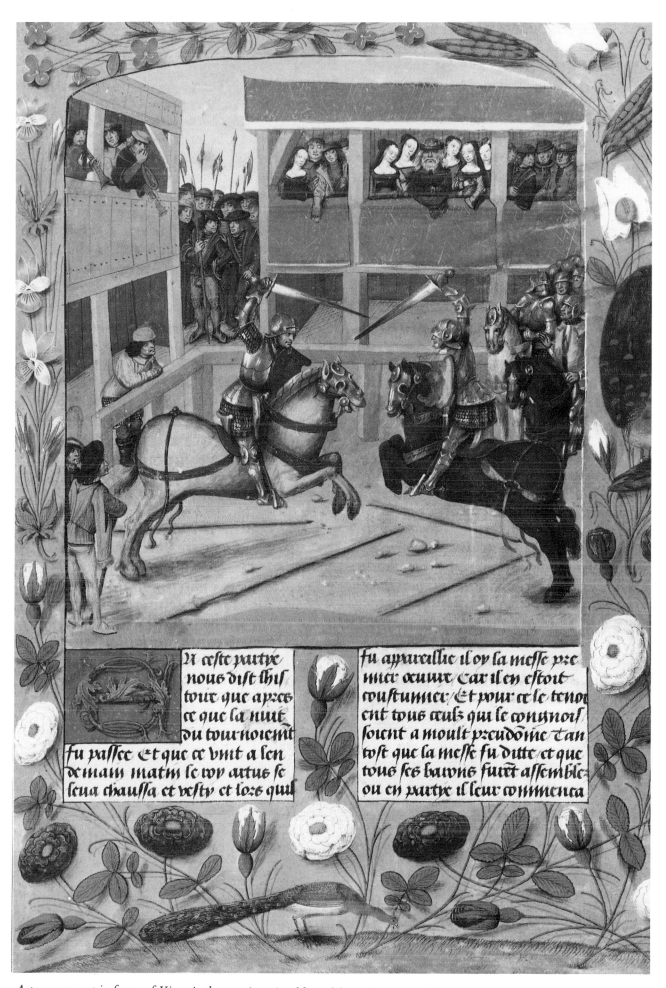

A ceste partie
nous dist this
tout que apres
ce que la nuit
du tournoiement
fu passee et que ce vint a len
demain matin se roy artus se
leua chaussa et vesty et lors quil

fu appareillie il oy la messe pre
mier œuure car il en estoit
coustumier et pour ce se tenoi
ent tous ceulx qui le congnois
soient a moult preudome tan
tost que la messe fu ditte et que
tous ses barons furent assemble
ou en partie il leur commença

A tournament in front of King Arthur, as imagined by a fifteenth century Flemish artist: the jousting is in its second stages, a duel with swords, and discarded lances are strewn around the lists. (Oxford, Bodleian Library, MS Douce 383 f.16)

the two parties and wrote John Cornwall's replies, and it was probably he who ensured that the correspondence survived. The seneschal's initial challenge was directed to Henry IV; in it, he said that he was young and wished to learn the skill of arms; in the past no knight was deemed worthy until he had jousted against a knight of the Round Table, and he would like to challenge a knight of the Order of the Garter as their modern successors. He offered twelve courses each with swords on horseback and with swords and axe on foot against three or more Garter knights at once. Henry IV replied, quite reasonably, that no knight in the past had tried to fight all the Round Table knights at once, and suggested a combat against just one Garter knight. The seneschal retorted that precedent made no difference to his present request, and that king Arthur would never have refused a challenge from a knight; but to show good-will, he would accept Henry's suggestion if the number of courses was increased to thirty-six in each category.

This correspondence was separate from the seneschal's challenge to John Cornwall, one of the most renowned English knights of his day, for a feat of arms of four against four. All the combats were to be fought on foot and *à outrance*, but lance, sword, axe and dagger could be used indiscriminately. If the English were victorious they could carry off the gold rods of the seneschal and his team. The correspondence was sent via the lieutenant of Calais, Sir Richard Aston; when John Cornwell reproached him for not passing on the seneschal's letters, he replied: 'It is my opinion that in these times you could have demonstrated your valour and more easily won the honour of a feat of arms by fortune of war than in this kind of challenge.'[31]

Delays in the correspondence meant that the seneschal eventually found himself facing the prospect of two sets of jousts *à outrance* within six weeks of each other. In the end, after much discussion, the seneschal's combat against John Cornwall was organised to take place at St Omer, before the duke of Burgundy; there is no record of the combat having actually taken place, but it seems likely that the challenges were fulfilled.

One of the hallmarks of the fifteenth century challenges of which we have records seems to have been the great distance travelled by the knights; sometimes their combats were incidental to their journeys, as in the earl of Warwick's case, but we hear more often of expeditions specifically for the purpose of fighting one such duel. At St Ouen in February 1415, we find a Portuguese knight fighting a Breton in the presence of the duke of Guienne.[32] In 1435, Philip the Good presided over a duel between Juan de Merlo, a Spanish or Portuguese knight, and Pierre de Bauffremont: Monstrelet specifically points out that the contest was fought 'without any defamatory quarrel, but solely to acquire honour'.[33] There was some difficulty over the lances to be used, as Bauffremont's were longer than those brought by Merlo; so they agreed to use pairs of lances from each set in alternate courses; this, together with the Spaniard's problem with his horse, which shied at the lances, perhaps explains why only one was broken. The next day, they fought with axes, and Merlo disconcerted his opponent by fighting with his visor raised; when the combat was halted by the duke 'the Spaniard ... twice declared aloud that he was far from being pleased that so little had been done; for that he had come at a great expense, and with much fatigue by sea and land, from a far country, to acquire honour and renown'. The duke managed to reassure him that he had indeed acquired much honour.

The danger of such combats is underlined by the challenge fought at Paris by John Astley and Piers de Massy on August 29 1438, in the presence of Charles VII; Astley ran Massy through the head with a lance, killing him. This did not deter Philip Boyle, a knight from Aragon, from challenging Astley at Smithfield in January 1442: Astley

Juan de Merlo and Pierre Bauffremont, 1435

was again the victor, but his opponent was only slightly wounded. Henry VI, who halted the fight when Astley had Boyle at his mercy and was about to strike him in the face with his dagger, knighted Astley on the spot, and granted him a hundred marks a year for life.[34]

Four years later, at Arras, Galeotto Balthazar, a Spanish squire in the service of Filippo Maria, duke of Milan, who had left Milan about Michaelmas 1445 in order to travel, see the world, and perform deeds of arms to advance his reputation, fought Philippe de Ternant, his opposite number as chamberlain at the Burgundian court.[35] The dukes of Milan and Burgundy were brothers-in-arms, and Galeotto had been specifically forbidden by his master to fight in Burgundy unless he obtained permission from the duke. If he failed to find an opponent in Burgundy, or was refused permission, he intended to go on to England to fulfil his *emprise*. Philippe de Ternant met him and, having wanted for a long time to take up a challenge of this sort, negotiated the necessary approval. On 27 or 28 April, the combat duly took place, in the great market at Arras, within double-fenced lists 'of very large and spacious size'. La Marche, who has left the best account of the occasion, was the duke's only page that day. After the usual ceremonial, the fighting began with seven lance thrusts on foot.

Galeotto Balthazar and Philippe de Ternant, Arras 1446

A herald delivers a challenge to a joust: from a herald's collection of letters of challenge compiled in the mid-fifteenth century.
(BL MS Add 21370, f.1)

The Milanese squire, 'as soon as he held his lance, started to handle it and run as if he held no more than an arrow; and he jumped in the air once or twice so lightly and quickly that you could see that his armour and equipment did not hinder him in the least'. Philippe de Ternant adopted the opposite approach, thrusting himself solidly into the ground at each step; when the two encountered each other, he drove his leg almost a foot into the sand. The run-up was carefully marked out with cords as seven paces of two and a half feet each. The lance thrusts were followed by eleven sword blows, all of which passed off without incident, except some damage to the armour, even though the blows were heavy and skilful on both sides. In the combat with axes, Ternant managed to sidestep as the Milanese squire came towards him on the first encounter, and nearly felled him with a massive blow on the neck. However, the fifty blows with axes were accomplished, and the proceedings continued the following Monday on horseback. Galeotto appeared on a horse equipped with armour studded with 'great steel spikes', and the marshal in charge of the lists ordered these to be removed, since they were not allowed in the lists. Galeotto's tactics were evidently designed to make use of this armament, as he charged at his opponent and nearly knocked him off his horse with the force of the collision. Ternant's sword-strap broke, and he was unable to reach it as it hung from his horse's neck; it finally fell from its scabbard as Galeotto rained blows on him, and the combat was stopped while it was restored to him, in accordance with the rules. The swordplay was fiercely fought, and the duke stopped it after Ternant had probed the chinks of his opponent's armour with the point of his sword; he was unable to injure him, because his armour was so good. The prescribed thirty-one blows were not accomplished, but the duke declared himself satisfied, and the Milanese squire was feasted in the traditional way before his return home: it was judged one of the finest feats of arms for many years.

Jacques de Lalaing and an English squire, Bruges 1449

In 1447, Jacques de Lalaing, who had fought a challenge against the Sicilian knight Jean Boniface at Ghent in November 1445,[36] and had tried to undertake a similar *emprise* in France which Charles VII had vetoed, set out for Spain in search of an opponent. In Navarre, his challenge was accepted, but the contest was forbidden. He reached the court of Castile, whose king, Juan II, had been an ardent jouster, as we have seen; Diego de Guzman was given permission to enter the lists, and the combat took place at Valladolid in February 1448. Diego de Guzman fought in a helmet which had belonged to Juan de Merlo, the challenger at Ghent in 1435; it was badly altered, with steel which was so soft that every blow of Lalaing's axe inflicted a wound on Guzman's forehead until he was almost blinded by the bleeding. Guzman threw down his axe, wrenched Lalaing's out of his hands, and seized him by the throat; being much the larger and stronger he would have thrown him to the ground if the king had not stopped the fight.[37]

Lalaing fought a similar combat at Bruges in 1449, against an English squire; many ladies and the duke of Burgundy were present, but although the knights and squires of the duchess's household accompanied the Englishman, La Marche notes that she herself was not present, and that he had never seen her at a joust or tournament.[38] Although the duke judged the Englishman's axe to be more powerful than that used by Lalaing, Lalaing agreed to let him use it. The Englishman fought with closed vizor, but Lalaing used a little war helmet or sallet, with his face exposed. The Englishman tried without success to take advantage of this, but Lalaing parried his blows; and the contest was equal until the Englishman caught the open end of Lalaing's gauntlet and cut his arm severely. Despite this wound, the duke allowed the fight to continue, in case he was accused of favouring Lalaing; and Lalaing succeeded in throwing his adversary to the ground, thus ending the fight according to the agreed conditions. The

Above: the empress of Germany takes the earl of Warwick's badge from one of his knights and wears it as a favour while the earl jousts in her presence in 1414. Below: the earl's herald delivers letters of challenge to the French king, Charles VI, in 1414. The shields are those displayed at his pavilion; the joust was fought under different conditions according to which shield the challenger touched. (BL MS Cotton Julius E IV art.6 ff.17v, 14)

Englishman claimed that he had only touched the earth with his knees and elbows, but was overruled by the judges.

In 1465, Edward IV's brother-in-law, Anthony Woodville, Lord Scales, issued a challenge to Anthony, Bastard of Burgundy, to which we have already referred; it attracted a great deal of attention and almost every contemporary English chronicle mentions it. Such events were rare in England, and this seems to have been part of the imitation of Burgundian courtly life by the courtiers of Edward IV: it was followed in 1478 by a tournament on the Burgundian model for the wedding of the duke of York. The challenge was said to have been imposed on Lord Scales by the ladies of the English court, who on 13 April 1465 surrounded him and tied a gold band to his thigh, containing a 'flower of remembrance' and articles for a joust. It was two years before the challenge was taken up; when the Bastard finally reached London, he did so in high style, and there were conferences over the precise terms of the combat, and the king took a close interest in the arrangements. Spiked horse armour was specifically forbidden, but despite this, the Bastard's horse was severely wounded in a collision with Lord Scales, and died either on the spot or the next day. There was immediate suspicion that Scales had used spiked armour, but he was able to clear himself, though a piece of metal, apparently from his sword, was said to have been found in the unfortunate beast. The combat on horseback had been brief, and that on foot was not much longer; when Lord Scales had the advantage after a few strokes of the axe, the king stopped the fight. The proceedings continued with other challenges by Burgundian knights against Englishmen, but it was Scales' fight which was remembered.[39]

Even as late as the 1490s, we find the Chevalier Bayard organising a combat *à outrance* in Picardy, in which forty-six knights and esquires, many of them Scots, fought in two groups. Each knight went in turn to the barrier dividing the two sides and fought three courses against one of the opposing team. It lasted two days, and was described by Bayard's biographer as a most successful 'little tournament'. Bayard himself was awarded the prizes by unanimous agreement, but redistributed them among the visitors.

Perhaps the most remarkable of all chivalric duels were those fought by the emperor Maximilian. He fought a large number of such combats, with a great variety of weapons, as the illustrations to the romances about his chivalric adventures show. A good example of such an imperial duel is the fight between him and Claude de Vauldray, the defender of the *pas d'armes de la Dame Sauvage* twenty-five years earlier, at the imperial parliament at Worms in 1495.[40] Although the fighting was not spectacular, the eagerness of Maximilian for chivalric as opposed to inherited fame is extraordinary. Claude de Vauldray was probably careful not to press his opponent too hard, but there is no suggestion that the match was anything other than a normal challenge. Maximilian succeeding in taking de Vauldray's sword from him, and at this point the fight was stopped.

The individual challenge, which had always had an element of trial by battle in it, gives way in the seventeenth century to the duel, with its heightened emphasis on honour, and hence a greater insistence on a decisive outcome: to have fought a challenge was deemed honourable enough, and there was less emphasis on victory or defeat. But if the challenge became more deadly, the tournament became more ritualised. The private tournament, already becoming rare in the fifteenth century, disappears entirely with the emergence of the new autocratic monarchies, where the royal court was the only place for such events. The tournaments at the great diplomatic meetings in 1520 between Henry VIII and Francis I, known as the Field of Cloth of Gold, belong to this pattern: the sporting side of this event was as carefully

arranged as the actual political discussions.[41] Unusually, and out of deference to a delicate diplomatic situation, the defendants were the two kings jointly with seven of their knights each. It was proclaimed in France, England and the Low Countries, but the only challengers were in fact other English and French knights. The exact details of the tiltyard survive, as there was much correspondence over the arrangements, as well as a picture of it, though the latter is largely imaginary. It does show the 'Tree of Honour', with the customary three shields for the challengers to strike accordingly to the type of joust they wanted; there was also a *perron*. The rules for the combats themselves were also very precisely laid down; even the type of armour was specified, and various 'pieces of advantage' were forbidden. Rules were also laid down for scoring, and judges appointed, to be assisted by the heralds.

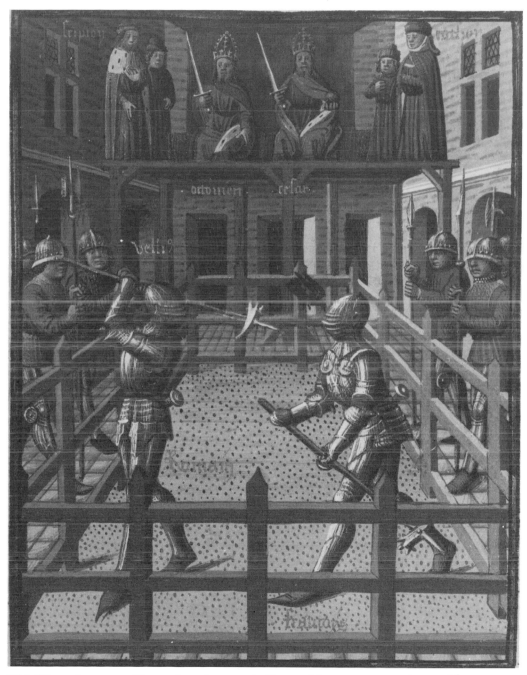

This fifteenth century illustration of a scene in Roman history portrays a joust with axes.
(BL MS Harley 4375, f.171v)

The challengers arrived in 14 'bands', averaging ten in each. The two kings fought intermittently in the tournament; Henry, as was his wont, seems to have been over-eager: on one day, 'he ran so freshly and so many courses that one of his best coursers was dead that night'. Francis appeared in a series of superb costumes whose mottoes combined over a space of three days to spell out a chivalric theme: 'heart fastened in pain endless/when she/delivereth me not of bonds', in contrast to Henry's use of patriotic motifs. In all, more than 327 spears were broken in the jousting. Despite the elaborate precautions, one of the French knights was killed: even more tragically, it was in a joust against his brother. The tournaments followed: these were not full tournaments in the traditional sense, but combats of two against two. In the course of these, the Master of the French Horse, wearing only light armour, ran a course with a heavy spear, and other feats of horsemanship were performed between combats. There was much exchanging of gifts of horses; if one of the kings admired a steed, the owner was virtually obliged to hand it over, but was usually well compensated. Henry in particular was given to displaying his skill in such matters. The tourneys were followed by combats on foot between pairs of knights, with blunted spears, swords, and (in the English fashion) two-handed swords. The two kings were naturally at the head of the list of prize-winners, though both do seem to have acquitted themselves well, heading the scoring in the jousts on some days.

Philip II at Binche, 1549

The jousts at the Field of Cloth of Gold served no political purpose other than to cement Anglo-French friendships: in this, they were only temporarily successful, for France and England were at war within two years. Chivalry – as always – took second place to politics. For an example of a Renaissance tournament with an overtly political message, we need to turn to the festival at Binche in 1549.[42] In the middle of a lavish festival given by the mother of the emperor Charles V, Mary of Hungary, a theatrical tournament was presented, in the manner of the prologues to the fifteenth century *pas d'armes* but acting out the dramatic narrative which had previously only appeared in literary form. The prelude, in the form of two successive petitions to the emperor, set out the plot, which was a carefully thought out and picturesque version of the usual romantic stories woven around a *pas d'armes*.

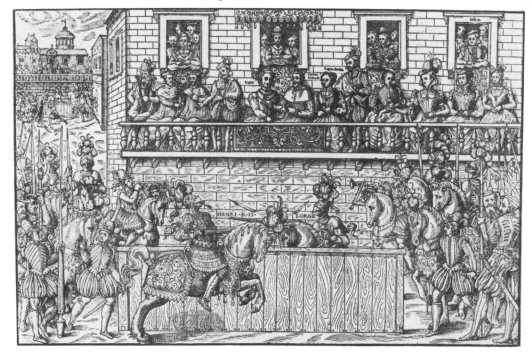

A contemporary engraving showing the fatal blow which killed Henri II of France in a tournament at Paris on 30 June 1559; the fragment of the duc de Montgomeri's lance can be seen protruding from his vizor. (Fotomas Index, London)

The evil enchanter Norabroch held various knights prisoner in the invisible Castle of Darkness; to counter his magic, the good queen Fadade had placed three great columns on the neighbouring Fortunate Isle, one of jasper and two others with a sword held fast in it, inscribed with a prophecy, which foretold that the knight who drew the sword would overcome Norabroch's magic and release the prisoners. To reach the Fortunate Isle, three knights had to be overcome in single combat, and those who were defeated by them joined Norabroch's prisoners.

The tournament was fought in the usual way, but with suitable scenery and theatrical effects; the challengers all adopted disguises, and some accompanied them with appropriate embellishments. The Knight of Death appeared with singers in black velvet chanting funerary responses, and the jousts were interrupted by sudden storms or doleful cries from the prison. One knight succeeded in defeating the three knights and drawing the sword, but found that the prophecy decreed that only a prince could succeed in the quest. At the end of the second day of jousting, a knight named Beltenebros appeared, vanquished the defending knights and drew the sword. Having identified himself as a prince, the Castle of Darkness became visible; with the magic sword, he overcame the magician's knights and broke a mysterious flask by which the spell was maintained. As soon as the prisoners were freed, he identified himself as Philip, Charles V's heir.

Because the outcome of the festival at Binche could have only one result, we must assume that in Philip's case the three combats were stage-managed. It was possible for other knights to reach the Fortunate Isle, but the prophecy was designed to eliminate them. On the other hand, Philip had to succeed in the jousts in order to get to the final stages, and under ordinary circumstances, this could not be guaranteed. Although there are many instances of kings or princes winning tournament prizes, the Binche scenario is most unusual in relying on a pre-arranged victory, particularly as Philip was a competent but not outstanding fighter, who came second in a foot challenge at Whitehall five years later.

After 1550, it became increasingly unusual for monarchs and princes to take part in serious jousts, and one unlucky accident was in itself enough to put an end to the tradition of royal participation. On 30 June 1559, Henri II of France took part in a tournament at Paris to celebrate his daughter's wedding to Philip of Spain. He jousted against Montgomery, the constable of France, and both spears were shattered; but Montgomery failed to lower his broken end quickly enough. It caught Henri on the face; a splinter went through his visor and pierced his temple, causing the wound from which he died ten days later.

Death of Henri II of France, 1550

But the danger of tournaments was nothing new, and the death of Henri II would have had little long-term effect if there had not been other factors working against the tournament. The religious wars in France and Germany and the changing techniques of warfare itself effectively put an end to the tournament pure and simple in both these countries after 1550. In England, Italy and Spain, it was the changes in warfare which led to a decline in the tournament as a sport, though it is easy to overlook the continuing role of the cavalry charge with couched lance: it was still part of the training of British regiments in the early twentieth century. The technique of lance combat was not abandoned suddenly: it merely declined in status, from a central place in late medieval strategy to a very minor role in seventeenth century warfare. And the late medieval foot combats introduced the latest techniques into the world of the tournament, particularly fighting with pikes, which the Swiss infantry perfected in the late fifteenth century.

Changes in warfare

The tournament continued in its other role, as a triumphal occasion, until the end of the sixteenth century. However, it was no more than one ingredient in a complex mixture of parade, theatre and 'magnificence', and quickly became a merely formal part of the proceedings. For instance, in the famous festival given at Bayonne in 1565 by Catherine de' Medici, the 'tournaments' do not seem to have involved much real fighting, but rather a display of horsemanship, and the drawings and tapestries recording the occasion emphasise the harmless exercise of running at the quintain, and the equestrian ballet rather than such action as did take place in the lists. Subsequent French 'tournaments' in 1572 and 1581 consisted of running at the ring (*course de bague*), and no genuine jousting seems to have taken place.[43] In Italy, the Este court at Ferrara saw a series of thematic tournaments on the lines of the festival at Binche, where the fighting was merely an episode in a dramatic scenario, with a specific title. *Il Tempio d'Amore* of 1565 was probably outlined by the great poet Torquato Tasso, and was played out in an arena with a series of elaborate entries for each new group of participants. The combats were pre-arranged – or if not, the outcome was ignored – and were purely symbolic; they neither furthered the plot nor had any intrinsic interest for the spectators.[44]

Accession Day tilts in England

The Italian and French tournaments become by the early seventeenth century 'carrousels', not unlike the games on horseback which we saw presented before Charles the Bald eight hundred years earlier. These equestrian ballets lie outside our scope, and it is only in England that a semblance of the old tradition flourished, in the Accession Day tilts held under Elizabeth I. There were jousts to celebrate Elizabeth's coronation in January 1559, and three further jousts around London that same year, so it looks as though such activities were actively encouraged by the queen from the beginning of her reign. The first accession day festival was ten or eleven years later, but the celebrations were sporadic until 1580; from then until the end of her reign we have records of an Accession Day joust in every year except 1582 and 1592: the series continued throughout James I's reign. Under Elizabeth, the tilts were part of the ritual surrounding the cult of the Virgin Queen, and the dramatic element was provided by the individual knights. Perhaps the best example of this is the triumph devised for the ambassadors of the duke of Alençon in 1581, when the French prince was seeking Elizabeth's hand in marriage. As at Binche, the allegorical setting was appropriate to the occasion, and all the proceedings, including the fighting, were scripted to achieve a single outcome. Sir Philip Sidney and three other knights, calling themselves the 'four foster children of desire', attacked a fortress of 'perfect beauty', which was defended by twenty-two knights, including a pair as Adam and Eve (both wearing armour decorated with apples and fruit) and an Unknown Knight. Each of the four challengers jousted six courses against the defenders of the fortress, then fought with swords and finally at the barriers. The four then made a speech to the queen declaring their submission, and she in turn presented them with an olive branch

Ivory border from a fifteenth century French chessboard, showing jousting knights attended by squires. (Florence, Museo del Bargello) (Photo Scala)

'in token of her triumphant peace and of their peaceable servitude'.[45] The tradition of *'imprese'* or complicated mottoes grew to such an extent that printed sheets were produced to explain the appearance of the knights and the meaning of their inscriptions; Sir Henry Wotton, in James I's reign, commented that 'some were so dark that their meaning is not yet understood, unless perchance that were their meaning, not to be understood'. The main theme, under Elizabeth, was a romantic cult in her honour, with much reference to the overpowering effect of the queen's grace and beauty on the hearts of her loyal knights. In James's reign, the themes were less focussed, and there were mutterings of dissent: Francis Bacon, at the end of the reign, saw such occasions as mere vanity:

> For jousts and tourneys and barriers, the glories of them are chiefly in the chariots, wherein the challengers make their entry, especially if they be drawn with strange beasts, as lions, bears, camels and the like; or in the devices of their entrance; or in the bravery of their liveries; or in the goodly furniture of their horses, and armour. But enough of these toys.[46]

Bacon might disdain the tournament, but they were highly popular with spectators, and with many of the participants. Sir Henry Lee, Elizabeth's Master of the Armoury, was the driving force behind the tilts of her reign, and the personal enthusiasm of Prince Henry, James I's eldest son, gave an added impetus to what had become a rather formal occasion, to the extent that he aroused his father's suspicions – no very difficult task in James I's case, but an interesting comment on the potential of the tournaments as a political weapon. A contemporary writer noted that Henry 'put forth himself in a more *Heroick* manner than was usual with *Princes* of his Time, by Tiltings, Barriers and other exercises on horseback ... which caught the peoples *eyes* ...'.[47] Henry died at the age of eighteen in 1612, and although princes continued to appear in dramatic tournaments, the 'heroic' manner had vanished. The shadows of warfare gave way to the illusions of theatre, and the tournament as a contest of skill between fighting men expert in arms was no more.

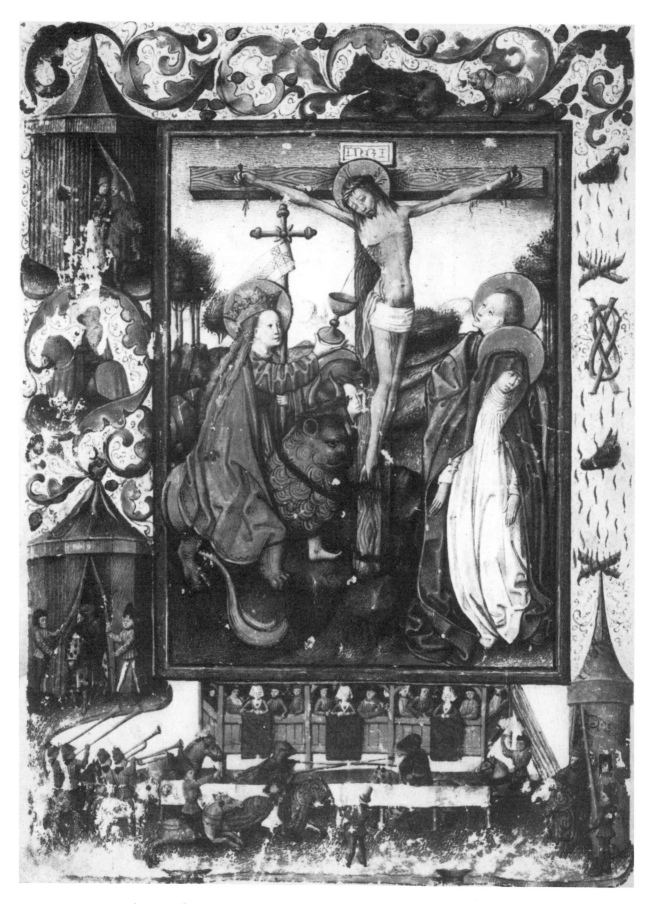

The Crucifixion provides an unusual context for a tournament miniature; the border shows knights emerging from their pavilions to enter the lists. The religious reference may be to the idea of Christ jousting with the devil. (Oxford, Bodleian Library, MS Douce 93 f.100v)

6
The Dangers of Tournaments:
Spiritual Condemnation and Public Disorder

From the very earliest days, tournaments were condemned by the church and banned by secular rulers. Throughout their heyday in the twelfth and thirteenth centuries, they were forbidden in ecclesiastical law, and knights who took part in them were liable to the severest spiritual penalties. Their enormous popularity did nothing to weaken the church's opposition, and rulers who were able to do so tried to regulate them by secular law. So for many years a knight who entered the lists might well have done so in defiance of both God and king.

The church declared its opposition to tournaments at a very early stage. The ninth decretal of the Council of the church held at Clermont in 1130 laid an interdict on all tournaments and forbade ecclesiastical burial to anyone fatally wounded in the sport, though the sacraments of penance and the *viaticum* were not to be denied to any victim who sought them. The reason given for the prohibition was simple: tournaments imperilled men's lives and put their souls at risk.[1] The sport was a dangerous one, and the sin of homicide was easily committed, even if unintentionally; and as it was also a showcase for knightly prowess, those taking part could fall into the sin of pride. The reasoning was sound, and the church's response was perfectly appropriate; but the recognition of the dangers of tourneying and the prohibition came too late. The sport was too well-established, and the church's authority in such matters too weak, for the ban to be an effective deterrent.

Immediate opposition of church to first tournaments

Despite this, the official attitude of the church remained unchanged for nearly two hundred years. At first, the decree of the Council of Clermont was simply repeated at successive councils. It reappeared for the last time (with the actual word *torneamenta* added) at the Third Lateran Council in 1179[2] at a time when the tournament was enjoying widespread support in northern France, just before the celebrated period when patrons such as Philip count of Flanders, Henry the 'young king' of England and Henry count of Champagne were promoting it as part of a new flowering of the chivalric ethos. The romances of Chrétien de Troyes, which belong to the same time and place, confirmed the tournament as central to knightly life; not only was such an event the highpoint of each romance, but it was also the arena where all the values of chivalry were on public show. It was here that knights proved their noble blood and their prowess through their skill, here that they attracted the attention and ultimately the love of their ladies, here that they displayed the knightly virtues of courage, courtliness and *largesse*.

Against the growth of such a strong sense of knightly identity, which made the tournament its apogee, the church fought a losing battle. Perhaps for this reason, no further blanket bans on hastiludes were issued after 1179 by either church councils or

popes. This did not mean that there was a change of heart – far from it; but future bans were limited to specific objectives and implied (if they did not actually state) that they were for a limited length of time.

To combat the powerful emotive hold of tourneying over the knightly imagination, the church held forth its own most attractive and inspiring ideology, that of the crusade. Instead of fighting for earthly glory, knights could win heavenly glory, eternal peace and yet still gain the recognition of their peers for their prowess in the field. Instead of fighting to no real purpose, knights could employ their military skills in an irreproachable cause. There was some merit in this argument; chivalric mythology supported the idea that to go on crusade was to achieve the perfection of knighthood. The problem lay in the fact that, realistically, most knights expected to go on crusade only once in their lifetime and therefore did not recognize any incompatibility between spending time at tournaments and going on crusade. The two were not mutually exclusive, despite the church's attempts to depict them as such.

Saint Bernard Saint Bernard of Clairvaux, the great Cistercian monk who was himself of noble family and therefore recognised the attractions of the secular knightly life, seems to have been one of the first to link crusades and tournaments to the detriment of the latter. As early as 1149 he condemned Henry, son of the Count of Champagne and Robert, brother of the king of France, for arranging a tournament *à outrance* against each other after Easter, despite the fact that they had only just returned from the Holy Land.[3] Celestine III took this one stage further by writing in 1193 to the English bishops to prohibit tournaments and to encourage knights to go on crusade to the Holy Land where they could exercise themselves in arms with greater benefit to the health of both soul and body.[4] In 1245 the penalties were applied more stringently; the Council of Lyons prohibited tournaments for three years on pain of excommunication.[5] This would have greater bearing on the everyday life of potential tourneyers, as excommunication would cut them off from all the offices of the church with immediate and public effect – a more realistic penalty than refusal of church burial in the relatively unlikely event of death in a tournament. However, the imposition of a three year ban does seem to imply that the church had, by this period, withdrawn its general prohibition.[6]

Papal ban of 1312 The last formal papal ban was imposed as late as 1312 with extremely stringent penalties which clearly meant that the prohibition was intended to be observed. Clement V called on all the princes of Europe to free the Holy Land from pagan hands and then prohibited not only tournaments but also jousts and even round tables. Anyone taking part in any form of the sport was to be excommunicated and the pope reserved to himself the right of absolving excommunicants, except at the point of death. This was not all, however, for all those who aided and abetted tourneyers by watching, supplying or sponsoring them were to incur the same penalties. The pope declared that no-one in their right mind could doubt that hastiludes were a great hindrance to preparations for another crusade, since they endangered souls and caused the deaths of men, the wasting of money and the destruction of much-needed horses.[7]

There were, however, a great many who did doubt the pope's conclusions and the bull caused a tremendous furore, not least because it was so long since an attempt had been made to prohibit tournaments because of the crusade, and never before on such an all-embracing scale. By this time, too, the joust was almost a part of daily life all over Europe, the pastime of kings as well as knights of more humble origins. The bull aroused great passions, particularly in France, and a campaign was launched to get it overturned. One of the most powerful advocates against the ban on tournaments was

Pierre du Bois, who was supported by Philip the Fair. He argued that papal prohibitions had been ignored in the past and would continue to be so; that such contempt for ecclesiastical authority would only be increased by continuing prohibition; and that, as a result of tourneying against the church's prohibition, knights were being excommunicated, and thus effectively prevented from becoming crusaders. Far from preserving knights for the grand purpose of rescuing the Holy Land, the ban on tournaments was having an opposite effect by rendering them unfit for the prosecution of holy war since excommunicants could not take the cross. Even if they did go on crusade, the presence of excommunicants in the Christian armies would attract God's wrath and cause the venture to fail. It was, du Bois argued, better to ignore the minor sin of tourneying so as to avoid the major catastrophe of failure against the pagans. Du Bois even offered a radical alternative to the pope: would it not be a powerful incentive to knights to take the cross if the church turned legitimate tourneying into a privilege offered only to crusaders?[8] This argument was an extreme one but it reflected a strong groundswell of opinion in the church and in secular society. It could no longer be argued seriously that tourneying was an enormous risk to the lives of men and horses; the development of different forms of the sport and the improvements in armour and regulations, which had arisen from spontaneous developments within the sport rather than from outside regulation, had all tended to make tourneying a much less risky affair. Nor was there any pragmatic hope that the money which knights spent on such events could ever be successfully diverted to the cause of the crusade.

When John XXII came to the papal throne at Avignon in 1316 one of his priorities was the removal of the church ban on tournaments. Within eleven days of his accession he issued a bull, *Quia in futurorum*, which finally admitted the church's defeat in the face of the overwhelming popularity of hastiludes. Having rehearsed the arguments used by his predecessors for prohibiting them, he declared that he now understood that the crusade was actually being impeded by the prohibition because some potential crusaders were refusing to take up the status of knighthood unless they could hold hastiludes.[9] This rather specious argument was undoubtedly a cover for the real reason, which was that the sons of Philip the Fair of France had put political pressure on him. Whatever the reasons, it was no longer practical for the church to hold out against a sport so universally practised, and John XXII was simply bowing to the inevitable when he withdrew the sanctions against those who tourneyed and those who were in any way involved in them. There was no point in antagonising those on whose political support he depended over a point of principle which had, in any case, been undermined by changes in circumstances.

Removal of ban by John XXII

The official attitude of the church at the highest level was therefore clear enough during the period up to 1316. For the churchmen working in the community, however, official attitudes were one thing and dealing with a recalcitrant and powerful secular nobility quite another. Not only were the latter group nearer at hand than a remote Italian pope or a long-disbanded church council, but they were more often than not members of the same families as the bishops and abbots charged with carrying out the church's decree; perhaps even more important, the local church was reliant upon the goodwill of the neighbouring aristocracy for financial and political support. Local churchmen had to tread a fine line so as not to find themselves at odds with the secular nobility.

At times the threat of excommunication of tourneyers would be used to assist a particular secular prince. In 1215, for example, Prince Louis and his invading Frenchmen were menaced in this way because the tournaments they were holding in England were aggravating the chaos of the Magna Carta crisis.[10] Likewise, the Papal Legate was

Excommunication of tourneyers

given powers to excommunicate tourneyers and place their lands under interdict in the troubled early years of Henry III's personal rule because tournaments were being used as meeting places for baronial conspirators.[11] In both these instances, there was a specific and practical political reason for the prohibition and therefore there was no problem in administering it.

Burial of knights killed in the lists

Problems arose most often when a knight was killed in hastiludes. The official church line was that he should be refused ecclesiastical burial, but this was difficult to enforce. Occasionally, a hard line attitude would be taken. In 1175, Archbishop Wichmann of Magdeburg, for instance, refused to give Church burial to the son of Conrad marquis of Lusatia even though he had been penitent, received the sacrament, taken the cross, made confession and been absolved by a priest present when he died (the priest clearly being less indomitable than his archbishop). Eventually, making at least some political capital out of the incident, the archbishop gave way, but only on condition that the dead man's relations all swore on holy relics never to tourney again or allow others to tourney in their lands. Even then, the archbishop refused to allow the burial to go ahead until he had received approval from Rome, and the unfortunate tourneyer was, in the end, buried in the proper way some two months after his fatal accident.[12] This is clearly an out-of-the-ordinary case, however, and the archbishop was probably driven to this course by a series of deaths in local tournaments, as noted by the chronicler who tells the story. The attitude of most clerics seems to have been much more amenable. In 1163 the archbishops of Rheims and Canterbury together petitioned the pope to allow the church burial of a knight killed in a tournament; although the pope refused, on the grounds that he could not make an exception because it would encourage the growth of the pernicious sport,[13] the conciliatory attitude of his archbishops seems more in keeping with that of most churchmen. In fact, the evidence would tend to suggest that most tournament victims were quietly buried in the local church or abbey without any great attention being paid to the circumstances of their death. Geoffrey of Brittany, son of Henry II of England, was buried with due honour in the cathedral at Paris when he was killed in a tournament in 1186, only seven years after the last conciliar prohibition.[14] In England, Geoffrey de Mandeville, fatally wounded in 1216, was buried in the Priory Church in London; Gilbert Marshal, killed in 1241, was buried honourably in the New Temple in London with his forefathers; and both Hugh Mortimer, killed in 1227, and John Mortimer, killed in 1318, were buried with their ancestors in Wigmore Abbey.[15] When men of such standing were killed indulging in their favourite sport it would take a brave (and altruistic) churchman to turn away the body. In one instance, the body of John de Vaus killed in a tournament at Thirsk in 1267 was actually sent to the priory at Durham with letters from the Lord Edward recommending the monks to receive it with due honour. The monks, quite naturally, did as they were told and even went to the trouble of recording his name in their book of martyrs so that masses would be said for his soul.[16]

It was not only long term patronage that churchmen risked losing if they adhered strictly to the rule forbidding ecclesiastical burial, but also short term gifts: friars and monks were usually recipients of the prolific *largesse* which flowed at hastiludes, partly, no doubt, to salve the tourneyers' consciences but partly because they were the customary objects of donations. It is quite clear that priests attended hastiludes and performed services for those attending them. It became standard practice for jousters and tourneyers to attend mass before going to the lists and accounts of tournaments such as the *Tournoi de Chauvency* emphasise the important role that religious services had to play during the several days of festivities – and this in a period when

hastiludes were under strict interdict.[17] Indeed, since 1227 priests had actually been forbidden to attend tournaments, though it is clear that they did; at about the same time as this decree, the bishop of Winchester was accused of allowing his household knights to attend tournaments.[18] Though he denied the charge, it was almost inevitable that household knights of bishops, just like those of secular nobles, would spend their free time in martial sport.

Once *Quia in futurorum* had removed any lingering doubts about the propriety of churchmen being involved in hastiludes we find numerous examples of close co-operation. As early as 1252 the monks of Walden Abbey had played host to a round table, but in the fourteenth century the bishop of London's palace in London became a frequent venue for lodging and feasting tourneyers.[19] By the mid-fifteenth century it was possible for René of Anjou to state in his *Traicté de la Forme et Devis d'Ung Tournoi* that it was always best to lodge in a place of religion when arranging jousts, because the cloisters were the most convenient place to display the participants' arms prior to the combats.[20] And in the early sixteenth century we find prayers specifically written for different moments in a joust, such as the moment when a knight leaves his pavilion to enter the lists.[21]

Religious houses as hosts to tournaments

It would be wrong to create the impression that the higher echelons of the church prohibited hastiludes and the lower ranks simply ignored or found ways round this prohibition. The case was not so clear-cut and there was a very public debate about the rights and wrongs of the question. The preachers of the thirteenth century, in particular, were vehement supporters of the anti-tournament lobby and they put forward their case with a powerful mixture of reasoned argument and threats of hell fire and damnation. Jacques de Vitry, bishop of Acre, writing before 1240, was one of the first to point out that tourneyers committed all the seven deadly sins: pride, because of their desire for praise; envy, because they resented greater praise for other tourneyers; anger, because they struck out when tempers became frayed in the sport; avarice, because they desired other knights' horses and equipment and even sometimes refused to ransom each other; gluttony, because of the attendant feasting; sloth, because of the reaction to defeat in combat; and lust, because of the desire to please wanton women by wearing their favours in the lists.[22] The theme of the seven deadly sins would be invoked time after time by preachers and poets, perhaps most memorably by Robert de Brunne in his *Handlyng Synne*,[23] but other side-effects of tourneying were also considered. Thomas of Chartres complained in one sermon that tournaments were a great cause of debt and that they encouraged violence; he quoted the example of peasants coming to watch the sport armed with great sticks only to find themselves disarmed and beaten up by the tourneyers.[24]

Opposition of preachers

One of the most damning indictments of tourneying came from the pen of the Dominican, John Bromyard, who saw the darker side of the sport. Tournaments were governed by no law (except the law of destruction) and were lawless. The young lord was drawn into tourneying and other chivalric sports which quickly emptied his pockets so that, on the advice of his counsellors, he turned to his lands and imposed heavy dues and exactions on his tenants. The poor were also his victims on the way to and from tournaments, because the lord purchased food and equipment from them, but only paid with tally sticks which he failed to honour and which proved worthless. All this expense, which ruined his lands and his already impoverished tenants, was purely for vainglory.[25] It is worth quoting in full one of Bromyard's more bitter passages, which is clearly an accurate reflection of the harsh realities of such occasions. When nobles went to tournaments it was, according to Bromyard, only to acquire topics for future conversation:

John Bromyard

Who has been heard to praise, or could praise any of them for strenuous battling with the enemy, or for their defence of country and church, as Charlemagne, Roland, Oliver and the other knights of antiquity are commended and praised? But rather for this – that they have a helmet of gold worth forty pounds, aillettes and other external insignia of the same style and even greater price; that so-and-so carried into the lists a huge square lance such as no-one else carried, or could carry, or that he flung horse and rider to the ground; and that he rode so well and wielded that lance of his so nimbly, as if it were of the lightest: or again, that so-and-so came to Parliament or to the tournament with so many horse.

This brilliant vignette of knightly conversation is followed by a diatribe against the tourneyers:

And what, after all, is praise of that kind but praise of the impious, of wretches and of the timid? . . . For they expose themselves in places and times of peace and not of war; and to their friends, not to their enemies. Of what value are arms adorned with gold, then, that only make the enemy bolder . . . which too, when in flight from their foes, they fling away, so that they may flee the faster – as happened of late? What praise is it to bear a most mighty lance against a man of peace, and to fling horse and rider to the ground, and not touch the enemy with any lance whatever, because one does not want to approach him near enough to let him touch one with the largest kind of weapon? Or what praise is it that such a man rode so well and wielded his lance with such ease, that he conducted himself so nimbly against his friend and neighbour and fled so nimbly from the enemy of the realm? What praise is it that such are glorious and seek praise in prohibited deeds of arms, as in tournaments and the like, while in deeds of virtue, such as in just wars and in defence of their own country, they are timorous, cowardly and fugitive, allowing the enemy to devastate the land, to plunder and to pillage, to burn the towns, destroy the castles and carry off captives?[26]

Horror stories about
tourneyers

Though written in the fourteenth century, Bromyard's work was a compilation of thirteenth century sources, which would have served as the raw material for sermons; his criticisms would therefore have reached a large audience. When arguments such as these failed, the preachers fell back on horror stories to frighten the miscreant knights out of their bad habits. Bromyard himself cites the fate of tourneyers who suffer in hell parodies of their lifestyle on earth; they are forced to wear armour which is nailed to them and cannot be taken off, they are given evil smelling sulphurous baths and then afterwards, instead of the warm embraces of wanton young women they are obliged to endure the amorous attentions of lascivious toads.[27] As if this was not enough to scare the living daylights out of any knight foolish enough to wish to tourney, other sources relate terrible ghost stories. The earliest of these is a simple story about an unknown knight who is killed at the moment of victory in a fiercely fought tournament, recorded by Walter Map in the 1190s; but the fact that those killed in hastiludes were not supposed to receive ecclesiastical burial lent itself to stories about souls unable to find eternal rest. Thomas of Chantimpré, for example, had a ghoulish collection of stories including demons in the shape of crows flying over a tournament field to presage the terrible number of fatalities that were to occur, visions by a tourneyer's widow of the sufferings her husband was undergoing in hell and a ghostly tourneyer who took his servant to find his forgotten corpse.[28] Such stories were commonplace and found their way into chronicles, annals and even poetry of the day

as well as the more obvious books of moral examples. The thirteenth century French troubadour, Rutebeuf, for instance, was following the official papal line in one of his poems when he demanded of the tourneyer how he would answer on the day of judgement when God asked him for which land he had died.[29]

Miracle stories favourable to tournaments

On the whole, however, troubadours and minstrels followed the line adopted by their secular masters and wrote in praise of tournaments and the chivalric ethos. In answer to clerical animadversions on hastiludes they produced a sort of inverted world in which tournaments and expressions of faith were inextricably mixed. Thus, for instance, a popular miracle story (the first version of which appears in the late twelfth century) described how a knight who always heard masses before going to a tournament arrived at the lists one day to find that an angel (other versions have the Virgin Mary herself) had tourneyed in his stead and captured as many earls in his name as the knight had heard masses that day.[30] Perhaps the commonest linking was in the terminology of hastiludes which was transferred to religious affairs in a way that almost seems blasphemous. The troubadours described the crusade as a tournament between heaven and hell to which all knights were summoned and, conversely, some crusade recruiting songs suggested that knights should go on crusade in their lady's service so as to win their lady's love.[31] Even Christ himself is described as a tourneyer; in *Piers Plowman* He jousts in Jerusalem, wearing Piers' arms, against the devil, false law and death. The allegory is carried further, and the blind knight Longinus jousts against Christ and wounds him, then falls to his knees and begs for mercy.[32] Clearly, this sort of parable was intended to bring the New Testament to vivid life for contemporary knights, and the popularity of the theme is reflected in the numbers of surviving poems which pursue allegories of this kind.[33]

Positive side of the sport

On the whole, therefore, the Church decided by the fourteenth century that there was little harm to be found in allowing knights to enjoy their tournaments provided the fighting took place in the right spirit. Humbert of Romans perhaps summarised this practical attitude best when he criticised tournaments as being the means by which weak-minded young nobles were ruined; they spent vast sums on them in the pursuit of vain honour. It was the complete negation of all the values which mattered. If, however, knights took part in tournaments with the object of exercising themselves in arms so that they were better soldiers when they offered themselves in the service of the crusade, this was highly commendable. Tournaments were dangerous in that they could so easily arouse the wrong passions, but they could, if used properly and approached in the right spirit, be tolerated as a means of promoting the crusade.[34]

The argument had therefore come full circle, and the crusade, which had once been the principal justification for papal prohibitions on hastiludes, was being used by moderates as a vindication of them. There was no real reason why the two should be incompatible. Tournaments proved to be one of the best places for preaching the crusade and for attracting large numbers of knights to take the cross. In 1199 Thibault count of Champagne and Louis count of Blois led a huge number of knights who took the cross at a tournament at Écry; many Flemish knights took the cross at a round table at Hesdin in 1235, following the example of the duke of Burgundy. Even as late as 1390, the jousts at St Inglevert were a surprisingly fertile recruiting ground for the duke of Bourbon's North African crusade later that summer.[35] There was powerful logic to support the idea that tournaments promoted the crusade: it was comparatively easy to preach the cause of the cross at a gathering of chivalry of this kind, and, more important, there was a great deal of moral pressure to take the cross. Once one major leader had been won over, his companions were eager to prove themselves his

equal in valour. And even if men were not recruited at tournaments, money could often be raised there; as early as 1180, William Marshal gave his winnings at a tournament at Joigny to those who had taken the cross.[36]

By the time that papal objections to tournaments were finally and publicly withdrawn, it was an essential part of the cult of Christian knighthood that the knightly aspirant should make his way through the three *mestiers d'armes*: these were, firstly, jousts and the lesser forms of hastilude; secondly, tournaments; and thirdly, war. Above and beyond all these, however, as the absolute pinnacle of any knight's secular career, was the crusade. The tournament and its mythology had proved more powerful than the opposition of the church, and had become part of the doctrine which had once outlawed it.

Tournaments a threat to public order

If tournaments were seen by the church as a threat to men's salvation, secular authorities saw them as a threat to public order. A gathering of armed men was a potential threat to public order, and this was certainly one of the main reasons why the kings of England and France attempted to exercise such strict control over them in the twelfth and thirteenth century, as we have seen in chapter two. Similar bans were enforced in other European countries by kings whose authority was effective. The Aragonese laws of 1235 enshrined the ban in the statutes of the realm. The French kings replaced intermittent proclamations with a longer interdict in 1260, when St Louis banned the sport; his edict was renewed in 1280 by Philip III. In 1230, the emperor Frederick II, addressing a charter of privileges to Lübeck, included an absolute ban on tournaments because of the crime and disturbances they brought in their wake; and in 1362 the town council at Nuremberg barred all its citizens from taking part in them for similar reasons.[37] Boncompagni of Florence, in his letterbook in the 1220s, quotes as an example an imperial statute imposing a general prohibition on tournaments – 'we sanction this general edict, that no knight shall presume to wage war in tournaments of his own free will' – but there is no record of its having been issued.

On one occasion, a tournament was held as symbol of a claim to sovereignty. This was at Montpellier in 1341, which Jaime III of Majorca claimed as his. He proclaimed a joust there in January 1341, in defiance of the ban on tournaments which Philip of Valois had proclaimed for the duration of the war with England, since he did not recognise the French king's authority. The jousts were duly held, and when the French king's lieutenant in Languedoc protested, Jaime III responded by proclaiming another joust in the lieutenant's presence, which he duly held.[38] His triumph was short-lived, as he was relying on the support of the king of Aragon, which was not forthcoming. What is interesting about the episode is that a tournament was seen as a sufficiently public spectacle with which to challenge a monarch's rights.

Plots and assassinations

More typical, however, was the use of tournaments to hatch conspiracies or to carry out assassinations. The tournament at Staines in 1215 was closely linked with the baronial plans which led to king John's signature of Magna Carta; but more sinister plots were involved on other occasions. There was said to have been a plot to kill Piers Gaveston at the tournament to be held for Edward II's coronation; Pedro the Cruel of Castile was reputed to have tried to assassinate the master of Santiago at a tournament in 1356, only failing because the necessary instructions were not given;[39] and Henry IV and his sons were supposed to have been the targets of a similar plan at Oxford in 1400. All these were simply accusations; a successful plot would probably

This fifteenth century joust in a German town square is policed by footsoldiers with pikes, while the mayor watches from the town hall.
(New York, Pierpont Morgan Library, MS 775, f.275v)

have been described as an accident, and we cannot be sure that the long list of notables killed in the lists does not include some well-concealed murders.

The problem of public safety and tournaments is illustrated as early as the 1180s by a passage in Chrétien de Troyes' *Perceval*, where the lord of Tintagel walls up his gates to prevent a tourney from taking place inside the town, and only allows it to take place outside when all his retainers and archers have been summoned.[40] The English *Statuta Armorum* issued by Edward III in 1292 is a formal legal attempt to prevent tournaments from disrupting public order. It is aimed not at the tourneyers themselves, but at their retinues and attendants, who were the usual source of trouble – the supporters, not the players, in effect. Their numbers, armour and weapons were all regulated, as was their right to intervene in the proceedings. In addition, no spectator or official was to be armed: the marshals were only to carry the blunted swords which were the token of their office. And all officials were to wear proper identification, in the form of surcoats or tabards with the appropriate coat of arms.

German civic precautions

In the German towns in the 1370s special precautions of this kind are well documented. The tourneyers at Göttingen in 1370 were greeted with a declaration from the town council that they were welcome as long as they behaved themselves and paid their debts.[41] At Cologne in 1378 there were payments to archers guarding the gates during the tournament,[42] and the presence of guards is described in detail in an ordinance from Speyer in 1433:[43] the two mayors are to station themselves on either side of the lists with 100 well-armed citizens, the town banner is to be hoisted (presumably as a signal of a state of alert), and 600 men are to held in readiness in the guildhalls. Only those belonging to the retinues of accepted participants are to be allowed to fight. To avoid friction between the tourneyers and the townsfolk, a detailed set of prices is published; a similar set of regulations survives from Strassburg in 1408.[44] At Regensburg in 1434, a bond of 1000 florins had to be put up before a tournament was held.[45]

Quarrel at Regensburg, 1393

What could happen when things went wrong is easily illustrated; we have touched on the English sources, and to the episodes already mentioned should be added the so-called 'Fair of Boston' in 1288, when squires holding a *béhourd* ran amok and burnt half the town. And we have looked at the far more serious incident at Basle in 1376, in which tensions between townsmen and tourneyers had political overtones.[46] Seventeen years later, in Regensburg, the duke of Bavaria and his sons requested permission to hold a tournament on the Sunday before Ascension. The town council agreed, and the local bishop postponed a religious procession so that it could take place. The watch was put on alert, and fire precautions were taken: water was brought up to the rooftops. Troops were hired and instructed to remain armed day and night, and two hundred of them were posted in and around the town hall. All the gates were closed and guarded, except for three, which were shut once the tourneyers had entered. Almost at once there were problems: the duke wanted to tourney outside his own palace, while the town council insisted on the traditional site, the heath, for security reasons. In the end they gave way: permission was granted for Saturday and Sunday, on the understanding that it would never be given again. The tournament went off without incident, but at the dance afterwards a fight developed between a member of the household of the duke's son Albrecht and another of the tourneyers. The town council sealed off the building to prevent Albrecht and his household from taking revenge. Albrecht was furious at the treatment of his men, but the town council stood firm, and he was eventually pacified. The incident was regarded as serious enough for someone to write a full account of it in the town records, and it is to this that we owe a vivid glimpse into the realities of a fifteenth century tournament.[47] The

riots at Pavia in August 1453, discussed in our survey of Italian tournaments, shows us the town governors actually failing to suppress a riot after a tournament, but here the ancient Guelf and Ghibelline rivalries still ran high in the city, even though their origins were long since lost in the mists of time, and the tournament was merely a pretext for reviving old feuds.

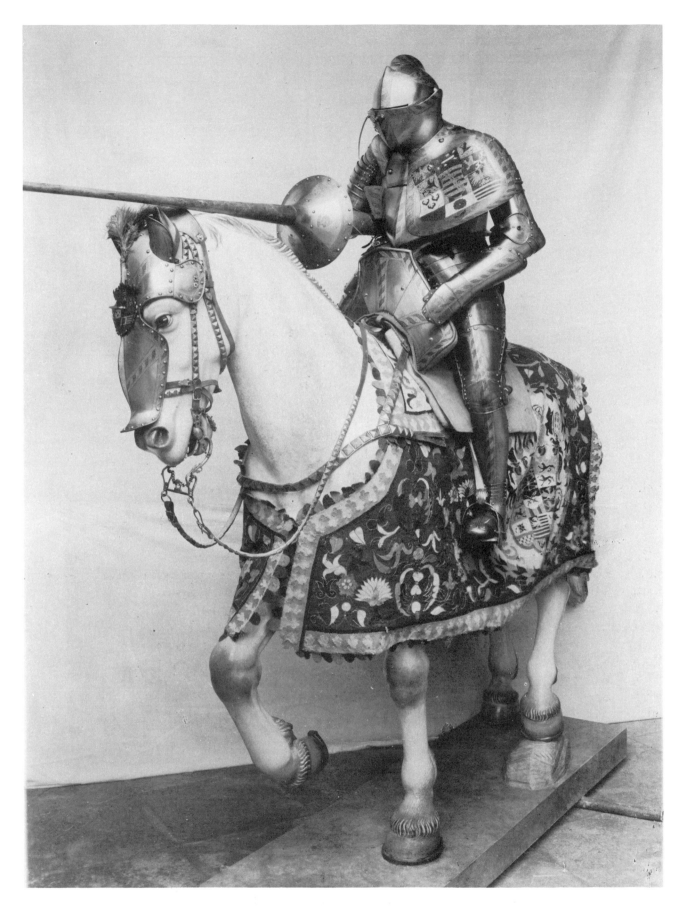

Sixteenth century jousting armour with armorial inlay by Anton Peffenhauser, and a caparison of c.1610 showing multiple quarterings.
(Germanisches Nationalmuseum, Nürnberg)

7

Tournament Armour

Armour was always an essential part of a knight's equipment and the development of specially designed armour for hastiludes was a natural solution to the particular problems caused by martial sport. Physical protection was vital, whether the combat was in deadly earnest or in play and a knight's personal safety was just as much at risk in the rough and tumble of the *mêlée* as it was in battle. Yet it is surprising how long it actually took for specialised tournament armour to be introduced; it is not until the late thirteenth century that we begin to hear about it. The reason for this is probably very simple. While the *mêlée* style tournament closely resembled the circumstances of real warfare there was no need to wear anything other than the armour worn for war. The type of combat, the circumstances and therefore the risks were very similar and war armour – though crude and often inadequate – answered their needs. It is highly significant that the first references to specific pieces of armour for tournaments and jousts occur at the end of the thirteenth century when, as we have seen, the joust was emerging as a more specialised form of combat. This gave great impetus to the search for better forms of protection than had hitherto been available.

The armour for both the tournament and the joust had to meet two main criteria: the first, and most important, was to meet the dangers peculiar to the different types of weapon, whether lance, sword or dagger; the second, more specific to the joust, was to enhance the personal image of the knight by the splendour of his equipment. The war armour used in the late eleventh century, when the tournament seems to have made its first appearance, was basic and simple in design. In the search for effective defences which were also light enough not to impede movement, knights had to make do with mail which was made up of inter-linked metal rings. This mail was flexible enough to be worked into costume for the whole body; though heavy, it was much lighter than armour made of solid plates of metal, which had to be so thick to give the equivalent degree of protection from blows that it was not a practical proposition for combat. Mail could not deflect blows like plate, however, and in consequence bruising was inevitable.

To avoid the dragging effect of the sheer weight of mail, several separate pieces of armour were fashioned. The main piece, which, with variations, remained in use until the end of the fourteenth century was the *hauberk*. This was simply a shirt of mail covering the torso which hung loose to the knees and thus protected the thighs. By the twelfth century, the *hauberk* had been extended to include long close fitting sleeves with mufflers to protect the arms and back of the hands (the palms were left exposed because this made it easier to handle weapons). At about the same time, mail *chausses* or leggings were introduced because the knight's legs were vulnerable on horseback. A close fitting mail hood, known as a *coif*, was invariably worn; this could be either a continuation of the *hauberk* or a separate item but it always formed a layer of

Twelfth-century armour

Pieces used with mail

The great helm

protection beneath some form of helmet. The earliest form of head protection in the tournament was the conical helmet which extended at the front into a nasal panel to protect the most exposed part of the face. The eyes, however, remained without defence. The invention of the great helm towards the end of the twelfth century was a major advance in defence technology. Not only did it cover the entire head and face but, because it sat on the shoulders, it also encased the neck. Made from several plates of metal bolted and welded together, with a padded lining to soften the effect of buffeting, it was a cumbersome piece of equipment. Vision was poor as there were only two narrow horizontal eye slits and breathing was difficult, particularly during exertion, as the ventilation holes were limited in size and number. The description of the young Parzival emerging from combat red faced and streaked with rust where the sweat had come into contact with his helm, though unromantic, was probably true to life.[1] Likewise, the day William Marshal ended up with his head on an anvil while the blacksmith tried to beat his helm back into shape so that it could be removed, was probably repeated many times in knightly life.[2] Despite these difficulties, the great helm was an invaluable piece of equipment, and it remained in use for well over a hundred years.

The crest

One consequence of the introduction of the helm was that the knight became anonymous: his face could no longer be seen and therefore he could not be identified, either by friend or by foe. The solution to this problem was the introduction of armorial bearings. The flat top of the helm was an obvious place to display an easily recognisable device and the crest was the result. This varied in complexity from a simple bunch of feathers to enormously elaborate recreations of heraldic beasts or symbolic objects, delightfully portrayed in the miniatures from the great collection of German love poetry in the Manesse manuscript.[3] These were probably constructed out of light materials – cloth over a wooden frame, perhaps – and would have been totally impractical for real warfare. In a similar way the cloth garments worn with armour to reflect heat and deaden the impact of blows were adapted for display purposes. The *surcoat*, for instance, the long flowing robe worn over the *hauberk* which was probably adopted by Crusaders in imitation of the Saracens and thereby introduced to Europe, became a place to exhibit a personal coat of arms. Even as late as the battle of Crécy, in 1346, the English heralds were sent round the battlefield to identify the corpses of the French nobility by the coats of arms on their surcoats.

Linen 'armour'

The cloth adjuncts to armour provide our first, rather tenuous, examples of what may have been armour specifically worn for hastiludes. As early as 1216 Prince Louis' invading French knights were fighting a tournament in England against their English baronial allies using lances only and clad in linen armour (*in lineis armaturis*); the garments in this case were probably padded or quilted to give some protection to the combatants.[4] This is clearly the interpretation to be put upon the linen tunics (*plicato linea tunica*) which were worn by knights in the region of Brussels who gathered regularly to tourney using only shield and lance in the mid-thirteenth century.[5] At about the same time, the Lord Edward participated in his first tournament at Blyth; again, the combatants were clad in linen garments (*in lineis et levibus*) rather than in conventional war armour.[6] The interesting thing is that, though an effort had obviously been made to control the sport and limit its effects, the tournament is cited because there were casualties and even fatalities in each case. Padded garments and restricted weapons had thus proved to be ineffectual even when the tournament was a 'friendly' between allies and compatriots.

The next step, therefore, was to introduce other materials for armour which would be more effective without reducing the knight's mobility. Again, the developments in

tournament armour reflected the general changes which were taking place in the field of war. The latter years of the thirteenth century saw experimentation with a number of different materials, including plates of various metals (which were still unsuccessful because of their weight), horn and, more important, leather and whalebone. Leather armour, more properly known as *cuir bouilli*, was extremely versatile. It was flexible enough to be moulded into close fitting defences and yet, once it had been boiled and hardened by soaking in hot wax, it was strong enough to withstand and even deflect blows from lance or sword. Added to these advantages was its most precious attribute – its lightness which left the knight unencumbered for combat. The earliest piece to be made from *cuir bouilli* seems to have been the *cuirass*, a single shell protecting the chest and part of the stomach; sometimes it was buckled at the sides so that a matching panel could be worn as a back plate. However, it rapidly came into use in other pieces which, like the *cuirass*, would be worn over the mail of the *hauberk* but usually under the decorative *surcoat*. Though not usually visible, they gave a second layer of protection and deflected blows in a way that mail could not do.

<p style="text-align:right">Cuir bouilli</p>

One particularly fine (and possibly unique) example exists of a set of accounts for a tournament where all the armour was to be made of *cuir bouilli*. On 9 July 1278 Edward I of England held a *béhourd* in Windsor Park; thirty-eight of his chamber knights and closest associates took part in the sport and all were supplied at the king's own cost with their arms and armour for the event. Each knight was given a harness (i.e. a complete suit of armour) with his own personal arms which included leather helms and *cuirasses*; the only difference in armour was that the twelve noblest participants were allowed gilded helms whereas the less aristocratic ones had to be content with silvered ones. An interesting extravagance was the purchase of eight hundred little bells to decorate the armour; crests and *aillettes*, decorative shoulder pieces, were also worn. The horses were equally provided with protection; *cuir bouilli* cruppers and *chanfreins* defended the body and head respectively. The knights' arms were strictly limited: there is no mention of lances in the account and all that was provided seems to have been a wooden shield and a sword with a silvered whalebone blade and gilded leather hilt.[7] The fighting at Windsor Park seems to have been intended mainly for entertainment but the chance survival of this particular record of purchases suggests that combats of this type were not uncommon; there is nothing in the wording to suggest that it was either a unique or innovatory occasion.

<p style="text-align:right">Béhourd at Windsor, 1278</p>

Cuir bouilli continued to be an important material for armour throughout the fourteenth and even into the fifteenth century; the inventory of Simon Burley's effects taken in 1388 shows that he possessed leg and foot harness for the jousts made of *cuir bouilli* and Antoine de la Salle's treatise, *Des Anciens Tournois et Faictz D'Armes*, written in 1458, describes arm defences of the same material.[8] Whalebone enjoyed a much shorter span of popularity. It too was light and strong but it was more expensive, in shorter supply and presumably more brittle than *cuir bouilli*. It was apparently in vogue around the end of the thirteenth and beginning of the fourteenth centuries because, apart from the swords provided at Windsor Park, there are incidental references such as the tourneying shoulder piece made of whalebone (*baleine*) listed in Raoul de Nesle's armorial inventory.[9] Thereafter, however, whalebone seems to have been superceded as a material for armour.

An early fourteenth century armorial treatise gives a useful summary of what the well-dressed knight of the period would have worn for combat.[10] The Latin treatise on how to arm a knight differentiates between the costume for tournaments, for war and for jousts. First of all a fire should be lit, a carpet laid out and the knight should strip to his shirt and comb his hair. For tournaments he should put on leather shoes and

<p style="text-align:right">How to arm a knight</p>

leggings over which plates of steel or *cuir bouilli* should be placed to protect the thighs, calves and knees. Next came his *aketon*, a quilted coat worn under the armour, over which would be worn a mail shirt and coif (*camisia de Chartres, coyfe de Chartres*) and, as a final outer layer of protection, a leather *hauberk* or *cuirass*. A *surcoat* of some kind, carrying his armorial bearings, would then be placed over all the functional armour, and the knight could put on his whalebone gauntlets. His costume was completed by his sword, whip and helm. For war the knight would wear virtually the same armour, with only German steel plates (*plates de alemayne*) and a good throat defence (*gorgeres*) being specifically singled out for special mention. The main difference appears to have been the weapons which were to include sword, axe and dagger; a note is made that the shield is rarely carried in war because it impedes more than it assists. For jousts, the author suggests an *aketon, hauberk* and *gambeson*, the last being a quilted *surcoat* made of precious cloth, preferably silk. Steel plates, a shield, a *bascinet* and a helm completed the outfit. The treatise is an oddity; it is apparently unfinished and no effort is made to actually define what the different types of combat are. Despite these drawbacks, the treatise is a useful summary of the equipment an early fourteenth century knight would have been expected to have to hand and it makes clear that, as yet, there was no armour designed solely for sport. This is of especial importance because the period was one of great change and development in

Plate armour

armour. The most significant of these was the increasingly widespread use of plate armour. Technological advancements began to make it possible to produce tempered steel of a quality which could protect without being so thick and heavy as to be impractical. By the 1330s plate was in use throughout knightly costume. Metal plated gauntlets, plate defences for the upper and lower arm (*bracers*), chin and neck (*gorget*) and legs and feet (*greaves* and *sabatons*) all appear about this time. As armour for the limbs improved in quality the *hauberk* shrank upwards and became the diminutive *haubergeon*: the *surcoat* also became shorter so as not to impede movement. An innovation was the coat of plates, also known as the pair of plates, which was worn over the *hauberk* but beneath the *surcoat*; this leather or cloth garment lined with overlapping metal plates became the commonest defence of the fourteenth century. As early as around 1340, however, the coat of plates was already developing into a rudimentary breast plate as the various smaller plates were fused together to form a more effective defence.

Armour specifically for tourneying

It is precisely in the mid-fourteenth century, during this period of great experimentation in armour, that we begin to hear of armour designed exclusively for hastiludes. There had been isolated references before: Jean, lord of Joinville described in his *Life of St Louis* how his own servants had wrapped him in a tourneying hauberk (*un haubert a tournoier*) to protect him when he came under fire near Damietta.[11] Likewise, Raoul de Nesle had a *haubers a tournoier* in the inventory of his effects drawn up in 1302.[12] In neither instance, however, is there any indication what, if any, difference there was between *hauberks* for war and for hastiludes. This is a problem that bedevils all studies of tourneying armour because the sources, which begin to proliferate from about the second quarter of the fourteenth century, are mainly inventories, financial and household accounts and wills. In each case the object was simply to list the armour, not to describe it in any detail, and therefore, though we are aware of an increasing difference between armours for different functions, it is virtually impossible to define those differences with any certainty.

Edward III of England's household accounts are a particularly rich source of references to tournament armour. From the 1330s onwards he made regular purchases for the many chivalric festivals he promoted and attended. One of the

earliest pieces of specialist armour to make its appearance was the *maindefer* which *Maindefer*
occurs frequently in the accounts from 1333[13]; the name implies that this 'iron hand'
was a plate gauntlet and, to deduce from later evidence, it was probably a rigid defence
which was designed to clasp round the lance. It was only used in jousts, because it was
not possible to adjust it for the use of the other weapons which would be needed in the
tournament. The first mention of a breastplate is a little later, around 1340, but 16
shillings appears to have been the going rate for a new *poitrine pur justes*.[14] This was
distinct from the breastplates for war but we can only speculate that they may have
had additional pieces which made them different from conventional ones. One possi-
bility is that the *poitrine pur justes* may have had an embryonic *arret* or hook affixed to
it on which the jouster could rest his lance and balance its weight correctly in prepara-
tion for riding a course against his opponent. Like the *maindefer*, the *arret* would only
be of assistance in the joust where one form of combat took place and it would make
sense to differentiate the various breastplates by this distinguishing feature. The *arret* *Arret*
de la cuirasse, as it was more properly known, was supposed to be introduced some
fifty years after the date of the first references to breastplates for jousts[15] so, once
again, this is only speculation.

The suggestion that the jousting breastplate may have already been fitted with an
arret as early as 1340 is supported by the same accounts of Edward III which also list
grates.[16] These were special fittings for the jousting lance which were designed to
engage in a bracket so that the jouster could put the full weight of horse and man
behind his blow rather than simply relying on the strength of his own arm. In addition
to these items there were any number of other items of armour which were apparently
the same as those for war, even though they were designated as being for jousts. A
possible clue to the difference may lie in the fact that the many pairs of plates, for
example, are all supplied with costly coverings ranging from leather to silk and
velvet.[17] Ornamentation, for the benefit of spectators, may therefore be the answer,
but this solution would not seem to adequately cover the problem of the helm, which
would appear to have taken at least three differing forms. As early as 1322, the
inventory of Roger Mortimer's effects lists three helms for jousts, one for war and six

Design for a horse-trapping; an early sixteenth-century sketch.
(BL MS Cotton Augustus A.III f.28)

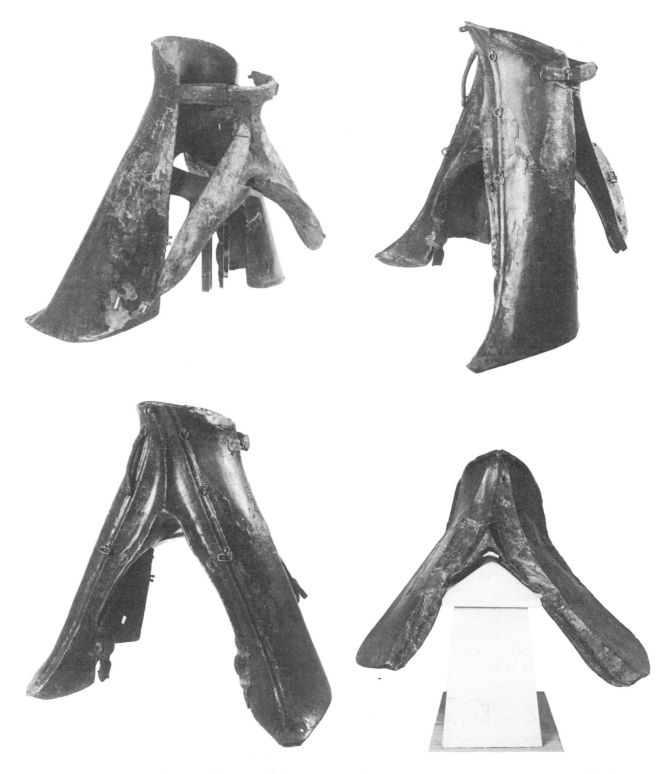

Above, and below left: front, side and back views of a German tournament saddle from the second half of the fifteenth century, giving an idea of the 'high seat' which supported the rider.
(Museum der Stadt Regensburg)

Lower right: early fifteenth century tournament saddle from Schaffhausen, designed for use in the 'high-seat' type of joust; it supports the rider in a half-standing position.
(Schweizerisches Landesmuseum, Zürich)

for tournaments (*iij galea pro justis; j galea pro guerra; vj galeis pro torniamentis*).[18] Four years later, Sir Fulk Pembridge left his *bascinet pur le torney* and a *healme pur torney*, together with a tourneying sword and a large array of war arms and armour, to his eldest son.[19] By the middle of the fourteenth century the great helm had been replaced in warfare by the *bascinet*, a more tightly fitting and conical shaped helm which had its own shoulder cape made of mail. The helm, however, remained the mainstay of hastiludes; though by this time the tournament too was dying out, the great helm sitting on the shoulders was still the main head defence of the joust.

By the last two decades of the fourteenth century advances in metal working were so great that it became possible, at last, to encase the knight from head to toe in steel plate. Italian and German armourers were especially valued for the quality of their work and the Milanese armourers, for example, supplied knights throughout Europe. All the individual pieces were now hinged or jointed so that the plate followed the contours of the body and the vulnerable areas between pieces were protected either by underlying mail or by superimposed roundels which would deflect blows. The *hauberk* was no longer necessary and the *surcoat* was replaced by the *jupon*, a tight-fitting doublet covering only the trunk. This was still necessary, as the need to identify the knight remained as strong as ever and it was here that he displayed his personal coat of arms, badges or devices. The only major innovation of the period as far as tourneying armour was concerned was the frog-mouthed helm which made its appearance on the Continent about 1400. This had much more shape than the old helm and it followed the outline of the head more closely, having a rounded top and a front which curved upwards and outwards to create a sort of lip at the eyeline; this was the distinctive shape which gave it its name. The advantage of the frog-mouthed helm was that it offered a smaller target area and less purchase to the opponent's lance, while giving greater protection to the wearer. The *veue*, or sight-line, was so designed that the jouster had full vision only when leaning forward in the correct position for beginning his course with his lance couched. During that time he had to assess his opponent and train his lance for contact. Just before the actual impact, he would sit upright again and that same movement would lift the helm so that the eyes were completely protected by the projecting lower lip. It would also render the jouster completely blind so that he was unable to take further action without returning to the couched position. It would seem likely, given the problems caused by attempting to complete a course blind, that the frog-mouthed helm was introduced at the same time as the tilt or barrier which divided the opponents. A trained horse would then be able to keep to its set path without endangering its rider by veering into the other comba-tant. The helm was fastened to the *cuirasse* by metal hasps at the front and back so that a blow received on the head (in theory at least) did not unhelm him.

This was evidently not the only type of helm in use for hastiludes at the end of the fourteenth century; just as earlier inventories had distinguished between armour for war, hastiludes and tournaments, now they differentiated between armour for war, hastiludes of peace and hastiludes of war. Though the term 'hastiludes' here seems to have meant jousts, and though the differences between jousts of peace and war are clear enough, it is still impossible to tell what the criteria were for identifying the various items. One possibility is that those for jousts of war simply had extra pieces to strengthen them. It is more likely, however, given the determination of jousting challenges to make the conditions as difficult as possible, that armour for jousts of war reflected more closely the armour for war than for hastiludes in general. We know, for example, that armour for hastiludes was beginning to be archaic in comparison with war armour. It would seem logical, therefore, that knights seeking jousts of war

Full plate armour

Frog-mouthed helm

would prefer to have equipment which reflected the real risks of battle. This view is supported by the conditions of jousting challenges,[20] which are frequently insistent that the combatants should have no artificial advantage from their armour and weaponry, and by the terminology of some inventories. The inventory of the Duke of Gloucester's effects drawn up in 1397, for example, lists two *bascinets* for jousts of war and three *helms* for jousts of peace.[21] This may be a scribal idiosyncrasy but, on the other hand, it may reflect an actual practice of wearing *bascinets* for war and jousts *à outrance* and helms, like the frog-mouthed helm, for jousts of peace. We have a very full inventory of the armour of the Gonzaga princes at Mantua in 1406, which lists over a hundred pieces of tourneying armour in all, including 'five cuirasses for private jousts' (*giostra a familia*), 'three old jousting helms', 'three broken cuirasses for the jousts, one covered with the Gonzaga arms', and, among the harness, 'eleven large jousting saddles badly damaged': all of which is a vivid reminder that not only was the

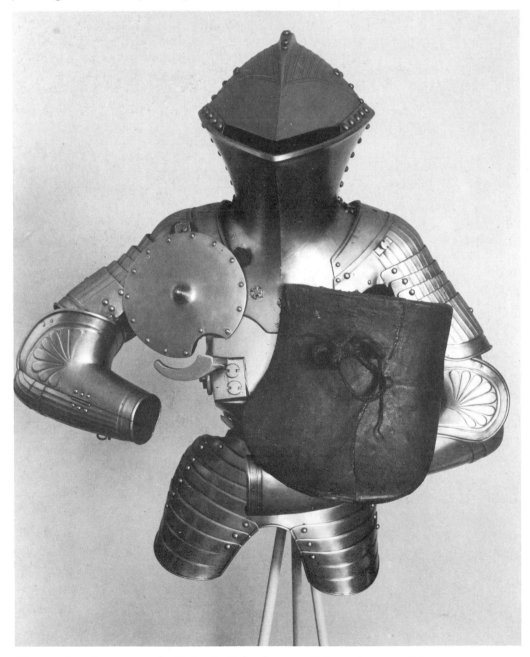

German jousting armour by Valentin Siebenburger of Nuremberg, c.1530.

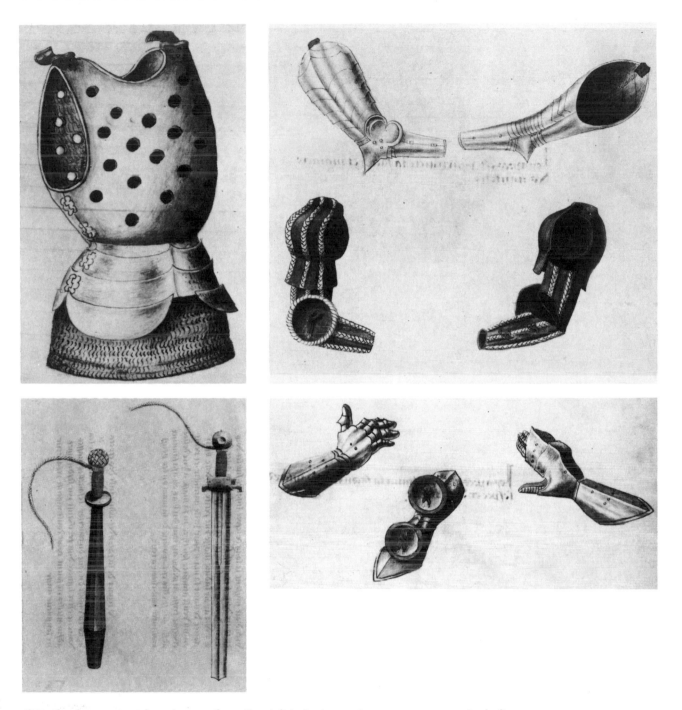

Details of armour and equipment from René d'Anjou's treatise on tournaments, including the cuirass to protect the body, and the pieces which protected the arms and hands. The weapons are the mace (kolben in German) and the tournament sword. (Bibliothèque Nationale MS Fr 2693 ff.21v, 23, 31v)

equipment expensive, but it was also often damaged. Because armour was so costly, old and damaged pieces were kept so that they could be accounted for when an inventory was taken.[22] An ordinary knight might well have to borrow armour; Friedrich of Brandenburg was told by a friend in December 1485 that he could not lend him his tournament armour because Friedrich's servants had already borrowed various bits of it.[23] At the *Passo Honroso* in 1434, the Aragonese knight who was killed was wearing a borrowed helmet, and Pero Rodriguez de Lena was very careful to emphasise in his account of the jousts that the dead knight had declared that he had never had a piece of armour which fitted him better.[24] There is an obvious implication: borrowed armour was often such a bad fit that it was dangerous.

Weapons Despite the radical changes in armour taking place, the weapons used in tournaments and jousts remained much the same over the centuries. As early as the twelfth century there had been a clear distinction between arms of war and arms of peace; in the former case the conventional weapons of war were simply carried over into tournament practice and so lances, swords, maces, axes and even arrows were allowed. Once foot soldiers disappeared from the tournament field at the end of the thirteenth century,[25] bows and crossbows also vanished as they were not knightly weapons; in any case, their use had never really been approved of because they did not test the skill of the competing knights.[26] Ordinary lances, swords and maces of varying kinds remained in use for tournaments *à outrance*. For arms of peace experimentation was more necessary because improvements could always be made. The earliest way of limiting the danger was to remove the sharp edges and blades of weapons. For tournament swords, this probably meant a completely different weapon from the conventional one for war as the blades could not be dulled for temporary purposes. The fighting took place mainly on horseback so the weapon used was a longsword which had a longer reach than the swords later developed for foot combat. For lances the solution was a lot simpler: the same wooden shaft would serve for either sharp or rebated blades. It was customary to have brightly painted lance shafts for war and these naturally lent themselves to the pageantry of hastiludes. Though lances of peace were not unknown in William Marshal's circles[27] the first reference to the coronal does not occur until the mid-thirteenth century. Matthew Paris, describing a Round Table at Walden, says that the combatants had rebated lances with a 'little plough-share (*vomerulus*) which the French call a *soket*' at the end.[28] It was not long before this became the standard crown-shaped coronal with its three stunted points. The particular benefit of this design was that there was less chance of the lance catching in the armour of an opponent; an additional advantage was that the weight of the lance blow was more dispersed than using a single point, however blunt.

Though the shape of the lance changed little over the years, alterations were made to improve performance, such as the grate and *arret* which we have already noted. The shape of the shield was also changed to maximise the lance's effect in the joust. While a more or less triangular shaped shield was used in war, at the end of the fourteenth century the unusually shaped *écranché* shield was introduced for jousts of peace. This *Écranché shield* was more oval in shape, but a large bite out of the right side meant that the aim of the lance was unimpeded without endangering the protecting of the left side of the body. This was undoubtedly the shield which knights displayed when they wished to offer themselves in combat in a joust of peace; if jousts *à outrance* were also offered the conventional triangular shield would be displayed beside it. Knights taking up a challenge of this nature would strike the shield of peace or war to indicate in which kind of combat they wished to engage.[29]

By the mid-fifteenth century we begin to get a clearer picture of the armour worn for hastiludes, partly because tournament treatises become more prolific and partly because actual examples of armorial pieces begin to survive. An anonymous treatise, *Du Costume Militaire des Francais en 1446*,[30] describes the war armour of a man-at-arms: each piece, from *cuirasse* to gauntlets, completely enclosed the part of the body it was meant to protect and the joints between were protected by large *rondelles*. The head-piece was a *salade à visiere*, a form of *bascinet*. Of more interest for our purposes is the description of jousting armour. The helm is given particular prominence, together with the three lower pieces which attached it to the *cuirasse*, and it is stressed that the nails should be smooth so that they do not catch the lance of an opponent. The French *écranché* shield, made of wood but strengthened by layers of deer horn, was attached to the neck by cord so that it could not be dropped and lost in combat. The torso was enclosed in either a *cuirasse* or a brigandine, neither having any major difference from war armour except special buckles or rings for attaching the helm to the body armour. The left side of the body, which was the target of the opponent's lance, received added protective plates: a huge gauntlet which extended above the elbow and a large rigid plate over the left shoulder and part of the chest. The right side of the body was less heavily armed and, as it was the jouster's lance arm, more freedom of movement was necessary. *Rondelles*, rather than additional rigid pieces were adopted and the gauntlet, known as a *gaynpayn*, was also more lightly armed. The object of all the extra pieces was to ensure that even if one protective layer was lost in combat, another remained beneath; most of the pieces also seem to have been attached by crampons or chains so that even if they were dropped or knocked off they could easily be replaced. The French, apparently, wore leg armour, while the Germans metal-plated and extended their saddles to completely cover the legs by a special saddle bow.[31] As the knight's weapons in this form of combat were swords and wooden clubs (*bastons de mesure*), and the fighting would take place in a *mêlée* rather than in the concentrated atmosphere of a joust, the armour had to be more flexible and more lightweight. For this reason, rather than always wearing plate metal armour, the combatant is offered the alternative of *cuir bouilli*. The helm, for example, in this form of sport is not the frog-mouthed helm but the ordinary war *bascinet* with a different visor; as depicted in the illustrations it appears completely open for maximum vision and ease of breathing but with a set of vertical bars to protect the face from slashing swords or clubs. A *brigandine* is again suggested as a alternative to the more rigid *cuirasse* but additional garments are to be worn beneath for increased protection. Harness for the limbs should be as for war but short spurs and a short coat of arms are recommended as the least inconvenient in combat. The crest, made of *cuir bouilli* and attached to the top of the helm is given pride of place at the head of the list of armour to be worn.[32]

Armour in 1446

Antoine de la Salle, writing in 1458, describes almost identical armour for the combatants in his treatise, *Des Anciens Tournois et Faictz d'Armes*. He too calls the combat a tournament though it is clear that he is describing a *béhourd*. Interestingly, he makes the comment that he has only ever seen two, one held by Anthony of Brabant and one by Philip of Burgundy; both were nearly fifty years prior to the time of writing.[33]

The problem of equipment seems more acute in the fifteenth century, but this is perhaps because – as usual – we have better documents. Horses in particular were always a major headache: in the early fifteenth century, letters between the German princes show that the availability of suitable mounts was the commonest difficulty facing a would-be participant in a tournament. Wilhelm of Saxony, agreeing to lend a

Horses for jousting

horse to his cousin Albrecht, adds a nice touch to the transaction when he adds, 'and if you win the praises of pretty girls and ladies as a result, as we have done in the past, and God willing, will soon do again, we shall be delighted to hear it.'[34] The problem was partly to find horses which were good enough for jousting. Five years later, Wilhelm sent Albrecht two horses, but warned him that they had never been used for jousting before.[35] Friedrich of Brandenburg replied in 1496 to a request for horses from count Philip by explaining that he only had two for himself, of which 'the chestnut is so tired from its recent journey from Worms that we had to keep it back at the recent jousts at Nuremberg in case it could not run the course properly'. He is sending his stallion from Waldeck, which he also used at Nuremberg; the horse is liable to bolt, but he hopes that Philip will be able to control him; he asks that Philip should reserve him for his own use, and should not lend him to anyone else.[36]

At the *Pas de la Fontaine des Pleurs* in 1449, Jacques de Lalaing provided in the conditions that anyone who arrived without a horse and wished to take up the challenge would be lent one.[37] Even Philip the Bold of Burgundy borrowed horses on occasions, as at the jousts as Brussels in 1376, when the lord of Antoine lent him four 'destriers'.[38] The problem was undoubtedly made worse as the joust became a more and more specialised event: heavier armour was worn, and the horse had to be trained to charge steadily and almost head-on at just one opponent: swerving meant that the rider would inevitably miss his target. Furthermore, there were often regulations as to the size of horses: in 1482 Albrecht Achilles of Brandenburg instructed his son to see that 'the stallion by which the horses are to be measured' was at Nuremberg three weeks before Shrovetide, when a tournament was to be held there.

By the sixteenth century, the superb technicians of Italy and Germany could produce jousting armour so highly wrought and worked that any other ornamentation was superfluous. The Emperor Maximilian was a particular devotee of hastiludes and gave his name not only to a book of 'Triumphs' but also to a whole new genre of ingenious armour which was elaborately chased and fluted to such excess that, had the sport been at all realistic, it would have presented grave dangers to the combatants. The rather less serious nature of jousting by this period was also reflected in the

'Mechanical' armour mechanical devices now being produced more for the entertainment of spectators than for the protection of the participants. A typical example was the shield which, on being struck by an opponent's lance, would fall into pieces; it was operated by means of hidden springs. This type of mechanical trickery reflects the state of the sport in the sixteenth and seventeenth centuries when pageant and entertainment were far more important than any actual fighting. The armour for hastiludes of this period was infinitely more sophisticated than the simple attempts to find ways of improving personal safety from which it had evolved. From wearing only the ordinary defences of war, the tourneyer had progressed through increasingly specialised forms of armour which were designed to fulfil a genuine need for protection, to showpiece armour which was barely intended to be used for its supposed purpose. As the costs of producing such elaborate suits of armour increased fantastically, so their availability was effectively reduced to a small group of European aristocrats who alone could afford to spend such sums on entertainment. The introduction and development of tournament armour in response to the special needs of the different forms of combat also reflected the changing nature of the sport itself.

8

Tournaments as Events

In the preceding pages we have pieced together something of the history and development of the medieval tournament, and of its political and social background. But the event itself remains to be analysed; even though there is a vast difference between the rough and tumble of twelfth century tournament and the stylised pomp of its sixteenth century equivalent, we can nonetheless find common ground between the two, and a surprising number of traditional elements unite them. Even with the inevitable distortions resulting from the patchiness of the records and the bias towards spectacular occasions, we can attempt to draw some general conclusions. What follows is very much a preliminary sketch, which may encourage others to undertake more detailed research; it necessarily draws on material we have already used in tracing the history of the tournament.

Types of tournament

There was a very wide range of types of tournament. We can classify them into three types, with variations as to the framework, rules of combat and weapons. First comes the original mass tournament, the *mêlée* proper, fought between two teams of knights either in the open field or in the lists, described in chapter 1. The field tournament without enclosing barriers in the twelfth century style does not seem to have survived beyond the thirteenth century; the German *Feldturnier* of the fifteenth and sixteenth century is merely a tournament outside a town rather than within the confines of a city square.

The mass tournament, except as a pre-arranged show combat like the *carrousel*, gives way in the late fourteenth century to the individual joust, which first appears in the late twelfth century, but only reaches its most developed form with the use of the tilt down the centre of the lists in the early fifteenth century. Both the joust and the tournament were usually formal, regulated events, as the previous chapters have shown. There is, however, a third major category, the practice tournament, where the surrounding ceremonies and rules were less strict. Practice in its simplest form was provided by the quintain, a wooden device mounted on a pole at which the knight aimed with his lance; it usually represented a Saracen with a shield, and if the shield was struck fairly, it swung aside to give the knight a clear path. Another form was a ring suspended on a cord, which was to be carried off on the tip of the lance; both these sports have survived until the present day in a few country towns in Italy, an apparently continuous tradition from the middle ages.[1] In Spain and Portugal, the *juego de cañas*, a mock-tournament fought with bulrushes, was popular alongside the

tournament and in association with bullfighting; at Jaen in 1462, Miguel Lucas de Iranzo's household 'passed some time each day in jousts and *juego de cañas*.[2]

Béhourds The most interesting of these practice jousts, however, is the *béhourd* or *bohort*, which has been something of a mystery until now. The earliest use of the word *buhurt*, a term which seems to describe informal jousts, is to be found in a chronicle from south Germany about 1150; it is possible that it was the original German term for tournaments, and the French-derived word *turnier* only later supplanted it. The verb *béhourder*, to hold a *béhourd*, is found in French from about the same period; the earliest French translation of Geoffrey of Monmouth's *History of the Kings of Britain* uses the word in the passage we have quoted in chapter 1, where it is the equivalent of 'imitation battle'. A romance written in the early years of the thirteenth century in south-east Germany describes a fierce *béhourd* which 'would have been a tournament if they had been wearing armour'.[3] It is mentioned in the rules of the Order of Knights Templars in the mid twelfth century: whereas tournaments were strictly forbidden as a breach of canon law, the brothers were allowed to '*bohort*' provided that no spears were thrown.[4] And in the literary tradition of the period the *béhourd* is an essential part of court festivities: knightings and weddings end with a *béhourd* and a dance. In the German version of Chrétien de Troyes' romance *Erec*, a *béhourd* is held immediately after Erec and Enide's wedding, followed by a tournament three weeks later: in the original, this *béhourd* is missing. We have no specific historical evidence for the *béhourd* in this period, probably because it was an informal and impromptu occasion, by contrast with the more highly organised tournament. It may also have been less dangerous and less controversial, in that it fell outside the church's condemnation of tournaments. In Italy in 1208, we find a nobleman near Rome who was a vassal of the pope 'playing at *buhurts* from afternoon until suppertime' when Innocent III came to visit him.[5]

The *béhourd* continued to be practiced alongside the tournament in both Germany and Italy; it appears most frequently in thirteenth century sources, and then gradually vanishes. It is almost always associated with festivities: at a great court in Verona in 1242, 'the knights held a *béhourd* in the marketplace and the ladies danced on a kind of stage built outside the town hall.'[6] In Spain and Portugal, it is connected with bullfights and the throwing of spears at targets (*jogo de tavolada*)[7] But the sheer informality of the *béhourd* entailed other dangers: in Venice in 1288, an ordinance was issued, in connection with highway regulations, that anyone who was taking part in a *béhourd* should have bells on his harness, so that he could be heard as he approached, implying that the sport was practised at large in the streets; and in Bologna in 1259 a statute was enacted against those taking part in a *béhourd* attacking the bystanders with a spear, if the latter were on foot. The same ordinance was repeated at Treviso in 1313, where – obviously because no armour was being worn, as we have already seen – it was laid down that all participants should have a shield, on pain of a forty shilling fine. Equally, as in the rule of the Templars, spears were not to be thrown, but must be held firmly in the hand. However, there were very occasionally deaths at *béhourd*: in 1261, when count John of Holstein came to Lübeck at Christmas, to hold his accustomed *béhourd*, one of the participants took the opportunity of settling old scores with the count, and in the ensuing quarrel, was killed by the count, who had to take sanctuary in a church.[8]

Bells Striking corroboration of the *béhourd*'s popularity and of its widespread practice comes from the laws of Aragon in about 1300: any knight or squire riding in a *béhourd* 'without bells or hawk-bells' who kills someone is guilty of homicide; but if he has bells, he is to be acquitted of blame.[9] Bells were worn on harness at the 'tournament' at

Windsor held by Edward I in 1278, which was fought in leather armour with whale-bone swords, and seems in fact to have been an elaborate form of *béhourd*,[10] though bells were later used purely to heighten the effect of magnificence: at the *pas de l'Arbre d'Or*, the count of Saulmes had bells 'like cowbells' on his horse.[11] We should probably include as *béhourds* the jousts in linen armour recorded by Thomas of Chantimpré at Louvain in the thirteenth century, though the joust in silk shirts at Augsburg in 1442 seems to be a different affair, a daredevil venture, because only one course was run, and sharp weapons were used. Equally, the weapons could be in-formal: an encounter using wands from a lime tree is described as a *béhourd* in 1375.[12] They were always a popular recreation with esquires and others who were not knights, particularly in England, and this may have added to the risk of disorder. In Alexander Nequam's wordbook *On the Names of Everyday Objects*, *tirocinium*, literally a tournament for newly-created knights (*tirones*), is equated to *béhourd* by thirteenth century commentators. *Béhourds*, like all tournaments, could be dis-orderly; they were banned in England in 1234 because of the ill-will they caused, and the 'fair of Boston' in 1288 which ended in a riot was technically a *béhourd*.

In Germany, as the full-scale tournaments became better-regulated and more peaceful, so the *béhourd* slowly disappeared and the distinction between the two forms was largely forgotten. The word itself was gradually supplanted by the French-derived *turnier* and only appeared as an old-fashioned name for the sport in chivalric romances which harked back to the golden days of knighthood. In Italy, on the other hand, the *béhourd*, or, to give it its Italian name, *bagordo* flourished throughout the middle ages, and contributed to the emergence of the 'carrousel' or non-combatant display of horsemanship, in the sixteenth and seventeenth century. Because the equipment required was minimal – a shield and a spear, without the expense of full armour – it became a pastime for the citizens as well as the nobles, and is found as an additional form of celebration in many accounts of festivals: *giostre, bagordi e molte belle feste* (jousts, bagordi and many fine celebrations) becomes almost a refrain in the Italian chronicles. The *bagordo* continued alongside the joust in Italy, whereas else-where the joust supplanted it: in Italy, it was not regarded purely as training for the joust or tournament, but as a sport in its own right, and hence was not dependent on enthusiasm for the tournament proper. Its rough and tumble informality was little use as practice for the highly formal joust.

We can categorise tournaments and jousts in a number of other ways. The frame-work can be elaborate and theatrical, as in many of the Burgundian tournaments and the round tables, where a specified situation is the basis for the contest: either a single knight or a team of knights defending a given place in the *pas d'armes*, or a fraternity of knights in peaceful competition with each other in the round table and its variations (*forest, Gralsfest*). The fifteenth century German *Gesellenstechen*, literally 'fellows' joust' seems to have been a similarly friendly occasion, entailing less rivalry than a challenge combat. The rules under which the contest was fought also gave it a distinct-ive atmosphere: the hostile form, using sharp weapons, *à outrance*, was suitable only when a semi-warlike combat was in view, and was much rarer than the use of arms 'of peace'. The weapons to be used might also be restricted, and particularly in the fifteenth century, many events were fought on foot only. The German knights were particularly fond of the tournament with maces (*Kolbenturnier*) which only appears occasionally elsewhere, and the axe makes its appearance from the late fourteenth century onwards; but the usual weapons were always the spear and the sword.

The technical terms for different jousts, however, can be misleading, as they do not necessarily imply special rules. For instance, the German *Scharfrennen* is simply the

Bagordi

Technical names

use of sharp weapons; the *welsches Gestech* or foreign joust indicates the presence of a tilt down the centre of the lists, while the *Hohenzeuggestech* employed a special saddle with a built-in shield protecting the thighs and stomach. It is true that Maximilian invented a number of variations, including jousts where the spring-loaded shield was designed to fly into pieces if the release point was struck accurately, or more dangerously, jousts without helmets. But these were the inventions of one enthusiast rather than genuine, widespread forms.[13] Other kinds of jousts can no longer be reconstructed with certainty, such as the jousts 'a domenini' which appear in Italy from 1463 onwards, and are also found in Italian descriptions of Paris jousts in 1549; they were regarded as dangerous, but we can only conjecture where the danger lay.[14]

Reasons for holding tournaments

Can we detect any particular reasons why, or occasions when, tournaments were held? The first and most obvious was group or individual enthusiasm for mock warfare, and in that sense 'your play needs no excuse'; tournaments were held because the participants enjoyed them. However, they were also held because the participants enjoyed real warfare, and it is not surprising that truce or peace was generally a pre-condition for tourneying – real war brought other pre-occupations with it. Truces in particular, a time when hostilities were merely suspended and rivalry had deeper undertones than usual, were a fertile time for tournaments, especially those fought with weapons of war. Examples can be found as early as 1197, when Richard I's army is said to have fought tournaments at Tours during a truce,[15] and as late as 1495, when Bayard was fighting the Spanish in Naples and arranged a combat of thirteen against thirteen during a two months' truce.[16] During the Hundred Years' War, tournaments were a regular feature of periods of truce or peace, the jousts at St Inglevert in 1390 being the most notable example. In such circumstances, the argument that tournaments were the best form of practice for real warfare was entirely convincing.

Sieges Sieges were also a period when jousts of a more or less serious nature were frequently held. Three of our earliest examples of tournaments are found in connection with sieges, at Würzburg in 1127 and at Winchester and Lincoln in 1141, and the borderline between jousting in play and a lance-combat in deadly earnest is very slender. However, when at the siege of Valencia in 1238, two Saracen knights challenged any two knights from the Aragonese army to joust with them, the event is nearer to a formal occasion. Jaime I of Aragon describes the occasion in his *Chronicle*:

> Don Exemen Perez de Tarazona, who was afterwards lord of Arenós, came to me and asked me to give him that joust, together with Miguel Perez de Isór. I told him I marvelled much at him, that a man who was such a sinner as he was, and of so bad a life, could ask to joust; I had my fears that we should all be brought to shame through him. But he begged of me so hard that I assented; he jousted with the Saracen, and the Saracen overthrew him. Pere de Clariana then went against the other Saracen, and at coming together in the joust, the Saracen turned and fled, and he pursued him, till he got across the Guadalaviar, and among his own people.[17]

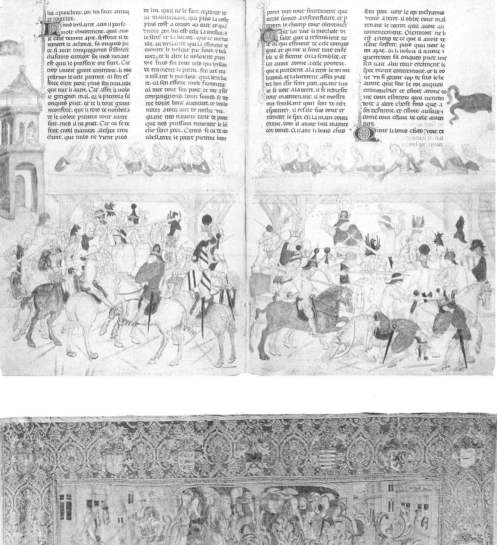

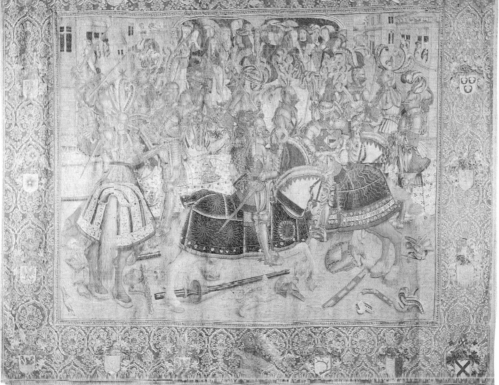

A mêlée; the artist has drawn the stand from which the spectators are watching with particular care, and it gives a good idea of the nature of these temporary structures. Meliadus, Italy, c.1350. (BL MS Add 12228, f.182v–183)

Tournament tapestry now at Valenciennes: this was ordered by Friedrich Elector of Saxony while he was in Antwerp in 1494 as a present for his uncle duke Albrecht, and shows a tournament which took place there on October 19 and 20. (Photo Giraudon)

The sieges of the Hundred Years' War produced similar jousts; how close they were to war is underlined by the episode of Sir Walter Mauny at the siege of Hennebon in 1341. On arriving at the town with a relief force, he was entertained by the countess of Brittany. After the entertainment, he led a sortie against one of the siege-machines, and retreated, with the newly-roused French army in pursuit; he exclaimed 'May I never be embraced by my mistress and dear friend if I enter castle and fortress before I have unhorsed one of these gallopers!', and turned his horse to meet them. The skirmish became more serious, but the English, having unhorsed the first onslaught, retired in good order. This was warfare in earnest, but the participants treated it as a kind of superior tournament.[18] At Rennes sixteen years later, the young Bertrand du Guesclin, on the threshold of his military career, fought several courses with a Breton or English knight during the siege, one of the earliest examples of a purely chivalric challenge.[19]

End of campaign
The end of a campaign could also be marked by jousts or tournaments. In 1225, in eastern Germany, the knights of Ludwig of Thuringia marked the capture of the castle at Lebus by holding jousts. In fourteenth century Italy there are half a dozen examples: at Florence in 1329 to mark the end of war with the neighbouring town of Pistoia, at Padua to mark a victory over the Venetians in 1379, at Venice for the capture of Treviso in 1338 and for the surrender of Candia in 1364, at Bologna in 1392 for the end of a campaign against Genoa.[20] These occasions, as we know from Petrarch's description of that at Venice in 1364, had something of the old classical triumph about them, with processions and organised manoeuvres on horseback as well as jousting, but the fashion does not seeem to have spread much beyond the Italian city-states.

Throughout Europe, the tournament was an accepted part of great ceremonial occasions in peacetime by the fifteenth century. We find examples in connection with formal royal entries into cities, diplomatic meetings, coronations, knightings, and on a more personal level, christenings and – above all – weddings. The idea of knightly sports as part of solemn occasions such as the assembly of a royal court is to be found as early as 1135 in Geoffrey of Monmouth's *History of the Kings of Britain*,[21] and there were plans for a tournament at Frederick I's great court at Mainz in 1184. About the same time, John of Marmoutier, writing a biography of Geoffrey duke of Anjou, Henry II's father, describes how a tournament was fought immediately after his
Knighting ceremonies
knighting, and two of the round tables recorded in the thirteenth century were associated with knighting ceremonies.[22] In Vienna in 1279, Hugo Tuers jousted with his eighty year old grandfather on the day of his knighting. At Galeazzo of Milan's wedding and knighting at Modena in 1300, the citizens of Parma paid for the costumes of nobles and squires from Parma who jousted there.[23] In 1324, Pandulf Malatesta was knighted at Rimini, amid a great gathering of lords from the neighbouring states, and there was jousting;[24] similarly, at the knighting of John II of France at Paris in 1332, we find his father-in-law John of Bohemia taking part. And so the examples can be multiplied: the conjunction of the knighting ceremony with chivalry's greatest festival was a natural one. As Ramon Llull put it in the *Book of the Order of Chivalry*, when describing the making of a knight, 'that same day him behoveth to make a great feast and to give fair gifts and great dinners, to joust and sport and do other things that appertaineth to the order of chivalry …'[25]

Because other state ceremonies involved the holding of great courts, at which large numbers of knights assembled, the tournament became associated with these as well. These range from ceremonial courts designed simply to impress the onlookers, such as those held by the Gonzagas at Mantua in 1340 and 1366,[26] installation of great

officers, as with Alvaro de Luna in Castile in 1423, when he was made constable, or recognition of a lord of his heir, such as Francesco Carrara at Padua in 1388 or the successive heirs to Castile in 1423 and 1425. In fact, any of the business of a royal court could be a favourable time for holding a tournament, and in most cases the events would not be recorded in sufficient detail for the jousting to earn a mention. Three particular occasions, however, regularly provide mentions of tournaments or jousts: coronations, royal entries into cities and diplomatic occasions. The earliest mention of jousting at a coronation or its equivalent comes from the election of Rainieri Zeno as doge at Venice in 1253,[27] and at Acre in 1286 there was a round table at the coronation of Henry of Cyprus as king of Jerusalem. Early in the fourteenth century we find jousting at the coronations of Edward II of England in 1308, Philip VI of France in 1326, Alfonso IV of Aragon in 1328, and as far afield as Sweden, for the coronation of Magnus in 1336. Similarly, the ritual of royal entry into a town was largely a French and Spanish custom in the fourteenth and fifteenth centuries; the earliest example of a tournament in this context is that at the entry of Philip VI into Paris in 1328, when thirty knights took part. The arrival of the king at a major city was in a sense a diplomatic occasion: both the ruler and the citizens were mindful of their respective privileges and authority, and hence a formal welcome was needed, to display the goodwill of both sides. We find tournaments at international diplomatic occasions as well, such as the tournament at Friesach on 12 May 1224, when Leopold of Austria and two local magnates met for a conference. Curiously, scholars have tried to discredit Ulrich von Lichtenstein's account of the occasion precisely on the grounds that a tournament would not have been held at a diplomatic meeting:[28] but evidence from elsewhere shows that the opposite is true, and that they frequently figured at such events. In 1280, for example, when the French and Aragonese kings met at Toulouse, Pedro III and his knights jousted, though it is not clear whether it was purely an Aragonese affair, or whether the French took part.[29] Ten years later, when Wencelas of Bohemia did homage for his kingdom to the emperor Rudolf at Eger, the jousts were part of the official proceedings.[30] In 1340, when Waldemar of Schleswig and king Waldemar of Denmark met to sign a treaty at Lübeck, their retinues had to leave their weapons outside the town, but some of them stayed outside and jousted.

Coronations

Diplomatic meetings

We have already noted the series of jousts held for the king of Cyprus in 1363–5, and in the fifteenth century we find a number of jousts held specifically in honour of an embassy, such as the English ambassadors at Paris in 1415, or the ambassadors sent to Lisbon in 1428 to fetch Isabella of Portugal for her wedding to Philip the Good: there were two days of jousting, described in some detail by the official who reported to Philip on the proceedings. Interestingly, he appears to have been unfamiliar with both jousting challenges and the use of a barrier in the lists; it is not impossible that this diplomatic contact had a considerable influence on the shape of later Burgundian festivals. The culmination of diplomatic encounters in the lists was of course the Field of Cloth of Gold in 1520, when the tournament scores were on the verge of becoming a major factor in the outcome of the negotiations themselves.

Above all, however, the tournament was associated with weddings. This surprising conjunction is very frequent from the end of the thirteenth century to the middle of the sixteenth century, and in German princely families the tournament became almost *de rigueur*. The first notice of a tournament at a wedding is in Lambert of Ardres' history of the counts of Ardres in the 1180s, when Arnold of Ardres married Gertrude of Flanders.[31] In the thirteenth century – as so often – we only hear of tournaments at weddings when some disaster or drama is involved: at Merseburg in

Weddings

*Overleaf: the inspection of helms before a tournament: the judges have ordered a helm to be removed. One of the magnificent series of late fifteenth century illustrations to René d'Anjou, Treatise on the form and devising of a tournament.
(Bibliothèque Nationale MS 2693 ff.47v–48)*

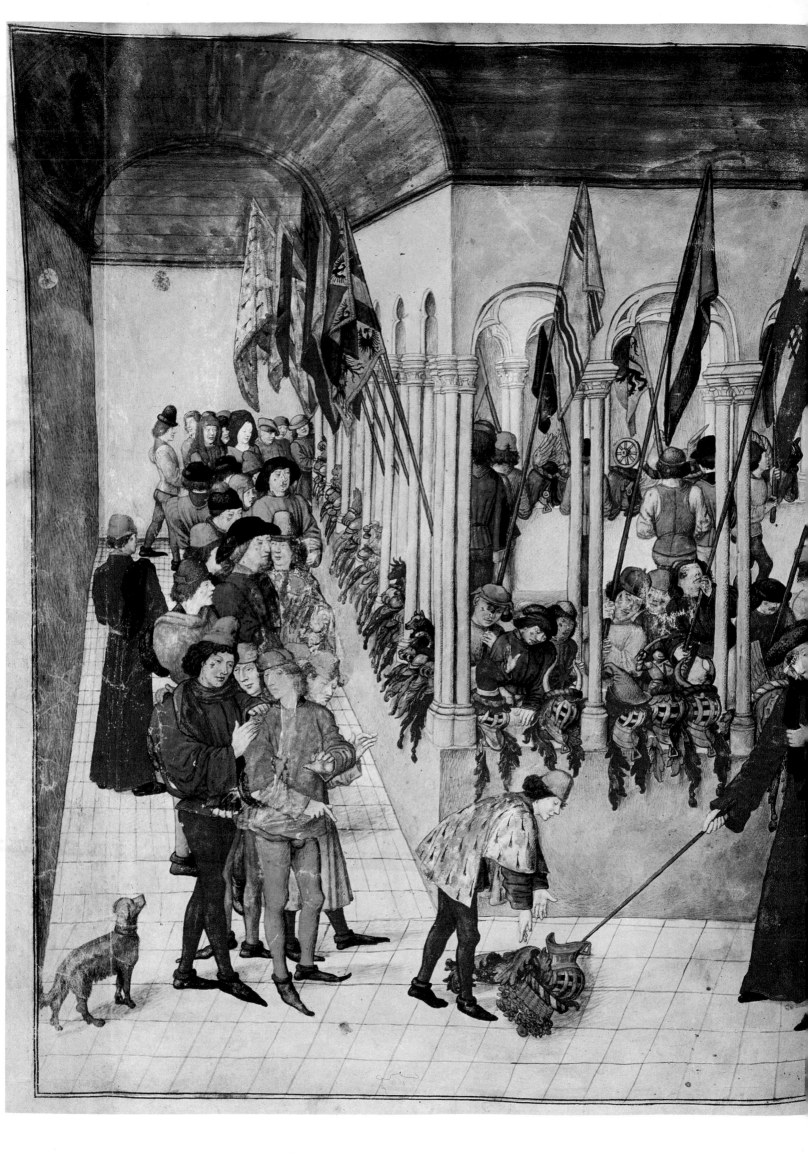

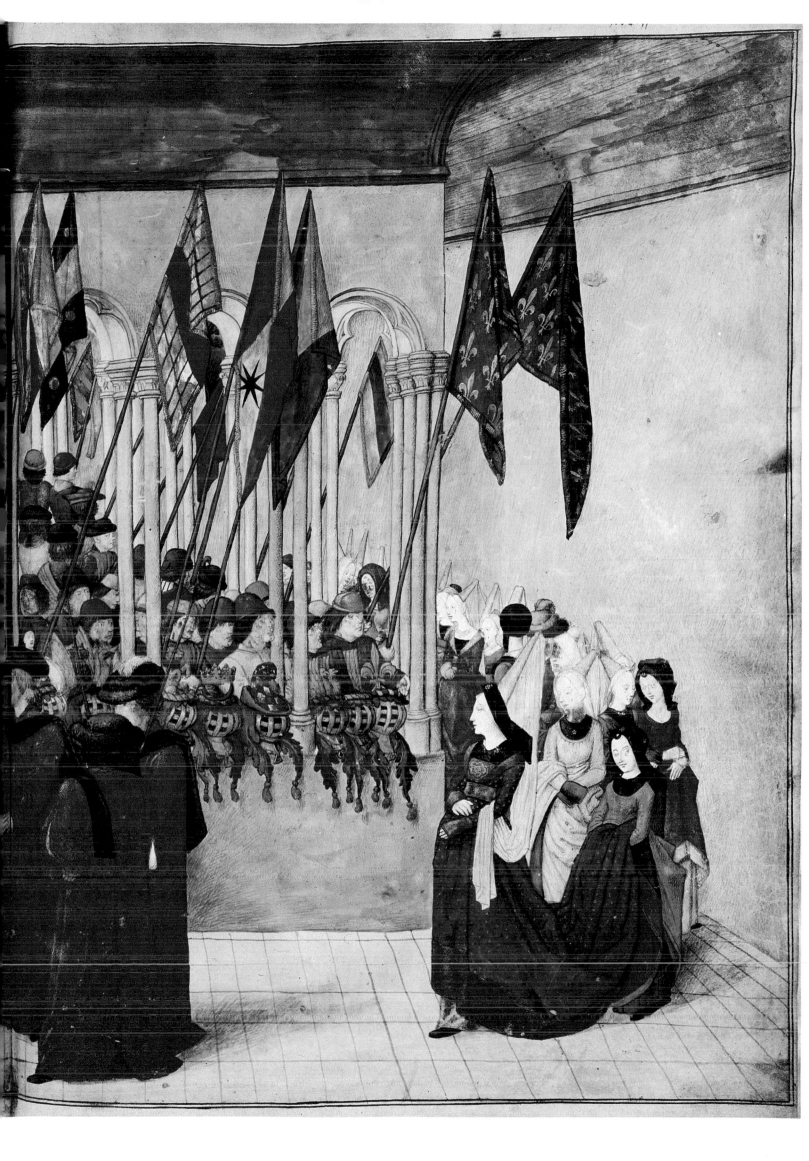

1268, the bride, Cunegunde of Saxony, saw her brother mortally wounded, while at the wedding of Edward I's daughter Eleanor in 1293 to the count of Bar, John duke of Brabant, was run through by the spear of his opponent and killed.[32] The most obvious gap in the records is for Edward I's knighting and wedding at Burgos in 1254: surely, given his taste for chivalry, there must have been jousting on such an occasion. But the meagre English and Spanish records say nothing about it, and his first tournament seems to have been at Blyth two years later.[33] Disasters figure again at Basle in 1315 in the jousts for the double wedding of Frederick of Austria and his brother: the count of Katzellenbogen was killed, the scaffolding collapsed, injuring many of the ladies, and many jewels were stolen.[34] At the wedding of Philip VI of France and Jeanne of Burgundy at Paris in 1328, the jousting was of a high standard, and the lord of St Venant distinguished himself by unseating the duke of Normandy at the first encounter: but the chronicler ends more sombrely by relating the death of the count of Eu, constable of France, from an accidental lance-thrust in the stomach.[35]

<p style="margin-left:2em">*Weddings at Burgundian and Saxon courts*</p>

By this time, tournaments were an accepted feature of noblemen's weddings, from the Holy Roman Emperor down to relatively minor figures. The great Burgundian festivals of the fifteenth century were closely linked to weddings: Philip the Good and Isabella of Portugal at Bruges in 1429, Charles the Bold and Margaret of York in the same town forty years later. But for an insight into the organisation of such occasions we have to turn to the letters of Albrecht Achilles of Brandenburg. In August 1476 his son was to marry the daughter of Ernest of Saxony, and we have his letter outlining the arrangements for the occasion, most of which is concerned with details of the proposed jousts. The jousters whom he had selected were sent letters in June inviting them to take part: the duke provided ten of the challengers and his son a further ten. The servant in charge of the armoury was to equip them, and was responsible for seeing that the armour was safely returned afterwards. Only a limited number of horses were to be brought, as the duke did not want the whole troop to exceed a hundred horses, including those ridden on the journey and the carthorses. He would provide the jousters with the over-garments (which would have borne his arms or device) for the lists. The specifications for the size of horses and the armour were sent; unfortunately, we do not learn what these are, as the definition is simply 'the measure used when they jousted at Landshut'. In the event, some of the participants complained that the horses were too high, and not in accordance with the measurements, and various groups jousted separately among themselves.[36]

We also find jousting at less high-ranking weddings: in 1429, there were jousts at the wedding of the mayor of Regensburg, though he evidently aspired to the nobility, since he left the town service for that of duke Heinrich of Bavaria soon afterwards.[37] Likewise, when Wilwolt von Schaumburg married the daughter of a court official at Würzburg towards the end of the fifteenth century, there were about a thousand guests, and jousts of three types were held, the festivities lasting for three days.[38] Wilwolt had something of a reputation as a warrior, and this display is in keeping with his character, but in 1553, a tournament also figured in the wedding ceremonies of his character, but in 1553, a tournament also figured in the wedding ceremonies of Caterina Fugger, who belonged to the great Augsburg banking family,[39] an event carefully recorded by Hans Burgkmair in a specially commissioned tournament book. However, only the very wealthy or the very enthusiastic could afford to mount such an event: cost as much as snobbery restricted the holding of wedding tournaments to a very small elite. John Aubrey describes the tilting at Wilton for the marriage of Henry Herbert, later earl of Pembroke, to the daughter of the earl of Shrewsbury in 1563:

here was an extraordinary show; at which time many of the nobility and gentry exercised, and they had shields of pasteboard painted with their devices and emblems, which were very pretty and ingenious. There are some of them hanging in some houses at Wilton to this day, but I did remember many more. Most, or all of them, had relation to marriage.[40]

This can have been little more than a parade, and in the seventeenth century the jousting on such occasions becomes a *carrousel* or orchestrated series of manoeuvres on horseback.

First jousts

A knight's first joust could in itself be something of an occasion. At a relatively modest level, we find the lord of Cronberg on the border of Germany and Holland proudly recording in the family deeds that 'Philip my eldest son took part in a tournament for the first time at Wiesbaden'; this was in October 1410. A much grander entry into the lists for the first time was that of John count of Nevers, later duke of Burgundy, in 1388: the ducal accounts record payments not only to the heralds who attended the jousts and the squire against whom he fought, but also furs given to the wife of Josset the armourer when the latter armed the count for jousting for the first time.[41] In 1445, Olivier de la Marche records that Philip the Good held jousts at Dijon 'in flat saddles and in jousting armour' expressly so that young men and apprentice jousters could learn the art: among those taking part were Adolf of Cleves who went on 'to joust more often and win more often than anyone else I know of'.

Time and place

As well as particular events, major tournaments were specifically associated with given times of year. In view of their association with weddings, it is not surprising to find that the most common single date for tournaments of any size was Shrovetide, the festival before the austerities of Lent. The association may go back as far as the very beginnings of the tournament: when a group of young nobles came to visit St Bernard at Clairvaux just before Lent, in the course of a tour in search of tournaments, St Bernard tried to persuade them not to bear arms in the few days before the fast, and, not without difficulty, succeeded.[42] In this case, the association with Lent may have been pure coincidence, but there is at least a hint that this was a likely time for 'those detestable fairs called tourneys'. The first certain evidence is appropriately, from Venice, home of the carnival in succeeding centuries: six gentlemen from Friuli on the mainland challenged the men of Venice at Shrovetide 1272. Sixty years later, we find Edward III jousting at Guildford in March 1329 just before Lent, and a specifically Shrovetide joust at Pegau in central Germany in 1331 in which a local nobleman was killed.[43] Shrovetide carnivals – from the Latin 'carni vale', or 'farewell to the flesh' – were by no means general at this period, and it is only from the late fourteenth century that we find continuous series of Shrovetide tournaments, as at Cologne from 1371 onwards, where the city council regularly rented a house overlooking the hay market so that they could watch the jousting.[44]

But there seems to have been such a tradition in Italy, for which we have no specific documentation, because we know that the month of February was connected with tournaments. We find this link in a series of poems on the months by Folgore di San

Overleaf: the dukes of Brittany and Bourbon fighting with swords on horseback, from René d'Anjou's treatise.
(Bibliothèque Nationale MS 2693 ff.32v–33)

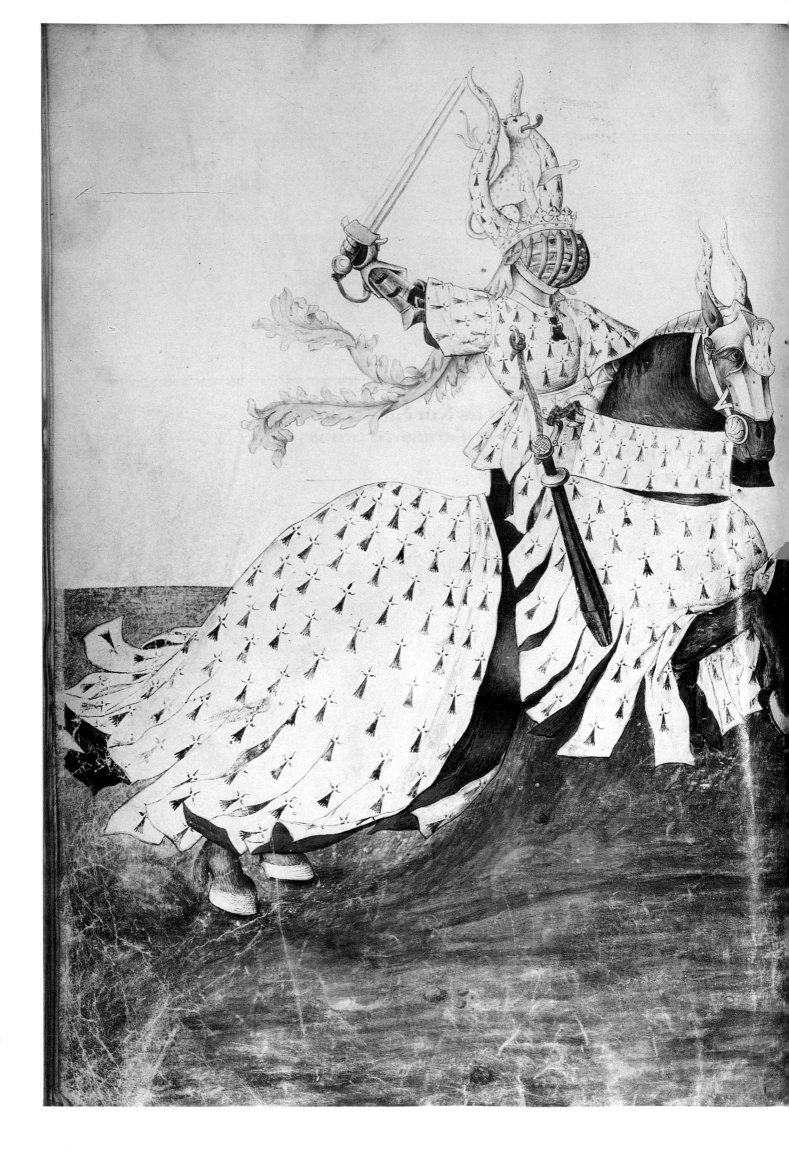

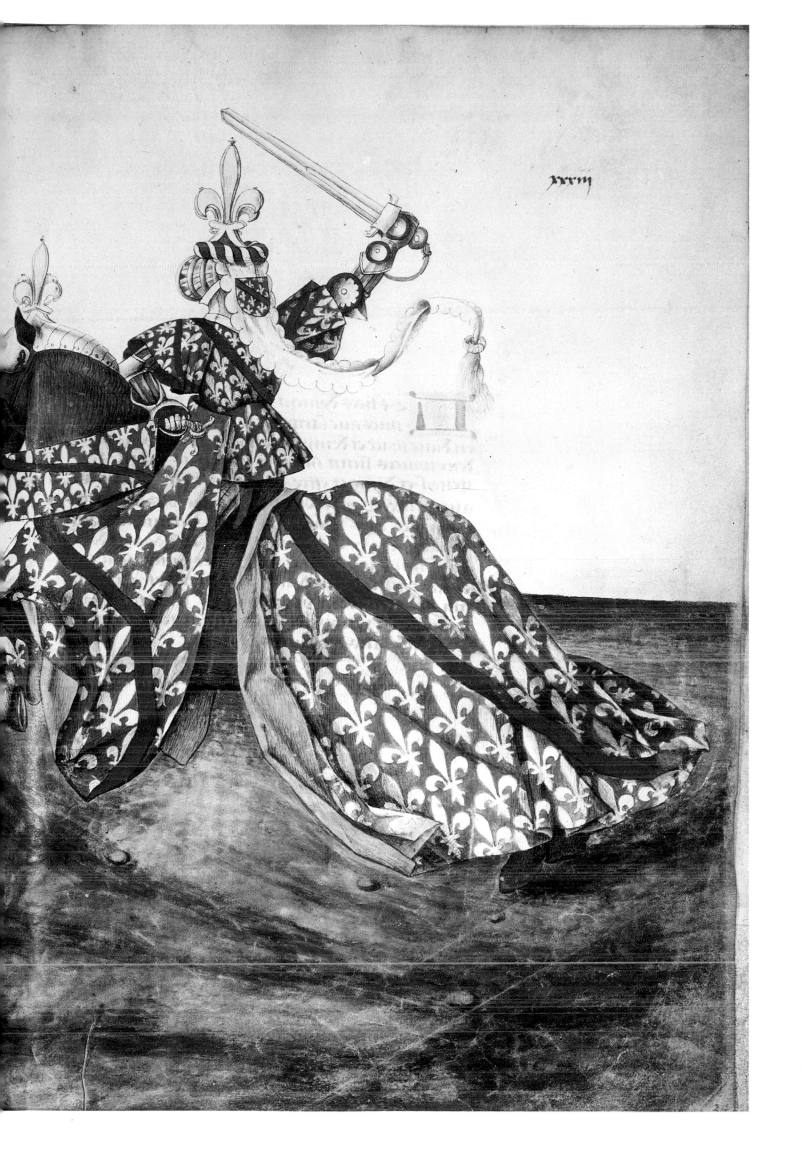

Gimignano, and in a similar series of frescoes depicting the months at the castle of Buonconsiglio in the north-east of Italy, where the month of February is represented by a tournament. In France, Charles VI held a Shrovetide joust at Troyes in 1420, and the first Sunday in Lent is called '*béhourd* Sunday' in documents of that period; but it is in Germany that the tradition was strongest, with examples from Nuremberg in 1401, 1446, and 1454: in the latter year Albrecht of Bavaria and Ladislaus of Bohemia took part, and the nobles jousted against the Nuremberg patricians. There is a delightful illustration in Marx Walther's tournament book which may represent a Shrovetide joust, with figures in fools' clothing in the lists: the tournament was evidently regarded as part of the carnival itself. Jousting made one of its very rare appearances in Rome itself during the carnival of 1473, when cardinal Riario, nephew of Sixtus IV, gave two prizes for jousting, to be awarded by a panel of judges. The jousts were regarded as a great success: not only were none of the participants injured, but there were none of the usual robberies and other crimes common in the city at carnival time.[45]

Time of year Tournaments were also associated with Christmas and Easter, but to a much lesser degree, and Martinmas, at the beginning of November before winter set in, is another date that recurs in the records. Christmas jousts were very much a question of the enthusiasm of a given household for jousting: the three best examples are the court of Savoy in the 1340s, the English court in the second half of the fourteenth century and the court of Saxony at Ansbach in the 1480s, all groups renowned for their interest in the sport who evidently held fairly informal jousts during the Christmas period. Easter and Whitsun, which were equally times when royal courts assembled, also saw jousting: the most memorable example is the Castilian joust on Whitsunday with the king and his team dressed as God and the Twelve Apostles.

Day of the week Taking an even narrower focus, can we identify a particular day of the week associated with tournaments, and even a time of day? Here we come down to practicalities. In general, tournaments were not held on Sundays or holy days, though there are plenty of exceptions which prove this rule: and again in general terms, Monday or Tuesday were popular days for starting a tournament, particularly if it was to last several days. Folgore di San Gimignano makes tournaments the characteristic of Tuesday in his sonnets on the days of the week, a companion sequence to that on the months of the year.[46] René d'Anjou, in his treatise on the holding of tournaments, implies that Tuesday was the customary opening day.[47] This would mean, as we shall see, the 'vespers' or practice for new knights, was on the Monday, and three days of jousting could be completed before Friday, which was of course a fast day.

Time of the day As to the time of day, tournaments usually began in the afternoon, largely because the process of arming the knights and organising them was a protracted one; there are several examples of events which only began late in the day, with a consequent shortage of time. At Chauvency in 1285, the tournament began 'at vespers', which in summer would imply about 6 p.m. So it is not surprising to find that jousting took place at night: Edward III jousted at night at Bristol on 1 January 1357, an event 'the like of which for magnificence had not been seen before'.[48] Nocturnal jousts were popular at the Castilian court in the second quarter of the fifteenth century: at the end of the jousting held by the king of Navarre during the great festival at Valladolid in 1428, knights continued to fight throughout supper. Likewise, a tournament given by Alvaro de Luna in 1436 at Alcala de Henares continued after dark at his lodgings, by torchlight. In 1448, a foot combat was held at night at Escalona, by the light of torches suspended from the ceiling, and jousting during or after supper was also a feature of some of the great Burgundian festivals.

Organisation

Once a time and a place had been chosen for a tournament, how was it organised? First of all, word had to be sent to those who might want to take part, or a specific challenge had to be issued. In the twelfth century, given that tournaments were banned by the church and also by secular rulers, the arrangements were evidently made among a small circle of enthusiasts, augmented by knights who 'rode in search of tournaments' like St Bernard's visitors in 1149. The enthusiasm for tournaments in Picardy and the Low Countries in the 1170s and 1180s was relatively local, and developed from the eagerness of a small group of great lords to take part in the new sport. Baldwin of Hainault in 1168 was the first of these, and he was followed by count Philip of Flanders and Henry, the eldest son of Henry II, in the 1170s and Arnold of Ardres in 1181–2, as well as Geoffrey duke of Brittany and many lesser lords. Each of these maintained a retinue for tourneying purposes, and it was therefore a relatively simple matter to arrange a tournament: indeed, they were so frequent that in many cases the date and place for the next encounter must have been fixed at the end of the preceding tournament. A book of formula letters prepared by a Florentine lawyer with connections in the German imperial court in the early thirteenth century contains a specimen letter inviting a knight to a tournament:

> Word has gone out in various parts of France that various princes and an infinite number of knights are to gather for a tournament in Flanders next Whitsun. So that you may increase your fame, we exhort you not to delay in coming to such a joyful and exciting gathering.

This is followed by another specimen letter, dissuading a knight from tourneying on the grounds of danger and expense![49]

Expeditions by a lord in search of tournaments could produce a series of encounters. Edward I set out on such a tour with a large company of knights in 1260, and fought in tournaments in France: he met with little success, losing horses and armour and finally being wounded himself in June 1262.[50] Bursts of local enthusiasm for the sport leading to a series of tournaments can be found throughout the middle ages, usually inspired by the interest of an influential nobleman or prince, though occasionally they seem to have been spontaneous, as in Germany in 1377, when the Augsburg chronicler notes that 'the lords, knights and squires held numerous tournaments thoughout the country'.[51]

Tours in search of tournaments

The lord of Cronberg's record of his son's tourneying activities quoted earlier shows us a series of events within a few months, and other German records indicate that the date of the next tournament was often fixed at the end of the previous one: at Nuremberg in 1434, the prizes or 'dank' involved the obligation to hold a tournament:

> The first 'dank' went to the count of Katzellenbogen, to hold a tournament a fortnight before Shrovetide: the second 'dank' was given to von Rechberg, a fortnight before Martinmas near Essling; the third 'dank' was given to Frauemberger, on St Catherine's day at Regensburg; the fourth 'dank' went to the younger margrave Albrecht, because he had jousted very well even though he was not yet knighted, to be held at Shrovetide at Neuenstadt.

Overleaf: the king-at-arms about to start a tournament, from René d'Anjou's treatise. The detail is carefully depicted, down to the two men with axes ready to cut the ropes and the men-at-arms with staves positioned between the double fence around the lists. (Bibliothèque Nationale MS 2693 ff.62v–63)

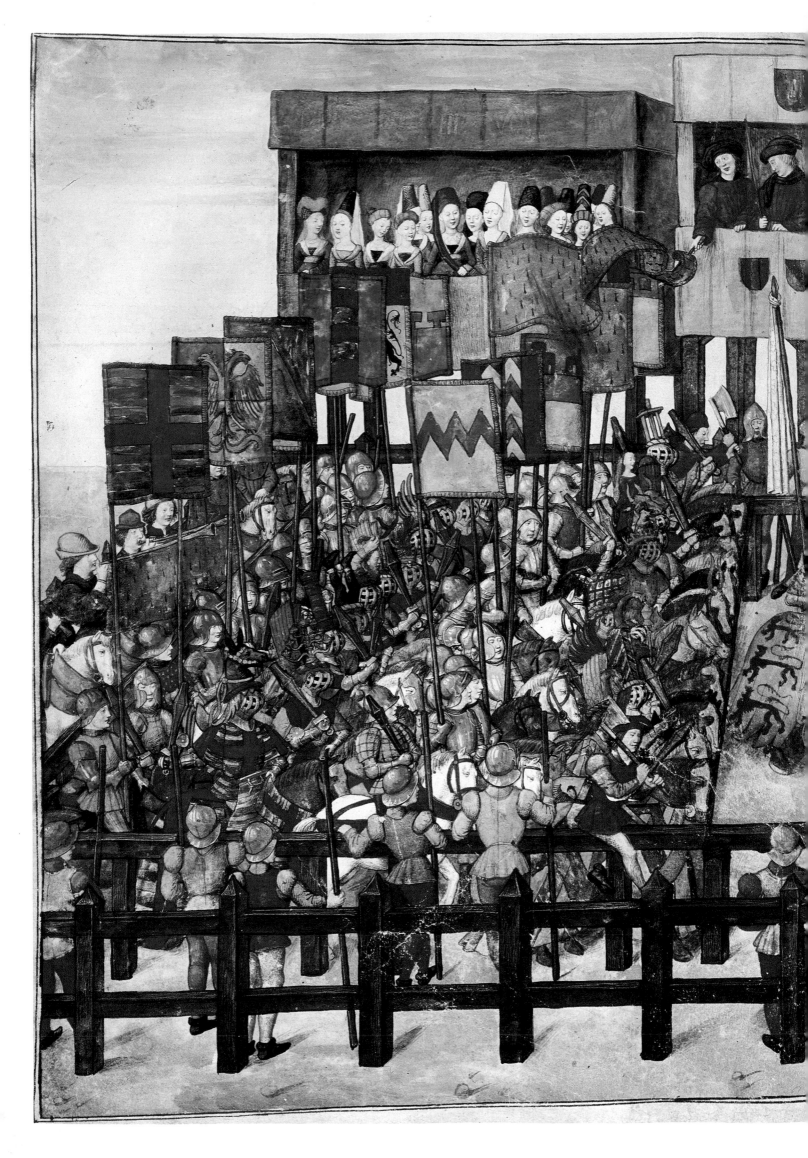

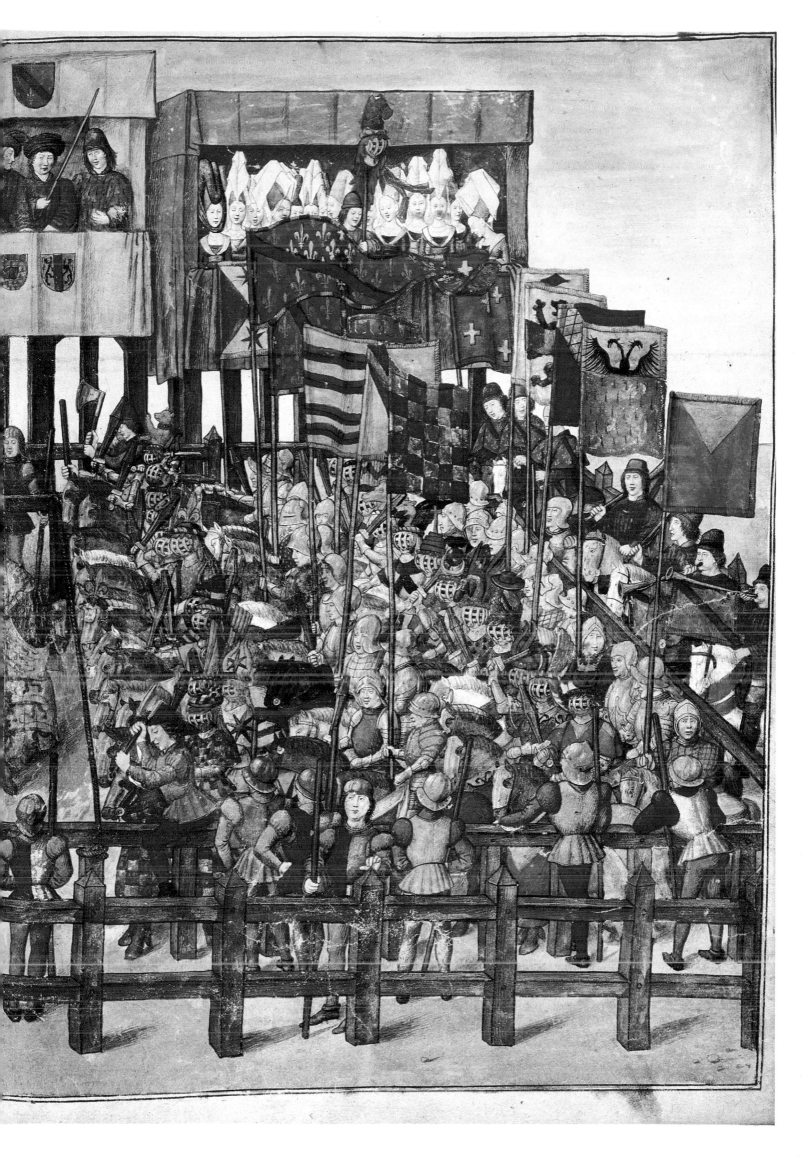

As tournaments became less frequent in the later middle ages, a more complex system of summons had to be arranged. From the fourteenth century onwards, the usual method of publicising a princely tournament was to send out heralds; the English royal accounts show Edward III doing this in 1344. We have already noted how duke Albrecht Achilles of Brandenburg arranged for letters to be sent to the jousters whom he wanted for his son's wedding months before the event: the setting up of a major tournament could involve years of planning. The best account of the organisation of a tournament that we have is in René d'Anjou's treatise on the form and devising of a tournament, written about 1455–60, after his series of splendid festivals. It reflects his own experience of organising such festivals, though he says that he has also investigated German and Flemish customs, and older French traditions. Much of what he describes would have been familiar to the tourneyers of earlier centuries, though the fifteenth century tournaments were more ceremonial, with a greater insistence on rank and status. For a start, only a prince, or a great baron or banneret should hold a tournament. Before issuing a challenge, he should find out privately whether it will be accepted or not, evidently to avoid public embarrassment. The challenge itself should be presented by a king of arms or leading herald, who is to offer a blunted sword of the type used in tournaments to the recipient of the challenge; if the latter accepts, he takes the sword, saying that he undertakes the tournament solely to give pleasure to the challenger and to please the ladies, not out of any ill will. He then selects the four judges from a list of eight provided by the challenger's herald. Once the judges are selected, and have accepted their task, the tournament is to be proclaimed by the king of arms in person in the courts of the challenger and the defendant, and in the king's court; other heralds are to be sent to the courts of lesser nobles.

René d'Anjou's treatise, c.1455–60

Challenge to tournament

The proclamation of the tournament contained the essential rules for the occasion as well as the details of date and place. The arms are specified – clubs of a set measure and rebated or blunt swords, and the tournament armour is discussed in detail: René prefers the French style to that of the Low Countries, where the method of arming a knight makes him end up looking wider than he is tall, 'and so I will say no more about it'. The general layout of the lists is also specified.

Assembly of jousters

All those wishing to take part are to assemble four days before the tournament itself, when the princes and other lords who wish to display their banners at the tournament – a sign of status which also implies that they are producing a team of jousters for the occasion – enter the town where the event is to be held in solemn procession. All those taking part have to display their shields at the window of their inn. The judges are to take up lodgings in a house of religion or somewhere where there is a cloister or courtyard in which the shields of the tourneyers can be displayed on the evening of the tournament. On the evening of the day of arrival, a dance is held, during which the shields are inspected: four cases are given for which a knight may be excluded from the tournament, a question to which we shall return later.

René evidently envisages a number of teams under the leadership of great lords rather than individual contestants, and in the remaining pages of his treatise he specifically describes a tournament and not the series of jousts which formed the major part of his own festivals. The overall organisation was much the same, with challenges issued well in advance, but the jousts would attract individual knights from much further afield. The ceremonial was usually determined by the scenario written for the occasion, and theatrical settings and pageantry played a much greater part than in the event which René describes. But whether jousts or tournaments were involved, the picture is one of an event which required careful planning and considerable

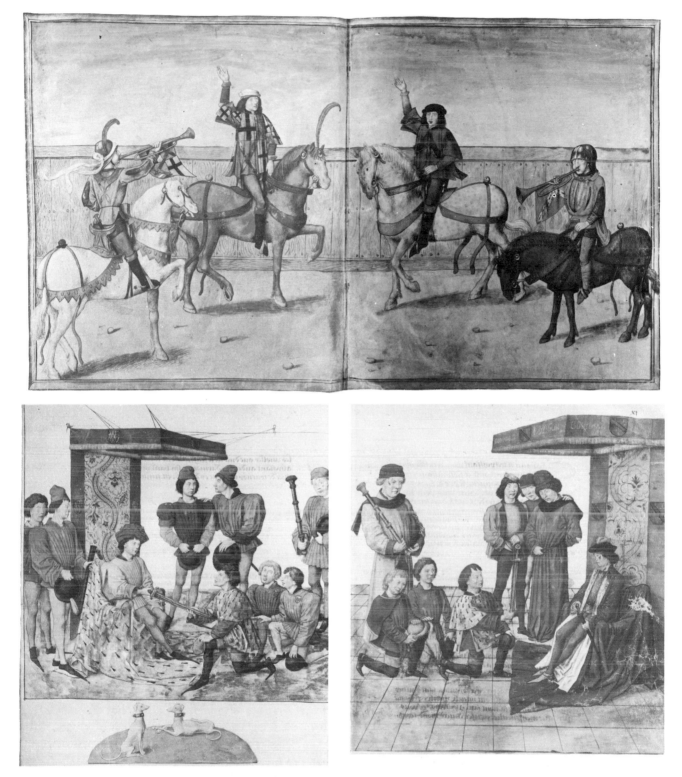

The preliminaries to a tournament: above, two heralds and two pursuivants sound and proclaim a tournament.
Below left: the duke of Brittany gives a sword as token of his challenge to his herald, with instructions to take it to the duke of Bourbon. Below right: the latter receives the sword from the herald. From René d'Anjou's treatise.
(Bibliothèque Nationale MS Fr 2693 ff.30–1, 90, 11)

Overleaf: the mêlée with swords, from René d'Anjou's treatise. In their enthusiasm, the knights have broken out of the lists; notice also the banners displayed.
(Bibliothèque Nationale, MS Fr 2692 f.67v–68)

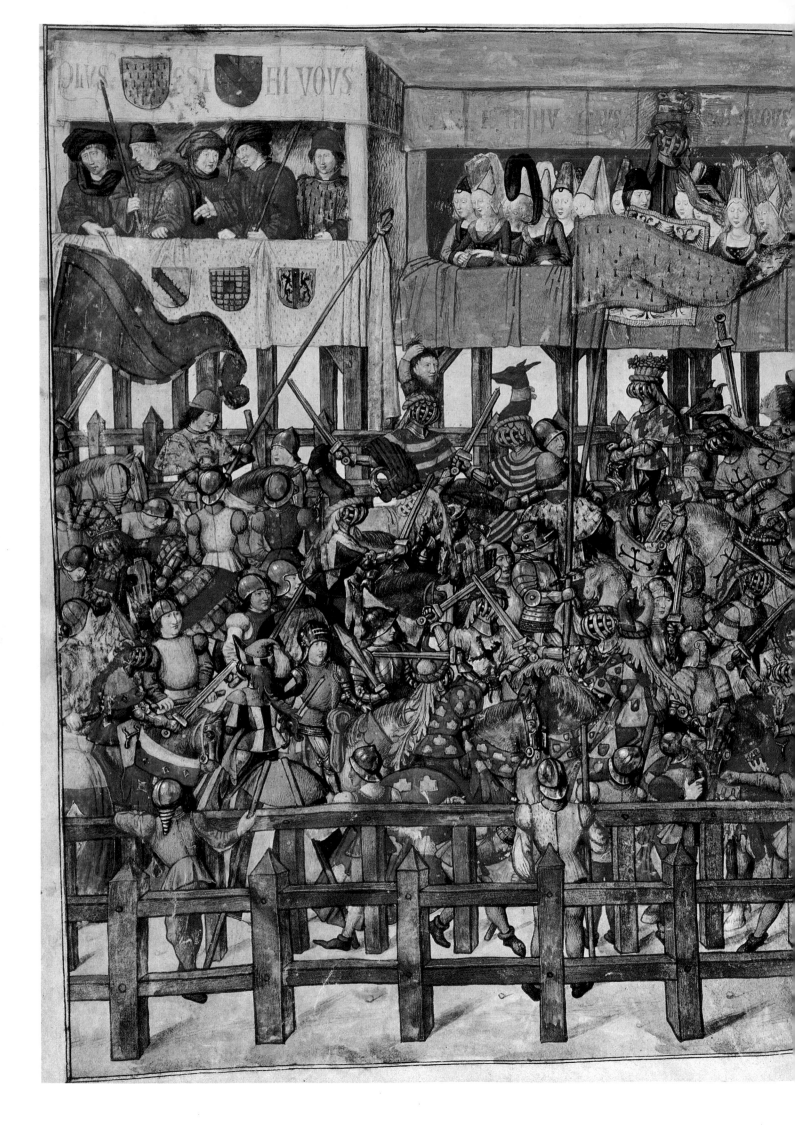

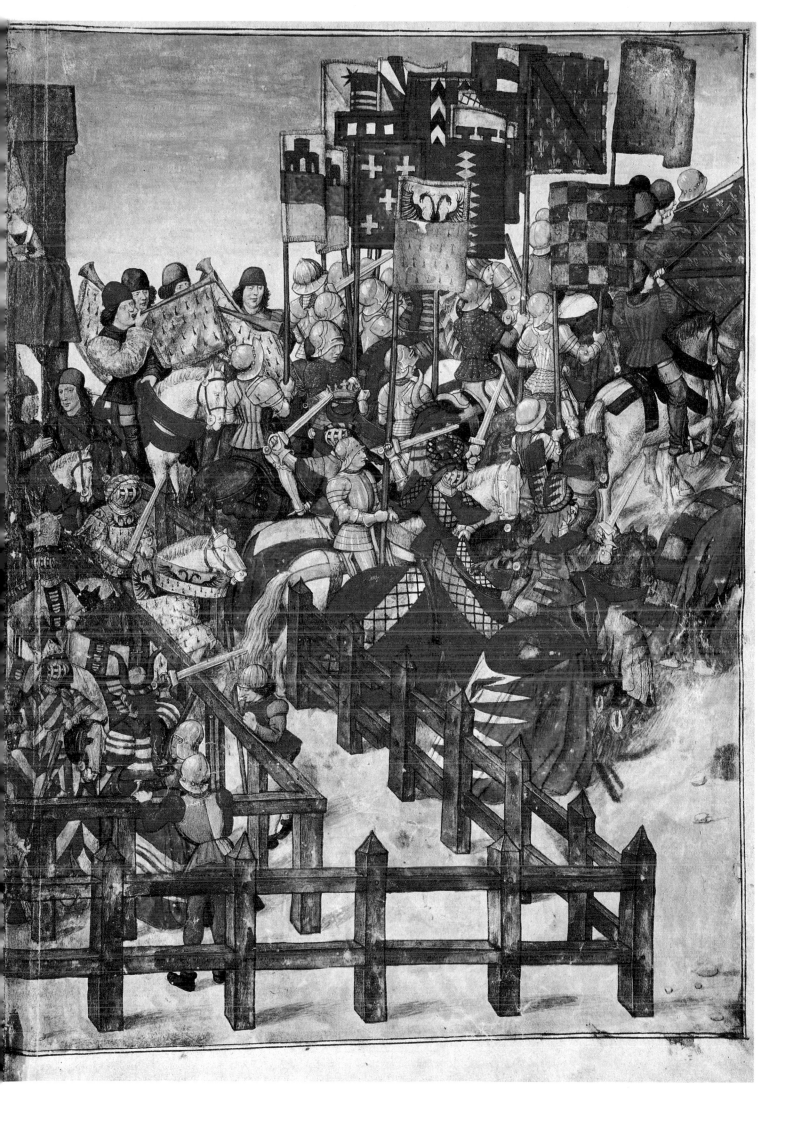

resources of both manpower and money. For the town where a tournament took place, it could be an economic windfall, and there are numerous ordinances from the German cities which regulate prices at the inns during tournaments, to prevent the visitors from being exploited.

Numbers A major tournament did indeed involve very large numbers of people, quite apart from the knights themselves. When the Black Prince celebrated the birth of his eldest son at Angoulême, a reliable witness tells us that there were 154 lords, 706 knights, and – perhaps less accurately – 18,000 horses:[52] though such a figure is far from impossible if we consider that each participant might well bring two horses for the jousting, and one riding horse: and an average of ten attendants each, with baggage horses, would quickly bring the total up to something like that figure. The ten jousters who went to the Brandenburg wedding in 1476 were part of a company with about a hundred horses. Most events were on a smaller scale, however: where jousting rather than a tournament was concerned, there might be only a dozen participants, and we have seen how few challengers appeared at some of the fifteenth century passages of arms. But – and this is equally true of the Angoulême gathering – many knights would be present as spectators. Sometimes the number of combatants was specified, thirty against thirty or fifty against fifty: this type of combat recurs frequently in the Spanish records in the 1420s and 1430s. The German jousts, on the other hand, seem to vary widely in numbers. At Göttingen in 1368 we actually have a list of the participants in the records of the town's expenses for hospitality, which gives a total of 162 knights and attendants, quite apart from those whose names were not recorded.[53] As many as 353 jousters took part in a Nuremberg tournament in 1434, while at Landshut in 1452, so many knights turned up that two separate tournaments had to be held.

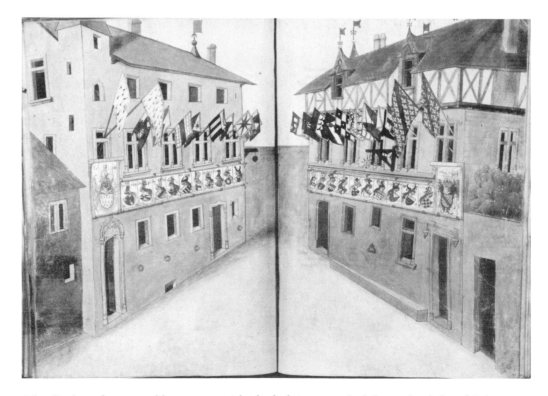

The display of arms and banners outside the lodgings: on the left are the duke of Brittany and his followers, and the right the duke of Bourbon and his followers. From René d'Anjou's treatise.(Bibliothèque Nationale MS Fr 2693 ff.54v–55)

Qualifications and restrictions on taking part

In the early days of tournaments, there seems to have been little restriction on those who could take part: anyone who could acquire a suit of armour was welcome. In practice, this usually meant that the participants were knights and squires, but this was only gradually formalised. The concept of a separate event for younger knights and squires was an early development, and this gradually grew into the idea that only knights could take part in tournaments. But this was far from universally accepted: we have already discussed the long tradition of bourgeois tournaments in the Low Countries, where the citizens would assemble for an annual joust.[54] In the Baltic towns we find the 'courts of king Arthur' or *Artushofe*, a kind of bourgeois order of the Round Table; these often included annual jousts as part of their ceremonial.[55] And in the great south German cities, we find the leading citizens, such as Marx Walther, jousting as a team against the nobles.[56] In Italy, where knighthood and feudalism were less sharply defined, jousting was an almost entirely civic sport.

So it was only in England, France and Spain that knighthood and tournaments were closely associated, and the patronage of tournaments was the exclusive preserve of the magnates. However, perhaps the most exclusive tournaments of all were to be found in Germany, as a kind of reaction to the general openness of entry into the lists in the towns. From the late fourteenth century onwards there was a determined attempt to restrict admission to tournaments to those of knightly descent, a movement closely linked with efforts to rally the knightly class as a political force. Only those whose great-grandfathers had taken part in tournaments were to be allowed to participate, and stringent rules against unknightly behaviour were introduced. These regulations reached their height in the 1480s, but their origins go back at least a century, and owe something to French customs: Anthoine de la Salle notes wryly that some would-be

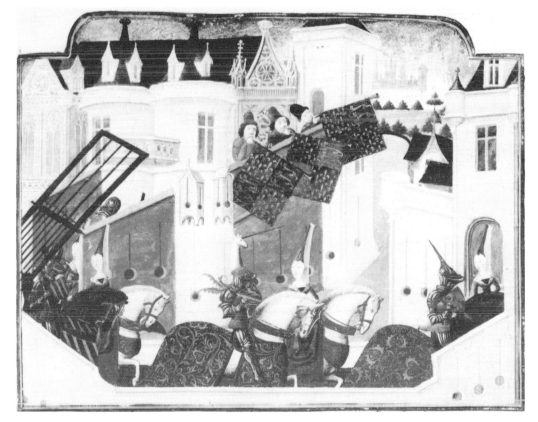

Entry of knights and ladies into the city of Pavia for a tournament: from a fifteenth century French manuscript.
(BL MS Harley 4379 f. 99)

jousters in a tournament in Lorraine in 1445 had difficulty in remembering how to describe (or blazon) their arms, and were afraid that they might be refused entrance, so he did his best to help them. René d'Anjou describes penalties for infringements of knightly conduct in his treatise in tournaments in the 1450s very much in the same vein as those to be found in contemporary German manuals: his list is simpler – with only four headings – but the punishment of putting the knight concerned on his saddle on the barrier surrounding the lists for the duration of the tournament, after beating him and confiscating his horse, is also found in the German records. The exclusions are found at their most elaborate in the regulations for a tournament at Würzburg in 1479 which deliberately set out to revive the then neglected sport. Fourteen clauses list those who are not to be admitted, ranging through perjurers, slanderers, cheats, cowards, adulterers, destroyers of churches, and bandits to those who cannot show that their ancestors tourneyed in the last fifty years and anyone tainted by trade, just as one of René d'Anjou's four disqualifications was for usurers.[57]

Two years later, at Heilbronn, the offences are divided into two classes: minor offences for which a beating only is decreed before the knight is expelled, and those for which the knight is to be placed 'on the barrier' as well. The first category includes adulterers, those who have married outside the nobility, those born out of wedlock, and those who engage in trade, in other words social rather than criminal offenders.

Obviously, such a public and formal procedure required proper proof, and the way in which accusations were to be made and considered was also laid out. The accuser had to make his charge at the inspection of helms before the tournament, as in France; the accused could ask for the matter to be put to arbitration, but if a knight succeeded in falsely accusing another knight, he was to be punished at any future tournament. Anyone who put another knight on the barrier without advance notice – presumably by *force majeure* – was to be permanently excluded from tournaments.[58]

Tournament as court of honour

The tournament thus briefly became a kind of social court of honour. We first hear of this association of matters of honour with the tournament in 1286. The duke of Bavaria was widely believed to have executed his wife on a trumped-up charge of adultery; at a tournament at the imperial court held at Cologne, a hundred knights appeared bearing shields showing a headless lady, 'to shame the duke', at which the court was disbanded. We have already quoted Pero Tafur's eyewitness account of a tournament at Schaffhausen in 1434, where social regulations similar to those at Würzburg were in force.[59] Tafur was, however, only a spectator; Wilwolt von Schaumburg's biographer tells us what it was like to actually inflict a beating on an adversary in the lists. The quarrel arose out of accusations made by Wilwolt's young cousin against a certain Martin Zollner, who had swindled him out of his inheritance. Wilwolt ordered his men to attack Zollner in the tournament; they pulled him out of his saddle, laid him on the horse's back and beat him. Then they cut his girth and put him on his saddle on the fence surrounding the lists. Wilwolt explained his actions at the dance after the tournament, but Zollner tried to challenge him as he rode home. Their friends reminded them that such a duel would be in breach of all the rules, and the matter was referred to the next tournament. Wilwolt produced such good evidence that Zollner withdrew from the lists, but continued to challenge Wilwolt to a duel elsewhere, until he was defeated in the law-courts by Wilwolt's cousin and made to pay up.[60]

The real aim of these rules is to preserve the unity and character of the old nobility of birth against the threat posed by the increasing wealth of the townsmen and merchants, and the stress laid on the exclusion of children of misalliances between men of

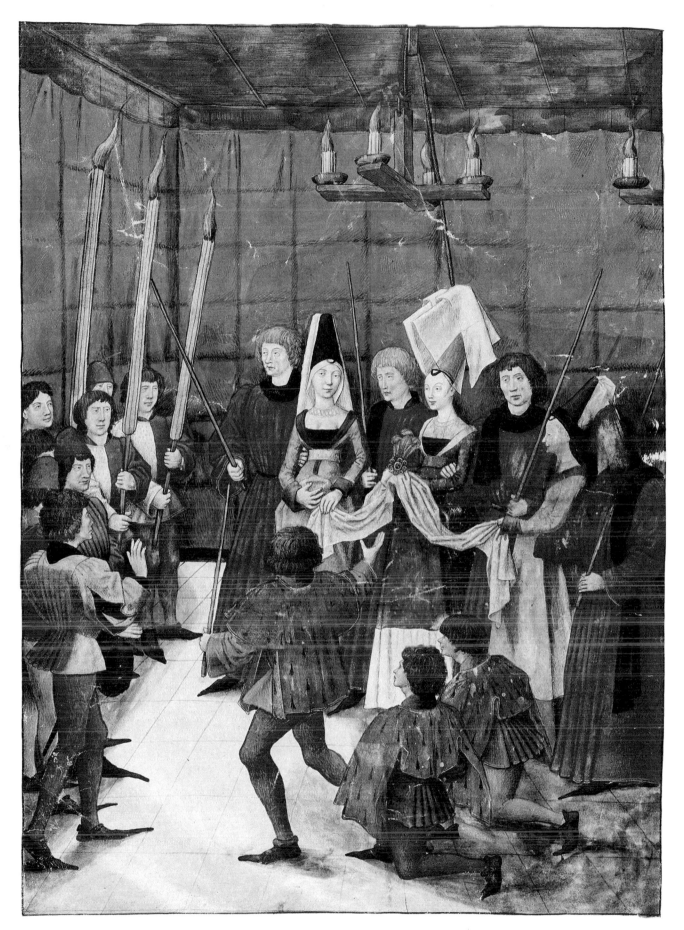

The presentation of prizes, in this case a jewel with a spray of ostrich feathers. From René d'Anjou's treatise. (Bibliothèque Nationale MS Fr 2693 f.70v)

Tourneying societies

noble birth and the daughters of merchants – a traditional way of restoring aristocratic family fortunes – is particularly interesting. The most tangible form of this deliberate revival of knighthood as a class is to be found in the tourneying societies, which aimed to become a kind of guild of knights centred round their favourite sport, but also with distinct political overtones. Confraternities of knights were not uncommon throughout the middle ages, and we have seen how secular royal orders like the Banda and the Garter had strong links with the world of tournaments. The earliest indication that such associations existed purely for the sake of tournaments is in Basel in about 1265, with the appearance of the two groups called 'the Stars' and 'the Parrots', so named from their respective banners of a great white star and a green parrot which they carried in tournaments. The green parrot was an emblem of the Virgin, and there is some evidence for jousts held annually on the feast day of Our Lady.[61] However, the tourneying activities of the two groups were only part of a much wider political rivalry, which spilled over into real warfare, and involved the contest between the bishop of Basel and Rudolf of Habsburg. The jousting was a formalised and respectable form of much deeper tensions in society.

A much closer parallel to the fifteenth century German tourneying societies is that founded by Henry of Lancaster in February 1344, when he received letters patent from the king confirming his appointment as leader of a group of knights from Lincolnshire who had agreed to meet each year on Whit Monday to joust at Lincoln. He was to be captain for life, and their meetings could be held even if a general ban on

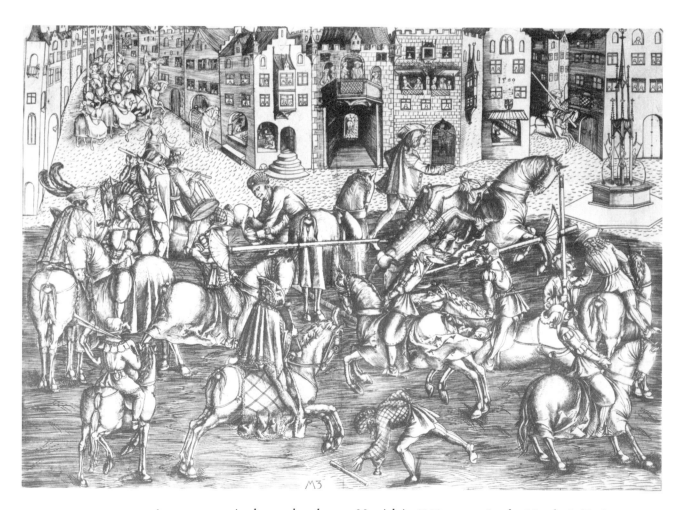

A tournament in the marketplace at Munich in 1500; engraving by Matthaüs Zasinger. Both musicians and squires are given an important place in the proceedings. (Staatliche Graphische Sammlung, Munich)

tournaments was in force or a war was in progress. Only if the king himself was holding a tournament on the same day were they not allowed to joust. We know nothing more of this society, although Henry himself continued to joust for another fourteen years.

The earliest German records which give us details of a tourneying society date from 1361, when a group of nobles from upper Bavaria formed a confederation with the political objective of bringing the young duke Meinhard of Bavaria under their control. The tournament was to act as a kind of annual assembly for the association, whose members were to wear the same livery at social occasions: 'and the society shall hold a court once a year, namely that is a tournament'. All members are to attend, or to pay a fine equal to the cost of actual attendance. A council of four is to be appointed to oversee the members, and members are to help each other in war. A chapel is to be founded in Freising, where masses are to be said for the members. All members are to own a warhorse if they can. At the annual meeting, all members must bring their wife, sister or adult daughter 'to honour the society'. Other rules provide for the recruiting and expulsion of members.[62] Again, we know little of what became of the society after its foundation: but with the *Gesellschaft mit dem Esel* (Society of the Donkey) we are able to trace its existence from 1387 to 1435.[63] The rules, which do not survive in their original form, seem to have been similar to those for the Bavarian society, but the leader was a 'king' who was elected annually. The primary object was to form an association of knights who would offer each other mutual support in adversity; beyond that, the society was intended to offer a suitable atmosphere in which chivalric culture could flourish. This was done through the society's feasts, of which the tournament was an essential part. The meetings were usually at Frankfurt, where the society rented its own quarters, including a dance-hall, from the town, and held jousts on the Romerberg. Unfortunately, we have only a very late version of the tournament regulations, dating from 1481, which seems to be copied from other sources.

Other evidence shows the societies in operation in the 1430s. A letter from the Society of the Ibex to the count of Jülich and Berg, dated 20 October 1438, asks him for advice and opinion as to the organisation of a tournament to be held next Shrovetide in Mainz, implying that the society was not influential or experienced enough to arrange such an event without help.[64]

By the 1470s and 1480s, after a period of relative decline, we find a dozen or more societies, who eventually grouped themselves into four 'lands', Rhineland, Swabia, Franconia and Bavaria, to give the sport a kind of overall controlling organisation.[65] The members were rarely the great princes, though we find Albrecht of Brandenburg writing to his son about his family's connection with the 'Perner' tourneying society. He describes how his ancestors and his father had belonged to the society, and he has joined the revived society in his own name and for his sons: 'we were always, with God's help, foremost in tournaments, and intend with God's help to stay there'.[66] The officers were usually elected from the lesser nobles: a letter from Konrad von Schellenberg, deputy of the king of the society of the Falcon and Fish, summoning a member to a tournament at Constance on June 19 1486 survives: he calls himself simply 'knight', with no higher title.[67]

The ordinances relating to tournaments proclaimed at Heilbronn in 1485 have come down to us; written by a committee of four of the tourneying societies, they declare that 'anyone who lives in a town of his own free will ... or engages in trade' cannot take part in a tournament.[68] The Heilbronn ordinances consist of 43 articles, and they are much more concerned with the status and morals of the participants than with the regulation of the fighting. A long list of offences merit the drastic punishment

German tourneying societies

Revival in the late fifteenth century

Heilbronn ordinances, 1485

of being 'put on the barrier'; the offender was beaten, unhorsed, and put on his saddle on the wooden fence which enclosed the lists, rather as though he was in the stocks. Many of the offences for which this punishment was prescribed were criminal – murder, highway robbery, rape and arson – but others, such as pursuit of a feud without due and proper notice, are questions of knightly ethics. Such a punishment could only be carried out if the offender was notified beforehand at the inspection of coats of arms and helms, and false accusations were severely dealt with. Lesser misdeeds, such as marrying outside the nobility or engaging in trade, were punished simply by confiscating the offender's horse. The social regulations extended to the dance after the tournament as well; only participants in the tournament were to be allowed to dance, and elaborate prohibitions against excessively costly dresses were laid down: women were only to bring three or four embroidered dresses, and noblemen were not to wear gold and silver ornaments on their doublets. It is only at the end that the regulations touch on the actual organisation of the tournament, and even then it is principally to ensure correct announcement of the event, to limit the number of retainers, and to provide for safe-conducts for participants. The actual fighting is scarcely mentioned; one of the last clauses decrees that only one tournament each year is to be held in the boundaries of the 'four lands' (Bavaria, Swabia, Rhineland and Franconia) so that such events may be properly regulated and suitably impressive. There is a distinct feeling that the occasion has become more important than the sport, because frequent tournaments would have undoubtedly enhanced knightly skills.

Tournament rules

The rules to be observed during a tournament grew in complexity as the sport matured. As we have seen in chapter 1, in the twelfth century, there were only a handful of limitations. The critical distinction between tournaments and war was of course that the object was to unhorse and capture opponents, never to kill them and preferably not to injure them. From a very early date, areas of retreat were provided, where knights could retire to rest themselves and their horses, and repair their armour. There were also boundaries of a kind by the end of the twelfth century. It was agreed that knights who were captured forfeited their horses and had to find a ransom, but could not be held prisoner once they had promised to pay. This had not always been the case, as a letter from Henry, son of count Theobald of Blois, to abbot Suger in 1149 shows: he asks Suger to intervene to get his vassal Reginald to release Anseric of Royaumont, whom he had captured in a tournament.[69] There were also quite complicated arrangements about the intervention of footsoldiers in support of a knight, either to help him to capture another knight or to prevent him from being taken himself. By the early thirteenth century, there were evidently agreements that certain types of blunted weapons would be used on a particular occasion, and it seems that the 'round tables' were a kind of temporary association in which each member swore to obey set rules covering the combat. These rules developed into the pre-conditions attached to all the great passages of arms in the fifteenth century, and into the ordinances of the German tourneying societies: we know little about the actual rules for fourteenth century tournaments, though there is evidence for tournament judges and even scoring in Bologna in 1339. The three 'superestantes zostrae', 'overseeing the joust' are named, their duty being to see who won; a notary was present to write down

the blows at their dictation. The most interesting evidence for fourteenth century regulations is also the most tantalising, Geoffrey de Charny's 'Questions on jousting and tournaments' written in the 1350s for the members of the shortlived French Order of the Star.[70] Alas, we have only the questions, none of the answers. But the questions do shed some light on the problems that arose. The 'Questions on jousting' are concerned almost entirely with the winning and losing of horses. When should a knight be awarded the horse of the opponent he has just vanquished: for instance, does this apply if no terms have been proclaimed before the joust, and is it also valid for squires? And when should a knight who had killed or injured his opponent's horse make reparation? If both knights fall, should they exchange horses? If a knight acts as a substitute for another who is wounded, and wins a prize, should the prize go to the wounded knight or to his stand-in? Evidently the capture of horses was of just as much concern in Geoffrey de Charny's day as it had been when William Marshal made his fortune in the tournaments of the 1180s.

Geoffrey de Charny's 'Questions'

The questions on tournaments open with a different set of problems, chiefly those of service in a retinue, and the occasions on which a knight retained by one lord can fight under another's banner. We learn that it was the custom for all knights to swear an oath at the beginning of a tournament; if a knight failed to swear such an oath, should he be excluded? What exactly constitutes a tournament, and what happens if knights continue to fight after it has officially been declared at an end? Here we learn of the presence of *diseurs*, arbitrators or judges: the word occurs as early as the 1230s in the romance of Fulk Fitz-Warin, where 'judges, heralds and *diseurs*' are grouped together; by the fifteenth century, René d'Anjou talks of 'juges-diseurs', and the two functions have evidently merged, if indeed they were ever separate. The problem of whether a horse should be forfeited or not reappears in later questions; other points of debate concern late entries, and what should happen if knights continue to fight of their own accord after the tournament is formally declared at an end.

All this paints a more mercenary picture of the sport than we get from other sources. The capture of horses was highly important, as the overall prizes were often of less value than a single horse, though the honour of winning the prize was more important than the financial gain: William Marshal was once awarded a 'fine pike' as a prize, and one source even claims that talking parrots were offered to the winner.[71] The Italian civic tournaments give a fairly consistent pattern, such as the splendid helmets created by the jewellers of Florence as prizes for jousts there; French and Burgundian tournaments usually had a jewel as a prize, and the 'dank' at a fifteenth century German tournament was similar. Lengths of cloth were also occasionally given, but the prizes at Bruges in 1429 are typical: rubies, gold chains and diamonds.

Prizes

For a detailed account of the rules for armour and fighting, we have to look at the ordinances for the Würzburg tournament of 1479.[72] Here there are twenty brief articles on admission to the tournament, followed by rules for the type of sword to be used – at least three fingers broad and blunted on edges and point. No other concealed weapons are to be carried and the sword is only to be used in the first part of the tournament. The swordplay is in fact the second part of the proceedings, the *Nachturnier* or 'after-tournament'; the first stage is fought with batons, a peculiarly German tournament form. No-one is to carry more than one baton, and regulations for the behaviour of the attendant footsoldiers or squires are laid down. Interestingly, the 'weapon master' was to see that the tourneyer could continue in the lists for as long as five hours, during which time the servants could only intervene in order to hold their masters' horses.

Würzburg tournaments

Scoring It is only in the late fifteenth century that real evidence of scoring has come down to us: until then, it appears that breaking lances or unseating opponents were the only incidents which had a definite 'scoring' value. Sir John Tiptoft's ordinances of 1466 set out a scoring system, 'reserving always to the queen and to the ladies present the attribution and gift of the prize, after the manner and form accustomed'.[73] These are best set out in a table, as Tiptoft's account is confusing:

Highest score: unhorsing an opponent or bringing down both man and horse
Second highest: breaking two spears coronal to coronal, i.e. tip to tip
Third highest: striking the visor three times
Fourth highest: breaking most spears

Disqualifying incidents:
striking a horse
striking a man with his back turned or when he is without his spear
hitting the tilt three times
taking off the helm twice, unless caused by problems with the horse

Broken spears score as follows:
breaking a spear on an opponent between the saddle and the base of the helmet: one spear
breaking a spear from the tip down: two spears
breaking a spear and unhorsing or disarming an opponent, or breaking a spear coronal to coronal: three spears

Left: a richly illuminated Tudor jousting cheque, recording jousts at the Field of Cloth of Gold in 1520 between members of the French and English royal households. Eight courses were run. Right: another jousting cheque showing how scores were marked.
(Society of Antiquaries, MS 135; BL MS Harley 2358 f.22)

Penalties:

breaking a spear on the saddle: minus one spear

hitting the tilt once: minus two spears

hitting the tilt twice: minus three spears

breaking a spear within a foot of the tip does not count as a broken spear, but as a good blow.

In tournaments, there are other disqualifications: a blow beneath the waist or under the barrier with a pike, use of any device to fasten the sword to the hand, dropping a sword, resting on the barrier during the fight, and failing to show a sword to the judges beforehand. We have a few surviving scorecards or jousting cheques from Tudor times: these indicate, however, that scoring had become less complicated since Tiptoft's day, and only broken spears were usually being counted.[74]

Tournament sites: the lists

We have mentioned the early tournament fields, on which the only distinctive feature were the specified retreats where knights could rest and recuperate. As the sport became more organised, the wide-ranging *mêlées* of William Marshal's day gave way to a more disciplined and restricted form of fighting, enclosed inside palisades or ditches. As spectators were more and more part of the proceedings, so it became essential to provide some protection for them, and to surround the fighting area with a stout fence. This soon became a double fence: between the two barriers were stationed the footsoldiers and squires who went into the fray to help their masters if they were in danger. In the fourteenth century, in the German towns, we find the town guards posted there, both to keep the tourneyers in and to prevent illicit entry into the fray. René d'Anjou describes in detail the stout wooden construction, the height of a man, with one high bar and one at knee level, made of strong timber, which was needed: in his day, the footsoldiers of the tourneyers and the armed guards mingled in the space between the barriers.

The area of the lists varied according to the number of participants: René says that they should be one quarter longer than wide. At Venice in 1332 Piazza San Marco was completely cleared, 'lest men should be injured by the horses and so that the game might be better performed'.[75] They had to be covered in sand and straw, and even then water-carriers might be needed to keep down the dust. We have the instructions of the clerk of the works at Nuremberg in the 1450s for preparing the marketplace for jousts: it was the duty of the New Hospital to see that it was spread with dirt or dung, but if sand was required this had to be arranged with the plasterers. The wood for the fences was stored in a shelter 'on the right hand as you go out of the Frauenthor'. He once had to do the job in a hurry, and it took him five hours with fourteen horses to lay the sand. The dimensions of the lists are to be agreed with the marshal in charge of the tournament.[76]

The lists

Perhaps the best description of lists comes from the records of the Field of Cloth of Gold, because the setting-up of these lists was the subject of much diplomatic correspondence between Francis 1 and Henry VIII. The field was 328 ft wide and probably 900 ft long, surrounded by a ditch and bank and double railing. The main spectators' gallery was on the other side, but less lavishly equipped. The two kings armed themselves in wooden chambers and tents inside the lists, while other comba-

tants had a small encampment linked to the lists by a bridge over the ditch. The 'tree of honour' was also within the lists.[77]

The tilt There was considerable debate at the Field of Cloth of Gold over the tilt, or barrier down the centre of the lists. The French wanted 'counter-lists', running parallel to the tilt, down each side; but Henry insisted on them being dismantled, and as a result the horses tended to serve outwards, and their riders missed their aim. The tilt itself was a relatively late innovation, and it was introduced with precisely the intention of ensuring that the horses ran true and did not swerve or collide. Such evidence as we have indicates that it was a Spanish or Portuguese innovation. Gutierre Diaz de Gamez, describing the adventures of his master Pero Niño at the French court in 1407 says that 'the French joust after another fashion than that followed in Spain. They joust without lists, and strike after the fashion of war'. Gamez was writing in the 1440s, and it is not entirely clear whether he was referring to the practice when Pero Niño was in

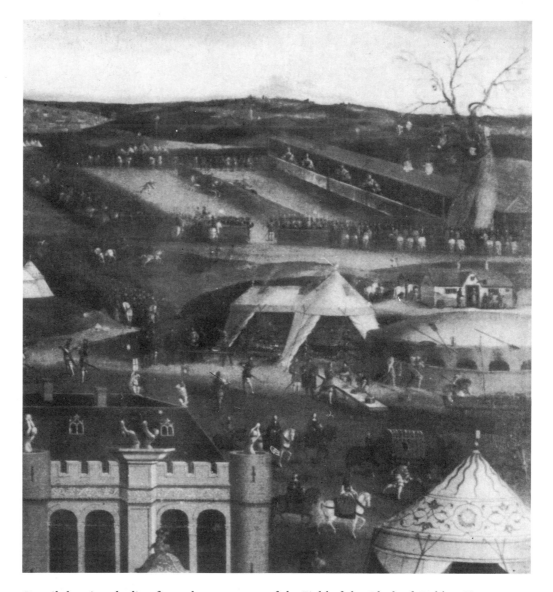

Detail showing the lists from the panorama of the Field of the Cloth of Gold at Hampton Court; although not strictly accurate, it does give a general impression of the layout, and of the 'tree of honour'.
(Reproduced by gracious permission of HM the Queen)

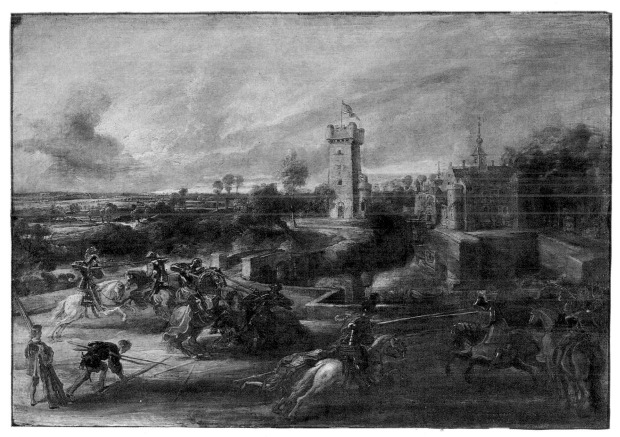

Tournament outside a stronghold by P. P. Rubens.
(Paris, Musée du Louvre) *(Photo Scala)*

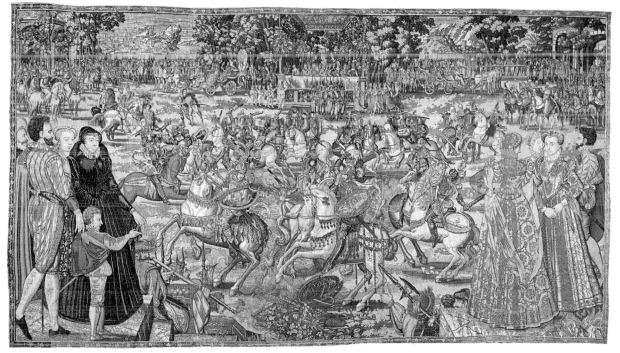

'Tournament of the Knights of Great Britain and Ireland' at Bayonne, 1565, from the
tapestries commemorating the festivals of Catherine de Medici: the participants are dressed
in classical armour, and the event was probably an early form of 'carrousel'.
(Florence, Uffizi) *(Photo Scala)*

France, or at the moment he wrote. There is certainly no evidence for the tilt in France before the 1430s, and we find the word used in Spain as a synonym for a joust in 1431 – to 'maintain a tilt' meant to hold a joust. At Valladolid in 1428 the king of Castile, the king of Navarre and the infante Don Enrique 'came to the tilt'.[78] The Spanish word is 'tela', cloth, and the tilt may originally have been a cloth suspended from a rope down the centre of the lists. It quickly became a padded wooden barrier, often brightly decorated: at Valladolid it was 'green and emerald halved'. The Burgundian ambassadors sent to fetch Isabella of Portugal in 1428 describe the Portuguese fashion of jousting as if it was a novelty:

> Next day, 27 September, after dinner, there was jousting in the Rua Nova in Lisbon, which was spread with a great deal of sand. There was a fence of stakes fixed into the ground at intervals, to joust along, which was hung with blue and vermilion woollen cloths.[79]

The following year, at Isabella's marriage to Philip the Good, two days of the week of jousting that was part of the celebrations were set aside for jousts in the Portuguese style. The barriers surrounding the lists were taken down, and a tilt of very solid wood covered in blue cloth was erected across the area of the lists, as high as the horses' shoulders. Shields covered in steel and steel helms were used, as well as campaign saddles rather than the jousting saddles. Jean le Fèvre notes that few spears were broken, not because of the tilt, but because the coronals slid off the polished shields at an angle. In the following year, 1430, Piers de Massy, before his fatal joust with John Astley at Paris undertook to 'make that fielde and the Telle in the myddis for to kepe our horses God save and kepe them from harme'. As late as 1465, when Leo von Rozmital visited Brussels, he and his Bohemian compatriots jousted in a different style to the Burgundians: 'for my lord's pleasure', Philip the Good 'arranged a tourney in a manner of his country across a barrier. Then many noble princes dukes and counts, clad in the most costly gold and other array, tilted together.'[80] The fashion seems to have reached France in the 1430s; the evidence of miniatures in copies of Froissart's *Chronicles*, showing the jousts at St Ingelvert in 1390 being held in lists equipped with a tilt confirms this. By the mid-fifteenth century, they were normal in the west, but in Germany jousters seem to have come round to using them only in the last decades of the century.

Jousting techniques

Although the tournament and jousting were very much an international sport, there were evidently local differences in technique. We know relatively little about the detailed skills in jousting involved; apart from one book by Duarte of Portugal in 1434, there are no treatises until the sixteenth century on managing a horse and lance. What we glean is by chance, and often as a result of a casual comparison or remark. As early as 1168 there were distinct names for different strokes; the count of Flanders, attacked Baldwin of Hainault's companion Godefroi Tuelasne 'struck him in the midst of the chest with a blow commonly called "from the fewter"';[81] although the word *fewter* is found in many later texts, its meaning is uncertain; it may simply mean couched lance.[82] We can get a sense of basic tactics from the descriptions in the *History of William the Marshal*: the knights fought in close order, in orderly groups; if they

broke ranks or tried to be first into the fight, their action might result in defeat for their side. Philip of Flanders specialised in waiting until the opposing groups had broken up before attacking, and would then charge them on the flank, and hunt down any isolated knights.[83] The tactic of a charge on the flank ('a la traverse') is reflected in Wolfram von Eschenbach's *Parzival*, where five identifiable types of manoeuvre in a tournament are described. *Ze treviers* is Philip of Flanders' flank attack, while *zer volge* is simply the pursuit of a defeated enemy. *Zem puneiz* seems to have been the opening head-on charge, each knight aiming for his opposite number to the left, the lance couched across his horse's neck and aiming for his opponent's shield. *Ze rehter tjost* is the straightforward joust between two knights. *Zentmuoten* is a manoeuvre in which an individual knight turns to challenge a group pursuing him.

Apart from these glimpses, we learn only that differing regional styles had developed by the fourteenth century. About 1300 we hear of a distinct Swabian style of armour.[84] A poem describing the festivities at Speyer for the marriage of John of Luxembourg in 1310 implies that the Bohemians had a distinctive manner of jousting, and this tradition seems to have continued to the end of the fifteenth century. We find Richard II buying a saddle in the Bohemian fashion for the jousts at Smithfield in 1386,[85] and in 1465 when Leo von Rozmital's comrades tourneyed among each other at Cologne, 'the tourney was in its manner quite extraordinary to those of Cologne, and caused much astonishment'. We have seen how the Spanish and French use of tilts was mentioned as a major difference by Diego Gutierre de Gamez: he goes on to note other divergences, such as the French custom of a free-for-all even in jousts, with multiple combats taking place. 'Their fashion of making a trial is to joust one against the other, with as great force and as hard as each man best can, except that in these trials they wear neither surcoats nor crests; they leave these for festivals'. And he also comments that 'the French, after they have run three or four courses, at once disarm'.[86] From the French point of view, the Flemish and German style was distinctive in terms of armour and saddles; René d'Anjou comments that it was like the French jousts in times gone by.[87] And Olivier de la Marche remarks on the way that the Spaniards wear their helms loose, which led to unnecessary injuries in one of the challenges at the *Pas de la Belle Pèlerine*.[88]

Different styles

By far the most detailed information on jousting technique is to be found in *The Art of Good Horsemanship*, written in about 1434 by no less a personage than Duarte, king of Portugal. It gives a vivid picture of what it was like to enter the lists; it is very rare to find a medieval text that speaks so directly of practical matters, the nearest parallels being the aristocratic manuals on hunting and falconry. Duarte's prime concern is of course with horsemanship pure and simple, but several chapters deal specifically with jousting. In the fourth chapter, he discusses the ways in which the lance should be carried:

Duarte of Portugal on jousting

> You can carry the lance in your hand in four ways; with the lance running along the arm with the arm extended; with the lance a little higher and crossing over the mane of the horse; with the lance over the left hand or arm; and with the lance either below or above the belt. In all cases it is necessary to balance the lance properly. Light lances are more suitable for carrying with the arm extended. It is dangerous to carry the lance across the mane of the horse as it may catch on trees or cause other problems. Carrying it over the left hand or arm is good practice if you want to fight towards the left or towards your back.
> On the waist is more appropriate for carrying heavy lances. ... In a tournament you carry your lance on your leg, supported by a pouch placed on the bow

of the saddle or on your leg as you prefer. Others prefer to carry the lance only on the thigh or between the thigh and the bow of the saddle, but those who carry it well without any other help show greater strength and skill. In any case it is necessary to have the lance well supported before charging with the horse as the lance may be pointing upwards or towards the left. To correct this problem you must do the opposite and lean your body backwards or towards the right ... When carrying the lance on the waist, one can commit the following errors; holding it in the middle, the tip too high, the hand too near the shoulder, in the direction of the face, the elbow too low. If you want to carry the lance properly you must do the opposite of what has just been described. It is more elegant, easy and profitable whether you are wearing armour or not.[89]

The next chapter deals with the actual handling of the lance and how to acquire the necessary skill:

When training anyone, do it with him standing on foot and show all that is required using a small lance or stick. This is what you should teach: if the lance is being rested on the leg, which is what most people do, hold it with your hand supporting it from below. If you rest it on your chest, put your hand as close to your arm as you can and bend it in such a fashion that it can be used as a rest for your lance. The weight of the lance must be supported by the palm of your hand and not your fingers. And when you want to place the lance under your arm lift it in such a fashion that the shaft is free from your arm, but once you have the lance under your arm, then hold the shaft as tight as you can, resting it partly against your chest, taking care not to twist or lean forwards but keeping a straight posture in order to be able to catch your breath. And do try to do it with a certain flair. This point is very important when aiming the lance without a lance-rest, as this way the lance is being supported in three ways: by the hand that supports it, by the arm that holds it tight, and by the chest against part of which it is being held. You must lift the lance with a sudden movement, as it is the easiest way. And when you pull the lance away from your waist move your arm away as it was explained above. If the lance has a guard make sure that during this operation it does not end up behind your waist, for it is very awkward and you can be hurt when not wearing any armour. And when you can handle a small lance move on to a big one gradually so that you do not run the danger of a rupture, backache, headache, or any pains in your legs or hands. When you can handle a lance on foot, then try it on horseback, but always have someone who can advise you of any mistakes you are making ... If you carry the lance under your arm, do not allow the tip to tilt upwards, especially if you are facing the wind or the horse is cantering, but hold the lance firmly in the position you want to use it and then guide it to meet your target. If you are riding at a gallop, the best practice according to our custom is to press your feet down squeezing your legs tight and allowing your body to go with the rhythm of the movement of the horse. At this point take the lance from your leg, position it on the lance rest and fit it under the arm as described above.

If you control the lance from the horse's neck and you are not using a lance-rest, when you want to lower it make sure it does not tilt, as was said before. And if you have a lance-rest, allow the stem of the lance to strike your elbow and holding it in this position you can then guide it into the rest. Never allow your lance to tilt down; let your hand support it properly. ...

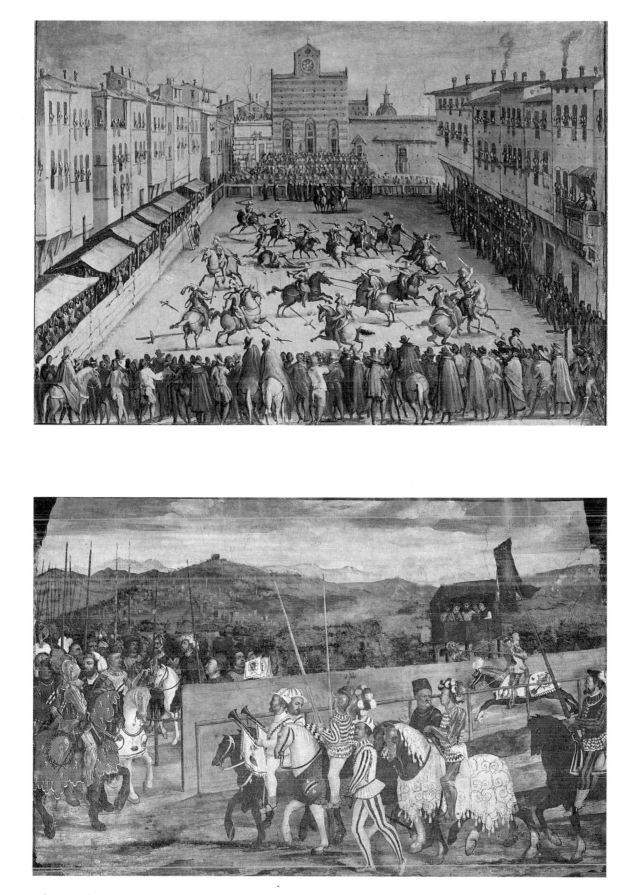

*Above: a late sixteenth century tournament in the traditional jousting site at Florence, the
Piazza Santa Croce.(Florenze, Palazzo Vecchio) (Photo Scala)*

*Below: a sixteenth century Italian painting of a joust, with a high boarded tilt.
(Malpaga, Castello) (Photo Scala)*

Duarte of Portugal on jousting

This is a piece of advice that I developed when I was fighting unarmed but with a long and heavy lance: when lifting it, before it fell on my shoulder I would allow it to slide through my hand a little. I did this in order to stay firm in my saddle and to prevent the weight of the lance from throwing me out of balance; and I think this is good practice. Yet there are some who know how to do this unarmed but find it difficult if encumbered by the armour, the lance rest, the arm shield or any other part of their armour, or by their equipment, or by their horse's, or because they are equipped beyond what is possible in order to keep their movements free. Therefore before you have to do all this in real fighting it is advisable to train yourself first, even on a stationary horse, and take your lance up to the lance rest three or four times whilst wearing full armour or equipped as you intend to be in battle or in tournament; this is very important in order to be able to handle your lance and aim it straight. If you want to fight unarmed one day, you must beware of wearing anything that might be cumbersome such as silk or clothes encrusted with small metal plates so that you cannot manoeuvre adequately while wearing them; ensure that the sleeve of your jacket is not too tight or too short, and that the sleeve of the surcoat does not get in the way when you want to bring the lance up under your arm.[90]

The sixth chapter deals with aiming at and striking a target, both in hunting and jousting:

I will discuss jousting first, as this is of the utmost importance, and men often fail to score a hit for lack of sight, poor control of their lances or horses, or lack of determination. As for sight, some close their eyes when they are about to hit, and yet they do not realise this because they are concentrating so much. Others realise that they close their eyes but cannot stop themselves from doing so. Others lose sight of their target because they are wearing their helmets or carrying their shields incorrectly. Others cannot see because at the point of meeting the other knight they only turn their eyes or their heads, but continue in the same straight posture. In order to remedy these four errors it is important to have someone whom you can ask where you failed or where you struck, for if you hit very hard you cannot find out by yourself. And if the person who is watching you finds that you are not hitting every time, or that you are straying from the target, he must tell you that you cannot see, and advise you to keep your eyes open; so that you can avoid the first error mentioned. And if you close your eyes because you cannot help it, that is a very difficult error to correct ...

And if the rider is not striking his target because he is pointing his lance too late, advise him to point it earlier, so that even if he cannot see, at least he is more likely to hit by chance, and when he succeeds, that will encourage him to keep his eyes open next time. Any errors related to the way in which you carry your armour or how you train can be corrected in the following way: when you are ready for jousting and mounted, lift your lance and hold it under your arm. Make ready your helm and shield, and hold the lance at the height you want for the charge; then move from one side to the other, but make sure that you can see half the lance, or at least a third of it, keeping it that way right to the end of the charge. And if you are not doing this, correct yourself immediately, for I do not think you can hit on target if you cannot see. In order to obtain good sight from inside the helm, you must first tie it at the back and then at the front, tightening it as best you can. This way the helm sits firmer and corresponds better to your line

of vision than if you do it the other way round. In order to see well at the point when you encounter your adversary, it is necessary that as he approaches along the tilt, you keep your body square on to him, and when you are about to strike, then turn your head towards him as much as you can, in order to see him directly and not through the corner of the visor ...

As far as the second point is concerned, i.e. control of the lance, there are also four main errors you can commit:
The first is to be badly armed or poorly equipped in respect of your arm, lance rest, shield, rondel or leather handle.
The second is because you are using a lance heavier than you can handle.
The third is because you are not secure in your seat and comfortable in your saddle.
The fourth is because you have your horse so badly collected that you lose control of the bit.
As to the first, a good remedy is to practice so many times that you do not suffer any hindrance from any part of your equipment by the time you take part in the joust. Try lifting your lance under your arm three times as suggested previously, until you have fully mastered it.
As to the second, never use a lance too heavy for you to handle.
As to the third, steadiness and skill is gained from knowing exactly how to perform, as I mentioned previously. And in this case I found it good practice, according to our custom, to ride rather upright, with the stirrups long, and having a well designed saddle: not too wide, not too tight, cut deep where the legs are supposed to fit, and provided with good cushions and padding. The saddle should not throw you backwards or forwards, but should allow you to ride steadily, skilfully, and with good control of yourself and your lance.
As to the fourth, the horse must be easy to control with the bit or the spurs; it should not be unruly, stop suddenly, or be so restless as to hinder the jousting rider. This can be remedied by being a little harder on the bit, but not so much that the horse shies or throws its head down; and you must not be heavy on the spurs, which should be short and blunt.

For, in my opinion, I do not regard as good jousters those whose horse is brought to them by the rein; then somebody else goads the horse for them with a stick. A good jouster must bring in his own horse, controlling it with the reins or the spurs, holding it back or spurring it on, and bringing it up to the tilt or heading it away as appropriate. For if the horse is handled in any other fashion, few can control their lances and perform well as jousters, even though a horse that charges very fast and wears head armour allows the lances to be held more steadily once these have been fitted into the lance rest.[91]

The following chapter returns to the main theme of horsemanship, but with specific reference to handling a horse in the lists. Much of the advice applies to riding in general; riders who are unable to control their horses because they have unsuitable bits, or who are unable to get their horses to charge in the desired direction lack basic skills. But it is fascinating to find the theme of the rider who does not attempt to control his horse, already mentioned in the previous chapter, brought up again; evidently there was a class of jouster, whether from inexperience or choice, who launched himself like a missile down the lists and hoped that he would make contact. Another intriguing detail is the presence of aids to help the jouster stay in the saddle:

in order to hold themselves firmly on their horses during the charge, some have ropes which come from the front part of the horse and are held in the hand with the reins. They pull these ropes so tight that the horses can scarcely be controlled with the reins ...

In order to avoid [this] mistake, concerning the ropes coming from the front or girth of the horse to help steady the rider and which do not give the rider any control over the horse, the reins must be used in the following fashion: once you have marked the place where you want to hold your reins [with a knot or bar] as described above, then get yourself armed and hold the reins either by the knot or by twisting them once around your hand. At this point, lean backwards in the saddle and fix your ropes where you hope to find them when you need them. The reins should be shorter than the ropes; the latter should not hinder the progress of the horse but should provide extra help to the rider if required.[92]

The last chapter concerned with jousting is perhaps the most revealing of all, because it deals with the psychology needed to become a successful jouster. No chronicler (and indeed, although we have not included them in our witnesses, no poet) gives us anything approaching the feel of entering the lists in the way that Duarte's down-to-earth description does:

Owing to a lack of confidence, those who joust can fail in four different ways:
Firstly, because they want to avoid the encounter.
Secondly, because they veer away, fearing the moment of encounter.
Thirdly, by failing to keep their body and lance steady because of the effort required.
Fourthly, they are so anxious to gain an advantage over their adversary that they end up by failing.

As to the first point, some fail because they are led by their own instinct to avoid the encounter, wanting to protect themselves from a certain opponent or because their horse is so weak or their lance is so thick that they know that they cannot enter the encounter without receiving some injury ... Some fail because of this first attitude, however, when people seek their own safety and avoid danger and trouble. It happens like this. When someone enters a joust, he is determined to fight, and this determination is still present when he takes hold of his lance. But as he approaches his adversary, his instinct advises him to avoid the encounter; his determination immediately contradicts this, and this inner struggle is conducted all the time he is charging down the lists. Sometimes his instinct pulls his body away from the line of charge and aims his lance away in order not to encounter his opponent. And as soon as he has missed his adversary, the jouster is very disappointed with himself and determined to be firmer next time. But when he takes part in other jousts, his free will decides to follow this weak and evil instinct rather than his strong and virtuous determination. ...

The second way in which you can fail – namely because fear leads you into straying away from the line of the charge – is also caused by the weakness of the flesh; but there is this difference. The first group I referred to simply decide to avoid the encounter and pull their lances away, but the latter are determined to be firm, and in bracing themselves and their whole bodies, they close their eyes, thus failing to encounter their opponent; or else in bracing their bodies, they brace their arm too tightly and cause the lance to deviate from its target. ...

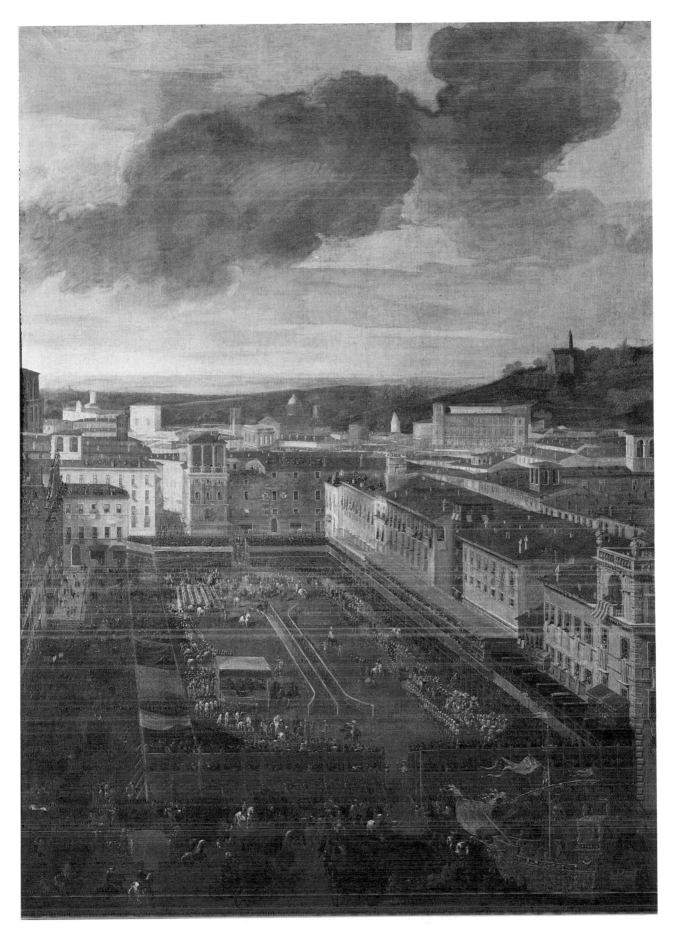

Seventeenth century jousts in the Piazza Navona, Rome, showing the arrangement of counter-barriers to ensure that horses ran straight. (Museo di Roma) (Photo Scala)

The last error comes from wanting to be in a position of advantage over your opponent; here the instinct is to avoid danger but nonetheless to strike and injure the adversary. If such a position of advantage does not present itself, this kind of jouster prefers to miss the encounter altogether ... This is done without taking any account of who or what they are competing against, or of what sort of horse they are riding ...

In order to avoid the attitudes described above, you must follow your reason and understanding. Consider what is the right course of action to take, and force yourself along that path, supported by your effort, reason and practice ... Think of your initial determination to strike home in the encounter as you first started riding the tilt; remember it throughout and do not allow yourself to be distracted from it. Remember how few accidents result from taking part in an encounter of this kind compared with the accidents which result from taking part in the 'juego de cañas' (game with canes) or from hunting or fighting in battle, in which people engage without any great fear. You should feel the same about jousting, and you will then be prepared beforehand for any shortcomings or fall, rather than wanting to avoid meeting your adversary. And if you hold firmly to this decision and are quite determined to follow it, you will perforce meet your adversary in the end. To guard against the tendency to brace yourself too firmly in preparation for the encounter, you can chose one of three alternatives: either to hold yourself and the lance in a relaxed fashion, or to hold yourself so tight that it is difficult to hold that position for long and by the time you come to the encounter you will already be more relaxed. And the third alternative is to carry the lance a little loosely so that by the time you tense yourself to get courage, it naturally comes into the right position to strike the adversary.

As to wanting to be protected by unfair advantage, this should be avoided by any reasonable jouster. He should take into account himself, his adversary, his horse, the lances being used, and then encounter his opponent. And if you think that you have an advantage, lower your shield, for I always feel that you cannot be a good jouster if you are unable to take some risk. And besides this, you can also take the following two pieces of advice. First, when you lower your lance under your arm, if your adversary is not too near, let the lance point a little lower than where you intend to hit. This is done for two reasons: first, in order to see more clearly the place where you intend to hit; second, in order to stop yourself from lowering the lance too far when you are bringing it down. The second piece of advice, and this is the main method of striking on target, is to have your eyes set firmly on your target and force your body and intention to remain set until you think you can see the iron tip of the lance arrive at its intended target.[93]

Duarte ends his main account with some comments on the role of servants on foot, which again shed unexpected light on the difficulties faced by the jouster; the problems of visibility and of mounting and dismounting were evidently considerable, even for good jousters:

And since I have written so much on how to joust, it seems fitting to write something about the men who serve on foot even though this has nothing to do with practised skill; but I have seen many jousters being poorly served irrespective of the large number of men they had with them. If a jouster has three men to serve him, he should place one at each end of the tilt and one in the middle. The men at both ends must see to three things: firstly, that when the jouster is

returning from the charge, he must keep him away from the tilt and help him to turn safely; for I have seen many jousters injure their feet because they turned a little short of the end of the tilt, particularly if it did not have an end guard as is the fashion nowadays. These jousters would strike their feet off the tilt. Secondly, he must help the jouster to take his feet off the stirrups if he wishes to do so. Thirdly, he must help to hold the horse steady in the place where the jouster wants it. And the man standing in the middle has three duties to perform: firstly, to pay attention to the jouster and to help him at once, if he needs assistance after the encounter; secondly, to collect the lance and hand it to the groom; thirdly, to collect any piece of equipment that may have fallen in the course of the encounter, and hand it to either of the men at the end of the tilt. And no matter how many servants you may have, they must always be organised in three groups, each performing one of these duties. They will be far more useful in this way than if they are all together with you.[94]

Duarte's point that jousters should not seek an advantage over their opponents is echoed in other sources in a slightly different context. Diego Gutierre de Gamez notes that the French fought with lances of equal size, and that only three master craftsmen were allowed to make them. The articles of many of the challenges of the fifteenth century stipulate that only lances and swords provided by the defender are to be used, and that the challenger is to have first choice. In 1481, Albrecht Achilles of Brandenburg wrote to Wilhelm of Jülich about arrangements for wedding jousts to establish the standard for armour and to set the measurement for the lances – 11 feet long from the coronal to the vambrace.[95] The German tourneying societies, as we have noted, also specified the weapons to be used in detail. Small wonder, then, that we find a knight writing to a friend in 1464 asking for advice as to some 'hidden art' which will give him an advantage in tournaments!

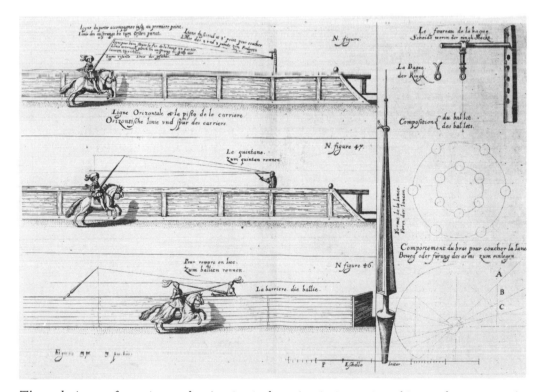

The techniques of running at the ring (top), the quintain (centre), and jousts (bottom), with details of the lance and ring at the right, and a diagram of the angles for couching the lance. (Fotomas Index, London)

The tournament as social occasion and the presence of ladies

The enthusiasm aroused by tournaments was not confined to the knights who took part. The tournament was a major social occasion from the early thirteenth century onwards, and the presence of ladies at such gatherings was taken for granted, though there is little direct mention of them. Pedro II of Aragon's tournament at Montpellier in 1207 in honour of his mistress is the earliest specific record of the patronage of ladies. About 1270, we hear of the marquis of Este holding a tournament in honour of a lady who was present, and ladies were present at Roger Mortimer's festival at Kenilworth in 1279, and at Chauvency in 1285. At Basle in 1315 many ladies were injured, and many jewels stolen, when a stand collapsed. By the 1330s, ladies were regular spectators at English jousts, and in 1331 the stands at Cheapside collapsed, again injuring many ladies. The implication is that the practice of building stands was a result of the presence of ladies, who could not be expected to mix with the excited rabble of citizens who were also watching. We catch glimpses of individual enthusiasts such as the countess of Luxembourg at Chauvency, and John of Bohemia's

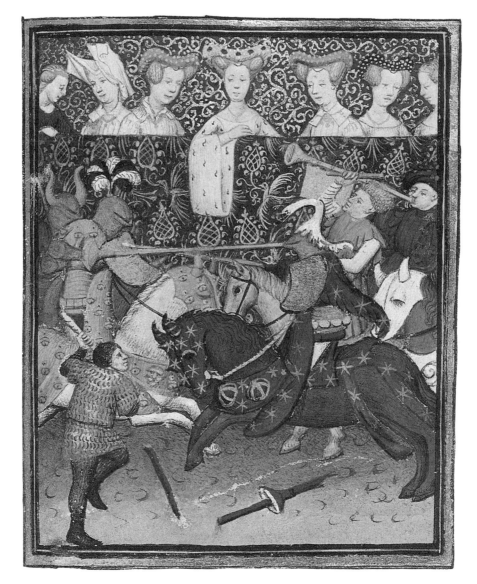

A fifteenth century joust before ladies. *(BL MS Harley 4431 f.150)*

second wife Beatrice; he is said to have married her precisely because of her love of tournaments.[96] In the 1480s Friedrich of Brandenburg held a tournament to entertain his mother, who was recovering from an illness. It is most unusual to find a lady who positively refused to watch, as was the case with Isabella of Burgundy: Olivier de la Marche describes how she would not watch a passage of arms in 1449, 'and I had never seen her come to watch a combat on foot'. Other ladies probably came simply for social reasons: Dorothea of Mecklenburg's request for a gilded coach to go to tournaments in 1467 reflects this side of the occasion.

Tournaments were from the beginning associated with dances; we catch a glimpse of this even in William Marshal's day, and there were dances at Kenilworth and at the tournaments of Edward III. At Chauvency, there was dancing every evening, and the ladies danced among themselves while waiting for the tournament to begin on the last day. Dancing was an essential part of Spanish and Burgundian tournaments, and it became formalised in the German tournament society regulations: those who committed a foul in the tournament were to be excluded from the dance, as were those who took part in the tournament without licence or without being properly qualified.

The prizes were traditionally given by ladies: William Marshal's prize of a fine pike was sent by the lady of a local castle, and a lady presented the bear which was a prize at the tournament near London in 1216. Sir John Tiptoft says that the award of the prizes was traditionally at the discretion of the ladies: again, we find this formalised in Germany in the shape of a *frauendank* or ladies' prize. However, the occasion at Ferrara when the ladies themselves competed for prizes in 1438 seems to have been an exception: after the jousts ended, 'all the ladies ran on foot in the lists. They had to run as far as a man could throw a stone.' The prizes were laid out at the other end, and were three fine pieces of cloth.[97] Here at least there would have been an easily distinguished winner: in the complicated scoring for jousts or the confusion of a tournament, the ladies' role in judging the results must have been a ceremonial one, the real work being done by the officers responsible for organising the tournament or by the judges themselves, as in René d'Anjou's description.

The other social aspect of tournaments was their function as spectacle, often involving ladies. The theme of the lady as inspiration goes back in literature to Geoffrey of Monmouth's *History of the Kings of Britain*, and reaches its height in Chrétien de Troyes' romance of Lancelot and Guinevere, in which Guinevere, unsure of the identity of a knight who has entered the lists incognito, sends word by a messenger ordering him to fight badly: when he at once turns from victor into vanquished, she knows that it is Lancelot. Perhaps because of the intimate involvement of Guinevere with tournaments in the romances, the proceedings at Le Hem in 1278 were under the direction of a lady playing 'Queen Guinevere'. We have already noted the 'round tables' which were a frequent form of tournament, and Sarrasin's poem about Le Hem provides us with a picture of a festival conceived in almost theatrical terms which may well have been typical of such occasions. In the Cyprus festivities of 1223, the courtiers are said to have 'imitated' the adventures of Arthur and his knights, and at Le Hem we find knights playing specific parts: Robert count of Artois acted Yvain, the knight with the lion; seven identically dressed knights appeared as knights who he had earlier rescued and sent to Guinevere, in the best tradition of the romances, and another took the unrewarding part of Kay, Arthur's bad-tempered seneschal. There was an ugly damsel as messenger, and all challengers had to be accompanied by a lady, and had to joust before they were admitted to the court.

So the literary framework of the round table tournaments had led into the theatrical world; and the jousters appear in many different guises. Ulrich von Lichtenstein is the

earliest example of this, and his Lady Venus is countered by a knight dressed as a monk. His apparently shocked response to the appearance of this challenger would imply that such impious disguises were still a novelty: in 1286 the courtiers at Acre appeared as nuns and monks at the festivities for king Henry's coronation, and we have already noted a series of jousts in religious disguises from the fourteenth and fifteenth century. The costumes would obviously have been simple enough to wear over armour, and must have been little more than a surcoat, a special crest and arms and perhaps devices on the horsecloths and trappings to indicate the character in question. The complicated tournament crests in standard use already represented a kind of costume; the jousters were already dressed for the part, and from there it was only a short step to playing with different costumes and identities.

Scenery of a rudimentary kind also appears in the lists at a relatively early date. Perhaps the most famous piece is the round table at Winchester, made in the mid-thirteenth century; though we cannot be absolutely certain that it was produced for a round table festival, this does seem its most likely origin. The trees of honour at the Nordhausen tournament of 1263 and its successors were a simple, early form of scenery, as was the canvas castle at the Mortimer jousts in 1328. The concept of scenery as a major element in theatrical presentation did not develop until the late fourteenth century, and we find tournaments adopting it at the same time, partly through their association with royal entries, and partly in the dramatisations of romance in the fifteenth century challenges. The idea of spectators on stands also gave the tournament a theatrical quality which few, if any, other events in the middle ages would have had, apart from the mystery plays presented by the town guilds.

The tournament began as an informal affair, martial exercises or mock warfare for knights and squires; by the beginning of the sixteenth century, form and formality have taken over, and the tournament is essentially an occasion, carefully planned in advance, held at specific times or for specific reasons, with its own literary and dramatic conventions. The apogee of the tournament is in the fifteenth century, when the reality of the fighting still balances the structure of ritual and theatrical invention superimposed on the martial exercise. So we come full circle to the events with which we began our exploration, such as the marriage of Philip the Good and Isabella of Portugal, in which magnificence and chivalry combine to make the tournament one of the great moments of medieval life.

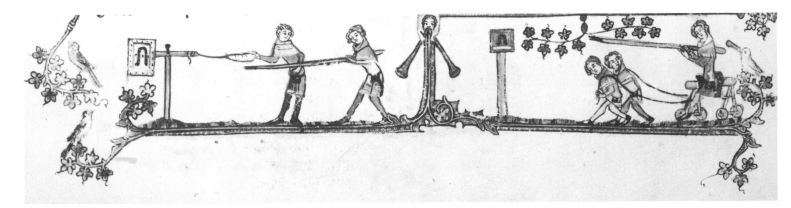

Squires training with a lance on foot, and on a tilting carriage: from the Romance of Alexander, dated 1344. (Oxford, Bodleian Library, MS 264 f.82v)

Epilogue

The tournament survived into the second decade of the seventeenth century in a form which the knights of three centuries earlier might still have recognised as their favourite sport; but with the outbreak of the Thirty Years' War in Germany in 1618 and the changing attitudes of the princes of the early seventeenth century towards their courtiers, both its vestigial military purpose and its function as an egalitarian sport among knights disappear. Maximilian might have made the tournament the preserve of the imperial court, but he fought with squires and courtiers alike as an equal. The absolutist rulers of the late sixteenth and early seventeenth century could not descend to such a level; they had to be set apart and glorified in theatrical spectacles, which, if they retained the name of tournament, had only a ritual enactment of a joust at their centre. Antonio Bandinelli, describing a tournament held for Don Juan of Austria at Piacenza in 1574, devotes 43 pages to a detailed description of the appearance of each competitor on a series of floats, while the jousting is over in a mere twenty lines. The theatrical element has submerged the original sport.

The only hero of the late sixteenth and early seventeenth century tournament was the prince himself. The great incentive of winning fame, honour or a lady's love by individual prowess had vanished, because the prince could brook no rivals, no stars of the joust. At the beginning of the sixteenth century, Castiglione had written in his highly influential book *The Courtier*:

> ... as far as sports are concerned, there are some which are hardly ever performed except in public, including jousting, tourneying and volleying, and all the rest in which weapons are used. When, therefore, our courtier has to take part in these, first he must arrange to be so well equipped as to horse, weapons and dress that nothing is lacking; and if he does not feel assured that everything is just as it should be he must on no account take part, for if he fails to perform well he cannot excuse himself by saying that this is not his profession. Next he should give full consideration to the kind of audience present and to who his companions are; for it would be unbecoming for a gentleman to honour by his personal appearance some country show, where the spectators and participants were common people.

Another factor in this change of direction was the development of horsemanship for display. A good horseman had always been admired in the middle ages; Gaston IV of Foix was admired for his display in the lists at Nancy in 1443. But the difference between the book by Duarte of Portugal and the works of the Neapolitan riding-masters in the 1550s is that a practical accomplishment has been turned into a formal ritual, if not an art form, in the shape of the 'manage'. This linked naturally with the ritual elements in jousting, the elaborate entries and parades, and ended by usurping the central place in such events. Warfare was imitated, not by a genuine contest but by a pre-rehearsed mock combat, which was only possible if the riders were expert enough to enact the same steps at each performance; the result is best described as a 'horse ballet'. The *carrousel*, as this new entertainment was called, can best be illustrated by one of the dozens of such events described by Claude-François Menestrier

in his treatise on the subject, the carrousel at Paris in 1606, we find a mixture of pure spectacle, symbolism and just a little real jousting. The carrousel was staged at night in the courtyard of the Louvre, and four teams of knights, representing the four elements, took part. The procession for the knights of the water had twelve sirens, a 'fountain-machine' and a chariot with sea-gods, followed by the twelve knights. Fire was represented by four smiths who hammered on an anvil, fireworks, the god Vulcan, but Air proved more difficult; Juno appeared as goddess of the air in a chariot with a large number of birds. A procession of Moors and two elephants heralded the knights of the Earth, and when all four teams were assembled, the knights fought singly, in pairs and threes and then all together: 'having broken lances, cutlasses, darts, arrows and shields in the *mêlée*, they each took a torch and returned to the Hotel de Bourbon.'

Even in the early seventeenth century, the tournament was still regarded by theorists as a valid training for war, but it was not only one among a number of such exercises. Medieval writers, such as João I of Portugal in his *Livro da Montaria*, had recommended hunting as training for war, since it required agility and horsemanship, as well as the handling of weapons. But the popularity of hunting was due to other causes: the chase has classical origins, and has outlived the tournament by several

The Eglinton tournament, 1839: the lists and the mêlée. These idealised pictures bear little relation to the rain-swept, sodden debâcle that actually took place.

centuries. A more direct replacement of the tournament as training in the handling of weapons was fencing. This originated in Italy and Germany in the late fourteenth century and was at first the preserve of professional swordsmen; initially it ranged across the whole range of defensive arts, including wrestling as well as fighting with weapons. Like the tournament in its early days, fencing was generally frowned upon by the authorities, although the German swordsmen formed organised guilds, the *Marcusbrüder*, during the fifteenth century. Fencing became an aristocratic pastime only when the element of wrestling disappeared, and pure swordplay was the accepted form of combat. The old heavy swords, designed for cutting, gave way to the fine thrusting swords developed by the Italian fencing-masters, who were soon the acknowledged champions of the art, with their light quick movements and deadly rapiers. The new style was taken up quickly in France and Spain, but did not find many followers in England until the late sixteenth century. It developed eventually into the modern short-sword fencing, but it was essentially an art for the duel – with which it was closely associated – and for sudden encounters; but it had no real application in the field, where artillery, the heavy sword and the pike ruled supreme in the seventeenth century.

The disappearance of armour in the late seventeenth century meant that any attempt to mount a proper joust became well-nigh impossible on grounds of expense; the armour for *carrousels* was often little more than an imitation of the real thing. The eighteenth century saw the rise of the military parade as an alternative and much less dangerous way of displaying a ruler's power and prestige. It was only with the renewed interest in things medieval at the end of the eighteenth century that efforts were again made to revive the sport. Most of these were very much in the theatrical vein, as with the festivals of Gustavus III in Sweden. Even the most famous of these revivals, the tournament at Eglinton in Scotland in 1839, owed much to a romantic literary idealism, although the participants made great efforts to learn the ancient skills properly; the tournament was preceded by a series of rehearsals in London, at which the jousting was more impressive than on the day itself, due to the terrible storm which effectively washed out the proceedings. It is conceivable that if the event at Eglinton had been a success, there might have been a serious following for jousts in England, though the enormous expense of the occasion was probably as much of a deterrent as the downpour, and more than one of the participants was reputed to have ruined himself in the Bond Street showrooms of the armour suppliers.

The minor forms of jousting, tilting at the quintain and running at the ring, survived throughout the eighteenth and nineteenth century, and can be found even today as genuine survivals in rural Italy. *Carrousels* were a traditional part of royal or princely occasions in Italy, Germany and Spain until the end of the nineteenth century, and in Italy there was sufficient enthusiasm for a tilting ground, probably for the quintain, to be constructed at a villa in Rome in the 1880s. Tournaments were even to be found across the Atlantic, particularly in the southern United States and in Maryland, where it still is the official sport of the state; once again, the context was a romantic return to the ideals of chivalry.

Today we can watch tournaments staged by skilled stuntmen, but the heart of the sport is missing, the intense competition for individual glory: they can never recapture the real enthusiasm of the medieval original, the excitement of spectacle in a world where colour and pageantry were a rarity, the genuine danger of the fighting. The joust and its ideals belong to the glories of the past, to the pages of medieval manuscripts, and above all to the imagination, which alone can recreate these extraordinary festivals.

Glossary

For a discussion of the types of tournament and the terms used see pp. 163–6. German terms are given on pp. 165–6.

à outrance: combat fought under war conditions, that is, using the normal weapons of war and (usually) wearing the normal armour of warfare. Death or serious injury frequently occurred in hastiludes of this type which were generally only fought in cases prompted by personal or national enmity. The terms is also applied to the weaponry used in such combats.

à plaisance: combat fought primarily for entertainment purposes using specially modified weapons with sharp edges and points removed or blunted. Modified armour was also worn which was especially adapted for the needs of the particular form of hastilude. The term is also applied to the weaponry used in such combats.

atteint: a term used from the late fifteenth century onwards to define an adjudged hit in jousting.

axe: a long handled battle-axe requiring both hands on the hilt to wield it which could be used on horseback but by the fourteenth century was more normally used on foot. Courses with the axe became standard in challenges from the 1390s onwards. Normally only used in combats *à outrance*.

barrier: a wooden structure, usually decorated with painted cloth hangings, which divided the paths of jousters ensuring that each horse ran a pre-determined course and thereby lessening the danger of horses crossing with concomitant risk to riders. Also known as the tilt.

béhourd: also *bohort*: a limited form of hastilude generally fought between esquires or knights in training, or as an impromptu response to a celebration. Weapons *à plaisance* – usually either blunted swords or rebated lances – were invariably used and usually only padded linen armour was worn.

berfrois: a grandstand, usually a temporary structure made of wood, built alongside the lists to enable spectators to view the hastiludes. A *berfrois* was usually reserved for the ladies but nobles, prominent citizens and visiting dignitaries were also allowed a seat. Also known as the escafaut or scaffold.

chivalric combat: strictly speaking, a form of judicial duel fought between an appellant and a defendant of knightly rank. An accusation of dishonourable conduct (usually treason) always lay behind the combat which was fought to the death before judges. This was not a form of hastilude but a trial by battle; the defeated candidate would be taken from the lists and executed.

course: in jousting, to run a course meant to run one length of the lists against an opponent, with or without striking him as the case may be. In other forms of the single combat, such as courses with dagger or axe, it meant a bout or round ending when an adjudged blow had been struck.

commencailles: also *encommencailles*. The preliminary skirmishes of a tournament when a few hand picked knights would display their skill in single combat before the general advance began.

coronal: crown shaped accessory which fitted the end of a lance shaft instead of the usual blade. Because it had three curved points it spread the weight of the blow and did not catch as easily in plate armour. Usually worn only in hastiludes *à plaisance*.

dagger: short bladed, double sided weapon used for administering the *coup de grace* to fallen foes. Courses on foot with the dagger were introduced to hastiludes at the end of the fourteenth century but only for combats fought *à outrance*. A blow to certain parts of the body was adjudged a hit.

escafaut: another term for berfrois.

estoc: forbidden stroke in hastiludes because it was used only to kill; usually a dagger thrust upwards under the ribs but a sword could also be used.

feat of arms: generally, a display of skill in different forms of combat and therefore involving a mixture of courses on foot and on horseback using lance, sword, axe or dagger.

fortunium: a term used seemingly only once, to describe a hastilude held at Hertford in 1241. The term literally meant 'a chance' or 'a lot' but it was probably coined for the occasion in order to avoid a royal prohibition on jousts and tournaments.

hastilude: literally a spear game. Any form of chivalric sport involving use of the lance

and therefore used as a generic term for tourneying.

joust: single combat on horseback using lances. Until the mid fifteenth century several jousters could be found in the lists at one time but only one combat took place at once according to the rules. When the barrier was introduced early in the fifteenth century, the risk of more than one knight at once taking up a challenge was substantially reduced.

lance: a long wooden shafted weapon, usually painted, to which either a double sided blade or a coronal could be fixed. Always used on horseback, it was the introduction of the 'couched lance' technique of fighting in which the lance was held tucked tightly under the arm, that prompted the development of tournaments as essential training exercises. In the early days, lance combats were an essential part of most chivalric sports but as they gradually lost their relevance to real warfare they became an anachronistic – through nevertheless a vital – part of the combat.

lists: the designated area for combat. In the case of tournaments this would extend over several miles of open countryside bounded by ditches, fences or simply specific landmarks. The term became more specifically associated with jousts where it indicated the enclosed area in which combats took place. By the fifteenth century the lists were purely and simply the long narrow stretch of ground between the stations of the opposing parties down which the participants ran their courses.

longsword: sword used by knight for fighting on horseback therefore having an extremely long two edged blade.

mêlée: hand to hand fighting at the height of the tournament, after the opposing teams had closed together. Participants could be fighting either on horseback or on foot if they had lost their horses. Weapons ranged from lance to mace to, more usually, sword.

pas d'armes: an elaborate form of hastilude popular in the fifteenth century involving staging, acting and a storyline which put the actual combat in context. Usually a single challenger would declare his intention to defend a narrow defile (represented in the scenary or by the lists themselves) against all comers.

peacock: a form of quintain.

quintain: a target attached to a pole which was used in lance practice. An ill-placed blow would cause the arm of the quintain to swing round and buffet the horseman.

rebated: weapons with their sharp edges removed or blunted. Rebated lances and swords were commonly used in hastiludes *à plaisance*.

recet: a designated place of refuge on the tournament field where knights could rest, rearm or hold prisoners.

round table: festivity lasting several days with strong Arthurian overtones. *Bohorts,* jousts and sometimes a tournament were an important part of the proceedings but other chivalric games were also played. Ladies enjoyed a prominent role in the events, leading the singing and dancing. Pageantry was always very marked and in many cases the participants actually assumed the names, armorial bearings and even characters of Arthurian knights.

seeking adventures: generic term used to indicate knights who travelled prepared for armed combat in any type of war situation or hastilude which presented itself.

tenant: knight who issues a challenge to fight hastiludes and then holds the field against all comers.

tilt: Anglicised term for joust, i.e. to fight with a lance in single combat. Also used from the fifteenth century onwards to describe the barrier which separated jousters.

tournament: strictly, a mass combat of knights ranged in at least two opposing teams fighting at a predetermined time and place within a designated area and governed by simple rules of conduct which even at their most rudimentary included the condition that taking prisoners, not killing them, was the object of the game. Horses, harness and the prisoners themselves could be held to ransom or, in the first two cases, held as booty. The tournament proper had virtually ceased to exist by the mid fourteenth century. The verb tourneying is used less precisely to indicate participation in all forms of hastilude.

triumph: a sixteenth century pageant at which hastiludes would usually take a more or less subsidiary role. The emphasis of the occasion was on display with fantastic costumes, mechanical contrivances, speeches and play acting.

tupinaires: a form of joust or tournament which appears only in French and English prohibitions; no description of such an event survives.

venant: tourneyer or jouster who comes to attend hastiludes in answer to a challenge.

vespers: also vigils, held the day before the tournament proper, usually in the evening. Often seen as an opportunity for the younger and less experienced tourneyers to try out their skills, it was also a practice run for the following day. Weapons and armour were usually limited to avoid casualties before the main sport began.

vigils: see vespers

Acknowledgements

With a subject which ranges so widely over time and place, we have had to rely on the goodwill of many scholars to keep us on a reasonably straight and accurate path, and to solve the many problems we have encountered. Special thanks are due to Harry Jackson of the University of St Andrews, who has given freely of his time and expertise to help us on the tournament in Germany, both by providing scarce material and reading drafts of the whole text; Martin Jones of King's College, University of London, also read through the final draft and made valuable points. Professor Werner Paravicini of the University of Kiel kindly supplied material not available in England. On the Spanish and Portuguese sections, our greatest debt is to Mrs Amelia Hutchinson of the University of Salford, who was kind enough to undertake the not inconsiderable task of translating the relevant sections of Duarte of Portugal's *Livro de Ensenanca de Bem Cavalgar Toda Sela*, perhaps the most crucial single text for what actually went on in the lists, as the last chapter shows. Professor R. B. Tate of the University of Nottingham gave helpful and much-appreciated guidance on the sources for Spanish tournaments at an early stage, and commented on the final result. For translation of S. P. Uri's important article in Dutch on the twelfth century tournament, we are indebted to Maria C. van Mastrigt. Eric Elstob found time from purely modern preoccupations to send (from Tokyo) a translation of the only Swedish article on tournaments we could trace. Neil Wright of Cambridge University disentangled with his customary skill some knotty points of medieval Latin. For a note of a sixteenth century tournament prayer, we are indebted to Jeremy Griffiths. Simon Jervis sent notes of a lecture by Professor Sydney Anglo at the Society of Antiquaries which we were unable to attend. Dr Susan Stern helped us to obtain photostats of material from the Universitätsbibliothek at Frankfurt. And last in chronological order, but by no means least, Miss Cecelia N. Eareckson of Pennsylvania went to considerable trouble to try to find out about jousting in Maryland.

The basic material for this book was provided by the resources of the London Library, Cambridge University Library, the Bodleian Library and the British Library; because of the nature of the subject, several hundred titles had to be consulted (sometimes fruitlessly) and we are most grateful for the cheerful efficiency with which these were provided.

Assistance in tracing manuscripts and obtaining photographs was generously given by Dr Eva Irblich of the Osterreichisches Nationalbibliothek, Dott. Angela Bussi Dillon of the Biblioteca Laurenziana, Florence, and Dr Bruce Barker-Benfield of the Bodleian Library, Oxford.

But over and above these specific debts, there are innumerable less tangible ones, informal conversations, references, words of encouragement from fellow-historians; if we have omitted anyone from the list above whom we should have mentioned, we can only plead that this has been a long-drawn-out and wide-ranging project. There are certainly errors in what follows; we can only hope that they are not too frequent, and thank all those who have managed to reduce their number.

Select Bibliography

Although the preparation of this book has involved the use of literally hundreds of different printed sources, as well as a handful of manuscripts, the titles which can be recommended for further reading are a mere dozen. Apart from the books listed below, the history of the tournament has rarely been accorded more than a paragraph, or at best a chapter, here and there.

The key works are *Das ritterliche Turnier im Mittelalter: Beiträge zu einer vergleichenden Formen – und Verhaltungsgeschichte des Rittertums* edited by Josef Fleckenstein (Veröffentlichungen des Max-Planck-Instituts für Geschichte 80, Göttingen 1985), the proceedings of a colloquium held in 1982 with contributions from distinguished French, German, Czech and Hungarian contributors; but unfortunately there is nothing from Spain. This wide-ranging survey is supplanted for England and France by Juliet Barker's *The Tournament in England 1100–1400* (Woodbridge 1986) which, despite its title, draws extensively on French material; and Juliet Vale's *Edward III and Chivalry: Chivalric Society and its Context, 1270–1350* (Woodbridge 1982) covers the Low Countries from 1280 to 1340 (approximately) as well as the Edwardian tournaments in England. There is a useful survey of late German tournaments in William Henry Jackson, 'The Tournament and Chivalry in German Tournament Books of the Sixteenth Century and in the Literary Works of Emperor Maximilian I', in *The Ideals and Practice of Medieval Knighthood: papers from the first and second Strawberry Hill conferences* ed Christopher Harper-Bill and Ruth Harvey (Woodbridge 1986). On the later English tournaments, Alan Young's *Tudor and Jacobean Tournaments* (London 1987) is a useful survey, while Ruth Harvey's *Moriz von Craûn and the Chivalric World* (Oxford 1911), chs III and IV, is valuable on both the literature and history of the tournament. The older works of F. H. Cripps-Day and R. Clephan do not reach modern standards of scholarship, but Cripps-Day (*The History of the Tournament*, London 1918, rptd New York 1982) has useful appendices of original documents.

Notes

Barker, *Tournament* Juliet Barker, *The Tournament in England* (Woodbridge 1986)

BLVS *Bibliothek des literarischen Verein in Stuttgart*

CDS *Chroniken der deutschen Städte*

Cripps-Day F.H.Cripps-Day, *The History of the Tournament in England* (London 1918)

EETS Early English Text Society

MGH SS *Monumenta Germaniae Historicae: Scriptores*

PL *Patrologia Latina* ed. J.-P. Migne

RHGF Recueil des Historiens des Gaules et de la France

RS Rolls Series

RTM *Das ritterliche Turnier im Mittelalter: Beiträge zu einer Rittertums* ed. Josef Fleckenstein (*Veröffentlichungen des vergleichenden Formen und Verhaltensgeschichte des Max-Plancks-Institut für Geschichte* 49) (Göttingen 1985)

SHF Société de l'Histoire de France

Vale, *Edward III* Juliet Vale, *Edward III and Chivalry* (Woodbridge 1982)

1. The Origins of the Tournament 19–33

[1] Nithard, *Carolingian Chronicles* ed. J.W.Scholz (Michigan 1970) 164.

[2] Virgil, *Aeneid* Bk V, ll.577–600 (tr. W.F.Jackson Knight (Harmondsworth 1956) 137).

[3] Lambert of Ardres, *Chronicon Ghisnense et Ardense* ed. D.Godefroy (Paris 1855) 49.

[4] Anna Comnena, *The Alexiad* ed. & tr. E.R.A. Sewter (Harmondsworth 1979) 416.

[5] *L'Histoire de Guillaume le Maréchal* ed. P.Meyer (Paris 1901) ll.2773–5, 3681–3.

[6] Geoffrey of Malaterra, 'De rebus gestis Roberti Guiscardi, Ducis Calabriae et Rogerii, Comitis Siciliae' in *Thesaurus Antiquitatum et Historiarum Siciliae* ed. J.G.Graevius (Amsterdam 1723) iv, bk.ii, ch.xxiii, col.26.

[7] *Recueil des chroniques de Touraine* ed. André Salmon (Société archéologique de Touraine, Collection des documents sur l'histoire de Touraine I) (Tours 1854) xvi, 125; xxxviii, 189.

[8] Anna Comnena (n.4 above) 326.

[9] Barker, *Tournament*, 152–4, where 'seeking adventures' is discussed in detail.

[10] Robert the Monk, *Historia hierosolymitana*, quoted in C. du Fresne du Cange, *Glossarium mediae et infimae Latinitatis* (Paris 1840) VII, 'Dissertations sur l'Histoire de Saint Louys VII', 33.

[11] *MGH SS*, XXI 608 col.1; the source is not above suspicion, as it is a fifteenth century variant copy of the thirteenth century *Chronicon Hanoniense* by Gislebertus.

[12] J.-F. Le Marignier, *Recherches sur l'hommmage en marche et les frontières féodales* (Lille 1945) 162.

[13] *Facsimiles of Royal and other charters in the British Museum* ed. G.F.Warner & H.J.Ellis (London 1923) i, no.12.

[14] Galbert of Bruges, *Histoire du meurtre de Charles le Bon* ed. H.Pirenne (Paris 1891) 9.

[15] Otto óf Freising, *Gesta Frederici seu rectius Chronica* ed. F.-J.Schmale (Berlin 1965) 158.

[16] C.-J.Hefele & H.Leclercq, *Histoire des Conciles* (Paris 1912) V.i, 729.

[17] Raymund de Penafort, *Summa de Poenitentia et Matrimonio* (Farnborough 1967) 161.

[18] Cripps-Day 39.

[19] Hefele & Leclercq (n.16 above) V.ii, 1102.

[20] *The Historia Regum Britannie of Geoffrey of Monmouth* ed. Neil Wright (Woodbridge 1985) 112 (tr. Lewis Thorpe (Harmondsworth 1966) 229–30).

[21] William of Malmesbury, *Historia Novella*, ed. K.R. Potter (Oxford 1955) 48–9. The whole question of terminology common to ordinary warfare and tournaments in the early and mid twelfth century needs further discussion: see M.H.Jones, 'Die tjostiure uz vünf scharn ('Willehalm' 362, 3)' in *Studien zu Wolfram von Eschenbach. Festschrift für Werner Schröder* ed. J.Heinzle and K.Gärtner (Tübingen 1989, forthcoming).

[22] *L'Histoire de Guillaume le Maréchal* (n.5 above) ll.175–8.

[23] Ordericus Vitalis, quoted in John Beeler, *Warfare in England 1066–1189* (Cornell 1966) 108.

[24] 'History of the Priory of Wigmore' in Dugdale, *Monasticon* VI, i 349.

[25] William of Newburgh, 'Historia Rerum Anglicanum' in *Chronicles of the Reigns of Stephen, Henry II and Richard I* ed. R.Howlett (RS) (London 1885) II 422–3.

[26] Otto of Freising, *Gesta Frederici* (n.15 above) 180.

[27] Rahewin's continuation of Otto of Freising, *Gesta Frederici* (n.15 above) 532.

[28] Hefele & Leclercq (n.16 above) V.ii 1102.

[29] Lambert of Ardres, *Chronicon Ghisnense* (n.3 above) 215–7.

[30] Roger of Hoveden, *Chronica* ed. W.Stubbs (RS) (London 1869) II 166; Robert of Gloucester, *Metrical Chronicle* ed. W.A.Wright (RS) (London 1887) II 735.

[31] *L'Histoire de Guillaume le Maréchal* (n.5 above) ll.1374–80.

[32] *Ibid.*, ll.3381–425.

[33] Chrétien de Troyes, *Erec et Enide* ll.2135–70 (*Arthurian Romances* tr. D.D.R.Owen (London 1987) 28–9).

[34] *L'Histoire de Guillaume le Maréchal* (n.5 above) ll.2723ff.

[35] *Ibid.*, ll.7209–32.

[36] *Ibid.*, ll.2840ff, 3102ff.

[37] Gislebert of Mons, *La Chronique*, ed. L.Vanderkindere (Brussels 1904) 97–8.

[38] *Ibid.*, 101–2.

[39] Roger of Hoveden, *Chronica* (n.30 above) II 276–8.

[40] *MGH SS* XXIII 155–6.

[41] Herbert Grundmann, 'Zur *Vita S.Gerlaci eremitae*', *Deutsches Archiv für Erforschung des Mittelalters* 18 (1962) 541.

[42] *MGH SS*, XXV 220–1 (*Ex gestis Sanctorum Villariensium*). We are grateful to Mr Neil Wright for providing a translation.

[43] *MGH SS*, XXIV 299 (*Historia monasterii Viconiensis*).

[44] William of Newburgh, 'Historia Rerum Anglicanum' (n.25 above) II 422–3.

[45] *Foedera* I.i.65. For a full discussion of the decree and its implications, see Barker, *Tournament* 11, 53–6.

[46] *Foedera* I.i 65.

2. The Tournament in North-West Europe to 1400 35–53

[1] Ralph of Coggeshall, *Chronicon Anglicanum* ed. J. Stevenson (RS) (London 1875) 172–3.

[2] Matthew Paris, *Chronica Majora* ed. H.R.Luard (RS) (London 1872–83) II 614–5.

[3] *Ibid.* II 650.

[4] *Curia Regis Rolls 1219–1220* VIII 158.

[5] *Rotuli Litterarum Clausarum* ed. T.Hardy (London 1833) I 539, 545, 547

[6] *Curia Regis Rolls 1225–1226* XII 451.

[7] *Calendar of Close Rolls 1227–1231* 113.

[8] *Annales Monastici* ed. H.R.Luard (RS) (London 1866) III 130 (*Annals of Dunstable*). ·

[9] *Calendar of Patent Rolls 1225–1232* 492.

[10] Matthew Paris, *Chronica Majora* (n.2 above) III 404; IV 157–160; IV 200–2.

[11] *Ibid.* V 17–18; V 83.

[12] *Ibid.* V 265.

[13] *Ibid.* V 367–8.

[14] *Ibid.* V 557.

[15] William Rishanger, *Chronicon* ed. H.T.Riley (RS) (London 1865) 31–2; *Annales Monastici* (n.8 above) IV 161–2 (Wykes).

[16] *Ibid.* IV 212.

[17] 'Copy of a Roll of Purchases for a Tournament at Windsor Park in the Sixth Year of Edward I', ed. S. Lyons, *Archaeologia* First Series, XVII (1814) 297–310.

[18] *Chronicles of the Reigns of Edward I and Edward II* ed. W.Stubbs, (RS) (London 1882) I 104 (London annals); *Annales Monastici* (n.8 above) IV 489 (Wykes).

[19] *Records of the Wardrobe and Household 1285–6* ed. B.F. and C.R.Byerly (London 1977) 5–7, 20, 22, 26, 34, 47; 'Account of the Expenses of John of Brabant and Henry and Thomas of Lancaster, 1292–3', ed. J. Burtt, *Camden Miscellany II*, Camden Society Old Series LV (London 1853) 4–7, 10, 12.

[20] *Calendar of Patent Rolls 1301–7* 86; *Calendar of Close Rolls 1302–7* 66; *Calendar of Fine Rolls* I 543–4.

[21] *Annales Monastici* (n.8 above) III 282 (Annals of Dunstable); IV 281, 445 (Wykes); Walter of Hemingburgh, *Chronicon* ed. H.C.Hamilton, English Historical Society (London 1849) II 8; London annals (n.18 above) I 104; *Vita Edwardi Secundi* ed. N. Denholm Young (London 1957) 6.

[22] R.S.Loomis, 'Edward I: Arthurian Enthusiast' *Speculum* XXVIII (1953) 118–9.

[23] *Vita Edwardi Secundi* (n.21 above) 2, 4; Johannes de Trokelowe, *Annales* ed. H.T.Riley (RS) (London 1866) 65; *Chronicles of the Reigns of Edward I...* (n.18 above) I 264 (*Annales Paulini*).

[24] *Ibid.* I 267; *Chronicles of the Reigns of Edward I...* (n.18 above) I 157 (London annals).

[25] The Dunstable tournament roll, wrongly ascribed to Stepney, is printed in *Collectanea topographica et genealogica* IV (London 1837) 63–72; J.R.Maddicott, *Thomas of Lancaster 1307–1322* (Oxford 1970) 96–103.

[26] *Vita Edwardi Secundi* (n.21 above) 6.

[27] *Calendar of Close Rolls 1323–7* 133; *Scrope and Grosvenor Roll* ed. N.H.Nicolas (Chester 1879) I 144.

[28] Dugdale, *Monasticon* VI.i 352; Robert of Avesbury, *De gestis Edwardi Tertii* ed. E.M.Thompson (RS) (London 1889) 284.

[29] *Chronicles of the Reigns of Edward I...* (n.18 above) I 352–3 (*Annales Paulini*).

[30] *Ibid.* I 353–4, 354–5; Avesbury (n.28 above) 285–6.

31 The second Dunstable tournament roll is recorded in *Collectanea* (n. 25 above) 389–95; Adam Murimuth, *Continuatio Chronicarum* ed. E. M. Thompson, (RS) (London 1889) 123–4, 223–4; Geoffrey le Baker, *Chronicon*, ed. E. M. Thompson (Oxford 1889) 75.
32 Andrew of Wyntoun, *Original Chronicle* ed. F. J. Amours, Scottish Text Society (Edinburgh 1903–14) VI 93, 129; Sir John Gray of Heton, *Scalacronica* ed. J. Stevenson (Edinburgh 1836) 155.
33 Henry Knighton, *Chronicon* ed. J. R. Lumby (RS) (London 1895) II 23.
34 Wyntoun (n. 32 above) VI 104–5.
35 Jean le Bel, *Chronique* ed. J. Viard and E. Deprez, SHF (Paris 1904) II 2–4.
36 Murimuth (n. 31 above) 124, 230.
37 *Calendar of Patent Rolls 1343–45* 196.
38 N. H. Nicolas, 'Observations on the Institution of the Most Noble Order of the Garter', *Archaeologia* XXXI (1846) 37, 38–9, 40–1, 42.
39 *Eulogium Historiarum* ed. F. Haydon, (RS) (London 1858–63) III 227; Le Bel (n. 35 above) II 240; *Issues of the Exchequer: Henry III to Henry VI* ed. F. Devon (London 1837) 169.
40 Murimuth (n. 31 above) 155–6, 231; *The Brut, or Chronicles of England* ed. F. W. D. Brie (EETS 1906–8) II 296; W. H. St John Hope, *Windsor Castle: an architectural history* (London 1913) I 98, 112–8, 122–4; Nicolas, 'Observations' (n. 38 above) 42–53; *Le Roman de Perceforest* (Paris 1528) II 520–9; Barker, *Tournament*, 92–5.
41 *The Brut* (n. 40 above) II 309; John of Reading, *Chronica* ed. J. Tait (Manchester 1914) 131–2.
42 *Ibid.* 150–1.
43 Barker, *Tournament* 92.
44 *Chronicon a Monacho Sancti Albani* ed. E. M. Thompson, (RS) (London 1874) 332–3; PRO MS DL 28/1/1 fos 3v, 4r; *Stow's Survey of London* ed. C. L. Kingsford (Oxford 1908) II 30–1; Barker, *Tournament* 100, 184–5; D. Sandberger, *Studien über das Rittertum in England* (Historische Studien 310) (Berlin 1937) 67–8.
45 *Rotuli Scotiae* ed. D. Macpherson (London 1814–19) II 87, 117, 119.
46 Wyntoun (n. 32 above) VI 359–62; *Calendar of MSS relating to Scotland* ed. J. Bain (Edinburgh 1888) IV nos. 404, 410, 411.
47 *The Brut* (n. 40 above) II 348; *Stow's Survey* (n. 44 above) II 31.
48 Barker, *Tournament* 184–5; *The Brut* (n. 40 above) II 343; *Historia Vitae et Regni Ricardi Secundi* ed. G. B. Stow (Pennsylvania 1977) 131–2.
49 Adam of Usk, *Chronicon* ed. E. M. Thompson (London 1904) 41; *Historia Ricardi* (n. 48 above) 169; *Pageant of the Birth, Life and Death of Richard Beauchamp* . . . ed. Viscount Dillon and W. H. St John Hope (London 1914) 9.
50 Barker, *Tournament* 97–8.
51 Wyntoun (n. 32 above) VI 420–1.
52 *Chronique du Réligieux de St Denys* ed. M. L. Bellaguet (Paris 1839) V 408, 410–4.
53 *Journal d'un bourgeois de Paris* ed. A. Tuetey (Paris 1881) 140.
54 *Inventaires et documents: actes du Parlement de Paris* ed. M. Boutaric (Paris 1863) I 19 (no. 233a).
55 Parisse, *RTM* 210.
56 *Flores Historiarum* ed. H. R. Luard, (RS) (London 1890) II 456, 466.
57 *Ibid.* III 30–1; Knighton (n. 33 above) I 265–6.
58 Sarrazin, 'Le Roman du Hem' ed. F. Michel in *Histoire des Ducs de Normandie et des Rois d'Angleterre* SHF (Paris 1840); Vale, *Edward III* 12–16.
59 Parisse, *RTM* 210.
60 Vale, *Edward III* 22.
61 Jacques Bretel, *Le Tournoi de Chauvency* ed. M. Delbouille (Liège 1932); Vale, *Edward III* 5–12.
62 *Les Olim ou Registres des Arrets* ed. le Comte Beugnot (Paris, 1839–48) I 161; *Inventaires* (n. 58 above) 220, no. 2292.
63 *Les Olim* (n. 61 above) I 405; *Ordonnances des Roys de France* ed. M. de Laurière (Paris 1723) I 328.
64 *Ibid.* I 420, 421–2, 426, 434–5, 493.
65 *Ibid.* I 509–10
66 *Ibid.* I 539–40, 643–4.
67 *Corpus Iuris Canonici* ed. A. Friedberg (Leipzig 1881) II col. 1215.
68 Le Bel (n. 35 above) II 194–7; H. Brush, 'Le Bataille de Trente Anglais et de trente Bretons', *Modern Philology* IX (1912) 513–41 and X (1912) 82–115.
69 Knighton (n. 33 above) II 76–7.
70 Brush (n. 68 above) IX 513.
71 Jean Froissart, *Oeuvres* ed. Kervyn de Lettenhove (Brussels 1866–) VI 22.
72 *Ibid.* XII 51, 59
73 Knighton (n. 33 above) II 260; *Foedera* VII 580.
74 Froissart (n. 71 above) XIV 43–50.
75 *Le livre des faits du . . . Jean le Maingre, dit Boucicault* in *Collection complète des memoires relatifs à l'histoire de France* ed. M. Petitot (Paris 1819) VI 424–31; Wyntoun (n. 32 above) VI 348–54.
76 Bibliothèque Nationale MS Fonds français 21809, item 15
77 Froissart (n. 71 above) XIV 151.
78 *Réligieux de Saint Denys* (n. 51 above) I 568–98.
79 Froissart (n. 71 above) XIV 20–25.
80 Gutierre Diez de Games, *El Victorial: Crónica de Don Pero Niño* ed. Juan de Mata Carriazo (Madrid 1940) 237 (tr. Joan Evans, *The Unconquered Knight* (London 1928) 142–3).
81 *Inventaires mobiliers et extraits des comptes des ducs de Bourgogne* ed. Bernard Prost (Paris 1902–8) II 509, 513, 527, 558.
82 *MGH Scriptores* XXIII 937 (Alberic des Trois Fontaines).
83 Baudouin de Condé, *Dits et Contes* ed. A. Scheler (Brussels 1866) I 47–9, 55–8, 168–70.
84 Vale, *Edward III* 31.
85 *Annales Monastici* (n. 8 above) III 388–9.
86 A. Behault de Doron, 'Le Tournoi de Mons de 1310', *Annales du Cercle Archeologique de Mons* XXXVIII (1909) 103–250.
87 Le Bel (n. 35 above) I 33–35.
88 R. Withington, *English Pageantry* (Cambridge, Mass. 1918) I 94.
89 R. S. Loomis, 'Chivalric and Dramatic Imitations of Arthurian Romance', *Medieval Studies in Memory of A. K. Porter* (Cambridge, Mass. 1939) I 87.
90 M. Lucien de Rosny, *L'Epervier d'Or* (Valenciennes 1839) 12.
91 *Ibid.* 42 n. 1.
92 *Ibid.* 6–8.
93 *Ibid.* 23–4.
94 Vale, *Edward III* 29.
95 *Ibid.* 40.

3. The Tournament in Germany 55–81

1 *MGH SS* XXX 602 (*Cronica Reinhardsbrunnensis*).
2 For the meaning of this word, see *Die Königssaaler Geschichtsquellen* ed. Johann Loserth, in *Fontes rerum Austriacarum, Scriptores* (Vienna 1875) VIII 404, where the heading reads 'De tabula rotunda sive foresta . . .'
3 *MGH SS* XXX 608 (*Cronica Reinhardsbrunnensis*).
4 Ed. R. Bechstein, Leipzig 1888: excerpts translated by J. W. Thomas, *Ulrich von Liechtenstein's Service of Ladies* (Chapel Hill, N.C., 1969). Citations are by stanza; an asterisk indicates that the stanza is included in the English version.
5 *Frauendienst* 600.
6 E.g. Toulouse 1280, Nuremburg 1290, Lübeck 1340; see ch. 8 below.
7 *Frauendienst* 1557ff.
8 *Frauendienst* 1517.
9 *Frauendienst* 1453–4.
10 *Frauendienst* 1560.
11 *Frauendienst* 995–99.*
12 *Frauendienst* 492–522.*
13 *Frauendienst* 1520.
14 *Frauendienst* 588–592.*
15 *Frauendienst* 707–9.*
16 *Frauendienst* 630–40.*
17 *Frauendienst* 1575–1609.*
18 *MGH SS* XXIII 950 (Alberic of Trois Fontaines).
19 *MGH SS* XVII 204 (*Annales Colmarienses Maiores*).
20 *MGH SS* XXV 480 (*Chronicae principum Saxoniae*).
21 *Annales Vetero-Cellenses*, ed. J. O. Opel (*Mittheilungen der deutschen Gesellschaft zur Erforschung vaterlandischer Sprache* I.ii) (Leipzig 1874) 206; *MGH Chroniken* II 563 (*Braunschweigische Reimchronik*).
22 *Die 'Laaer Briefsammlung'* ed. Max Weltlin (*Veröffentlichungen des Instituts fur Osterreichische Geschichtsforschung* XXI) (Wien 1975) 104.
23 *Ibid.* 108.
24 *Ibid.* 122: we are grateful to Mr Neil Wright for elucidating the text by suggesting the amendment 'in ascella' for 'mascella'.
25 *Ibid.* 126.
26 *MGH SS* IX 711, 731 (*Kalendarium Zwetlense Continuationes*).
27 *Die Chroniken der niedersächsischen Städte: Magdeburg I* (*CDS* VII) (Leipzig 1869) 168–9. For the tin figures see Ernst Nickel, 'Der "Alte Markt" in Magdeburg', *Deutsche Akademie der Wissenschaften zu Berlin, Schriften der Sektion für Vor- und Frühgeschichte* (Berlin 1964) XVIII 139.
28 *Chronica de gestis principum* [by Volkmar of Fürstenfeld] in *Fontes rerum germanicarum* ed. J. F. Boehmer (Stuttgart 1843) 14–15.
29 Rudolf von Ems, *Weltchronik*, cited in Werner Meyer-Hofmann, 'Psitticher und Sterner', *Basler Zeitschrift für Geschichte und Altertumskunde* 67, 1967, 9.
30 *Ibid.* 10, 18.
31 *Die Königssaaler Geschichtsquellen* (n. 2 above) 275.
32 Matthias Neuwenburg, *Cronica* in *Fontes rerum germanicarum* ed. J. F. Boehmer (Stuttgart 1868) IV 189.
33 *Ibid.* 191.
34 *Königssaaler Geschichtsquellen* (n. 2 above) 404–5.
35 *Ibid.* 413–4.
36 *Chronographia regum Francorum* ed. H. Moranvillé (SHF) (Paris 1891) I, 274, 462.
37 *Königssaaler Geschichtsquellen* (n. 2 above) 450.
38 *Ibid.* 520.
39 Matthias Neuwenburg (n. 32 above) 254.
40 Sigmund Meisterlin in *Chroniken der fränkischen Städte, Nürnberg III* (*CDS* III) (Leipzig 1864) 161.
41 *Chronik 1368–1406* in *Chroniken der schwäbischen Städte, Augsburg I* (*CDS* IV) (Leipzig 1865) 54.
42 G. L. Kriegk, *Deutsches Burgerthum in Mittelalter* (Frankfurt 1868) 586.
43 *Die Kölner Stadtrechnungen des Mittelalters* ed. R. Knipping (*Publikationen der Gesellschaft für Rheinische Geschichtskunde* XV, ii) (Bonn 1897) II 35, 37, 111, 42, 45, 117, 184, 258, 318, 320, 321, 327, 353, 358.
44 *Urkundenbuch der Stadt Göttingen bis zum Jahre 1400* ed. Gustav Schmidt (Hannover 1863, rptd Aalen 1974) 243–5, 258–60.
45 *Urkundenbuch der Stadt Strassburg: VI. Politische Urkunden von 1381–1400* ed. Johannes Fritz (Strassburg 1899) 318–320.
46 *Basler Chroniken* ed. August Bernoulli (Basle 1895) V 62, 120–1.
47 Christopher Lehmann, *Chronica der freyen Reichs Stadt Speier* (Frankfurt 1711) 827.
48 Georg Rüxner, *Thurnierbuch: das ist warhaffte eigentliche und kurtze Beschreibung von Anfang: Ursachen: Ursprung: und Herkommen des Thurnier . . . in Teutscher Nation*, reprinted by Sigmund Feyerabend, (Frankfurt 1578) f. clvii.
49 *Crónicas de los reyes de Castilla*, in *Biblioteca de autores españoles* ed. Cayetano Rosell, 66, 68, (rptd Madrid 1953) II, 529.
50 The best summary on tournament societies is that of Werner Meyer in *RTM* 500–512: see also chapter 8 below for a fuller discussion.
51 'Cronbergsches Diplomatarium', ed. O. Freiherr von Stotzingen, *Annalen des Vereins für Nassauische Altertumskunde und Geschichtsforschung* 37, 1907, 217; we have translated the dates into their modern equivalents, and supplied conjectural years.
52 *Deutsche Privatbriefe des Mittelalters* ed. Georg Steinhaufen (Berlin 1899) I 23–24.
53 *Ibid.* I 173.
54 *Ibid.* I 69.
55 *Die Geschichten und Taten Wilwolts von Schaumburg* ed. Adalbert von Keller (BLVS L) (Stuttgart 1859) 36; *The Diary of Jörg von Ehingen* tr. Malcolm Letts (London 1929) 26.
56 Pero Tafur, *Travels and Adventures* tr. Malcolm Letts (London 1926) 209.
57 Erich Haenel, *Der saechsischen Kurfuersten Turnierbucher . . .* (Frankfurt-am-Main 1910) reproduces 40 double-page spreads from these three books.
58 Bayerische Staatsbibliothek, Munich, MS Cgm 1931.
59 *Hans Burgkmaiers Turnier-Buch* ed. J. von Hefner

(rptd Dortmund 1978). Both the elder and younger Burgkmair worked on the two books reproduced in this volume.

[60] *Livre de tournois: Vat. Ross. 711 de la bibliothèque apostolique Vaticane* facsimile ed. Lotte Kurras (Fribourg 1984).

[61] Heide Stamm, *Das Turnierbuch des Ludwig von Eyb* (Cgm 961) (*Stuttgarter Arbeiten zur Germanistik* 166) (Stuttgart 1986) 56ff.

[62] Rüxner, *Anfang... des Thurnirs* (n. 48 above).

[63] Reproduced in *Hans Burgkmaiers Turnier-Buch* (n. 59 above).

[64] *Livre de Tournois* (n. 61 above) 21.

[65] Munich, Bayerische Staatsbibliothek, MS Cgm 1930, ff. 7v–8.

[66] *Ibid.* ff. 10v–11.

[67] *Ibid.* ff. 20v–21.

[68] For a useful account of Maximilian's tournaments see W. H. Jackson, 'The Tournament and Chivalry in German Tournament Books of the Sixteenth Century and in the Literary Works of Emperor Maximilian I', in *The Ideals and Practice of Medieval Knighthood* ed. Christopher Harper-Bill and Ruth Harvey (Woodbridge and Dover, N.H., 1986) 58–68.

[69] I. Grünpeck, *Die Geschichte Friedrichs III und Maximilians*, tr. C. Ilgen (*Die Geschichtsschreiber der deutschen Vorzeit: fünfzehntes Jahrhundert* iii) (Leipzig 1899) 56–7.

4. The Tournament in Italy and Spain 83–107

[1] *Carmen de bello balearico* quoted by L. A. Muratori, *Antiquitates italicae medii aevi* (Milan 1739) II 834.

[2] Thomas Szabó in *RTM*, 352.

[3] *RIS* XV 23n (*Cronica senese*).

[4] Martin da Canal, *La Cronique des Veniciens* ed. Giovanni Galvani in *Archivio storico italiano* (Florence 1845) 8, 656–61.

[5] Pompeo G. Molmenti, *La storia di Venezia nella vita privata* (reprinted Trieste 1976) I 189.

[6] Decree of 17 June 1367 quoted by Giambattista Galliccioli, *Delle memorie venete antiche profane ed ecclesiastiche* (Venice 1795) I, 231.

[7] *Le rime di Folgore di San Gemignano* ed. Giulio Navone (rptd Bologna 1968) 39.

[8] *Ibid.* 13; translated by William Heywood, *Palio and Ponte*, (London 1904) 191–2.

[9] *RIS* XIV 1141 (*Annales Cesenates*).

[10] *RIS* XII.v 55f (*Chronica de novitatibus Padue...*).

[11] *RIS* XIII 683 (Giovanni Villani).

[12] *RIS* XVIII.ii 52 (Matteo Griffoni, *Memoriale historicum de rebus bononiensium*).

[13] *RIS* XXIV.xiii 124f, 138, 148 (Bonamente Aliprandi, *Cronica da Mantua*).

[14] Eugene L. Cox, *The Green Count of Savoy* (Princeton 1967) 98–9.

[15] *Ibid.* 362–3.

[16] Luigi Cibrario, 'Della giostra corsa in Torino...' in *Opuscoli* (*Opere scelte di scrittori italiani del secolo XIX.*i) (Turin 1841) 5–7, 14–17.

[17] *Ibid.*

[18] Nicolas Jorga, *Philippe de Mézières 1327–1405 et la croisade au xixe siècle* (*Bibliothèque de l'école des hautes études 110*) (Paris 1896; rptd London 1973) 243–4.

[19] *RIS* XVII.i 450 (*Cronica Carrarese*).

[20] *Ibid.* 439.

[21] *Ibid.* 142–3, 499.

[22] Heywood (n. 8 above) 100–5, 118–9.

[23] *Ibid.* 149–50, 181–2.

[24] *Ibid.* 192.

[25] Riccardo Truffi, *Giostre e cantori di giostre* (Rocca S. Casciano 1911) 90–1.

[26] Details for 1392, 1396, 1415, 1419, 1427–9 *ibid.* 165–7: for 1406 from *RIS* XIX 950–2 (*Diario fiorentino*)

[27] Cherubino Ghirardacci, *Della historia di Bologna, parte seconda* (Bologna 1657) 458.

[28] *RIS* XVIII.ii (n.12 above) 96.

[29] Truffi (n. 25 above) 153–4.

[30] *Ibid.* 160–1.

[31] Francesco Petrarca, *Lettere senile*, volgarizzate da Giuseppe Fracassetti (Florence 1869) I 227–236.

[32] Truffi (n. 25 above) 146–50.

[33] 'Curiosità d'archivio: tumulto suscitatosi in Pavia in occasione d'una giostra...', *Archivio storico lombardo* II 1875 323–4.

[34] Truffi (n. 25 above) 68–9.

[35] Giuseppe Mazzatinti and Fortunato Pintor, *Inventari dei manoscritti delle biblioteche d'Italia*, (Florence 1901) XI 27–9.

[36] Giulio Porro, 'Nozze di Beatrice d'Este e di Anna Sforza', *Archivio storico lombardo* IX, 1882, 529–34; for Leonardo's part, Edmondo Solmi, *Frammenti letterari di Leonardo da Vinci* (Florence 1904) 223–4.

[37] Ramon Muntaner, *The Chronicle of Muntaner*, tr. Lady Goodenough (*Hakluyt Society Series II*, XI.VII, L) (London 1920–1) I 10.

[38] T. N. Bisson, *The Medieval Crown of Aragon* (Oxford 1986) 75.

[39] Article XIII of the Cortes at Tarragona, 1235: 'Item, statuimus quod non fiant tornejamenta voluntaria nisi fuerint in guerra.' *Cortes... de Aragon y de Valencia y principado de Cataluña* (Madrid 1896) I.i 130.

[40] *Los fueros de Aragón* ed. Gunnar Tilander (*Skrifter utgivna av Kungl. humanistika Vetenskapssamfundet i Lund XXV*) (Lund 1937) 139, 598.

[41] See ch. 8 below.

[42] Alfonso X, 'o Sábio', *Cantigas de Santa Maria* ed. Walter Mettmann (Coimbra 1961) II 239. The poem is based on a French story of the miracles of the Virgin.

[43] Muntaner (note 37 above) I 59.

[44] Bernard Desclot, *Chronicle of the Reign of King Pedro III of Aragon* tr. F. L. Critchlow (Princeton 1934) 18–19.

[45] Muntaner (note 37 above) I 93.

[46] *Ibid.* II 398.

[47] *Ibid.* II 404, 419.

[48] *Ibid.* II 433–4. Either Muntaner or the translator are not very clear as to the detail of the proceedings: it is not immediately apparent whether the joust was with staves on foot or lances on horseback. The latter seems more likely.

[49] See J. N. Hillgarth, *The Spanish Kingdoms 1250–1516* (Oxford 1976) I 234–6.

[50] I have been unable to find any record of a major tournament in Aragon after 1328, when there were tourneyers (*bornados*) at Alfonso IV's coronation (Muntaner, II 719). The huge compilation by Jeronimo Zurita, *Anales de la Corona de Aragon*, which is the major source for the later history of Aragon, appears to ignore tournaments entirely.

[51] For what follows, see D'A. J. D. Boulton, *The Knights of the Crown* (Woodbridge 1987) 53–4, 84; the original text is in *Crónicas de los Reyes de Castilla* (ch. 3 n. 49 above) I 231–2.

[52] Diego Ortiz de Zúñiga, *Anales eclesiasticos y seculares de... Sevilla* (Madrid 1795) II 202.

[53] *Crónicas de los Reyes de Castilla* (ch. 3 n. 49 above) I 293.

[54] *Ibid.* I 429.

[55] *Ibid.* I 472.

[56] *Catalogo del Archivo General de Navarra: seccion de comptos, documentos X 1376–7* ed. José Ramon Castro (Pamplona 1955) nos 833 & 857; 1387 jousts *ibid.* XVI 1386–7 (Pamplona 1956) nos 1147, 1174, 1180. Other details, Carlos Claveria, *Historia del Reino de Navarra* (3rd edn, Pamplona 1971) 504–5.

[57] Games, *El Vitorial* (ch. 2 n. 80 above) 139.

[58] Lope Barrientos, *Refundicion de la crónica del halconero* ed. Juan de Mata Carriazo (Madrid 1946) 29, 36.

[59] *Crónica de don Alvaro de Luna* ed. Juan de Mata Carriazo (Madrid 1940) 28–31.

[60] Pedro Carrillo de Huete, *Crónica del halconero de Juan II* ed. Juan de Mata Carriazo (Madrid 1946).

[61] *Ibid.* 10.

[62] *Crónicas de los Reyes de Castilla* (ch. 3 n. 49 above) II 423, 427, 429; *Crónica de don Alvaro de Luna* (n. 59 above) 53.

[63] Barrientos (n. 58 above) 46, 56.

[64] *Crónica del halconero* (n. 60 above), 130–1.

[65] *Ibid.* 24–6; Barrientos (n. 58 above) 59–66; Gutierre Diez de Games (n. 57 above) 328–9; *Crónicas de los Reyes de Castilla*, (ch. 3 n. 49 above) II 446–7. The detail of the king as God the Father with knights as the twelve apostles (or saints) in the first three sources only; the latter says that the king and his knights were dressed as huntsmen, and describes Alvaro de Luna's tournament as the final item. Labandeira (n. 67 below) says that the constable's event came first, but does not cite his source.

[66] *Crónica del halconero* (n. 60 above) 147–8; *Crónicas de los Reyes de Castilla* (ch. 3 n. 49 above) 512.

[67] There is a considerable literature on the *Passo Honroso*; the standard edition is Pero Rodriguez de Lena, *El passo honroso de Suero de Quiñones* ed. Amancio Labandeira Fernandez (Madrid 1977), which includes a bibliography.

[68] César Alvarez Alvarez, *El condado de Luna en la baja edad media* (Leon 1982) 88–93.

[69] Barrientos (n. 58 above), 109, is the only chronicler to specify the presence of the two Quiñones; the original text of the *Crónica del Halconero* (n. 60 above), 158, has a very similar list, but it is possible that the names were added after the *Passo Honroso*. See also *Crónica de don Alvaro de Luna* (n. 59 above) 144–5.

[70] For what follows see Pero Rodriguez de Lena (n. 67 above) *passim*.

[71] Fernandez, introduction, *ibid.* 16–18; *Crónicas de los Reyes de Castilla* (ch. 3 n. 49 above) II 567.

[72] Enrique de Leguina, *Torneos, jineta, rieptos y desafios* (Madrid 1904) 21.

[73] *Crónicas de los Reyes de Castilla* (ch. 3 n. 49 above) II 656; Leguina (n. 72 above) 19.

[74] *Ibid.* II 529.

[75] *Crónica de don Alvaro de Luna* (n. 59 above) 221.

[76] *Hechos del Condestable don Miguel Lucas de Iranzo* ed. Juan Mata de Carriazo (Madrid 1940) 55–56.

[77] Ferñao Lopes, *Crónica de Joao I*, ed M. Lopes de Almeida & A. de Magalhaes Basto (Lisbon 1948) II 232–5, 250.

[78] *Ibid* 224.

[79] See ch. 8 below.

[80] Jean Le Fèvre, sieur de St Rémy, *Chronique*, ed. F. Morand (SHF) (Paris 1876–81) I 209–11.

[81] Luis de Camoes, *Os Lusiadas* ed. J. D. M. Ford (*Harvard Studies in Romance Languages* XXII) (Cambridge, Mass. 1946) 396–7.

[82] Garcia de Resende, *Chronica dos valerosos e insignes feitas del rey dom Ioa II de gloriosa memoria* (Lisbon 1622) 79–84.

[83] *Die Chroniken der niedersächsischen Städte*, *Lübeck I* (*CDS* XIX) (Leipzig 1884) 477.

[84] For what follows see Ake Meyerson, 'Adligt Nöje: tornering och ringränning under aldre Vasatid', *Fataburen* 1939, 137–148. We are most grateful to Eric Elstob for providing a translation.

[85] Erik Fügedi, 'Turniere im mittelalterlichen Ungarn' in *RTM* 390–400.

[86] Boulton (n. 52 above) 36–7.

[87] Steven Runciman, *A History of the Crusades* (Harmondsworth 1965) II 354

[88] Nikephoras Gregoras, *Rhomaische Geschichte* tr. (into German) Jan-Louis van Dreten (*Bibliothek der Griechischen Litteratur* 9) (Stuttgart 1979) II.ii 251–2.

5. The Late Medieval and Renaissance Tournament 109–143

[1] See B. Guenée & F. Lehoux, *Les entrées royales françaises de 1328 à 1515* (Paris 1968) 11ff; and Roy Strong, *Art and Power* (Woodbridge & Los Angeles 1984) 7ff.

[2] Guenée & Lehoux (n. 1 above) 47 n.1.

[3] Jorga, *Philippe de Mézières* (ch. 4 n. 18 above) 144–201. We have only cited sources where we differ from Jorga's account.

[4] Petrarca, *Lettere senile* (ch. 4 n. 31 above) II 236n. We have not been able to trace Fracasetti's source.

[5] His presence at Angoulême is only witnessed by Froissart, whose account of the Black Prince's rule in Aquitaine is highly unreliable, as Richard Barber has shown elsewhere (in *Froissart: Historian* ed. J. J. N. Palmer (Woodbridge & Totowa, N.J., 1981) 28–31.

[6] Writs for the 1390, 1391 and 1411 jousts are preserved in Bibliothèque Nationale, MS. Fonds français 21809, items 16–55.

[7] *Journal d'un Bourgeois de Paris* (ch. 2 n. 53 above) 201(1424), 277(1431).

[8] Richard Vaughan, *Philip the Good* (London 1970) 146.

[9] *La Chronique d' Enguerran de Monstrelet* ed. L. Douet d'Arcq (SHF) (Paris 1857–62) IV 306–8.

[10] *Society at War* ed. C. T. Allmand (Edinburgh 1973) 25–7.

[11] Monstrelet (n. 9 above) VI 68–73.

12 Olivier de la Marche, *Mémoires* ed H. Beaune & J. d'Arbaumont, (SHF) (Paris 1883) I 282–335.

13 René d'Anjou, *Le livre du cuers d'amours espris*, English summary with introduction by F. Unterkircher (London 1975).

14 Guillaume Leseur, *Histoire de Gaston IV, comte de Foix* ed. Henri Courteault (SHF) (Paris 1893) I 144–170.

15 See M. Vulson de la Colombière, *Le vray theatre d'honneur et de chevalerie* (Paris 1648) 81–84, based on a contemporary account which is now lost.

16 G. A. Crapelet, *Le pas d'armes de la bergère* (2nd edn, Paris 1835) *passim*; A. Lecoy de la Marche, *Le Roi René* (Paris 1875) II 146–7.

17 Mathieu d'Escouchy, *Chronique* ed. G. du Fresne de Beaucourt (SHF) (Paris 1863) I 244–263; Olivier de la Marche, *Mémoires* (n.12 above) II 118–123; M. Eudes, 'Relation du pas d'arme près de la croix pèlerine', *Mémoires de la société des antiquaires de la Morinie* I, 1833, 302–337; Pagart d'Hermansart, 'Les frais du pas d'armes de la croix pèlerine 1449', *ibid.*, IX, 1892–6, 126–134.

18 Georges Chastellain, 'Le Livre des Faits de Jacques de Lalaing', in *Oeuvres* ed. Kervyn de Lettenhove (Brussels 1866) VIII 188–246; Olivier de la Marche, *Mémoires* (n.12 above) II 142–203. See also Alice Planche, 'Du tournoi au theatre en Bourgogne' *Le Moyen Age* LXXXI 1975 97–128.

19 Vaughan, *Philip the Good* (n. 8 above) 144–5, quoting a letter by J. de Pleine.

20 Leseur, *Histoire de Gaston IV* (n.14 above) II 39–59.

21 Felix Brassart, *Le pas du perron fée* (Douai 1874).

22 Version from Richard Barber, *The Pastons* (London 1984) 140–1.

23 G. A. Lester, *Sir John Paston's 'Grete Boke'* (Cambridge & Totowa, N.J. 1984) 118–22. The challenge is edited in Cripps-Day, lv–lix.

24 Gordon Kipling, *The Triumph of Honour* (Leiden 1977) 117.

25 Olivier de la Marche, *Mémoires* (n.12 above) II 123–201; another version by him, with less detail on the jousts, 'Traictie des nopces de monseigneur le duc de Bourgogne et de Brabant' is printed *ibid*, IV 95–144.

26 Wilwolt von Schaumburg (ch. 3 n. 55 above) 15.

27 Bernard Prost (ed.) *Traicté de la forme et devis comme un faict les tournois* (Paris 1878) 55–95, and O. Cartellieri, 'Der pas de la Dame Sauvage', *Historische Blatter* I, 1921, 47–54; on Sandricourt, A. Vayssière, *Le pas d'armes de Sandricourt* (Paris 1874).

28 Vayssière, 49–51.

29 Cripps-Day 126–8.

30 BL MS. Additional 21370 fo. 2ff.

31 *Ibid.*, fo. 7v.

32 Lefèvre de St Remy (ch. 4 n. 80 above) I, 211.

33 Monstrelet (n. 9 above) V 138–43; Vaughan, *Philip the Good* (n. 8 above) 146–7.

34 Lester, *Sir John Paston's 'Grete Boke'* (n. 23 above) 96–7, 98.

35 Vaughan, *Philip the Good* (n. 8 above) 148; Olivier de la Marche, *Mémoires* (n.12 above) II 64–79; Escouchy, *Chronique* (n.17 above) I 91–5; Chastellain, 'Lalaing' (n.18 above) 164–79.

36 *Ibid.* 73–89.

37 *Ibid.* 111–54; *Crónicas de los Reyes de Castilla* (ch. 3 n.49 above) I 656.

38 Olivier de la Marche, *Mémoires* (n.12 above) II 124–6; Chastellain, 'Lalaing' (n.18 above) 181–6.

39 Lester (n. 23 above) 103–117, 123–133; Sydney Anglo, 'Anglo-Burgundian Feats of Arms: Smithfield, June 1467', *Guildhall Miscellany*, 1965, 271–83.

40 Zotz in *RTM* 458–60; Wilwolt von Schaumburg (ch. 3 n. 55 above).

41 Joycelyne G. Russell, *The Field of Cloth of Gold* (London 1969) 105–141; Sydney Anglo, 'Le Camp du Drap d'Or', in *Fêtes et Ceremonies au temps de Charles Quint* ed. Jean Jacquot (*Les Fêtes de la Renaissance II*) (Paris 1960) 123–5.

42 Roy Strong, *Art and Power* (n.1 above) 91–4; Daniel Devoto, 'Folklore et Politique au Chateaux Ténébreux', in Jacquot (n. 41 above) 311–28.

43 Strong (n.1 above) 106–118.

44 *Ibid.* 53–4.

45 E. K. Chambers, *The Elizabethan Stage* (Oxford 1923) I 148.

46 Quoted from the *Essays* in D. J. Bland, 'The Barriers', *Guildhall Miscellany*, no. 6, 1956, 7.

47 Arthur Wilson, *The History of Great Britain* (1653) quoted in Roy Strong, *Henry, Prince of Wales* (London 1986) 153.

6. The Dangers of Tournaments 145–155

1 *Histoire des Conciles* (ch.1 n.16 above) V.i 729.

2 *Ibid.* V.ii 1102.

3 Saint Bernard to Abbot Suger, quoted in G. Duby, *Le Dimanche de Bouvines* (Paris 1973) 112.

4 Roger of Hoveden, *Chronica* (ch.1 n.30 above) III 202.

5 *Annales Monastici* (ch.2 n.8 above) I 271 (Burton annals).

6 Another interpretation might be that the three year period simply applied to the imposition of excommunication as a penalty and that at the end of three years tournaments would still be prohibited but with the usual penalty of withdrawal of the right to church burial.

7 *Concilia Magnae Britanniae et Hiberniae 1268–1349* ed. D. Wilkins (London 1737) II 437–8.

8 C. V. Langlois, 'Un mémoire inédit de Pierre du Bois', *Revue historique* (1899) 88–90.

9 *Corpus iuris canonici* ed. A. Friedberg (Leipzig 1881) II col.1215.

10 *Annales Monastici* (ch.2 n.8 above) III 51 (Dunstable annals).

11 *Foedera* I 301.

12 *MGH SS* XXIII 155–6 (*Chronicon Montis Sereni*).

13 *Materials for a History of Thomas Becket* ed. J. C. Robertson (RS) (London 1881) V 36.

14 Roger of Hoveden (ch.1 n.30 above) II 309.

15 Ralph of Coggeshall (ch. 2 n.1 above) 179; *Annales Monastici* (ch.2 n.8 above) I 119 (Tewkesbury annals); Dugdale, *Monasticon* VI.i 350, 351 (Wigmore chronicle).

16 *Durham annals and documents of the thirteenth century* ed. F. Barlow (Surtees Society CLV) (Durham 1945) 96–7.

17 *Le Tournoi de Chauvency* (ch.2 n.61 above) *passim*.

18 *Foedera* I 245–6.

19 Matthew Paris, *Chronica Majora* (ch. 2 n. 2 above) V 318–9. For later examples of the bishop of London's house being a lodging for tourneyers see *Chronicles of the Reigns of Edward I and Edward III ...* ed. W. Stubbs (RS) (London 1883) I 354–5; Froissart (n. 71 above) XIV 261ff.

20 René d'Anjou, *Traictié de la forme et devis d'ung tournoy* in *Oeuvres completes* ed. M. le comte de Quatrebarbes (Angers 1843–5) II 19.

21 Sotheby's sale catalogue 1 December 1970 (Major J. R. Abbey) lot 2894 (p. 82). We are grateful to Jeremy Griffiths for this reference.

22 Jacques de Vitry, *Exempla* ed. T. Crane (London 1890) 62–4.

23 Robert of Brunne, *Handlyng Synne* ed. F. J. Furnivall (Roxburghe Club) (London 1862) 79, 144–6.

24 Quoted in A. Lecoy de la Marche, *La chaire française au moyen age* (Paris 1886) 395–6.

25 John Bromyard, *Summa predicantium* (Nuremburg 1518) fos viii(v), xxix(v); xcii(r), cxci(r), cxci(v), ccviii(r), ccxli(r), ccxlii(v). Summary in G. R. Owst, *Literature and Pulpit in Medieval England* (Oxford 1961) 322–336.

26 *Ibid.* 333–4.

27 Bromyard (n. 25 above) fo. cxci(v).

28 Walter Map, *De nugis curialium*, ed. & tr. M. R. James, rev. C. N. L. Brooke & R. A. B. Mynors (Oxford 1983) 164–5; Thomas of Chantimpré, *Miraculorum et exemplorum memorabilium sui temporis libri II* (Douai 1605) II 444–7.

29 Quoted in Ruth Harvey, *Moriz von Craun and the Chivalric World* (Oxford 1961) 117.

30 Map (n. 25 above) 58–61; Bodleian Library, Oxford, MS Digby 11 fo.128(v).

31 *Les Chansons de Croisade* ed. J. Bédier (Paris 1909) 10, 32–3, 104, 139. The latter sentiments were echoed by Ulrich von Liechtenstein in his *Service of Ladies*; when his squire reproved him for declaring his intention to go on crusade to win his lady's love, Ulrich justified himself that God wished men to honour and serve womankind, and therefore he would not be angry with him (*Frauendienst* (ch.3 n.4 above) stanzas 1324–9).

32 *The Vision of Piers Plowman* ed. W. W. Skeat, (EETS) (London 1950) 296–7, 322–3, 326.

33 See for example Huon de Mery, *Le Tornoiement de l'Antechrist* (Reims 1851) 1–105; 'Le Tournoiement d'Enfer' ed. A. Langfors *Romania* 44 (1915–17) 511–58.

34 Humbert of Romans, 'De Eruditione Religiosorum Praedicatorum' in *Maxima Bibliotheca Veterum Patrum* 25 (Lyons 1677) Bk.II cap.lxxxv.

35 Geoffroi de Villehardouin, *La Conquête de Constantinople* ed. M. Natalis de Wailly (Paris 1882) 4–6; *MGH SS* XXIII 937 (Chronica Alberici monachi Trium Fontium); J. J. N. Palmer, *England, France and Christendom* (London 1972) 185.

36 *Histoire de Guillaume le Maréchal* (ch.1 n.5 above) I 129.

37 Zotz in *RTM* 473, 486.

38 C. Devic & J. Vaissète, *Histoire générale de Languedoc* (Toulouse 1885) IX 528ff.

39 *Crónicas de los reyes de Castilla* (ch. 3 n.49 above) I 472.

40 Chrétien de Troyes, *Perceval* tr. Nigel Bryant (Woodbridge 1985) 52–3.

41 *Urkundenbuch Göttingen* (ch. 3 n.34 above) 260.

42 *Kölner Stadtrechnungen* (ch. 3 n.43 above) 321.

43 *Chronica ... Speier* (ch. 3 n.47 above) 827.

44 *Urkundenbuch der Stadt Strassburg* (ch. 3 n.45 above) 318.

45 Carl Theodor Gemeiner, *Reichsstadt Regensburgische Chronik* (Regensburg 1800–24) III 61–2.

46 *Basler Chroniken* (ch. 3 n.46 above) V 62, 120.

47 Gemeiner, *Regensburgische Chronik* (n.45 above) II 297–301.

7. Tournament Armour 157–167

The outlines of the development of armour throughout the period have been drawn almost entirely from Claud Blair, *European Armour c.1066–c.1700* (London 1958); supporting evidence has also been taken from C. H. Ashdown, *British and Foreign Arms and Armour* (London 1909) and R. C. Clephan, *The Defensive Armour and the Weapons and Engines of War of Medieval Times and the Renaissance* (London 1900). These sources, which are invaluable for the study of armour, have not been cited in the notes, but the text owes much to their definitions and examples. No specific study of tournament armour exists, but Blair devotes a useful section of his book to it.

1 See for example the episode where Parzival is obliged to wash the grime from his face after combat: Wolfram von Eschenbach, *Parzival* ed. & tr. H. M. Mustard and C. E. Passage (New York 1961) 166.

2 *Histoire de Guillaume le Maréchal* (ch.1 n.5 above) I 11, 3102ff.

3 See pages 53, 55, 59.

4 Matthew Paris, *Chronica Majora* (ch.2 n.2 above) II 650.

5 Thomas of Chantimpré, (ch.2 n.28 above) II 446–7.

6 Matthew Paris, *Chronica Majora* (ch.2 n.2 above) V 557.

7 'Copy of a roll of purchases for a tournament at Windsor Park in the sixth year of Edward I', ed. S. Lysons, *Archaeologia* First Series XVII (1814) 302–5.

8 Bodleian Library, Oxford, MS Eng. Hist. B 229, fo. 4; Antoine de la Salle in *Traités du Duel Judiciaire* ed. B. Prost (Paris 1872) 210–11.

9 Blair, *European Armour* 157.

10 British Library MS Additional 46919 fo. 86v–87r.

11 Jean, sire de Joinville, *Mémoires*, ed. M. F. Michel (Paris 1859) 96.

12 Blair, *European Armour* 157.

13 See for example 'An armourer's bill', temp. Edward III' ed. H. Dillon, *The Antiquary* XX (July–December 1890) 150.

14 *Ibid.*

15 F. Buttin, 'La lance et l'arrêt de la cuirasse', *Archaeologia* 99 (1965) 77–178, esp. 102.

16 'An armourer's bill' (n.13 above) 150. This is by no means the only mention of grates, the inventory of Roger Mortimer's effects, compiled in 1322, lists one, and there are other examples. See 'An inventory of the effects of Roger de Mortimer', ed. A. Way, *Archaeological Journal* XV (1858) 359.

[17] 'An armourer's bill' (n.13 above) 150.

[18] 'An inventory of the effects of Roger de Mortimer' (n.16 above) 359.

[19] British Library, MS Stowe Charter 622.

[20] British Library, MS Additional 21357 fo. 4.

[21] 'An inventory of the goods and chattels belonging to Thomas, duke of Gloucester', ed. Viscount Dillon and W. H. St John Hope, *Archaeological Journal* LIV (1897) 305.

[22] Truffi (ch. 3 n. 25 above).

[23] *Deutsche Privatbriefe* (ch. 3 n. 52 above) I 87.

[24] Rodriguez de Lena, *Passo Honroso* (ch. 4 n. 67 above) 368.

[25] Although footsoldiers seem to have disappeared from the lists as a result of the growth of customary rules, they were also banned by decree, as in the English *Statuta Armorum* of 1292.

[26] *Florilège des Troubadours* ed. A. Berry (Paris 1930) 360, quoting the Monk of Montaudon, who was writing at the end of the twelfth century.

[27] *Histoire de Guillaume le Maréchal* (ch. 1 n. 5 above) I ll. 1310–12.

[28] Matthew Paris, *Chronica Majora* (ch. 2 n. 2 above) V 318–9.

[29] See the accounts of the jousts at St Ingelvert (pp. 42–3 above) or at the 'Pas de la Fontaine des Pleurs' (p. 118 above).

[30] *Du Costume Militaire des Français en 1446* ed. René de Belleval (Paris 1866) 1–12.

[31] René d'Anjou (ch. 6 n. 20 above) II 13.

[32] Antoine de la Salle (n. 8 above) 193–221.

[33] Cripps-Day, 111 & n. 2.

[34] *Deutsche Privatbriefe* (ch. 3 n. 52 above) I 87.

[35] *Ibid.* I 118.

[36] *Ibid.* I 316.

[37] Chastellain, 'Lalaing' (ch. 5 n. 18 above) 195.

[38] *Cartulaire des comtes de Hainaut* ed. Leopold Devillers (Brussels 1881) V 627.

8. Tournaments as Events 169–208

[1] Lucien Clare, *La quintaine, la course de bague et le jeu des têtes* (Paris 1983) 63.

[2] *Hechos de Miguel de Iranzo* (ch. 4 n. 76 above) 73.

[3] Wirnt von Gravenberg, *Wigalois* quoted by Jackson in *RTM* 264n. For discussion of the *bohort* in Germany, see Jackson in *RTM* 263–6; for Italy, see Szábo in *RTM* 354–5; for its later forms, Barker, *Tournament in England* 148–9.

[4] *La règle du Temple* ed. H. Curzon (SHF) (Paris 1886) 184.

[5] *Annales Ceccanenses* quoted by Szábo, *RTM* 354n.

[6] *Annales Veronenses*, quoted *ibid.*

[7] Ramón Lorenzo, *La traduccion gallega de la Crónica general y de la Crónica de Castilla* (Orense 1975–7) II 253–4.

[8] *CDS* XIX, *Lübeck* I (ch. 4 n. 83 above) 102–3.

[9] *Los fueros de Aragon* (ch. 4 n. 41 above) 139.

[10] *Archaeologia* XVII (ch. 2 n. 17 above) 303.

[11] La Marche, *Mémoires* (ch. 5 n. 12 above) III 163.

[12] 1375 encounter: du Cange, *Glossarium* (ch. 1 n. 10 above) I 713. For the information about Nequam's text, we are indebted to Tony Hunt's forthcoming *Teaching and Learning Latin in the Thirteenth Century*.

[13] Ortwin Gamber in *RTM* 530.

[14] Truffi (ch. 4 n. 25 above) 71–72n.

[15] *Chronica Monasterii de Melsa*, ed. E. A. Bond (RS) (London 1868) i. 279

[16] J. de Mailles *The Right Joyous... History of... Chevalier Bayard* tr. Sara Coleridge (London 1906) 84–86 (ch. xxiii)

[17] *The Chronicle of James I, King of Aragon... (written by himself)* tr. John Forster (London 1883) 387

[18] Froissart (ch. 5 n. 71 above) IV 44–6.

[19] *Ibid*, VI 22.

[20] See ch. 4 n. 27 above.

[21] See ch. 1 n. 20 above.

[22] John of Marmoutier, 'Historia Gaufredi Ducis Normannorum...' in *Chroniques des comtes d'Anjou* ed. L. Halphen & R. Poupardin (Paris 1913) 180.

[23] *MGH SS* IX 711, 731 (*Continuationes Kalendarii Zwetlense*); XVIII 724 (*Annales Parmenses Maiores*).

[24] *RIS* XIV 1141 (*Annales Cesenates*).

[25] Ramon Llull, *The Boke of the Ordre of Chyvalry* tr. William Caxton, ed. A. T. P. Byles (EETS 168) (London 1925) 75.

[26] *RIS* XXIV. xiii 124f, 141 (*Cronica di Mantua*).

[27] Molmenti, *La Storia di Venezia* (ch. 4 n. 5 above).

[28] Thomas, *Service of Ladies* (ch. 3 n. 4 above) 15–16.

[29] See ch. 4 n. 44 above.

[30] *Königssaaler Geschichtsquellen* (ch. 3 n. 2 above).

[31] *RHGF* XIV 445 (Lambert of Ardres).

[32] *MGH SS* XXV 480 (*Chronicae principum Saxoniae*); XXV 546 (*Balduini Ninovensis Chronicon*)

[33] See ch. 2 n. 13 above.

[34] Matthias Neuwenburg, *Cronica* (ch. 3 n. 32 above).

[35] *Petite chronique française de l'an 1270 à l'an 1356* ed. M. Douet d'Arcq (*Mélanges publiés par la société des bibliophiles françois* III) (Paris 1867) 18–20.

[36] *Politische Correspondenz des Kurfürsten Albrecht Achilles* ed. Felix Priebatsch (Publikationen aus den K. Preussischen Staatsarchiven 67) (Leipzig 1897) II 254–7.

[37] Gemeiner, *Regensburgische Chronik* (ch. 6 n. 45 above) II 474.

[38] *Die Geschichte... Wilwolts von Schaumburg* (ch. 3 n. 55 above)

[39] *Hans Burgkmaiers Turnier-Buch* (ch. 3 n. 59 above) 61ff.

[40] John Aubrey, *The Natural History of Wiltshire* ed. J. Britton (Devizes 1847) 88.

[41] *Inventaires mobiliers des ducs de Bourgogne* (ch. 2 n. 81 above) II 409, 415, 483.

[42] *PL* CLXXXV 157 (*Life of St Bernard of Clairvaux* by William of St Thierry c. 1140–5).

[43] Vale, *Edward III* 172; *MGH SS* XXX 608 (*Cronica Reinhardsbrunnensis*).

[44] *Kölner Stadtrechnungen* (ch. 3 n. 43 above) 37n.

[45] Truffi (ch. 4 n. 25 above) 146–150.

[46] Folgore di San Gemignano, (ch. 4 n. 7 above) 13–14.

[47] René d'Anjou (ch. 6 n. 20 above) II 16.

[48] *Eulogium Historiarum* (ch. 2 n. 39 above) III 227.

[49] Ludwig Rockinger, *Briefsteller und formelbücher des eilften bis vierzehnten Jahrhunderts* (*Quellen zur bayerischen und deutschen Geschichte 9.i*) (Munich 1863) 162.

[50] *Annales Monastici* (ch. 2. n. 8 above) III 216–8.

[51] *Chroniken der schwäbischen Städte: Augsburg I* (*CDS* IV) (Leipzig 1865) 54.

[52] Richard Barber, *Edward Prince of Wales and Aquitaine* (London 1978) 184.

[53] *Urkundenbuch der Stadt Göttingen* (ch. 3 n. 44 above) 234–5, 258–60, 291–2.

[54] Vale, *Edward III* 25.

[55] Theodor Hirsch, 'Ueber den Ursprung der Preussischen Artushöfe', *Zeitschrift für preussische Geschichte* I, 1833, 1–32.

[56] Munich, Staatsbibliothek MS Cgm 1930, fos 5v–6.

[57] René d'Anjou (ch. 6 n. 20 above) lxxviii.

[58] Jackson in *RTM* 55.

[59] Pero Tafur, *Travels* (ch. 3 n. 56 above) 208–9.

[60] Wilwolt von Schaumburg, (ch. 3 n. 55 above) 48–52.

[61] Meyer-Hofmann, 'Psitticher und Sterner' (ch. 3 n. 29 above) 18.

[62] Karl-Ludwig Ay, *Altbayern von 1180 bis 1550* (*Dokumente zur Geschichte von Staat und Gesellschaft in Bayern* I.ii, Munich 1977) 230–1.

[63] Alfred Friese, 'Die Ritter- und Turniergesellschaft mit dem Esel', *Archiv für hessische Geschichte und Altertumskunde* XXIV, 154ff.

[64] Werner Meyer, *RTM* 506–8.

[65] Priebatsch, *Albrecht Achilles* (n. 23 above) III 47.

[66] *Deutsche Privatbriefe* (ch. 3 n. 53 above) I 187

[67] *Ibid.* I 240.

[68] Printed in L. A. von Gumppenberg, *Die Gumppenberger auf Turnieren* (Würzburg 1882) 125–131.

[69] *RHGF* XV 511 (Letters of abbot Suger).

[70] Geoffroi de Charny, 'Demandes pour la jouste...' Brussels, Bibliothèque Royale Albert Ier, MS 11125, fos 41–50v; Jean Rossbach, 'Les demandes pour la jouste, le tournoi et la guerre', unpublished thesis, Université Libre de Bruxelles 1961–2. A copy is deposited in the Bibliothèque Royale Albert Ier.

[71] Meyer-Hofmann, 'Psitticher und Sterner' (n. 61 above) 18 n. 82.

[72] *Die Gumppenberger auf Turnieren* (n. 68 above) 62–66.

[73] Sir John Tiptoft, 'Ordinances, Statutes and Rules' in Cripps-Day, xxvii ff.

[74] Sidney Anglo, 'Archives of the English Tournament: Score Cheques and Lists', *Journal of the Society of Archivists* II, 153–62.

[75] Molmenti, *La Storia di Venezia* (n. 14 above) I 189.

[76] *Endres Tuchers Baumeisterbuch der Stadt Nürnberg*, ed. Matthias Lexer (*BLVS* LXIV) (Stuttgart 1862) 255.

[77] Russell, *The Field of Cloth of Gold* (ch. 5 n. 41 above) 110–2.

[78] *Crónica del halconero* (ch. 4 n. 60 above) 19.

[79] Vaughan, *Philip the Bold* (London 1962) 183.

[80] *The Travels of Leo of Rozmital...* tr. & ed. Malcolm Letts (Hakluyt Society Second Series CVIII) (Cambridge 1957) 173.

[81] *RHGF* XIV 570 (Gislebert of Mons).

[82] Blair, *European Armour* (note to ch. 7 above) 61 & n. 8.

[83] J. F. Verbruggen, *The art of warfare in western Europe during the Middle Ages* tr. S. Willard & S. C. M. Southern (Amsterdam 1977) 38–9.

[84] W. H. Jackson in *RTM* 376.

[85] Barker, *Tournament in England* 173.

[86] Gamez, *El Vitorial* (ch. 2 n. 80 above) 142–4.

[87] René d'Anjou (n. 34 above) lxxiii.

[88] La Marche, *Mémoires* (ch. 5 n. 12 above) 142–4.

[89] *Deutsche Privatbriefe* (ch. 3 n. 52 above) I 50–51.

[90] J. Macek in *RTM* 376.

[91] Pero Tafur, *Travels* (ch. 3 n. 56 above) 178.

INDEX

Back endpaper: the arrangement of the lists and stands: the central stand is for the judges. The double fence arrangement is carefully shown, with sliding bars at the entrances, and the ropes already in position for the start of the tournament. From René d'Anjou's treatise. (Bibliothèque Nationale MS Fr 2693 ff.34v–35)

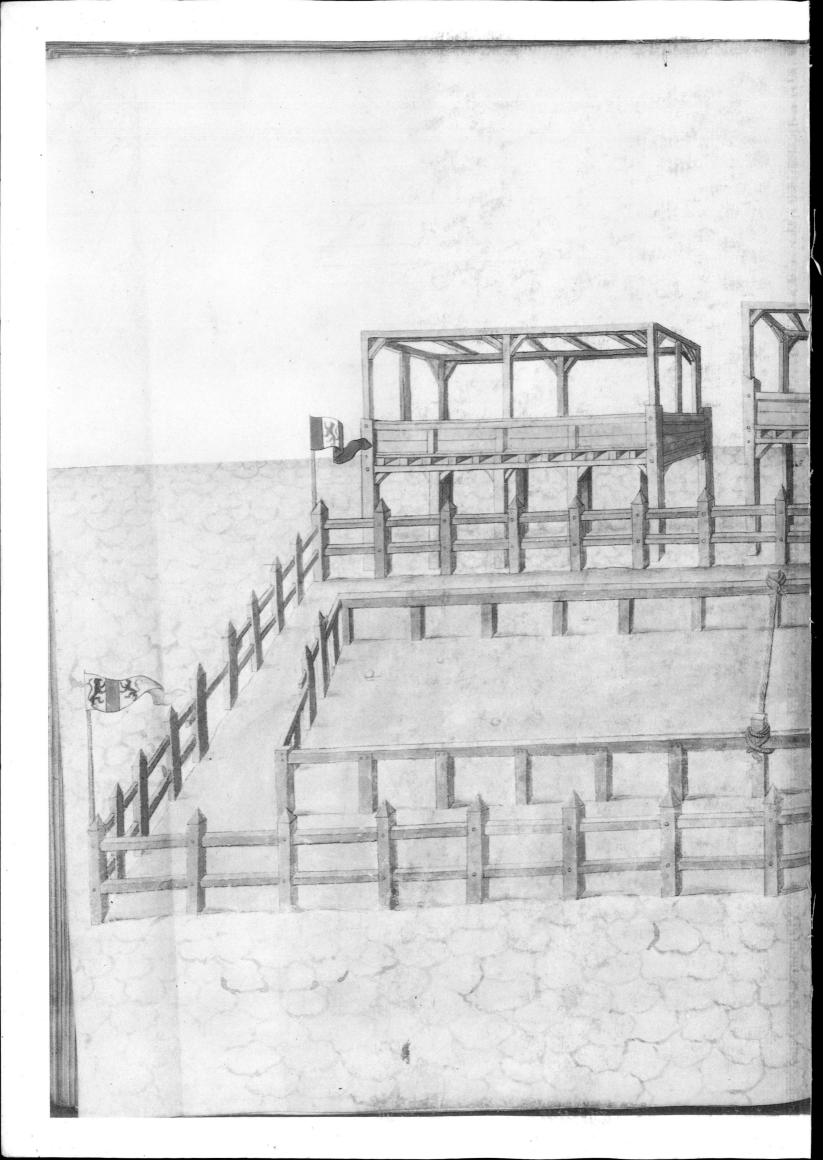